WHERE
THE CYPRESS
RISES

Virginia Ryan was born in Australia, and attended the National School of the Arts in Canberra, where she then briefly taught photography before moving to Egypt in 1982. She later trained in art therapy at the Edinburgh Faculty of Art Therapy in Scotland. She is a professional artist, exhibiting frequently in Italy and abroad. A fluent Italian speaker, she has spent many years, including during childhood, in different regions of Italy.

Virginia writes passionately about issues such as dispossession, exile and a search for a true base, which she sees linked not only to her own peripatetic career and life of travel in countries as varied as Egypt, Brazil, Yugoslavia, Scotland and Italy, and from late 2000, Ghana, but with the need for a spiritual, psychological and material 'place' within every one of us. These issues, constant in her art-making, became prominent during the years in the early 1990s when she lived in Belgrade and witnessed the breakup of the former Yugoslavia. Her studies in art therapy have been of lasting influence in how she sees this linking with the need to create an internal 'home' and safe place.

Her book grew spontaneously from a diary. *Where the Cypress Rises* is a tapestry of feeling and observation that graphically describes the conflicting emotions involved in leaving one place and beginning again in another. This theme, and that of the similarities and differences of the experiences of others, both foreign and native-born, are interwoven with an awareness of both the richness of culture and tradition in Umbria and of the forces of change. The internal journey that we all, along with Virginia, undertake reveals that in the end nothing is safe, that 'home' is where we start from but can never really return to, and that change is the only constant.

WHERE THE CYPRESS RISES

An Australian Artist in Umbria

Virginia Ryan

Lothian
BOOKS

Acknowledgements

I acknowledge with thanks the permission of the authors, Roberta Restani and Don Pietro Elli from the Basilica of San Pietro, Perugia, to translate *La Bella Storia di San Costanzo*, as well as Don Martino, presently Abbot at the Basilica; and all the people of Trevi, both native- and foreign-born, who agreed to be part of the book, who told me their stories and put up with my endless questions; my agent, John Cokley at Strictly Literary; Felicity Drake; my Australian family, and most of all my parents, Patricia and Hugh Ryan; and my children Chiara and Julian, for all their understanding, a big thankyou.

Author's note

Although *Where the Cypress Rises* begins in 1995, in order to be faithful to the chronological diary form of the book, the years 1996 and 1997 have been compressed into one twelve-month period.

Thomas C. Lothian Pty Ltd
11 Munro Street, Port Melbourne,
Victoria 3207

National Library of Australia
Cataloguing-in-Publication data:

Ryan, Virginia, 1956– .

ISBN 0 7344 0135 3.

1. Ryan, Virginia, 1956– . 2. Artists, Australian –
Italy – Umbria – Biography.
I. Title

759.94

Design by Lynn Twelftree
Photographs: *front cover*, Domenico Pistola;
back cover, Chiara Izzo; *page iii*, Antonello Turchetti
Printed in Australia by Griffin Press Pty Limited

Travel arrangements
kindly sponsored by

cit
World Travel Group

For Giancarlo

Of this very joy of living, there is greater proof in Italy than elsewhere. Buildings, pictures and sculpture seem to be born, like the flowers by the roadside, to sing themselves into being. Approached in the spirit of their conception, they inspire us with the very music of life. No really Italian building seems ill at ease in Italy. All are happily content with what ornament and colour they carry, as naturally as the rocks and trees and garden slopes which are one with them. Wherever the cypress rises, like the touch of a magician's wand, it resolves all into a composition harmonious and complete.

— FRANK LLOYD WRIGHT (Berlin, 1910)

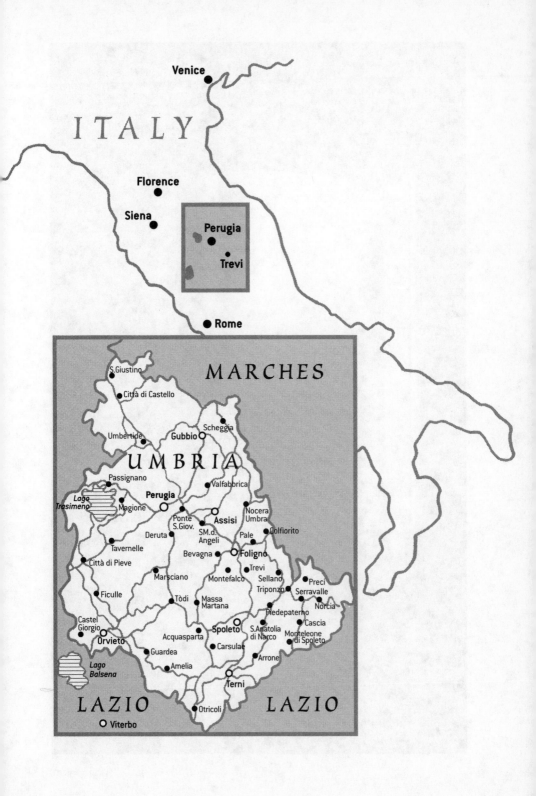

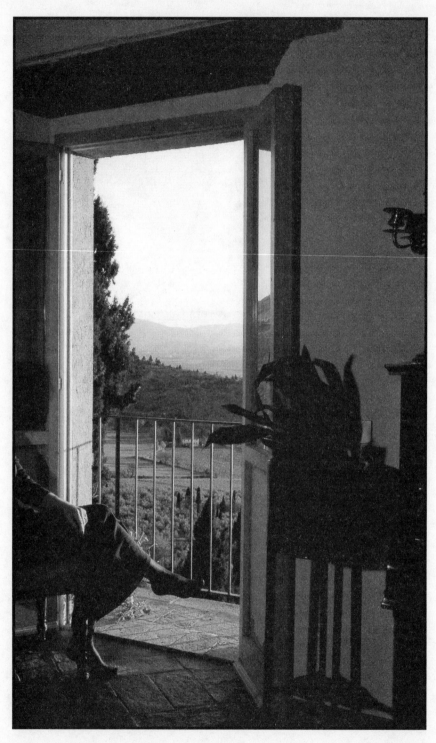

[Piero Gasparri]

Introduction

IT WAS MIDSUMMER. The afternoon's drowsy heat, scorched and peppery, spread itself across the Umbrian landscape. On far-off mountaintops storms were brewing, and distant thunder seemed to rise from a sun-struck earth, an incantation from other times. The endless journey from Edinburgh was almost over. At last.

The further south we had driven the previous week down Europe's highways and byways, the more each day had merged into the next, until finally dissolving into one interminable, soporific heatwave. We drove on as if in a trance towards the hill-town of Trevi, and cast aside travel weariness in the excitement of seeing our new home again. The object of our desires was an abandoned olive mill clinging to the edge of olive slopes on the outskirts of the town, purchased quite impulsively the previous summer.

One year on, recollections of the moment when we'd first left the ancient Via Flaminia and followed signs leading to this Umbrian village were becoming as hazy as a mid-summer's afternoon. Somehow the memories now seemed to belong to far-distant times, to someone else's dream.

Then, on yet another distant rise, I spotted the line of cypresses that rose from the valley and pointed towards 'our house'. They were already touchingly familiar trees, reproduced on a postcard saying 'Welcome to Trevi' that I'd stuck on my Edinburgh refrigerator with

a multicoloured cockatoo magnet some months before. On damp Scottish mornings, I'd peer at it as coffee brewed and raindrops dribbled down Victorian windowpanes, pleased our future world was to be so picture-postcard perfect — and so impossibly sunny.

It had been arranged with the builders that, on arrival in Trevi, my partner Giancarlo was to pick up the keys — our keys — that had been left with the landlady of the nearby guesthouse, tucked under the shade of a cluster of pines.

We followed directions and soon found the guesthouse, which turned out to be an impressive villa from the seventeenth century. It felt so good to arrive. When we opened the doors of the car, a shot of hot summer air hit us, the smell of dust, pink geraniums and sun-dried pine needles.

We knocked on the main door, and politely informed the rather stern-faced and very long-legged signora who we were.

She was almost as tall as Giancarlo, and nodded down at me from a great height. 'Ah, *si, si,* the people from Scotland — *dalla Scozia!* Welcome! You are here for the keys. *Le chiavi–*'

She disappeared inside, only to reappear within seconds, her manicured hand holding an impressive bundle — weighty, knobbly keys of iron, jangling from her bejewelled fingers. Giancarlo thanked her, and enquired if there were any rooms vacant, for we needed a place to sleep for the first night or two until we'd set up our holiday camp inside the walls of the Millhouse, our worksite on the other hill.

'Yes, you are in luck. I have room available. But then, after, you intend moving to that Millhouse with the *bambini*, the children?'

'Ah, you know the place, Signora?' I asked eagerly, for I was proud of our new acquisition.

'*Si.* Everyone does. But–' she took a deep breath, and added dramatically, 'it is a ruin, *una rovina!* You cannot take the children there!'

A dismayed look spread across her features as she gazed with pity at our children, Chiara and Julian, who were busy gazing in the other

2

direction, at the swimming pool. Then she glared briefly at me as if I was the archetypal bad *mamma*.

'We will decide that when we see how the work is going, Signora.' Giancarlo glanced across at me, and raised his eyebrows. The signora caught the look.

'Of course. *Certo*, certainly.' She tossed back her head arrogantly, lips closing tightly.

I turned away.

'Come over here, kids.' I put my arms around them protectively, reminding myself that we'd told Chiara and Julian this particular vacation was to be a fun-filled 'working' holiday. I'd primed them for clearing the garden and planting child-friendly sunflower seeds in Umbria's hard-working topsoil. And in the last few days, as Edinburgh faded into the distance, I'd spent hours consulting my faithful gardening encyclopaedia that I kept in the glovebox, and had begun to imagine quite magical transformations: everything from laying garden paths and creating alcoves under the olives to the finer aspects of interior decorating, 'Trevi style' — such as painting future bedrooms in the pink and light-blue tones once used by Umbrian peasants.

But a more pressing priority, of course, would be getting to know all those first things that make Italian communities familiar: everything to do with local customs, particularly festivities and food. Number one priority would be opening up lines of communication with local children who were, after all, our children's future school-mates. Surely Trevi's swimming pool and piazza would do the trick. It was just a question of time.

Everything had felt so possible, so natural really — until then, standing in front of the Signora. Turning back again and meeting her imperious gaze, I felt apprehensive waves breaking on hidden shores. But then, I told myself, that was nothing really. Given the investment in emotional and financial terms, a moment's doubt was to be

expected, after all. I banished my unease to the outer regions of my mind, and smiled confidently. I could be as arrogant as any Italian matron.

A truckload of supplies from the Edinburgh house had been sent over the previous week: mattresses, a table and chairs, kitchen utensils, gardening tools. Fired with enthusiasm, we couldn't wait to get started, to make our dreams come true. That was all we'd talked about these last few days! The Signora had no right to cast judgement, like some sort of family matriarch. What did she know, anyway? I was an artist, not some caricature of stuffy landed gentry, Italian style. I was not afraid to get my hands dirty.

She disappeared again, and came back with smaller, neater keys for our rooms. We dropped off our bags, to the children's disappointment ignoring the glistening blue water of the swimming pool, and climbed straight back into the car. 'Just one more time', I promised them.

We drove the last two kilometres across the hill towards Trevi at a snail's pace in order to soak up the view, which from that appropriately named road — the Panoramica — was spellbinding. The stone walls of the town before us appeared to glow in the soft, late afternoon haze so that all human construction seemed to have sprung from the earth and rocks on which it rested. It was all as quintessentially Umbrian as the first time we had come upon it last year. Still the same. It had been like this for centuries, after all.

'There's the house, Daddy!' squealed Chiara in delight, pointing across the valley. 'I remember it now! Look, that long one above the line of trees!'

Giancarlo stopped the car and we tumbled out, huddling together, squinting and pointing excitedly, like the tourists we used to be. Julian ran to the car, and came running back with his toy binoculars. I grabbed them, pushing them hungrily against my eyes. In the bleached light, towering over the roof-top of our Millhouse clutching

4

the next sweep of slope, I spotted a huge shiny crane, its metal shapes shimmering in the heat against the roundness of rock; a massive piece of machinery perforating the timeless Trevi skyline, implying major surgery. It looked so much more imposing — more threatening — than anticipated.

I squinted, attempting to focus my gaze, then handed the binoculars back to Julian who was protesting vigorously. 'Is that the house? It is, isn't it — the one with the crane?'

Giancarlo nodded. He didn't seem particularly surprised, I noticed with private relief, for in that moment a nasty realisation hit — that I didn't actually know what to expect. Of course we had known only too well of the many ancient, rotting beams needing replacement in the roof, and had agreed to get on with it from the safe distance of Scotland, but exactly what it all entailed was still not quite clear. I suppose until then the whole business had remained quite abstract.

Giancarlo stamped out his cigarette on the quietly sizzling bitumen, and climbed back into the car. He sat drumming his fingers on the dashboard. 'Come on, you lot! *Andiamo!* Otherwise it'll be too dark to see anything till tomorrow morning. Let's go.'

I called back, 'OK, OK, we're coming', and grabbed Julian's hand. We clambered back into the car.

As we drove off, the wise words of our Romanian friend Vasile, an architect living in Scotland, sprang to mind. A few years before, he had restored almost singlehandedly an abandoned church near Edinburgh, transforming it into a spacious picture gallery. One Sunday afternoon, while a group of us had stood admiring the handsome new beams, the restored ceilings covered in nineteenth-century religious imagery, he had reflected that a sensitive architect always approaches a building site much as an artist does paints, brushes and canvases — the raw stuff of creative work.

I fervently hoped Umbrian builders would have a similar approach, never having seen their working methods at first hand. So far, the

bulk of our negotiations had been faxed from Trevi to Edinburgh, backwards and forwards across the English Channel.

Giancarlo turned left, and proceeded up the little road known as the Road of the Mills until we reached the stone walls. The car came to a halt. We had reached our destination.

I looked at my watch. It was 5.30 p.m. — *le cinque e mezzo*. The building site was deserted. All the workmen must have gone home, or else were having an extra-long siesta. A yellow-disc sun, still emitting intense heat, floated above the horizon over the neighbouring town of Montefalco, famous for its Benozzo Gozzoli frescoes and Sagrantino wine. We parked under the sprawling fig tree that seemed to grow from the wall.

I stood by the car and stretched, freeing my body from days of forced immobility, and observed Giancarlo. He looked quite lighthearted. He was turning to me, pulling the house keys from his pocket like some sort of Neapolitan magician.

'Shall we take a look, then? *Diamo uno sguardo?*'

I smiled back, 'Might as well, I guess.' My voice was softer than usual.

Giancarlo playfully jingled the mass of clanking keys, carrying them as if gold, then slowly placed one in the rusty lock of the great wooden doors, where for centuries weatherbeaten men with mules and huge barrels of olives had come to press the oil.

Over the door a ceramic Madonna and child smiled down at us.

I winked up at her, and once again crossed my fingers, this time behind my back. I followed Giancarlo inside, into the cool darkness.

ζ

That's when things started to change — when everything became a before or an after.

Things seemed to fall apart, just like that.

Once inside I looked around. What was appearing before my eyes

surely couldn't be true — a vision of chaos and disorder. For what, only twelve months before, had displayed itself as a lyrical movement of interconnected, apparently solid storage rooms and internal courtyards now exposed its true self — a builder's battleground, where destructive forces had been let loose to create havoc all around. It was a very different place.

I stood stock still. Dust particles floated down from the rotting rafters and surrounded me, made visible by the last rays of light filtering through the windows. Remnants and rubble were strewn higgledy-piggledy all over the floor, amassed in dark corners. Huge wooden barrels, which for countless years had contained ripened olives awaiting pressing, dotted the devastated scenario. Each lay on its side like a wounded soldier, shrivelled and empty of fruit. I became uncomfortably aware that the expression plastered across my burning face was slowly changing from a quite tentative, but none the less delicious, anticipation to disbelief.

I turned to Giancarlo, wanting to cling, to melt into him. His lips attempted a smile, but the expression was forced — I knew him well enough to know that. His mouth froze mid-frame. So he felt it too, that strongly. He frowned, as if trying to make some sense of it all.

I suppose it was only a few minutes that passed, but it felt like an eternity as we groped around in the rubble and gingerly negotiated the dark and cobwebbed stairwell. A quite palpable sense of unreality, of dispirited apprehension, had tainted the mellow afternoon.

I climbed the stairs and stepped out onto the landing, only to be confronted with further damage. Looking up, my head reeled. The entire upstairs area of 500 square metres was roofless.

'Headless', I murmured to no one in particular, *sotto voce*. 'What the hell!' The absurdity of the situation almost made me laugh. For this was not a house. There was no shelter at all; just the pathos of crumbling walls supporting nothing under a slowly setting sun.

The crane's cold metal skeleton hovered over the vast blue-and-white emptiness.

We had all been jolted into a voiceless state. Even Chiara and Julian had become uncharacteristically quiet, acutely aware that this wasn't the image their mother had created of a happy-go-lucky indoor camping site; a safe place in which to dream summer dreams, to build a future.

I tried to think my way around what seemed to have happened, to escape the net, but my mind had gone entirely blank. We had consented to all necessary interventions, but the local Umbrian surveyor, subcontractor and builders had actually meant this? It would have been easier to start from scratch!

Giancarlo stood in a corner, his arms crossed, smoking nervously. I hated to imagine what thoughts were going around in his head. I said nothing, stood still for a while, then drifted aimlessly through the suddenly unfriendly spaces, feeling like a fly in a spider's web. I imagined myself sprouting wings, flying up past where the roof should have been — up, up, up, into the endless, bleached sky. And then I wondered if Giancarlo was avoiding looking at me, if he was angry at me for getting him into this in the first place. I could think of nothing to say. It all felt so desolate. So impossible. And so sudden. But surely this feeling of having made a big mistake wouldn't last!

Julian, being the youngest in our menage, recovered first. Having got the picture, he then exercised his young person's right to leave the problem with the adults and went exploring. He came upon old green bottles piled up in a corner, and within minutes began lining them up on the floor, one by one. Homecoming soldiers. He became absorbed in his game and oblivious to us as we shuffled about in the twilight. Chiara held my hand.

The air was charged with embarrassment. At least it seemed that way to me — as if, in a flash, Giancarlo and I had seen each other for

the first time as totally fallible, and I didn't like this at all. Deep down it occurred to me that we were acting out a cruel parody of present-day refugees, searching around for something to call our own, like the ranks of dispossessed we'd observed from the safety of our home in the early 1990s when posted to war-obsessed, belligerent Belgrade.

We stayed on, lingering, not knowing what to do or say, trying to come to terms with this unwelcome turn to our story.

Then, at a certain point, Giancarlo turned to me. He hesitated, 'It's a bit of a mess.'

I snorted. 'A bit? Why didn't they tell us? What shall we do now?'

I could hear my voice rising. I clamped my mouth shut. The words must not come out.

We sat down on the solid brick pavement. I felt myself crumbling into the floor, crumbling into the dust. Outside, beyond the walls, the sun was setting slowly. *Adagio, adagio.*

Was there to be no happy ending then? My heart beat wildly, like my own private tin drum. I placed a trembling hand over it, as if to hold the heartbeats in. Bereft of the roof above our heads, it was as if the earth had begun shifting underfoot, and I wanted to run, run and hide, anywhere; the desire to turn away was overwhelming. Turn away from the house, from Italy, from Giancarlo. Suddenly it was all too clear why no one had previously taken on the restoration of that sprawling, messy tumble of interconnecting rooms. It was an impossible task, unless one had a bottomless bank balance! I was seeing things as they really were for the first time. Why hadn't we seen it all before? No wonder the Signora at the guesthouse had been so critical. She was right. We were the fools.

Twilight darkened into night. Julian finished his game and came asking for water. There was none. 'We'll go now, don't worry', I told him. Chiara laid her head in my lap. Giancarlo smoked another cigarette, lost in his own thoughts. I felt for them. How could we have been so foolhardy, so shortsighted? And more to the point, what

might be salvaged? We were snared, and I wanted to find an escape route, a way back to my dreams. It occurred to me that I had never really felt trapped before.

I wanted terra firma beneath my feet, for that had been the quest. But everything was shifting.

¢

Tonight my heart continues to pound, keeping me awake.

I sit by the window at the guesthouse and stare at the big fat moon. Giancarlo is sleeping, and snores loudly, but I must come to terms with what has happened before I can find rest.

Since seeing our decapitated house this afternoon, a debris-ridden rubbish dump rather than an Italian paradise, I felt the rightness of moving here has lost all meaning. Just like that. It was all ridiculously fragile, then. Everything feels foreign again. But can I lose faith so very, very easily? Is there no substance here?

I run over the scene in my head, over and over. Outside, the moon disappears behind a cloud. I realise I am angry — really angry. But at whom, exactly? Suddenly even to envisage that headless room upstairs as a future sitting room, where in future winters we'll warm ourselves and all imaginary new friends by a blazing fire is totally absurd, I can see it now — a stupid outsider's fantasy.

It feels like an initiation gone wrong, or something similar. The before and the after.

I turn from the window and stare into the dark, trying to define the outline of Giancarlo's body under the crushed white sheets. He is still snoring, but more gently, ensconced in a different world. As my eyes follow the rising and falling of his chest, I wonder what temporary madness possessed us to bury our life savings in such a heap of rubble? I bite my lip. Why do perfectly rational people like us suddenly seem to go quite mad and do things like this?

What flight of fancy led us to sell our tiny apartment near Sydney

Harbour and an oversize Victorian terrace in Edinburgh to invest in a broken-down Italian ruin, where we have no connections, no friends and perhaps never will. And it's not a holiday house, after all. This is the real thing. This is real life. We are going to live here, and soon — in a matter of months.

I imagine what the workmen will think of us tomorrow, breezing in from Scotland with our delicate pot plants and elegant summer clothes, with half-baked notions about spending the summer among a heap of ruined bricks and stones, surrounding ourselves with layer upon layer of dust. They will disapprove of me. Their children and grandchildren would never play in the dirt, after all. They spend their holidays at Club Med, or escape the heat on pristine hilltops.

I lie down beside Giancarlo. I'd just have to fake it tomorrow; keep lit some spark of enthusiasm — for the children, for Giancarlo. And to trick myself. If for no other reason, then for pride's sake.

When I close my eyes, clouds of powdery dust seem to float under my eyelids. It is hours before I make my way to the other side, to a more restful place.

¢

Morning. Chirping birds fly over the Millhouse. Sternfaced as the Signora at the guesthouse, head held high, I drag the dirty orange hose past the workmen and down stone steps. I must water a ridiculously poignant collection of ornamental roses and heathers trucked over from Scotland last week.

Misfits. The plants and us. It is absolutely essential they survive, and if they can live in the Millhouse, so can we. Our credibility is mixed up in the whole messy fiasco, but it is absolutely essential not to cave in, whatever is happening inside the building and my heart. I cling to the need to appear above it all, just as hardy little rock-plants cling to these ancient stone walls.

There is an old workman who appears from somewhere in the

shadows, telling me with a twinkle in his eyes that he has taken care of the plants between their arrival by truck and our more recent appearance. Chiara listens intently. I thank him, and we shake hands. He walks away.

Then she says, 'That man's got a gentle face. He's old to be working here.'

I nod, and we watch him go. Knotted and gnarled like an ancient olive tree, shrivelling up with age, he positively radiates kindness, and embodies many of the best qualities of Italian workmen. There is a particular authenticity about him, as if he has never worn a mask.

I imagine that, although they would never show it, these polite workmen must think us romantic fools, typical city people with ludicrous notions about 'quality of life' in rural communities. And I have a burning sensation of being unmasked when he turns and smiles back at me. Flustered, I feel like a fraud.

Yet in his watery brown eyes, there is no trace of cynicism.

Later, upstairs, we find a bunch of *operai*, workmen, placing a great beam above us. The beginning of a new roof. But this morning it brings no relief. The beam feels more like a prison bar than protective covering.

Giancarlo calls up to them, and they yell something back cheerfully in dialect. I can't catch a word, damn it. This Umbro sounds so different! I sigh loudly. What I would give for a small, controllable apartment in a busy, uncontrollable Roman street! And to think I opted for this instead.

Hours later, I am appalled to hear myself whining with an inescapable hint of bitterness that it was one thing selling a vast ruin like this to dreamers like us with the roof on — after twenty years on the market — and quite another matter reselling it in this 'headless' state. That is, if we want to back out. Today I do. Is that my voice, are these my words? I don't want such whinings to nervously spill forth, for there are things best left unsaid. Giancarlo has a distant look on

his face. He lights yet another cigarette but does not answer me, will not be drawn into this potential battleground.

As if to pick a fight I then remind him, quite unnecessarily, that twenty years' savings — and years of future work — are invested in restoring these crumbling walls. He turns away from me, and stares out the window at the spread of fertile valley below.

As I stand there among the apparently broken remains of our dreams, staring up at the cloudless sky, I know there is no turning back, however much I might yearn. We are stuck with the Millhouse, and I'll just have to put all the pieces together again.

<div align="center">℘</div>

My love affair with Italy began when I was a child and first came to Europe. I can still conjure up a vivid image of my family stepping off the passenger liner, the *Achille Lauro*, in Genoa one blustery January morning in the 1960s. I remember the smells of the port, of ships and markets and city sleet, and it was then that I fell, hook, line and sinker.

Since then, there has been much coming-and-going in my peripatetic life: back to Australia, a holiday in Europe some years later, and leaving again in 1982 after marrying Giancarlo, an Italian diplomat, who on first meeting managed to overthrow my pre-conceptions of the diplomat mindset. Because I am an artist, I thought I'd be able to move my career with me — I thought I could have it all. And I wanted to get away from Australia, which at the time felt too confined, although later I realised that that was just the smallness of my vision. At the time I just wanted out.

Giancarlo and I had flown off together to Alexandria in Egypt in 1982, a city of illusions, of ghostly layers of dust and damask. *El Iskandrija*. There we had lived by the palm-lined corniche for nearly three years; Chiara was born, took her first steps, and said her first words in Arabic. My studio had been on the top floor, flooded with

Mediterranean light and salty sea air, high above the acrid smells that permeated street level. Way back then I had been happily ignorant of the inevitable tensions that arise when shifting across the planet, constantly shedding skins and replacing them with others. Everything glowed; life was full of endless potential.

From there we moved on to Rome, Brazil, Yugoslavia and Scotland. There, I reel the names off as if that's all they were, just names on someone else's map. Of course, it was never like that.

Trevi, then, is a relatively recent development. It became a possibility a few years back when, after interminable late-night discussions in Edinburgh, we decided that, while Giancarlo negotiated the Byzantine labyrinths of the Italian Foreign Ministry in Rome over the coming years, Chiara, Julian and I would aim for the so-called 'intelligent option'. We would find the sort of place stressed-out urban dwellers dream of, in which to live a more productive life, where perhaps I might have a big, light-filled studio, and Giancarlo could de-stress on weekends; where the children would get to know the 'real' Italy of the provinces. Our special place was to be far from time-devouring traffic jams; a haven where time was still one's own.

Last summer we had combed the area between Todi and Assisi in Umbria, then Grosseto and the Maremma ('cowboy country', where they still tell stories of Buffalo Bill) in Tuscany. We drove for days through a small world of quiet, unobtrusive towns basking in the diffused light and shadow of central Italy; the dignified leftovers of a more contemplative age. However picturesque, however much they might have delighted the senses of foreigners, no place had felt right. Too quiet, I thought; at least outside town walls. Giancarlo wanted some land, which meant generally a few kilometres or so from the village squares. I would go quietly mad in such places, for I was in no mood to disappear in some off-the-map backwater.

We had first arrived in what was to become our future home-town one hot July afternoon, around 5 p.m. when everything seems to

stand still. I was determined to squeeze in a visit to the Flash Art Museum in this place called Trevi before heading back to our hotel near Spoleto, for it was our last chance to get a dose of contemporary Italian art before driving back to Scotland. We had more or less given up the house quest and I wanted a bit of here-and-now culture. Too much of the past can become tedious.

It has always been a priority, wherever we are, to investigate what artists are doing in the here-and-now; otherwise I feel we're always looking backwards at Italy's Glorious Past. Italy is not only that. And we were due to drive back to Scotland the following morning.

We spotted signposts to Trevi from the Via Flaminia well before it came into view, perched above us, timeless and indifferent to the gaze of tourists whizzing by on their way to Assisi, or, in the other direction, to Rome. From a distance it appeared more intact than many other hill-towns, spreading itself generously around the hill above the olive fields.

While approaching, I consulted the guidebook, despite the children's groans. Trevi, it said, had begun as an Umbrian village, developing then into a Roman *municipium*. And there were different, more-or-less colourful theories on the origin of the town's name. In Roman times it was known as Trebia or Lucana Trebiensis. The simplest theory was that the name derived from the hill-town's proximity to a crossroad — the Trivium. Another far more appealing theory was that the area was inhabited by followers of the cult of Diana, the beautiful goddess of hunting, also called Diana Trivia. Yet the most credible theory was that the name sprang from the Umbrian word *trebiat*, meaning habitat, or small village. It is thought that the original settlement had been on the plain in the locality of Pietrarossa along an ancient byroad of the Flaminia. Pietrarossa still exists, and is now part of the greater Trevi commune. Yet there is also evidence of early habitations on the hilltop, near a temple dedicated to Diana,

that were probably a military encampment. During those times Trevi's location near the sacred springs of the river god Clitumnus (a couple of kilometres south) helped the town and surrounding location become quite sought after. Clitumnus was an important oracle, and in those days it was also possible to navigate the Clitumnus waters all the way to Rome, so that over the centuries the area became a popular holiday resort for stressed-out Romans. Even some of the Emperors had a soft spot for the place: Tiberius, for example, who built a theatre, and Caligula, who was in the habit of seeking advice from the river god before embarking on any major enterprise.

But all things come to an end, and when the Umbrians turned to Christianity quite early on, in the second century, Diana's temple on the hilltop was transformed into a Christian place of worship. It is still there, and is now the Cathedral of Sant'Emiliano.

During the fourth and fifth centuries waves of Gothic invasions and immense damage caused by recurrent earthquakes forced the long-suffering Trevani to abandon low-lying Pietrarossa and establish themselves once and for all on the hilltop. Those early inhabitants protected themselves with thick stone walls; none the less they were forced to survive between two quite formidable rival centres of power: Foligno to the north, and Spoleto to the south, until centuries later, in 1214, the Duke of Spoleto angrily razed the town. The tenacious Trevani reacted by developing a foreign policy of alignment with Perugia, which by then was challenging Spoleto as the capital of Umbria.

I put the book down, and stared out the window. There was always so much to learn about every little place in Italy. All the layers, the intrigue. We slowly zigzagged upwards through the olive groves. The earth looked so parched, like Australia, or Sardinia at the beginning of a drought. You could see rain had not fallen for weeks, leaving the stony hills barren. It seemed an unlikely place for a museum connected to such a well-known international magazine as *Flash Art*.

Later I learnt that the editor was born in the area, and still maintained close links with the town.

The American writer Nathaniel Hawthorne noted over a century ago that Trevi was in a strange situation for a town 'where I suppose no horse could climb, and whence no inhabitant would think of descending into the world after the approach of age should stiffen his joints'. Cars have obviously changed all that, but it still felt apart from the world, a long way away. Yet within minutes we approached the summit, and parked in a large, leafy square called, predictably, Piazza Garibaldi. We strolled through Trevi's narrow Via Roma, past the Teatro Clitunno, which looked very grand for such a small town, and entered the medieval Piazza Mazzini. There was one of those big plastic banners over a narrow alley on the other side, advertising the show of Italian artists we had come to see at the museum.

'It's that way!' I pointed, agreeing to stop at the bar for gelati before proceeding further.

Giancarlo took Chiara and Julian into the bar, Bar Roma, for he was in need of a strong coffee. I stayed in the piazza and cast my gaze around. In a corner I spied a *vetrina*, the local billboard for real estate. Although we had more or less tacitly agreed to give up the search for a while after too many disappointments, ingrained house-hunting habits propelled me to take a look.

'Old frantoio (mill), 900 sq. metres plus land', followed by a tempting price. There had to be a hitch, and yet it did sound like our sort of place. But then, so had so many others through Umbria and Tuscany. From what I could gather at the bar, the agent's address seemed to be right above where I was then standing, a tiny detail that dramatically changed everything from that day on, for we had nothing to lose in time or effort by hotfooting it up the stairs for a few more details. I grabbed Giancarlo, left the kids sitting at one of the outdoor tables to finish the icecreams, and up we went. Just for fun, I told him — just one last look.

The agent, handsome in a swarthy sort of way, welcomed us with a broad, cool smile. Then upon hearing which property we wished to view, he looked at us sceptically and sighed. '*Signori*, forgive me if I say so, but it's too big, a ruin! *Una rovina!* It's not for you. It needs a lot of work.'

I laughed, told him I was sure he'd be right, but wondered if we could have a quick look anyway. He sighed again, but agreed to take us down and, to Julian's delight, invited us all into his spiffy, shiny, red sportscar. We drove through a maze of back streets and alleyways, to an unnamed road just outside the bordering hamlet of Piaggia tumbling poetically down the southern hillside. There, we came on what could only be described as a typical Umbrian ruin — all crumbling bricks containing the stories of generations, torn apart by ivy, oozing atmosphere. I had to admit it did look a bit too much — too big, too much hard work, too much money to restore. But, as our handsome agent noted, it did have a couple of good points, besides the price: in easy walking distance of the Trevi centre, while gazing over a glorious vista of silvery olive groves. A winning combination, and, as we had discovered, exceptionally difficult to come upon.

The agent took out a bunch of great iron keys from his elegant leather portfolio. Engraved on them were the words 'Vecchio Molino', the Old Mill. He turned one in the lock of an oversize door. Directly above, a chipped ceramic Madonna and child smiled down from their niche in the wall. He courteously gestured for me to step first into the dark, musty interior. I placed my left foot on the threshold, and felt the freshness of the stone floor penetrate flimsy sandals. Through another doorway on the left, I spotted a massive granite olive-press in the next room, probably the first I'd seen so close-hand in my life.

I turned to Giancarlo and gasped, 'This is it!'

Giancarlo smiled at me. He knew me well. 'Can we have a look first?' he queried, his voice a mixture of affection and deep scepticism.

'Yes of course. But this is it, really Giancarlo, I just know it!'

Recollections of what we saw are too vague now, for the pictures in my mind have become entangled with what came to pass in the following year, and how the structure appeared after the works were complete. But we were overwhelmed by what we saw that day and naively felt the task of renovation was not beyond us, that we could probably stretch the budget. We were told what major work was entailed, but I for one did not actually realise how very major it was to be. *Mea culpa*, it's my fault! Looking back, it is clear that I had fallen ridiculously in love with the ancient walls, the view, the massive wooden beams, the fireplaces. Everything was as close to fantasy as reality could get. Our task was to act out the fantasy, breathe life into it. It was as if the house had been waiting for us.

A few minutes later, forcing our way through the prickly undergrowth on the rise behind the house, we were shown the hand-hewn stone walls of a little chapel half-buried in the hillside. This was an unexpected addition to the property, not mentioned on the faded paper on the *vetrina*. We could barely see the ancient stone walls, smothered as they were in dense blackberries. The agent dismissed it vaguely with a delicate fluttering of his stocky hands; he thought it was about 150 years old, and had been a family chapel.

'These little chapels are everywhere', he told us, and added with a chuckle, 'Remember, you are now in the land of saints, pilgrims and mystics.'

I wondered how many times he had said those words to other dreamers in the past. But he said it with a particular intensity that day — he knew we were caught, although I tried to appear nonchalant before him in order to keep some bargaining potential alive.

For the time being we had to be content with whatever small information we could glean on the church, the view, and those forty olive trees spread around the patch of land behind the Millhouse. It was a lot, after all.

Within an hour we were back at the agent's office near Bar Roma,

signing a deposit. Just to set the record straight, this was definitely not the way we usually went about things. But we could not delay our departure for Scotland the following morning, and back in Bar Roma we'd sniffed out village rumours of other eager buyers planning to transform it into a hotel. Whether the race was truly on, we'll never know. But it felt like it that afternoon.

The next morning we left Umbria, having signed away our future. And after all that, we hadn't even seen the Flash Art Museum, the only reason we visited Trevi in the first place.

On the trip back to Scotland we tried to remember what exactly we had seen inside the Millhouse, the layout of the building, the size of the rooms. Like a ship, I thought, spreading itself along the roadside. Long and narrow. We couldn't even agree on the number of rooms, and would have to wait for the map being faxed over the following week to know the answer. The inside had become a mysterious labyrinth, the slightly unreal embodiment of desires, the projection of our need to put down roots. Giancarlo and I were intoxicated by the building's potential, by the vaguely elusive, dreamlike nature of the whole event, and by our come-what-may recklessness. It flowed through us and into the children. Even Chiara succumbed to the enchantment, and began designing colour schemes for her future bedroom. She decided on sunflower yellow.

We felt on top of the world.

ℭ

Light and dark. Before and after. Now, just one short year later, everything is back to front, exposing a darker side. A cruel reversal — some petty tricks of the gods, wasting their time and ours — destroying good intentions, savings and dreams. Despair swamps me, despite the closeness of Giancarlo and the children. Flooding sensations of not belonging anywhere, of being disconnected. Of being in the wrong place at the wrong time. I tell myself sternly to stop being so melodramatic, but it makes no difference.

Way back at the beginning, half-hearted attempts had been made to imagine how such places might be in the coldest days of winter, which in central Italy can mean ice, snow and fog (it is much colder than the Umbrians let on). When I look around me now, I feel the cold chill of winter, despite today's summer temperatures. In the euphoria of discovering the Millhouse, it was as if Venus, so close to the sun, had enveloped us in her comforting mantle of beauty and love. I had imagined never feeling cold in my bones again, once ensconced within those massive protective stone walls. Now I can see that such a roofless ruin will never be a cosy refuge; no longer can I imagine myself snuggling up by a blazing fire with a good book and a glass of Rosso di Montefalco. All that had been some ridiculous caricature of rural bliss. Reality has brutally impinged.

Only a year ago it had been possible to visualise all those things — what has happened? What are we doing there? Our choice of the Millhouse means permanence, winter and summer, spring and autumn. Not just a place for holidays, but a place to live a life in, for the children to grow up in, to grow and blossom. It's terrifying to think that in a few months we will be moving down permanently from Edinburgh, even though I'm accustomed to moving, to starting again. I'd expected to feel delightfully smug at having escaped years of childraising in urban chaos; the image of being an artist in an Umbrian studio, I have to admit, had been powerfully seductive. But I've developed a bad case of soul-sickness. We have it all wrong!

Is it all about a roof? Roof, roots?

I can't now find the essential parts to anchor me, but whisper softly the ancient, empowering words '*Dum spiro, spero*, as I breathe, I hope'.

§

We have been here a few days now, but ever since revisiting our roofless ruin something bewildering is happening to my feet and hands. I have developed, literally overnight, a sort of heat rash all over

my left foot, which has suddenly become painful to walk on — a mass of minute bubbles erupting underfoot. For the last twenty-five years I have worn size 37 shoes — unbelievably, in the space of forty-eight hours my left foot has swollen to size 39. Two shoe sizes! When we make the daily pilgrimage up the Road of the Mills to liaise with the workmen, my foot is swaddled in bandages that are immediately coated in dust.

I hobble about like some worn-out, worn-down peasant; the part of me on which I stand, the base connecting me to the earth is like a map of seismic zones: breaks forming, skin cracking, crackling underneath. Sharp pains shoot up my leg, up my spine, straight to the heart. Like an arrow.

Temperatures soar, a heatwave all over Europe. Unable to sleep through the night, I am awakened constantly by the pounding of my heart breaking through the borderline of skin and bones — as if my physical substance were engaged in sabotage. There is a short circuit somewhere. While this incestuous battle rages, it seems I am forbidden to touch ground, this rocky patch of hillside that is now ours.

Despite the dust, I almost wish I could sleep in the Millhouse, in that great cavernous room downstairs that is home to the ancient olive press. Being built against the rock, at least it is always cool and fresh — but probably full of country mice, as the kids remind me while we sunbake by the pool at the guesthouse and I voice such desires.

Julian groans, pulls a face, jumps into the water. 'Mummy, you're strange. I wouldn't sleep there even if you paid me a hundred dollars. Yuck.' He climbs out and lies down on the hot tiles, his body glistening in the sun.

¢

Sleep! I am exhausted, afraid to close my eyes at night, for on the other side lurk night terrors. I awake suffocating; feeling we all might drown in an ocean of misguided choices. Gasping for air. Suddenly I

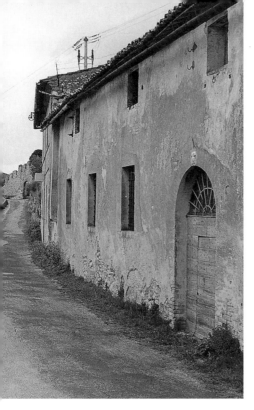

The Millhouse before restoration.

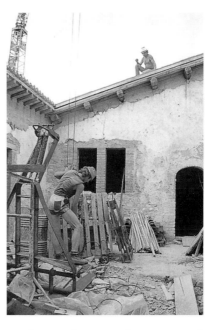

Workmen in the courtyard, once a covered stable for donkeys, horses and carts.

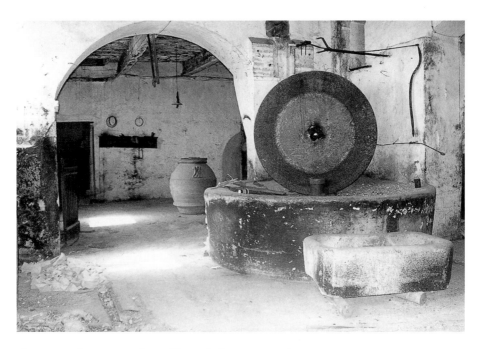

The ancient olive press in the Millhouse (before renovations).

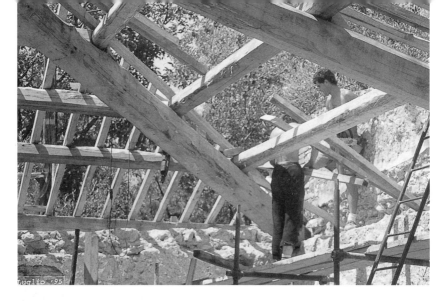

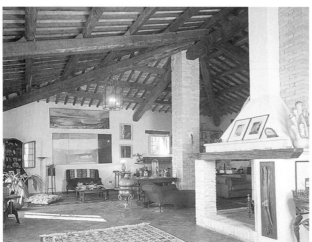

Putting the roof back on.

Partial view of sitting area,
once used for storing olives.
[Piero Gasparri]

Julian and Chiara running
through the sunflowerfields.
[Armando Gregori]

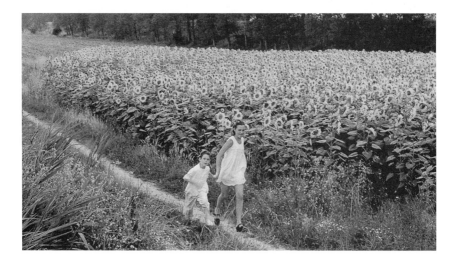

Sunday morning in
Via Roma, Trevi.
[Dino Sperandio]

Anne, at one of her first stalls.
[Afranio Metelli]

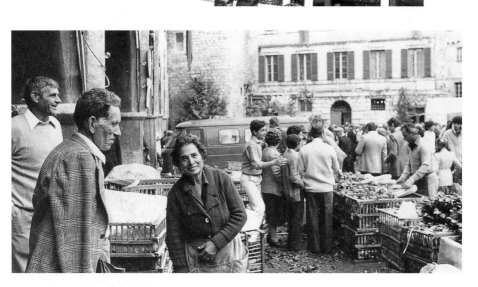

Black celery stalls in the Piazza del Comune. [Dino Sperandio]

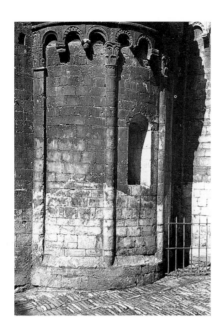

Romanesque detail of the Duomo.
[Vincenzo Giuliani]

Preparing for the annual procession of
Sant'Emiliano inside the Duomo.
[Dino Sperandio]

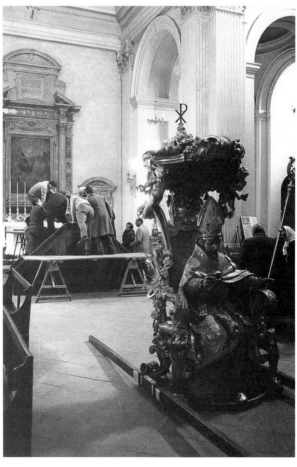

feel older, which is a new experience, for I have always felt so young.

As each bright summer day dissolves hazily into the next, the charade continues. I yearn to be transported anywhere, anywhere else; behind the maternal mask hides a traitor. I am in Umbria under false pretences, powerless, entwined in a plot that has become far too complex. Today every internal fibre secretly hates the house and 'jewel-like' Trevi. It is a fraud. I don't care what travel writers, romantics and tourist guides say. The magic has been blown away. If only I had enough courage to put a match to the lot. I crave cold, windy Edinburgh and our solid terrace in the West End — so safe, so unignitable; so reassuring, upright and solid.

¢

Late summer. The energy emitted from distraught nerve-centres is being channelled more and more into my left foot, which itches incessantly. Walking has become unbearably painful, as if daggers pierce the flesh each time I touch ground. Giancarlo has taken me to numerous medicine men: doctors, pharmacists, skin specialists. The car is brimming with plastic bags of depressingly ineffective potions. Nothing helps. I am losing my footing. Although still attempting the Herculean task of wearing a cheerful mask in front of the kids, the desire to turn inwards grows.

Searching too much for a base, a territory to call home, has only accentuated my alien status. That much I am sure of. Perversely, not being able to walk, I am losing the one base I already had. A sense of security built up systematically, year after year, is falling apart. I drift, falter, miss steps. It is becoming impossible to disguise the level of intensity. Chiara has seen through the charade. At night, before falling asleep she whispers in my ear, 'You can't turn back now, Mummy, just when things get difficult — it was you who wanted this'.

¢

23

A fortnight has passed, day after day of heat and heartburn and not being able to walk.

This morning I awake consumed by fever, and feel a left leg heavy as lead. Giancarlo places his warm hand on my inner thigh, the hot point of pain and feels the engorged gland — like a rock inside my skin.

'*Dio mio!* My God!' he exclaims. 'What is that?'

Perhaps I am being poisoned. Fear grips me, but my voice comes out calm and clear. 'I don't know. It hurts, though, and I don't think I can lift my leg. It feels strange — heavy. Let's find a doctor, quick.'

Giancarlo does not panic. We dress quickly, he takes the children down to breakfast; then I am bundled into the car, Chiara and Julian behind me. They know something is wrong. My forehead burns with fever. After an emergency visit to Spoleto hospital and being pumped full of antibiotics and jabbed with a needle of tetanus vaccine, we are advised to drive immediately to the city of Foligno, further north along the Flaminia, to consult a dermatologist who has been advised of our arrival. We pass Trevi on the way. I do not look up, but avert my gaze, sick to the core.

We reach the hospital. The dermatologist observes me in silence as I limp in on Giancarlo's arm. I feel the intensity of his gaze, as if he is my mirror. But his voice is soft when he asks if I have suffered some shock or bad news recently. His black curly hair and chubby, cherub face hover before me like an angel. The question hits a soft, tender place in my chest. I dissolve into tears, nod, feel released of some huge, heavy pressure.

He tells me that my left foot is full of water, 'blocked sweat', and, for Giancarlo's benefit, adds that he has seen something similar a couple of times over the years. Giancarlo stands slightly apart like a doubting Thomas, looking concerned, but understandably incredulous.

Folding his arms, eyes resting on me protectively, the doctor comments that it is symptomatic of an acute state of nervous tension.

'Signora, you cannot perspire because you are very stressed, very *nervosa*, very tense', he tells me. '*Si sente davvero cosi male?* Is it possible you feel so bad? May I ask what has happened to you? Do you really feel so bad?'

I stare at him. Is it possible, then? To feel so frightened, like nothing means anything, when only weeks ago life had been full of promises, possibilities — playful, even?

He stands on the shore as my waves break. I nod from the emergency bed, try to speak between sobs. He smiles encouragingly, reassuringly, during my bizarre tirade about a house without a roof.

'*Calma, calma*, there, there', he whispers, patting my hand. 'It will all be over soon.' For some reason I believe him.

Slowly, carefully, armed with a great gleaming syringe, he proceeds to draw a great puddle of water from the sole of my foot. As if a bubble had been burst, the sharp pain ceases immediately, like daggers taken from my side. I weep with relief.

I remember little else, but give up being conscious for a while, for now I am safe and can lose control.

For what must be hours, there is nothing. Somehow we arrive back at the guesthouse where the Signora, sniffing a drama, swings purposefully into action and keeps up a steady flow of comforting chamomile tea. Doctor's orders, Giancarlo tells me later. Whenever I awake, it seems that he or the children are there, always there. Sleep envelops me, like gently lapping waves, and I float in some vast, peaceful ocean for three days and nights.

¢

At some point I awake with a start, realising what an extraordinary somatic reaction to the need for 'home' has been acted out by my left foot, which rebelled, refused to touch the floor of our new home after the building had lain open and vulnerable — after being decapitated.

I sit up in bed. Was that what had happened then? I think of Primo

Levi. He said the creative act was one of making connections. Is this the connection I should make?

Chiara is playing nearby. Light filters through the windows, late afternoon light. She comes over to me and takes my hand.

'Mummy, are you all right now? I've been swimming, at the pool. Daddy's still there, with Julian.'

'Yes darling, I'm fine. What's the time?'

'I think about six. Do you want to get up now?'

'Not yet. I think I'll just sleep some more.'

I lie down, turn over. Chiara comes and lies beside me. She is hot, smelling of summer and lemon geraniums.

I close my eyes and think about the pain in my foot, about not having my feet on the ground, about not being rooted.

It is a strong connection, for apart from the questionable business of setting up and dismantling houses all over the place, I am an artist, a visual artist. And for years the visual content of my work, the images have been connected to notions of exile. Often actual footprints (mine, children's, friends') have wandered across the surfaces of my canvases — becoming over the last five years a recurring motif. It's as if finally one day, engulfed in non-belonging, my left foot really has manifested the emotions acted out previously on canvas; has declared its not-wanting-to-be-there. It is as if, on some deep psychic level, I have embodied one of my paintings. How strange. Not art reflecting life, but life reflecting art. What am I to learn from this?

I hear someone turn the shower on. Giancarlo is suddenly here, leaning over me. I look up at him and smile.

'How long have I been asleep? What's the time?'

Giancarlo laughs. He looks relieved. 'I never saw you stay still for so long. *Brava!* Good girl! It's 7 o'clock. Friday, mind you, not Wednesday or Thursday. Think you could make it down to dinner?'

¢

26

The days pass, somehow. First one week, then another. I look at my diary and see that there are only three days left before the return trip to Scotland and the Edinburgh Festival.

Bit by bit, our Italian building has begun to take on its new form. And it's such a relief.

Each of us will secretly be so glad to desert the building site, the sweltering heat and a guesthouse without air conditioning. And Scotland still feels like home — the familiar comforting Festival talk, book launches, exhibitions, and fireworks over the castle. That's my sort of place, my sort of life, not this endless digging around in the dirt and dust! I need to replenish my flagging spirits, to feed for a while on other people's boundless creativity. Back in the city we can slot in, and I suppose the weight of right-or-wrong choices will temporarily recede. It's hard to accept that we actually are cutting our 'holiday' short, but under such circumstances, who wouldn't? Giancarlo thinks it might make better economic sense to drive down again in October for another interim visit before D-day. I agree on the condition that Chiara and Julian remain in solid, no-nonsense Scotland.

Thankfully, miraculously, the roof is back on before we leave Trevi; that's essential for psychological wellbeing in these next few months! All the new beams and the ancient, baked *coppe*, the tiles, are back above our heads where they should be.

So, the Millhouse finally has its new head, and my foot is healing. I can touch ground. And things, as a consequence, are getting back into perspective. Meeting other foreign people who live here helps. A most capable, down-to-earth Englishwoman I met in Bar Roma a few days ago scoffed at me kindly when I told her about our traumatic renovations. With a powerful mix of British intonation and Italianate gesturing, she declared, 'But they put up those beams by hand as if they are knitting — you had nothing to worry about!'

Unbelievably, after such a nightmarish summer, the remaining few days of our stay have brought hints of passion for the Millhouse

sneaking back into conversations — come what may we have made our choice, and there is no easy way out. Giancarlo has not crumbled once; he is cooler, able to maintain a long-term vision. '*Sangue freddo*', he says, '*Sangue freddo*, keep cool.'

Keep cool! My feelings alternate, swing backwards and forwards like a pendulum, highs and lows. But in these remaining days a conviction grows that this might be some obligatory rite of passage; some sort of initiation. I can see that the falling out of love with our dream home has been far too brutal. Looked at in the cold light of morning, it is as over-the-top as the first step: the falling in love. Like all love stories, it couldn't possibly sustain that level of intensity.

We pack our bags and decide what clothes can stay behind in the Millhouse, and I leave them in a bag in a corner of my future bedroom on our final visit. I look around me, at the bare walls and through the window. The view never changes. I feel twitches of enthusiasm resurfacing from some inner reservoir. Perhaps the potential is still intact, but I can't quite trust it. Not yet. It's too up and down, and I'm tired, tired of being trusting, tired of being tossed upon such stormy seas, tired of protecting the children from negative thoughts.

Still, there have been some curious, happy interludes. A few nights ago we were told of the opening of a retrospective of paintings by a German painter who has become an adopted 'Trevano'. He told me that there were many foreigners in the area, and a number of writers and artists. Then he ceremoniously led us under the Teatro Clitunno to a series of large rooms that appeared to service a variety of the town's needs — exhibitions, dances, the occasional big collective dinner — where we came upon a large crowd looking at his work. The atmosphere was festive. We were introduced to a local historian, and struck up a conversation. I asked him if he had any information on the chapel in the garden, which had almost been forgotten as our attention focused on future kitchen and bedrooms.

He nodded. 'Of course! The Chapel of San Costanzo, built around the end of the last millennium!'

Giancarlo laughed. 'I think we are talking of two different places.'

But the historian shook his head confidently. 'No, no! I know the chapel well, and that you have bought the Millhouse nearby! You know, St Costanzo is one of the three patron saints of the city of Perugia. It is his little church you have — you are now the guardians. There are many stories about him — stories and legends, really. When next you come back to Trevi I will make sure there will be some more information waiting for you.'

We are reassured, excited by this new information. A good omen. Something is stirring then — something life affirming. My foot is much improved, and I can walk and wear shoes again.

§

Once back in Scotland, we kept up daily communication via fax with the builders and the surveyor. The business of living rolled along and I tried not to think of uprooting until it became unavoidable.

Then, in late October, Giancarlo and I drove back to Italy for ten days as planned. Once in Trevi, we still couldn't sleep at the house, although we set up a couple of bedrooms with camping gear sent down with the pot plants the previous summer. I was disappointed, but there really was too much wet plaster. The place still felt damp, although the workmen assured us it was just a matter of days.

We were relieved to see that some of the rooms had finally taken form, and Fabio, the painter, was busy varnishing wooden rafters; I watched him climb his great ladder and seem almost to cling to the walls like a monkey. How did he do that?

The long-suffering heathers had died, but no longer did I feel our survival dependent on theirs. One bathroom was even functioning, with its very own claw bath from Edinburgh, which fitted in perfectly. A selection of odd porcelain plates, cups and saucers sat on a shelf in

anticipation of the arrival of Mike, a painter from Edinburgh, who was coming to house-sit for us until December, to warm the house for us, to make it a human place.

One evening as Giancarlo and I stepped out arm in arm for the ritual *passeggiata*, squeaky clean after washing away dirt etched into hands spent cleaning down at the Millhouse, we came upon Franco, the historian, again, not surprisingly, for the Trevi piazza was still the focal point of local life. He spotted us too, waved, separated himself from huddles of friends under the porticoes, and came over to greet us. It was good to see a familiar face. We shook hands warmly. He told us that he had not forgotten his promise regarding the chapel, and that he had some interesting information to hand over. Giancarlo suggested we eat together the following night.

So the following evening, Giancarlo's birthday, Franco and his wife Mariella joined us up at the hotel, where we sat down to a feast of black celery, a Trevi speciality during the harvest month of October. As we admired the plump stalks full of spicy meats, Franco told me that the next year, once we had settled into local life, we would be treated to a vast array of medieval re-enactments, cart-races and food feasts spread throughout the month, under the umbrella title of Ottobre Trevano.

It seemed, then, that little Trevi was quite a lively place, which suited us just fine, even if I had no idea if I would truly warm to all these grass-roots, local community goings-on. It would be fun to find out, anyway, and it sounded great for the kids. It was all very well moving from the city, but I had no intention of feeling myself buried alive. I stored up Franco's tales for Chiara and Julian.

For the moment though, Giancarlo and I were far more hungry for information on St Costanzo — our resident saint. As we sipped our spumante, Franco placed a small bundle of photocopied pages on the table. On the top sheet was written:

Durastante Natalucci
HISTORIA UNIVERSALE DELLO STATO TEMPORALE
ED ECLESIASTICO DI TREVI
1745
[Universal history of the Temporal and Ecclesiastic State of Trevi]

For us, then, a strong personal connection with local history was being forged. The proof was there on the dinner table. Once again the sensation of having been thrust into something unexpected, larger than life, moved through me. As I leafed through Natalucci's writings, it was as if the link was reinforced between the chapel, the house, the earth, Trevi and us.

Franco leaned over, and read out loud:

San Costanzo, vescovo di Perugia e martire di Trevi; il quale, al parere di vari autori, condecorò il suolo Trevano con il suo sangue venendo decapitato l'anno 175 nella costa dove ora è la chiesa del suo nome, non lungi dalla porta del Cieco; dicendole il Blovio (Hist. ecles. an. 175, n.3) 'Tandem capite apud Trebium est'. Ed il Pellini (Ann. an. 173, f. 94) 'Il trebbio nel quale detto Santo morì' fosse ove ora è la terra di Trevi.

[St Constanzo, bishop of Perugia and marytr of Trevi; who, according to various authors, blessed the soil of Trevi with his blood, being decapitated in the year 175 AD on the hillside where there now exists a church bearing his name, not far from the Blind Man's arch; of which Blovio (ecclesiastic history of the year 175, n.3) wrote 'The head is to be found in Trevi. Pellini (annual of 173, p. 94) also wrote of 'The Trevi where the saint died', where now stands the township.]

- So St Costanzo, early Bishop of Perugia and now one of the patron saints, may have been martyred there where the chapel stands on our garden slope. Martyred by decapitation. An image of the house without its roof flashed before me, so that from that moment the

death of Costanzo and the re-covering of the Millhouse became irreversibly connected.

Franco mentioned that Natalucci, a local historian, had written that our little church was ancient in structure, with an arched roof and only one altar, built with squared stones, and that it was a parish church for five centuries. Then in 1573, the lands around the Millhouse and chapel, called the 'Costarella', had been incorporated into the parish of St Emiliano, patron saint of Trevi, whose cathedral still rose at the highest point of the town, over the remains of Diana's temple. Giancarlo and I were equally excited by these discoveries, although, as was our way, I projected outwards my enthusiasm while he, by nature more understated, sat back and chatted quietly to Mariella.

¢

On our last day in Trevi, some minutes after the electricity had finally been switched on, our painter friend, Mike, arrived by bus from London — stiff, crumpled and hungry, looking a bit like a pilgrim. It was strange to see him here in Italy rather than in Britain, where he fitted in so well. Initially he wore a startled expression. A touch of culture shock, I thought, watching him warmly.

As a welcome gesture, we invited him up to the trattoria for his first Umbrian meal, and suggested he try the ribbon-shaped *strangozzi* pasta with truffle sauce. When he tasted it I watched in dismay as he wrinkled his nose and grimaced.

'Mike, you don't like it! Don't eat it then!'

I tried not to take it as a personal insult, but I had to admit I felt let down. *Tartufi*, truffles, are an acquired taste and can overwhelm the uninitiated. We should have eased him in gently. The waiter observed him with brotherly concern.

Mike looked up in surprise and licked his lips; after a brief moment he began to chuckle.

'Don't like it? It's just that the Brits aren't very good at expressing sublime pleasure!'

That evening I showed him the local shops and told him about the weekly Friday market. We left him a 5-litre can of Olio di Trevi and beans, lentils, onions and some good-quality coffee with the espresso maker. I hoped he would not feel too much like a fish out of water up here on our 'Trevi island', as he doesn't speak Italian; but then what's so bad about feeling foreign? I told myself sternly that I must stop feeling that everybody's emotional state was my blessed responsibility — in particular the men whose paths cross mine.

¢

Back in Edinburgh. And there is no more looking back, no more shifting between here and Trevi, driving up and down Europe's highways. The countdown to the final departure begins in earnest. There are only seventy more nights in safe Scotland. Secretly I would still prefer to stay here, and once in a while still wake with a pounding heart, my body tense and twisted from night battles. But Trevi nightmares are becoming less frequent, and an equilibrium of sorts seems to be returning. The will to make the Millhouse 'home' has miraculously returned. I can imagine this. It feels real again.

¢

A few days later. It's 3.30 p.m. The children will be home from school soon. I sit by the bay windows in the sitting room, wondering how Mike is faring in Italy, listening to the For Sale sign rattle in the wind. At this moment I feel I might burst with relief at having rediscovered that there is something very deep-rooted pulling me to that distant fragment of Italy, transforming the Road of the Mills into the belly-button of the universe. Can I trust the feeling this time?

I have begun to savour the recollections of last week in Trevi — of waking each morning, flinging open hotel shutters, inviting in the warm October air carrying birdsong and church chimes. As if spellbound, I had found myself lapping up each moment of the day, whether in the garden with Nando, who became our temporary

gardener, or inside the building with the workmen. Nando had materialised one day after word had got around that there was some clearing to be done on our overgrown and thorny slope of a 'garden'. Like so many of the other men whom I had seen in Umbria, his face seemed chiselled by the elements, finely worn yet not worn out, its hard beauty defined by centuries of being from here, being of the land. He was an agile pensioner living just up the road from us, employing most of his waking hours growing vegetables — the taste of which were shockingly good after the watered-down versions generally munched on in the UK.

So when Nando arrived we had soldiered our way through the brambles, trying to envisage the form beneath the overgrowth. I'd asked how long it might take to clear the ground of the thick-growing weeds, and allow the olives, loquats and fig trees to breathe again. I was sceptical when he estimated three days' work if he were to tackle it alone, aided only by his trusted scythe. But I kept my lack of faith to myself, agreeing that he should start the next morning. And so, in the following three days, through thigh-high grass and prickly blackberries, Nando had indeed carved out the beginnings of what will always be a somewhat rough and rustic Umbrian garden — definitely low maintenance — but to my eyes, a most welcoming place to sit and gaze at the olive groves below on balmy summer evenings.

The slope is also home to a thriving population of agave, those hardy desert plants with thick fleshy leaves, sprouting of their own accord wherever soil nestles in cracks between sunbaked rocks. They grow abundantly on the south side of Trevi, and our garden is a year-round suntrap. Nando chopped off their spikes, lethal for little children playing in the garden, he told me. 'They'll hit someone in the eye, sure enough, Signora. The agave is a dangerous plant. *Molto pericoloso.*'

An Italo-Scottish friend in Edinburgh, a dedicated botanist, shakes his head when I tell him later of Nando's attack on the plants.

'No doubt he's right about the kids. But it's a noble plant in my mind, not to be hacked about. Still, if your Italian garden's really that full of them — it's up to you, of course. I bet you didn't know that agaves are named after a woman in Greek legend — Agaue. Can't remember why, but I'll look it up for you. And one of your favourite writers, Primo Levi, got pretty close to understanding their essence, I must say. If I remember well, it was he who wrote a poem about them. It's a proud plant, very independent, and the poem describes that well.'

He pauses. 'Must have it somewhere, come to think of it. I'll dig it out for you. I think my father will know where to find it.'

Sure enough, the poem is found, translated roughly into English, and arrives post-haste in our letterbox: I sit in our Scottish conservatory among the ornamental roses and maidenhair ferns, and read:

> AGAVE
> *I am not useful or beautiful,*
> *With no bright colours or perfume.*
> *My roots tear through the cement*
> *And my spiny leaves guard me.*
> *Acute as swords.*
> *I am silent.*
> *I speak only the language of plants,*
> *So difficult for you to understand.*
> *It's a different tongue, exotic,*
> *As I come from afar, from a harsh place*
> *Full of wind, poisons and volcanoes.*
> *I have waited many years before flowering —*
> *This high and desperate flower,*
> *Ugly, woody, rigid, drawn to the sky.*
> *It's our way of crying that*
> *Tomorrow I will die.*
> *Have you understood me now?*

<div align="center">

❡

</div>

Immediately after our departure from Trevi, Mike most sensibly moves the camp-bed into one of the completed bedrooms. At last the plaster was more or less dry. Used to an unheated Edinburgh flat, he has no fear of the imminent Italian winter. He writes to me from a temporary writing desk of progress with the renovations — some windows in, tubes placed for heating, painters' progress — and of initial reactions to the surrounding landscape:

> *Last time I was in the hills behind Trevi there was an absolute stillness, which felt, well, heavenly. There was an unearthly quality in the light, which was like a benediction, walking in a state of grace —I kid you not. Everything was covered with crunchy, powdery snow, tinged with orange and blue in the light and in the shade, but so blindingly clear.*
>
> *The silence was broken only by the tinkling of sheep bells like a gamelin orchestra playing around the hill. I do like the bells here, the nunneries with their graceful matins, vespers or whatever, and the outpourings from the* duomo [the cathedral], *on holy days. It's not like church bells in England at all; they are much more fastidious about keeping time here, for one thing, but there is something very ancient, eastern-sounding, about the melodies they play —like something from fifteenth-century Venice. And when one set of bells stops, another will start across the plain, a different tune but with the same spirit.*

A day or two after the letter arrives, Mike telephones, telling me he has been fighting off an army of scorpions, perhaps protesting the appropriation of their territory by humans. He knows them to be relatively harmless, 'Not like those ones you have over in Australia, but extremely unpleasant to have as flatmates!' he jokes, half-heartedly.

Mike is the silent, stoic type. Capable of extended solitude, he spends his days writing, painting, cooking and walking, intently observing the interplay of the sky, earth, mist, mountain and valley; wishing that he spoke the language, and that his girlfriend might arrive from Scotland to share this timeless beauty. But she's too busy writing a thesis on Scottish mermaid legends.

36

It is disorientating to think of Mike in Italy while day by day I unpick the threads of three years' life in Scotland, preparing for the removalists, dismantling the studio on the upper floor looking out towards Edinburgh Castle. I meet friends for coffee, joke about pulling apart the rich tapestry of relationships, city corners, rooms in the house, colours, sounds, cafes, theatres and hill-walks in this most rational of cities where wild winds howl and clouds hurtle by in a time-lapse sky.

<center>ℊ</center>

Last night, while great gusts blew autumn leaves around Grosvenor Crescent, I dreamt of Trevi:

I was wandering alone in the garden; it was a warm, bright morning.

I came upon a hole carved into the hill, almost hidden among the wild asparagus stalks and the fennel. A foxhole, perhaps?

I leant down to peer inside, but found myself suddenly climbing in, curious to discover where the opening might lead.

I crawled on all fours and felt myself turning slowly, like a cork in a wine bottle. I was panting like a dog. All of a sudden, at a certain point along the passage, the space expanded and I could stand again.

I slowly, carefully stepped forwards, deeper and deeper into the hill, burrowing away with my paw-hands at the earth blocking my passage. It was hard work, claustrophobic.

By then I was somewhere deep inside the hill and proceeded down what seemed an underground tunnel, touching the sides with my hands, feeling the moist earth. There were strange, deep rumblings coming from deep inside the hill, on the other side of the walls, like the whispers of a long-gone people.

After a while the path moved slightly upwards and I arrived at four stone steps, and stood before a heavy wooden door. I tried to open it. It creaked, but finally gave way.

I looked around and recognised the Church of San Francesco up in the town — a church that existed in waking time, and had for

<center>37</center>

*centuries. Yet it was, and at the same time wasn't; it was somehow
smaller, narrower, with a low, vaulted ceiling.*

*A hazy light shone through the windows, softly illuminating the
left corner where a group of four monks stood. Clothed in simple,
handwoven habits they were whispering words from a book placed on
the lectern; each glanced at me and slightly dipped his head as I
walked past. The four faces radiated kindness. I did not disturb them
despite a strong desire to know what they were reading, but returned
their gaze and nodded, feeling comfortable and accepted.*

*I went through another door and stepped out into a crowded alley
where I could hear the slow talk one hears on any village corner —
then or now, the timbre doesn't change.*

*The faces were familiar, as were the plastic shopping bags, the jeans,
the hair and makeup. I had stepped back into my world. But the
people looked straight through me, and when they bumped into me
they didn't even notice, but just walked on. Then I looked down, and
saw that I was invisible. What a strange thing! To feel everything, but
to be as transparent as the wind. Invisible. Free!*

*I strolled around happily, marvelling no one could sense my
presence except a little dog that barked at me until someone threw a
bucket of water from the window, which wet me too. I walked off.*

*Probably these people had no idea that behind the church door
were four monks emanating from some other, previous time.*

*But then my heart began to beat rapidly. It was a warning, like a
drum; I knew instinctively it was time to go back, past the four holy
men and down the four stone steps, along the secret tunnel buried deep
within the earth, connecting the church with the rolling, hilly slopes
of the Costarella where the cypress rises.*

When I opened my eyes in the deep of the northern night, I was
back in my Scottish bedroom. I lay awake for hours, listening to the
wind whistling down the chimney and raindrops pelting against the
avenue of windowpanes.

December

IT IS MID DECEMBER. Moving time. Chiara, Julian and I fly back to Italy, in the space of a few hours dropped into the vastly different reality of a medieval hill-town. Back to our 'Trevi island'. Mike left a few days before our arrival, stopping off in London on the way home. So for the immediate future it will be just us, and the workmen.

Our final image in Scotland was of pyjama-clad Mardy, our hard-living American neighbour, leaning over the balustrades of her top-floor apartment, calling down to us as we packed our suitcases into the car boot like fugitives in the grey fog. Mardy is a creature of the night; she wagged her finger in the dim dawn light, and laughed that this would be the first and last time she would be up at seven in the morning. That chuckling, but simultaneously wistful, last image of a loved Edinburgh friend brought a smile to my lips on those first cold and occasionally bleak days of settling into the Millhouse.

Giancarlo is still in Scotland, tying up the last details and closing the house, which I know I'll miss terribly, for it was as perfect in its formal Edinburgh setting as the Millhouse is against the purple-silver and olive-green of Umbria.

We'll be seeing Giancarlo less than in Scotland, for he will have little free time back in the Rome office. How will I feel spending most of my time apart from this man? It's a big change, but as we know from past experience, the pressure can be intense at the Ministry of

Foreign Affairs, so even if we lived in Rome it's not like we'd spend that much more time together. And the break might do us good.

My nephew drives us from Rome airport. He drives too fast, and Julian vomits somewhere before Spoleto. We want only to arrive.

On entering the Millhouse my heart sinks to discover the final renovations are still so far from complete. I never, ever expect the worst. But I smile and tell the children how lucky they are to have a house in Umbria, and that one day they will be glad to have these memories of the early days. Will they? We find ourselves camping out in the bedrooms, which double up as sitting room and kitchen, the bathroom as laundry. Thankfully Mike had made it cosy, however, and I am grateful and touched.

It is late when we arrive. We make up the sofa bed and all sleep together. I wish Giancarlo were here.

The following morning I am awoken by the sounds of hammering, of drills and country voices. I dress carefully, leave Chiara and Julian sleeping, and make coffee on the little hotplate Mike set up in the other bedroom. I brush my hair carefully and then go into the future *sala*, the sitting room, to face the workmen, the *operai*. This is it then. There are around ten *operai* this morning with a rigid predetermined hierarchy: the plumber, with his *simpatico* father (who will drop in every so often when he has other jobs in the area), the electrician with his chronically shy apprentice whose name I will never know, two plasterers, two painters and an Albanian youth called Alberto, whose job seems to be to run around helping whoever needs it most. He brings another friend along when the going gets tough.

They are all courteous enough, openly admiring of the fact that we really are prepared to live on a building site, for they inform me that they had been sure a signora and her children wouldn't resist and would move immediately into a hotel. I laugh when one of them declares that Australian women are renowned for this 'pioneer spirit'. This is greatly to my benefit, for it becomes a point of honour to get

the work finished so that we can unpack and start to live as everyone else does in Trevi. Italians take their domestic environment very seriously, as they do their clothes and food, and they do not like discomfort, or think of it in any way as character building.

The rest of the upstairs area is still partly windowless, without tiles on the floor, and the wind whistles freely through the wide-open spaces.

Tonight we negotiate wooden boards soggy with cement, learning quickly to dress with layer upon layer as we make our way over to where the little terrace will one day be, and gaze down into the valley dotted with twinkling lights beaming from cosy houses. The Mill-house feels like a hefty old ocean liner with us the only passengers, while everyone else bobs up and down cheerfully in little lifeboats below us.

The first couple of days pass in a haze, as I begin to map out and assume immediate territorial divisions — us here, the workmen there — personal survival techniques, boundaries to allow us to function during this transition, and create a semblance of privacy.

I mask my vulnerability and appear confident, capable, and surprisingly enough do appear to achieve my goals, in a haphazard sort of way. People have a wonderful capacity to assume new aspects to their apparently formed personalities when the moment calls for it. And the moment called for me to be resilient and optimistic. To show my appreciation for the workmen's persistence I wear a sincere smile all day, which is amply rewarded by their gruff courtesy and hard work. I hope I can keep it up.

It is essential to enrol the children swiftly into school — to take them away from the building site and possible pining for lost friends and the security of established routine. I don't think the reality of this new situation has hit them yet. Whatever novelty value there is will soon wear thin, and I need to divert the energy somewhere else, fast.

On the third morning I leave Chiara at the big iron gates of the

middle school. The one girl of her age we met last summer recognises us and approaches Chiara, inviting her to join the gaggle of friends. I could go down on my knees in gratitude. The atmosphere is charged with adolescent energy, lots of noise and the bright colours of parkas.

No doubt Chiara will be treated like a star for the next few days; her classmates have been waiting for her arrival, and newcomers to Trevi are a rarity. I try not to think about what will happen after she stops being a novelty, when the glamour and mystery wear thin.

As I watch her disappear through the iron gates I have a flashback to my own childhood. Still a child, I had shyly walked into an Italian classroom for the first time. That had been in Varese, in northern Italy — a well-heeled town, not familiar with peripatetic creatures from far-flung continents. We had sailed across to Europe in the *Achille Lauro* (the last years of passenger liners) after four years of primary school in a bushy outer suburb of Melbourne. Once in Italy, I soon came to perceive Australia as a distant peripheral place — but so full of raw freedom.

Sitting at my desk in Italy, this ten-year-old had missed Australian playtime dreadfully. I can still conjure up memories of that childish sense of non-belonging. I had felt trapped in the dark, forbidding corridors of the Scuola Morandi. It was all so severe, so different from my child-friendly Melbourne school. As far as I could figure it all out, kids had lots more fun in Australia. I sat at my desk and ached when I thought of the bell ringing for playtime back in Melbourne — the moment when I'd lean across to my best friend, Geraldine Fraser, and whisper 'I'll race ya!', and we'd set across the playground with hearts pounding, crossing our fingers we wouldn't be caught. Our secret destination had always been a seemingly vast, semi-forbidden wasteland at the back of the school oval. There, we spent countless lunch breaks building houses with great piles of bricks left over from classroom extensions. Perhaps my house-renovating habits were formed way back then, playing house with Geraldine Fraser.

In Italy it was different, colder — old corridors, old tiles, a stern *direttore*, a headmaster — and no real playground with swings or distant wastelands to colonise. And everyone had told me that Italians love kids! Unable to communicate through language, those first cold January days I had probably felt a ten-year-old version of a panic attack. I would sit stock still, suddenly struck dumb, unable to communicate, while I fixed my gaze on snowflakes falling gently outside, melting against the windowpane. They made me terribly thirsty. My mouth was always parched. Over the weeks my embarrassment and terror subsided as I gradually unfroze, became aware of warmth and curiosity written across those unfamiliar children's faces, faces that were soon to become familiar while Geraldine's beloved features inevitably faded.

This morning in Trevi such memories resurface. I think sensibly that Chiara will surely feel more relaxed than I had, for she already speaks Italian, however badly in need of a brush-up.

Next I drive over to the elementary school, hold Julian's hand firmly, and climb the stairs to a room where the noise factor resembles a Seria B soccer game. Some things have most definitely changed since I was an Italian student, for shouting in the corridors had been unthinkable in my old school, pre-1968 — no doubt partly due to that *direttore*; discipline and silence had been implicitly expected in the smallest of children. In Julian's new classroom one of his three teachers is trying in a heroically goodnatured way to establish quiet before the bell rings to commence lessons, while she surreptitiously drags on a cigarette. She greets us with a warm smile, attempts to hide the evidence behind her, but as we talk the smoke rises around her like feathery angel wings. Her face is kind, and intelligent. The walls are covered in the energetic scribbling and diagrammatic marks of her young students, who, in true Italian style, are already stylish in the relaxed way of the Provincia. I kiss Julian goodbye, and can feel the effort he is putting into this, for on no account does he wish to

appear a nervous outsider before these twenty secure little insiders. He squeezes my hand, then lets me go.

<p style="text-align: center;">ℭ</p>

Giancarlo arrives a few days later, and soon it is Christmas, and icy cold: an uneasy time for outsiders. Memories flood in, loneliness and the pangs of separation surface. I am confronted with the layers of other lives being acted out behind the ancient stone walls of the town.

I grit my teeth, vow to disguise the yearning for my other home: my parents' house by the ocean south of Sydney. I remember the last time I had walked through my parents' garden in Australia, which seems greener, more vivid with each visit, with white cockatoos squawking in the trees. How good it would be to sit once again under a gum with my sisters, brother and their families. I want to wake up to the sound of cockatoos and parrots, to kids on rollerblades racing down the concrete driveway next door, and see the sharp outline of rustling leaves dancing across the bedroom walls in the dawn light.

As an Australian I am forever programmed to associate Christmas time and family reunions with heat and sun. The images have become clichés: sticky sand clinging to sunburnt skin, the exhilaration of diving under a 3-metre dumper and being thrown around in a whirlpool of salty water; my children's lean little bodies jumping, splashing, bursting with the energy that comes with not being burdened with too heavy a collective past.

On Christmas Eve morning the phone rings early; Julian picks it up and hands it over. His face breaks into a smile. 'Mamma, it's Nana.' I take the receiver and hear my mother's voice, then my father's, speaking from a hot, bright place. I can just see her. Homesickness hits. I ache to be there, to eat summer foods, to walk among the windswept headlands and smell seaweed and ocean.

My secret seasonal melancholy is somewhat eased by the arrival of gifts from some of our new acquaintances: bottles of excellent

homegrown Sagrantino, a fortified red wine from Montefalco, and four or five coiled, snake-like cakes called *rocciata* (or *attorta* in Spoleto), believed to date from long ago when Italy was invaded by *barbari* from the north, its ingredients being similar to those of a Longobard strudel, whose form originally reproduced the eels of Lake Trasimeno.

Traditionally no two *rocciata* are the same, for each family has its own recipe handed down from mother to daughter. Eighteenth-century Capuchin nuns in Umbria made a similar cake called *serpentone*, the big snake. In a recipe book of the time they advised: 'Roll the dough, shape into a long, curled snake. Then take two small cherries or raisins and use them as eyes.' All the homemade versions of *rocciata* we taste are rich, spicy, fruity, and respect the traditional spiral form coated with pink cherry juice.

Then the plumber's father drops in with a beautiful antique soap holder for the claw bath — he grins excitedly as I open the pack. He is sure I will appreciate it. Does he feel sorry for me? For us? Does he sense my loneliness?

'Signora, it's been lying around for years — probably since the sixties when I think of it. But for us, you know how it is; we don't use those things any more. But I just knew you'd appreciate it. Foreigners always do!'

He sighs. For most Trevani shiny surfaces, plastic and stainless steel have replaced waxed wood and copper.

Despite the way we are camped out in the cold and damp building, the visits of new neighbours — Fabio the painter and his tiny wife Rita, Matilde and Giuseppe Gasparini from just down the road, a local film-maker and his girlfriend — help us feel we haven't been sucked into a friendless vacuum, and that my own attempts to find Christmas decorations in the packing cases are worth the children's efforts to decorate the tree set amidst building materials.

On Christmas Eve we find our way to midnight mass in the cathedral uptown. Notices have appeared on billboards around

the village inviting all Trevani to attend, and Chiara tells us that some of her classmates will sing in the choir, so going along is considered a good move. You cannot be in Umbria without getting caught up in Christianity, for it is the thread winding through all aspects of the culture.

Driving up to the piazza, I reflect on a Christmas card from Canberra, which arrived this morning — one of the first to reach our new address. An old school friend wrote that in her children's school in Canberra the Christmas pantomime and songs must make no references to the birth of Jesus, for fear of offending 'someone'; 'so "Jinglebells" is politically correct but carols are out', she tells me. From our Trevi island, unavoidably immersed in layers of Christian stories — a web weaving itself through time, a story of hopes and dreams, fears, superstitions, love and courage, it is hard to stomach the meanness of such enforced collective amnesia.

Inside the brightly-lit cathedral the priest solemnly announces in a booming voice that the congregation will soon step outside the church once again and into the darkness. We are to form a procession, retracing the steps of Mary and Joseph through the cold dark alleys, for we are to find a place where Jesus might be born. The large crowd, well protected in the obligatory furs and parkas, silently pours from the massive wooden doors. Each of us is handed a burning candle before beginning a slow walk through Trevi's medieval alleys. There are tiny nativity scenes on windowsills replacing the pink and red geraniums of summer; droplets of rain tap-tapping on umbrellas. The children become engrossed in the re-enactment, and I am aware of stirrings of appreciation for the *Italianità* of all this — the recreation or remaking of ritual. The cobbled path is slippery and cold underfoot, yet the company is comforting.

At a certain point along the way a subtle transformation takes place, for no longer are we a collective representation of Mary and Joseph, but become witnesses.

A murmur rises and dips through the crowd, as we see a young woman clad in blue leaning heavily on her simply-dressed companion, walking towards us. The couple knocks at each wooden door in passing. None opens, despite the cold and rain. In this most appropriate setting the crowd waits and watches in silence as the couple move forward; Mary, tired and heavy; Joseph, burdened with the manly task of finding her a safe place among strangers.

Then, just before us, someone switches on the lights of a small *cantina*, a cellar, its floor covered with straw; we all cram to see what is inside. The little room contains no furniture, just four walls of peeling whitewash, and in the middle Mary, Joseph and a baby nestling in a crib. 'Is that a real baby?' whispers Julian to Giancarlo, taking his hand. Giancarlo smiles and nods.

The padre and his assistant read from the New Testament as some of Julian's classmates, dressed as simple shepherds, kneel before the crib. Watching them, childhood recollections of enchanted Christmas nights, buried for decades, rise within me — of hyper-real southern nights, and constellations of Antipodean angels — and it seems a most natural way to celebrate, despite our newness in Trevi and yearnings for Australia. For in this cold corner of Umbria the moment is concentrated, totally alive — for both adults and children.

On Christmas Day we drive down to Rome for lunch with Giancarlo's sister, Anni, and her son, Luca, a student at Rome University. I still cannot provide the raw stuff of celebration in the creative debris and rubble of the Millhouse, and badly need someone to do it for me; thankfully Anni comes to our rescue, with chestnut-stuffed chicken (*pollo ruspante alle castagne*) and *panettone*. Afterwards, we drive up to the Gianicolo hill, and sit in an elegant bar drinking espresso, gazing down over the churches of Rome, their domes appearing to float above mists forming on the Tiber.

As evening falls we bundle the exhausted children back into the car, kiss Anni goodbye, and wind our way back along the Flaminia,

through the Terni valley illuminated since 8 December by the Christmas star high on the Miranda hill, and past Spoleto towards Trevi.

Over the following days celebrations continue. A few more visitors call in, but I am not yet ready to see old friends from Rome, and know so few people here that we are left very much alone. The children have begun to take their rollerblades up to the piazza, and are not unhappy, so my worst fears are assuaged.

On the morning of the 26th, the feast of St Stephen, we visit some of the nearby Christmas cribs; ever since St Francis celebrated Christmas by staging a live nativity scene for the illiterate peasants in a cave back in 1223, there has been an unflagging interest in Christmas cribs in Umbria. The first acting out of the Christmas story was a big hit, and while the Neapolitan crib makers of the seventeenth and eighteenth centuries are famous the world over, few are aware it probably all began with Francis in the hills of Umbria. Throughout the region, medieval villages, castles and churches have become perfect backdrops against which these live nativity scenes are set. For months crib aficionados have been busy toiling in back rooms, canteens and churches all over Umbria. It's a highly competitive business.

Our first stop is the 'artistic crib' of St Eraclio, to be found in the church of the same name inside the fifteenth-century Castello dei Trinci. This labour of love sets the mystery of the nativity against an Umbrian background, complete with moving figures and lighting effects made possible by about fifty mechanical movements, so that snowflakes fall, bakers bake, women draw water from wells, heavily-laden donkeys plod up and down hills. All the while, lights flicker across a host of flying angels.

The St Eraclio crib seems well known by those aficionados who abound in Southern and Central Italy, and as we enter there's an animated discussion going on about this year's improvements. I can't

believe the amount of work that has gone into this, the obsessive attention to minute detail.

We approach the priest, who invites our comments, and enquire which other cribs in the area might be most worth visiting. He shrugs when we ask him which are essential viewing, scratching his balding head: 'Well, they are all *bellini*.' He isn't going to give too much away after all, I realise, for this is a competitive business — but he does finally advise us to make our way up to Scanzano, a nearby township, to see the 'living crib' that will open to the public at 4.30 p.m., once the participants are over the serious business of digesting lunch.

When we arrive in Scanzano we see that the main street is closed off with a cord, and as we queue to enter someone tells us that it is the tenth year they have staged the re-enactment; another adds that there are over 150 local volunteers, all of whom have a very precise role to play. '*Sono bravi, Signora, sono bravi*', he assures me.

Despite the drizzle, right on 4.30 the cord is untied. We all file in and make our way slowly past about thirty *tableaux vivants* scattered alongside twisting pathways, in garages, canteens, shopfronts and temporary porticoes. The 'scenes' portray both the religious story and customs of the community, showing the activity of the craftsmen and farmers. If only the past had been taught like this, back at school! The damp air smells of exotic incense from the East, of freshly baked bread that veiled women hawk from a makeshift stall.

As night falls, torches and lamps light up dark corners. We edge towards the last scene. I notice once again that Umbrians don't push and shove in crowds, an infuriating habit of stressed-out Italians in big cities. These people still have time to spare.

The Grand Finale is, once again, a manger sheltering Mary and Joseph. Perhaps that's the pattern in all the living cribs: lots of small scenes before the actual nativity. A hearty Joseph welcomes us, and launches into a speech about peace and forgiveness, then wishes us health and happiness, '*Molto, molto felicità*', and bids us farewell. The

shivering crowd claps goodheartedly, and is finally directed towards the exit; but not before passing a pizza stall emitting sizzling smells of melting mozzarella and grilled tomatoes — impossible to resist. Post-Christmas dieting will just have to wait one more day.

By now it's pouring, almost hailing. An icy December wind drives frozen pellets headlong into my eyes. If only the Millhouse were really finished and we could return to warmth rather than wet plaster and cement, what a luxury that would be! I stand in front of the pizza stall shivering, stamping my feet, and waiting my turn.

January

CHIARA AND I PERCH ON THE WALL bordering the Road of the Mills and explain to our elderly Italian neighbours that each New Year dawns in Australia against a summer sun, a holiday backdrop of sea and surf. 'Summer — now, in the middle of winter?' they repeat, disbelieving.

I tell them it is far easier to feel one is being given another chance to begin again when the sky is a deep blue, when the children are barefoot, playing outdoors from dawn to dusk, and evenings are alive with cricket song. Matilde shakes her head; she does not approve of such unnatural goings-on.

This particular European New Year is truly a fresh start for us, however; and I cross my fingers that gains will far outweigh losses. As Giancarlo and I join in the New Year party organised up at the rooms under the Clitunno Theatre, I reflect that, on the whole, things are not turning out too badly since we've actually become full-time Trevani: the kids are coping with the schoolwork, I am coping with the workmen, and they are all coping with me. Still, I hope it won't be too long until they finish the kitchen and the living rooms, but know better than to hold my breath. As we raise our glasses and the clock strikes midnight, Giancarlo whispers in my ear, '*Buona fortuna*'.

'Good luck to you too, Giancarlo.' He takes my arm, and leads me onto the crowded dance floor. It is a change to feel warm, hot even,

51

as we move to the sounds of a very middle-of-the-road, smoochy Latino band.

'It sounds like something from the Italo-Australian club in Canberra, where you declared you'd absolutely never get married. Remember that?'

$ç$

We have only been living in Italy for three weeks, yet Scotland is already fading, it already belongs to the past. I had left an exhibition of drawings hung in Edinburgh, and until the show closed felt a part of me was still there, invisibly cohabiting with the pictures on the walls. Now it is over, and I must cut the cord — the pictures are coming down, being packed away, and those that are still mine will turn up here in Trevi one day, thus terminating a connection with a country that for nearly three years was our home. The children have their Scottish accents to bind them to the past, and I find myself listening to them intently, as if trying to capture some sense of what slowly, irrevocably, will be lost.

The first days of January pass quickly. Whenever the sun shines, we end up in the garden and dig our hands into the moist earth. Chiara and Julian continue their shy visits to the piazza, rollerblades underfoot, feeling their way around the permeable edges of local gangs.

I keep my ear to the ground, and pick up information on local goings-on from the newsagent's and the supermarket, where I hear the lead-up to the arrival of the good witch, *la Befana*, who in this part of the world has far more status than old Santa Claus. She is due to visit on 5 January, the night of miracles before Epiphany, a magic moment when water gathered at midnight will cause bread to rise without yeast, when oil and wine will pour from fountains, and when animals should be fed generously, lest they speak ill of their masters over the coming year.

Just who was the Befana, though? I flick through the dictionary:

Befana *1. Epiphany; 2. Old fairy bringing toys to children; 3. Gift, present; 4. Ugly [old] woman, harridan.*

Luck is not with us tonight, for we just miss seeing a Befana burning in the little township of Sant'Eraclio, down along the Via Flaminia. I had seen the event advertised in a regional tourist publication, and convince Giancarlo to come along too.

We arrive at the piazza just after eleven. But the party is almost over and the wires inside the huge effigy of the Befana are sizzling under dying flames. I stamp my feet and swear under my breath, for I have harangued the others into coming, and the timetable said the burning would take place at midnight — Giancarlo gets furious when I force him into things! The atmosphere is definitely post-festa, kept half-heartedly alive by Sant'Eraclio's very own party animals. Through more drizzle, loudspeakers ooze out some passionate South American numbers, and a few toddlers, smothered in winter garb, try out their steps to the delight of weary, but ever-proud parents. The one bar across the road is pulsating with youthful energy, while the older members of Sant'Eraclio meander home, arm-in-arm, chatting amicably under vast umbrellas.

I look around me for someone to complain to. But what's the point? After all, despite some publicity given to the event, there is no evidence of outside visitors. Apart from us, that is. This is not a show for tourists, newcomers, and outsiders, but more like a private street party, so no wonder the organisers feel no obligation to respect a programme printed in Perugia. Such examples of popular culture are very much contained within local communities. We had learnt a lot in the last few weeks, and I am no longer surprised to discover that inhabitants of a neighbouring town often ignore another town's ritual and feast days. On one level this containment lends itself to authenticity of local ritual; on another it reinforces *campanilismo*, the name given to a complex attachment to one's own small town.

There is no point in getting angry, unless I want to be stared at. But I am disappointed, for I had read that this particular Befana burning had origins in pre-Christian culture, and had been acted out annually in Sant'Eraclio for almost 2000 years — as ancient an evocation of witch burning as I am ever likely to come across, and quite unfair on the Befana, for she is a much-loved figure, considered a benign influence on naughty children.

I comfort the slightly damp kids, buy fairy floss and *lupines*, hop seeds, and promise to bring the children back again to catch the Befana the following year. They are not enthusiastic.

Still quite a celebrity in the central part of Italy, the Befana is obviously in no danger of losing her spell. Julian has now become a Befana-believer and, like all his classmates, places a large pair of boots on the windowsill for her when we get home, for he hopes to find them in the morning brimming over with sweets. He will. Traditional lore has it that naughty boys and girls would have their shoes filled with nasty, dirty coal, but this generation's world-view, combined with smaller families and the most indulgent parents since time began, does not allow for such awful eventualities. As I place toffees, nougats and chocolates against the soft fur inside the boots, I can remember ten-year-old me in Northern Italy placing my best shoes on the balcony, as instructed by my friends, just like Julian. My sister and I had awoken to find a delicious, sugary concoction of sweet *carbone*, 'coal', inside our shoes, tasting something like rock-hard fairy floss.

The following day, Epiphany, the children's last day of holidays, we visit new friends in their apartment in modern Spoleto, spreading out below the beautiful old town. It would be so depressing staying at the Millhouse, anyhow, with the rain making it even colder, and the workers still away. How I want everything to finish!

Piergiorgio and his wife, Maria Rita, who, like most Italian women, turns out to be yet another highly accomplished cook, have prepared

a variety of tempting local dishes to welcome us. But just being in a warm house is welcoming enough. In the kitchen Maria Rita has a big pot of Castellucio lentils simmering away on the stove, traditionally eaten by those in need of financial luck at the beginning of each year. In the cash-tight 1990s, Piergiorgio jokes, they have become very popular again. Then, for the first course, she prepares homemade pasta — ribbon-shaped *strangozzi* with truffle sauce — followed by rabbit *alla cacciatora* and roast chicken with rosemary. Not a lunch for the faint-hearted! As we relax in the warm kitchen Maria Rita skilfully organises this Epiphany feast while we try her *antipasti*: liver tarts and black olives. To prepare the olives, Maria Rita's mother has boiled turnips, and then plunged the olives in the same water for a couple of minutes. She then seasoned them in the best local olive oil, orange peel and salt. They are the best olives I've ever tasted.

What a relief to be in their orderly, lived-in apartment, where everything is dry and in its place. We relax, sink into the warmth and sit at the table for hours, sipping red wine, laughing. I can't wait to have the same sense of comfort again, back at the Millhouse. After lunch Piergiorgio announces we are to be driven uptown to see the nativity scene taking place in Spoleto's piazza. Chiara and Julian have made friends with the two children and are in heaven already, transfixed in front of the computer screen, playing soccer. They don't want to go anywhere, in the cold and drizzle. I sympathise, but realise that Maria Rita wouldn't dream of not having a stroll, a *passeggiata*, and showing us their city.

The rain continues falling as we approach the Piazza del Duomo. My feet freeze despite thick tights and fur-lined boots, but I am content to be milling about in a crowd, watching old friends greet each other. The Spoletini stand around in lively groups, watching, waiting, and waving to family members who have parts in the Nativity play. There is a large local choir, Roman soldiers and three wise men, shepherds and street hawkers, set against the Romanesque

backdrop of the cathedral. The cold is seeping through my skin and entering my bones, but it doesn't matter, although the next morning I will wake with sniffles and a burning throat. The play unfolding before my eyes, like the Scanzano presentation, is all the more heartening because of the community nature of the event; for while I read in the British press that once again Italy is beginning the year in chronic chaos, on a different, localised scale, energies are being efficiently pooled and deeply-felt traditions re-enacted. Young Italians may well have been going through a time of social stagnation, trying, but not too hard, to break away from Mamma's apron strings and well-intentioned paternalism, but in these small centres in Umbria, there is still plenty of time to get happy at the next local food festival or saint's day. And, sometimes, that is enough.

It all seems quite logical once you are here, and it is the dimension in which Italians beat other Europeans hands down. Community rituals act as a powerful binding-glue. Maybe it's when the scale slides from micro to macro, when issues become national, that fragmentation begins and domestic disorder prevails, making the country vulnerable to knowing asides on the part of Euro-sceptics.

ç

Our most expert plasterer and fireplace builder, Luigi, thankfully back on the job this morning, informs me of the local saying '*Epifania, tutte le feste si porta via*' (Epiphany over, all celebrations are taken away) when the routine of the hard-working Umbrians takes over again. There was a time not long ago when the period from Christmas to Epiphany gave the mostly vegetarian and impoverished peasants a chance to enjoy game, pig and poultry, to indulge in delights at the table denied to them for the other eleven months. For most of the year austerity had prevailed. But it seemed to me that in the 1990s this saying was misleading, to say the least, although Luigi didn't think so.

Within driving distance there is always some sort of festa going on, for, apart from anything else, there are just so many saints' days to celebrate — after all, this is the mystical heartland of Italy. Even if you choose to skip the first Christian martyrs in Roman times, from the first centuries of the late medieval period and throughout the thirteenth and fourteenth centuries, Umbria experienced the spread of monasticism and became a vital stamping ground of an astonishing long procession of holy men and women, some of whom would be called other, more clinical names in the 1990s — victims of affective disorders, perhaps manic-depressives or schizophrenics, their visions and hearings of voices psychotic hallucinations. Often as not, and just as well for them, those early saints were left free to act out their passions, and budding religious movements spread like wild-fire in those pre-printing-press times; the Benedictine order built monasteries well before the Franciscans who burst onto the scene in the thirteenth century, alongside the mendicant orders such as the Dominicans.

In Umbria it is easy to envisage convents and monasteries mush-rooming throughout the region, on hilltops overlooking harsh gorges and wild woods, and across the fertile plains. Their coming-into-being still permeates the air, as all who stop and listen are aware.

¢

A voice down the phone from Naples tearfully informs us that Giancarlo's sister, Lia, has died recently, and unexpectedly. I put the phone down. The news cuts through the silence of the misty winter landscape, and tells a different story, of a heart-wrenching banality. Of being ordinary.

Lia had been ailing for years, lost somewhere inside her own head, not seeming to be aware of what was happening on the outside. She had begun to sicken long ago. Had she given up on life way back

then? In the last three years her body and mind had aged dramatically. I don't know if Lia had ever been what you would call happy — maybe for a few years in the 1950s when she was young, when the world was a secure little village in the Naples hinterland, still picking itself up from the hardships endured during the war. She left school early because she disliked study, preferring to spend her days with her eccentric and lively grandmother — perhaps then Lia had a spell of lightheartedness. When her studious sister left the little world of the village to study at Naples University and then moved to Rome, Lia must have suddenly realised that the world was a bigger place. She too waved goodbye to girlfriends and local suitors (some of whom went on to make big money in the canned tomato trade), and followed, shadow-like. When her sister married, Lia married the brother. Soon after she had a baby boy.

Lia never got to know Rome. She lived a life of village rhythms: curtains down against the midday sun, mornings with her shopping bags at the market, followed by cooking 'La Pasta' for her husband and her son; dim rooms at siesta time, shielding her adored *bambino* from the big world outside.

When we lived in Rome in the 1980s and Chiara was small, we would drop her at Lia's sometimes on Sunday afternoon. Lia's face would soften and her eyes twinkle; she would tickle Chiara and play with her, then crack jokes at her own expense. In the best Neapolitan tradition, she was a master of self-irony. I would look at her, and see a sharp and lively spirit trying to escape. Giancarlo and I would thank her, and rush off restlessly to visit friends, go to the cinema, glad of a few hours' break from parenthood.

As her own boy grew Lia began to feel more and more marginal; more and more dependent on others and the television with its moronic diet of variety programmes, anorexic adolescent dancing girls and loud-mouthed wise guys. From then on the decline was rapid, diagnosed a few years back as premature dementia. She spent two

years in a clinic, shrivelling up like a sour lemon, her skin assuming the pallor of a fragile, cracked shell, as if isolating her from the world outside. When we saw her late last summer, I forced myself to hold her once-plump hand, to speak to her, as I wondered if she was still there behind the glazed eyes staring through me. Nothing? Something? I was embarrassed and humbled by the way the other women talked constantly to her, naturally, unquestioningly attempting to reach the closed shell within. At only one point did she show a sign of being there, with us. Grazia asked her time and time again if she was thirsty, and tried to convince her to sip orange juice through a straw. At a certain point Lia very slightly tossed her head back in quintessentially Neapolitan style and made the sucking 'tch' sound (itself inherited in Southern Italy from the Saracen invaders), which means no. The Lia-ness of the gesture shocked me out of a growing unease that we were speaking into a void.

And now, all of a sudden she really has gone and is buried, as is custom in Italy, the day after. Just like that. It feels so fast, too fast — almost a denial. I don't go to the funeral, for Giancarlo and Anni leave immediately from Rome, and someone has to keep the home fires burning. Giancarlo rings me in the evening, tells us he's picked up an oak seed in the cemetery where she is now buried in her husband's family tomb.

Come the spring we will plant the seed, and one day it will stand tall and strong: Lia's tree.

¢

Patterns are unfolding. Chiara and Julian return willingly enough to their cramped schoolrooms; snowflakes fall, dusting the earth, so that for a morning even the sad brown boxes along the Via Flaminia — the badly-designed offices, storehouses and showrooms — gleam appealingly. But not for long. Soon enough the sun comes out again and shines through the crisp air, sharp as cut glass, cruelly exposing

every architectural blemish along the highway. Tourists are always amazed by this: the degree to which Italy has been scarred by the debris, the disposable, the jerry-built, in the last thirty or forty years, like a collective death wish, so that the *bel paese* risks becoming the ugly country.

Giancarlo comes back from Lia's funeral and sits with me by the fire, sometimes talking about her and about other friends in Rome.

I count the days until the house will be free of workmen and I can close the front door. Once the windows are installed in the sitting room, I set up the computer and ceremoniously switch it on, while the painters whitewash the walls around me. My desk is yet another little island, incongruous, but a place to work. Now I have a place to go to in the morning, just like everyone else. It's a huge relief.

As I tap away, the lively banter of the workmen goes on around me, punctuated by an occasional outburst when something goes wrong and everyone converges to commiserate, then to set about finding a collective solution.

I learn a lot from all the workmen, but most from Luigi. He has been a bricklayer since 1948, when he was twelve. Luigi tells me of the tree of St Emiliano. He says it is one of the oldest olive trees still producing fruit in Italy, and rises from the earth quite near us, among a cluster of younger olives in nearby Bovara. It is named after Emiliano who passed this way some 1800 years ago. Now a revered saint and the Patron of Trevi, his wooden likeness is paraded through the streets every 27 January, the eve of his feast day.

'You should know about Emiliano, Signora,' he suggests one morning, slight disapproval in his voice. 'He's very important around here.'

I look away from the computer, and rest my chin on my hand. 'You tell me, Luigi! Tell me all about him.'

And what Luigi says to me goes something like this:

Emiliano was an Armenian by birth, and is said to have arrived in Spoleto in 296.

Hearing that there was no bishop in Trevi, he sent some of his followers to see if Christians were in fact to be found in that town. Remember Trevi was then down in the valley, for this was before the terrible earthquakes and the arrival of barbarians from the north. Emiliano's followers came back with news that in Trevi there were indeed Christians, and they desperately wished to have Emiliano come amongst them. Their wish was granted: Emiliano and his followers soon arrived, and set about converting Trevi's many pagans into Christians.

But not all were happy with this turn of events. It was a time of persecutions, and much secret activity on the part of the outlaw Christians. Soon word spread of Emiliano's activities, and, as is always the way, the men in charge inevitably came to hear of these revolutionary goings-on. In his fury, a local Roman emperor called Massimiliano decided to take action.

He began by setting a number of tests to try Emiliano's faith. Tricks. But, soon after, strange, unheard-of things began to occur.

It was whispered that attempts on Emiliano's life were doomed to fail, for Emiliano's rock-like belief in Christ appeared to protect him from his Roman persecutors. One day the desperate Massimiliano decided he had had about enough. The natives were becoming restless, and drastic action was required. He ordered that Emiliano be thrown into a tub of boiling lead. Faced with such a terrifying situation, it is said that Emiliano raised his eyes to heaven and prayed for help; sure enough Jesus stepped down from heaven and, hand-in-hand with Emiliano, entered the cauldron. The bubbling, boiling lead immediately cooled.

Many Trevani had gathered to watch. Amazement and wonder spread across the crowd like lightning bolts, and Massimiliano, acutely aware that things were getting out of control, took immediate

advice from his special counsellors. They decided to throw Emiliano into the river Clitumnus, where the river god, no doubt put out by all this Christian rigmarole, would finish him off. A rock on a rope was tied around his leg just to make sure there would be no sneaky get-away. But once more Jesus appeared and helped him ashore.

Massimiliano was at his wits' end; he ordered that this strange and dangerous man be devoured by wild beasts, in the last-resort fashion of the times.

By now the whole town was following events, and came to witness the would-be saint being thrown into the pit. But no sooner had the act been accomplished than the lions began to lick Emiliano's face and the leopards his toes; behind them other animals began to maul each other in their haste to lie at his feet. When a very relieved Emiliano raised his hands to bless them, they turned and walked away. He was safe.

The crowd applauded wildly, for by now he had earned and attained hero status. There was much clapping, and chanting for his release, which naturally infuriated Massimiliano even more. In an uncontrollable rage he ordered that all the spectators — traitors — be slaughtered. Local legend had it that over one thousand lost their lives, which must have meant that at the end of the day there weren't many Trevani left. After many days the Christians crawled out from their hideaways to remove the bodies strewn across the hillsides, strangely untouched by vultures, despite having remained outdoors, and buried them.

With a heavy heart, a desperate Massimiliano asked his counsellors, 'What must I do to this young man, whose words cause all to turn away from the gods?' They shook their heads doubtfully, until someone suggested that Emiliano be taken up even higher into the hills and tied to a wheel, which would then roll downwards, thus surely breaking every bone in his body.

For thirty days Emiliano languished in prison while the massive

wheel was prepared. On the day of reckoning, word spread amongst the remaining inhabitants to gather together; for this was to be the final test. As he climbed the hill, Emiliano beseeched God to manifest his power and rescue him. Once again his prayers were answered, for after the nasty business of tying him to the wheel was over, Christ appeared. Suddenly all the cords snapped and the wheel rolled off, slaughtering another five hundred unfortunates on its journey downhill.

A great terror spread throughout the land.

The seemingly endless travails of a long-suffering Emiliano, and of the Christians who followed in his footsteps were far from over. Massimiliano attempted to force Emiliano's three Christian brothers — Illariano, Dionisio and Ermippo — to renounce their faith and offer sacrifice to pagan gods; when they refused, the earth shook; they told Massimiliano that gods were falling from the sky.

Massimiliano imprisoned, and then decapitated, the luckless trio, while Emiliano was held in isolation, apparently unaware of the murders.

Days later Massimiliano called for Emiliano to be brought before him, announcing that his three friends had renounced the Christian faith and were now comfortably ensconced in the palace. But Emiliano had already had a vision of the three martyrs in paradise. He shook his head, and proclaimed, 'Before long I will join them in the kingdom of heaven'.

Massimiliano stared back at Emiliano. 'I have sent them afar to deal with some business matters.'

Emiliano's answer was brief. 'Massimiliano, you swine, you lie well, but this time you have told the truth, for you did send them on a journey. For they are in paradise, in the city of Christ!'

Massimiliano was speechless with rage. Still determined not to be outdone, he ordered that Emiliano's bones be torn from his body, that he then be decapitated and burnt on a great funeral pyre.

There was another great gathering to witness the martyrdom. Many, hearing Emiliano call out to his saviour and having either seen or heard of his miraculous past, converted to Christianity on the spot. Emiliano then knew that the time to join his saviour in paradise had finally arrived, and fell to his knees, beseeching God to protect the faithful, and forgive the faithless ones left behind.

He was taken some distance from the city, towards the location of Bovara, where the great white cattle were fattened by pagans before being sacrificed to Clitumnus. There, Emiliano was tied to a young olive tree. One of Massimiliano's henchmen approached Emiliano and hit him with a shovel, but it bent in two. He fell before Emiliano, and begged forgiveness.

A Voice was heard, emanating from the heavens, telling Emiliano that his time had truly come: a place had been prepared for him in heaven, and a choir of angels was waiting. Then the Voice proclaimed. 'You will liberate the people from storms, and be their refuge; you will be the help of the oppressed, the health of the infirm and a persecutor of demons'.

Hearing this, Emiliano begged for his torturers to whip him; they shook their heads in terror, for they too had heard words from above — but when he told them that unless they did as he asked, the gates of heaven would be forever closed to them, they kissed him and followed orders. Together with the crowd, they stood transfixed as Emiliano's body turned white and milk flowed from the wounds, while from the branches of the tree sprouted clusters of olives, the fruit of peace.

The tree, now known as the tree of Emiliano, has recently been dated as being of that period; its three knotty trunks rise in the very location where early writings say this took place.

On the night of Emiliano's feast day we follow Luigi's advice, and join in the celebrations. At 6 p.m. we walk up the steep back steps by the

Gasperinis' house, then along Guardian Angel Way to the piazza. Trevi is gaily illuminated with fairy lights, the town hall proudly glittering as if dressed for a party, with rich red cloths strung from the balcony. It's a perfect winter's night — crispy-cold, crystal-clear air.

We negotiate our way through the garish stalls selling calorie-laden nougat, nuts, jaw-breaking sugar concoctions and fairy floss. I buy Julian a new basketball at the toy stand, while Chiara disappears with a gaggle of girlfriends, uncertain as to whether she should represent the ballet school in the procession, or walk with the teenagers from the youth group. This is not the girl I knew in Scotland!

Giancarlo and I follow the sea of furs and parkas up to the cathedral, nodding at newly familiar faces along the way. The narrow lanes are lit with candles that glow from windowsills, for the centre of Trevi is well and truly lived in, unlike many neighbouring towns: some have become ghost towns, reanimated only at weekends with well-heeled holiday makers.

Walking along with these born-and-bred Trevani, why do I feel an edge of discomfort impinging on other, joyful sensations? Because we are still such newcomers and ambivalent about fitting in? I remind myself that this is still the beginning. I expect we'll always be privileged fringe-dwellers in a way — accepted, welcomed, but seen as marginal.

My foreigner's appetite for the facts of local history finds no corresponding emotions reflected on most of the faces traipsing up the alley, for, of course, the Trevani are not curiously captivated as we newcomers are. They are far too busy at their jobs, cooking, planting vegetables, purchasing cellular phones, motorbikes and expensive coats in the Foligno sales — sensibly getting on with life. No doubt, they'll still be honouring St Emiliano in yet another fifty years, another hundred years, despite a present diet of lowbrow television, Mediterranean muzak and a dizzying abundance of designer gadgets.

It wouldn't occur to most of them that their saints might lose their mass appeal, which on one level is reassuring — for the saints, the Italians and us. It all slots together so well in Italy — the layering, the repetition.

We stand outside the cathedral with our candles; a few handsome young Romeos, looking disconcertingly like Fra Filippo Lippi's angels, openly eye their Juliets, while children play tag underfoot. The rest of us quietly chat and, as is still the way in Italy, smoke just one more cigarette. Then the cathedral door swings ceremoniously open and the procession begins. I expect just that — a procession of people — but this is something else, for a series of small, very wacky floats carried by the menfolk spills from the inner sanctum. A great booming male voice reels off the names of the participants: the Anglers' club with a massive transportable fish tank full of trapped trout; the Bar Chalet with its wildly tacky pink icecream fountain, good enough to eat; the chemist's with a papier-mâché tower supporting perfumes, stationery and costume jewellery — bright baubles drip down the sides. The local supermarket has created the last float in the procession, which consists of a wooden cart laden with salamis, bottles of olive oil, dried sausages on strings, fleshy hams, and garlands of garlic and onions.

The atmosphere, despite the playful nature of the floats, is solemn: the float bearers are deadly serious, while I hold back an over-whelming desire to show my joy, to clap my hands in delight. Nearby a very British voice in the crowd declares to her partner, 'Really! Thank God for the Italians!' I look around, and see her ruddy face even redder in the candlelight. She looks so different from the smooth, finely chiselled, local faces.

Then the bishop and lesser holymen emerge. They are most solemn as they make their way along the street, bedecked in rich gold and reds. The baroque, wooden statue of St Emiliano is carried out on the shoulders of eight men, the painted gold resplendent under a rich

crimson canopy. The round faces of the carriers strain under the weight of the statue, which Julian whispers to me is about 400 kilos.

The crowd follows as the statue is paraded through the alleys, then out along the northern ring road of the old town, high above the sea of twinkling lights in the valley. The procession then stops, and the statue-bearers heave. Here there is another change of men, for the statue weighs heavily upon each set of shoulders.

The most symbolic moment of the whole evening follows, when the bishop performs the annual blessing of the countryside, repeated now over many, many centuries. The men rock the statue of St Emiliano slowly backwards and forwards, left and right in the sign of the Cross, as the blessing is repeated, mantra-like, through loudspeakers — another Christian overlay of ancient pagan ritual re-enacted to ensure a good harvest in the coming season.

It is unbearably cold. The last days of January are said to be the coldest of the winter calendar, and I can believe it.

The procession continues up a cobbled alley and into the piazza once again. There, the bishop, standing on a plinth above the shivering crowd, gives his final blessing, and wishes the Trevani a prosperous and holy twelve months.

I look around for Julian, but he's disappeared to the back room of Bar Roma, and is playing video games. At least it's warm in there. Chiara huddles under the portico with friends. She calls over, 'No school in Trevi tomorrow! For St Emiliano!'

She's happy. I take Giancarlo's arm, and say to him, 'Let's go home, I'm absolutely freezing. I'll go and get Julian.'

'Good idea. I'm ready. But I'm warning you, we'll have to get Julian past an endless row of candy stalls on the way!'

¢

As the children take on the shiny patina of *Italianità* and begin to parrot the harsh-sounding Trevano dialect, I inevitably become the

foreigner in our family unit, just as Giancarlo had been in Scotland. Everything shifts, and for a while, feels like it doesn't fit. I suddenly remember so vividly all those Italian 'migrant mums' in 1960s Australia, who had watched wistfully from the sidelines of football fields, as their children found new, local heroes and grew ashamed of vegetable patches in suburban front yards, and of bunches of smelly garlic in Melbourne kitchens.

¢

The feast day of St Costanzo, our resident saint, is also in January, just a day after St Emiliano.

Costanzo is one of the three patron saints of Perugia, and his church there is said to be badly in need of repair. A fundraising competition sponsored by the Perugia City Council is under way between pastrycooks and breadmakers to create the best *torcolo* of St Costanzo — a cake not dissimilar to the *rocciata*, a strudel-like cake, eaten in Trevi, although ring-shaped. The best cook, the newspaper announced, would receive a silver statue of the saint. Now considered a dessert, originally the *torcolo* was simple bread. Over centuries it has been enriched with aniseed, candied peel, butter and pine nuts. I've read that the shape originally symbolised female genitalia, and that many breads and cakes of the Italian peasants had been connected to fertility rites. The prewar peasants who offered it to their girlfriends on the eve of St Costanzo's feast day probably had few inklings of its highly charged symbolism.

¢

It is a startling moment when I open the local *Corriere dell'Umbria* and read the headline, 'It's St Costanzo's Day!' as I sip a cappuccino in Bar Roma, for it is the first time that I have ever bought this local paper rather than the national *La Repubblica*. The *Corriere* is handy for cinema programs, local politics, but serves up a diet of juicy scandals,

crimes of passion that excite the imagination once or twice, but are infinitely boring in their endless variations — it's the sort of seductive mindless matter I happily delved into at the hairdresser's. Every day this little paper manages to report some surreal story of misplaced wives, and complex love stories that ended in death or twists of fortune.

Yet today I am drawn to it, and sure enough it gives me essential information to flesh out the St Costanzo story. Sometimes I have the uncanny sense that we are all minor actors in an unfolding drama not of our own making, and someone, somewhere, is sending me messages lest I forget it.

The *Corriere* article says that St Costanzo is much loved by all Perugini for his great kindness. It continues that there are four different legends on his origins, and that there's probably a grain of truth in each version. One version is that Costanzo lived under the reign of Emperor Marco Aurelio at the end of the second century AD; another places him a century later, under Diocletian. In this version he was decapitated near Foligno — and that's where we come in, although the timing is confusing, as we're out by 100 years or so.

Costanzo is credited with being the Perugini's favourite saint, especially in popular culture where great faith is placed in his miracle making; he made the blind see and cured the lame. But he is most popular among the young women, who visit his statue in the church on his feast day hoping it will wink at them; a sign that they will marry within the next year.

In the afternoon I put on a heavy coat and sit by the stone walls of our chapel, basking in the winter sun like a lizard. I vow that next year, when life is finally orderly, we'll have a little commemoration by the stone walls of the too-long-abandoned chapel, and produce a batch of St Costanzo cakes. Sometimes, when time stops still, it seems I'll never go anywhere ever again, that life will become an unbroken chain of *feste*, olive trees, saints and unfolding seasons; that the rest

of my life will be spent repairing, digging and looking after this micro-cosmic but multilayered, corner of the planet. But I sense how far from the truth this is.

I find myself peering at the moist earth around the chapel like some eccentric botanist, searching the ground for evidence that winter will soon be over, while simultaneously soothed by countless birds twittering overhead — an Umbrian lullaby. Were they always here, or have they already returned from the south? The sounds float past, high above the constant, comforting rumbling of cars scurrying, beetle-like, along the Via Flaminia far below.

February

EVERY SCHOOLDAY I DROP THE KIDS OFF up at the piazza, then make a dash for the newsagent's. I have grown so hungry for news of the world outside. There is plenty to learn about in our new home, but it's business as usual 'outside', and I'm afraid of being cut off, despite living in the heart of Europe. Today I read of hostages in the Japanese Embassy in Lima, while in Algeria the slaughter continues. The world watches and does nothing. In Turkey, meanwhile, tonnes of testosterone are unleashed on the country's women, who are invited to disappear behind veils after a century of emancipation. And then there is the alternative news, a theatre of the absurd: in the United States the residents of Kingsville in Texas have been ordered by the city fathers to abandon the most common greeting in English, hello, guilty of containing the radical, diabolic 'hell'. From now on, it is to be substituted with heaven, and Kingsvilleans will greet each other with the neologism, *'Heavano'*.

In the Millhouse time passes quickly as we paint walls and scrub the ancient flagstones with acid to rediscover muted pinks and browns under centuries of dirt. Our living area, a storehouse for centuries back, is once alive with voices negotiating the quality and price of olives, and as I clean the stones I'm aware of wiping away generations of footsteps.

Winter is nearly over, and with it the worst of the cold — unless

this year we are due for a mad March, a *Marzo pazzo*. Snow still covers the foothills of the Apennines to the west, yet life stirs under the soil. The first green bulbs are probing the sunlight, and the bright yellow of the wattle blossoms anticipates the earthy, riotous joy of spring. It's as if our very blood is beginning to flow more freely. In the morning even the car starts up without a moment's hesitation, and in the piazza old friends linger just that bit longer in the watery sunshine.

I'm relieved to learn that we're considered by the Trevani to have purchased in the ideal location, for the south-facing hill basks in sunshine from early morning when the sun rises behind Monte Maggiore until it sets over Montefalco. Yet despite this exposure the replastered walls are still damp in parts, and my bones are constantly chilled as if wet from the inside out. It's become normal for us to stride around indoors in coats, and as I tap away at the keyboard each bright, crisp morning I'm still wrapped in layers of wool under a heavy coat. Through the window, past the mist-shrouded valley, Montefalco emerges like an island in a vast white sea. The scene is postcard perfect, and recalls a past when each hilltop community functioned very largely as a contained world. Hospitality to strangers was an unwritten law, but one had also to vigilantly safeguard the protective enclosure of stone walls built high above what were once vast marshes stretching along the valley floor, for the threat of sacking from other communes and northern invaders was real and constant.

When the winter sun shines, it's far warmer outside in the garden. I launch a full-scale attack against the invading weeds, which the ever-attentive Giuseppe Gasparini declares, quietly but firmly, are a perfect refuge for vipers and adder snakes, unless brought under control immediately. Nando, that now-you-see-me-now-you-don't garden wizard, mysteriously reappears one day, and sets about placing wooden steps up to the back wall. Giancarlo, inspired by developments, goes tree shopping; he plants a laurel, lavender bushes, an apricot, and Giuseppe's gift of a baby walnut.

Out front, where one day we plan to lay a cobblestone driveway in the local style — characteristic square borders of bricks filled in with stones collected on the rocky hillside — we plant a maple and three Aleppo pines, Umbrian cousins of the maritime pines that populate Mediterranean coastal resorts. These *pini*, along with the cypresses and olives, are the most common trees here, and once established seem to spring of their own accord from the earth.

I am warrior-like in my campaign against armies of soldier weeds, which have taken over and now guard the entry to the chapel. Some white lily bulbs are putting up a good fight for living space near the entry, and I cross my fingers that they'll flourish, despite armies of weeds and coming summer dryness.

Luigi, after plastering the walls of the courtyard, unearths a sleeping hedgehog one day while pipe-laying. He cradles it like a baby, carrying it into the courtyard to show Julian. Together they gently burrow it back into the ground. It sleeps through the whole adventure. We've heard stories of numerous tortoises slumbering nearby. Their underground haven is being crisscrossed with wires and pipes, while human footsteps thunder above ground. The territory is becoming a human habitat again. Will we all be able to co-exist?

Giuseppe Gasparini says that tortoises carry good luck on their backs, and that this patch has long been home to a veritable colony. That, he explains to Julian, is a good omen, a *porta fortuna*. But there's a slight modern-day hitch, a new bureaucratic complication. The law declares that next spring I must go to the local police station and make a declaration, for our tortoise neighbours are a protected species. So far, so good. Even I, a sworn enemy of petty laws and regulations, can see the sense in that. But, to complicate things, we'll then be obliged to build a fence around them; before our arrival they had always traversed the boundary-less landscape as free agents. If I were a tortoise, I would sniff the odour of well-meaning but misguided paternalism, and plan my escape.

¢

Then one Friday the workmen pick up their buckets, drills, hammers, ladders and paintbrushes, and depart from the new living quarters upstairs. Just like that!

'*È finito, Signora*', they exclaim, smiling with satisfaction. *Finalmente!*

I'm overjoyed to have some privacy, or ought to be. Yet the Millhouse suddenly feels too big — and as if I have shrunk.

As the days unfold about us, the rooms inevitably shed their building-site skins, and we finally take possession. The dust is swept away, and paintings are hung, somewhat haphazardly, but at least they're off the floor — perfection can wait. The hi-fi is ceremoniously plugged in, soothing us with an array of music from all corners of the world and back through time: Patsy Cline, Enya, Van Morrison, Caetano Veloso; from Mozart and Madredeus to the soul-stirring Canzoni Napoletane, and back again to Monteverdi. *Musica!* The sounds penetrate the cracks, the tiles and walls, and soar up, up to the ceiling where they settle, filling any empty spaces left by the workmen.

I miss my talks with Luigi and seeing his rough old hands at work. With Chiara and Julian establishing routines, and Giancarlo all week in Rome, lonely moments sometimes hit, despite the rush to get things organised. But now I can get on with the important stuff — setting up my studio.

Yet I hesitate, for many moments I wish I could just step outside the door and be back in Edinburgh, meet a friend for coffee, window shop, spend the morning in a bookshop. I tell myself that this pining for shops, galleries, tearooms, cinemas and cafes is part of adjusting to being outside city things, that it won't be forever. Meanwhile, it is essential that I keep creating my own Italy, that I act out the fantasy and make it real; and so I continue fabricating complex explanations as to why we had ended up here.

Fairytale or nightmare? There will be time enough, afterwards, when all this has become normal, to deconstruct the story.

¢

Jenny and Gregor, young artists from Edinburgh, come to stay: to draw and paint Trevi, to weave more of the web connecting the Road of the Mills to Scotland. They are the first of many.

¢

Slowly but surely Trevi doors creak open, and we are invited to step inside, are welcomed into other people's intimacy. There is mutual curiosity, but also the beginning of potential acceptance of us as new members of the community.

Last Tuesday, while sheltering under my umbrella waiting for Julian and his classmates to pour out from school gates, I was approached by a couple of women, one the thin and elegant wife of a large and prominent lawyer, and her attractive young friend, whom I had already noticed. They introduced themselves, and asked if Giancarlo and I would come to a dance party in the villa, positioned on the north-eastern slopes of the Valle Umbra, along an old dirt road below the monastery of San Martino. They told me that the party was yet another Carnival celebration, although most people would not be in fancy dress. Did they realise what a favour they had done me? Finally, a chance to step out of work clothes and into the private space of these new neighbours! I do not display my loneliness, but there are crushing moments when it wears me down — this being new, being different, and being foreign. Will it always feel like this?

A few days later in the *sala musica* of the villa, a gorgeously feathered man in drag — all pinks, yellows and gyrating hips — pulls me around the dance floor. It's like Brazil! He tells me he's an antique dealer from Bevagna. Between swirls, he adds that there are three essential questions asked of all newcomers to Umbria: Who are you?

Where did you come from? And, most importantly, why did you come? The last question is the one that says it all — about us, about them.

It's easier to just dance, and forget the rest for a while. That's what Carnival's for, after all. There is a Fellini-esque moment when a well-known art-critic-cum-politician steals away with a dark-haired signora, leaving husband and teenage daughter wondering loudly what on earth has happened. But I miss the whole thing — I'm too busy dancing with my feathered friend.

The question on everyone else's lips, more for a taste of forbidden scandal than anything else, is what are the two of them up to, and where have they hidden themselves? The dishonoured husband sets off to ferret them out, and within minutes has found them. She sobs, cries to be left alone. There follows a very public shouting match, which spares no one at the party.

Naturally the 'Don Giovanni' comes out unscathed, for his celebrity status protects him; he has declared loudly on television and radio that he is one of the few remaining Libertines, and has created an aura that few dare challenge — even, it seems, betrayed husbands.

The music stops, and while the furore blows about me, I sit down by the founder of an important contemporary arts magazine, a local-boy-made-good; we begin chatting. He tells me he now lives in a loft in Milan, but travels to Trevi for exhibition openings at the Flash Art Museum, and for family reunions. He maintains a complex love–hate relationship with Umbria, but returns often, perhaps to replenish jaded city spirits. Then he adds he has plans to open another museum, down along the Via Flaminia, to house major contemporary artworks now in storage, and that it will be one of the finest contemporary architectural statements in Italy. Anything would be better than the constructions down there now, I venture. He agrees, and the names of top architects slip easily off his tongue.

¶

Soon after, the town council throws a Carnival party in Piazza Mazzini.

It kicks off at 4 o'clock with games for the kids. Chiara, having outgrown such childish events, prefers to hang out by the *fontanella*, the little fountain, with her classmates. But for the smaller children, it's a big event; they've even had a trial run at school in the morning.

Unlike most Italians, we haven't invested in lavish costumes; rather, there had been a flurry of last-minute improvisations. I'm too preoccupied decorating the house to think about my body. And anyway, we're artists, and know how to improvise!

After lunch Julian raids his wardrobe and re-emerges in black — dark glasses, black jeans and shirt, leather jacket with tassels from the Tijuana markets in Mexico, against which he hangs fake-gold chains. His face whitened with theatre paints, a furry black moustache across his upper lip, he appears a composite of young Einstein and a Mafioso. With a toss of his gelled head he announces, '*Sono un rock star!*' Most of his classmates are transformed into cartoon characters, Punch, and pirates.

Slap-bang in the middle of the piazza stands a huge effigy of Carnival himself, his grinning face nodding over little groups of families and friends gathered beneath. It feels somewhat surreal, reminding me of village scenes in Central Europe. Is it the greyness of the day or the sobriety of the adults' clothes against the gaudy, doll-like figure in the centre — scarecrow, sacrificial lamb and perfect scapegoat? This is not the lavish, luxurious display of Latin people, but seems to spring from some other source — a fusion of Umbro–Roman–Longobard. The austere piazza is minimal-Umbro, its heart occupied by the huge figure with its jack-in-the-box head. A music man grinding his organ, a monkey at his feet, would fit the scene perfectly, and I am reminded of the last time I felt such an atmosphere — five winters ago in Budapest on a foggy, damp morning. A small, bent man had stood in the mist outside St Stephen's Cathedral, playing

his tinkering tunes for a group of melancholic Russian soldiers. They hoped to make some cash selling the memorabilia of years of military service in Hungary before heading back to Moscow. Their caps and red-and-gold badges, symbols of an era that was ending, were placed neatly on blankets on the frozen ground for the benefit of tourists.

Slowly, as the watery light fades, the children form a circle around the Carnival effigy. Holding hands, they begin to skip around and around him, while volunteers light fire-torches on each side. The flame flickers, anticipating the coming bonfire. A band plays under the portico its mix of children's songs, middle-of-the-road Mediterranean and samba, while a maxi Mini-mouse skips across the cobblestones.

Night falls. Paola, a teacher from Foligno, dresses as a clown and joins the children. They clap their hands, and she incites them to cry *'Brucia, brucia Carnivale!* Burn, burn!' The few children on the sidelines join in as well. In the midst I spy a woman from England called Caroline, dancing with her two small children.

If she can do it, so can I. For a second Julian and I look at each other, then hold hands and enter the circle. We laugh out loud as we skip and turn. A bit like a carnival in Brazil, I tell Julian. Not the big Rio Carneval, but in little towns across the country with their street parties. And in the background, like a heartbeat, the sound of clapping, of chanting continues. Burn, burn!

Carnival's bobbing head is removed ceremoniously with a long broomstick, then carried through the crowd like spoils from the battlefield. Another decapitated man! There are mutterings of protest from the crowd as the head is paraded through the piazza, for the Trevani feel they've been cheated of a proper burning. And they have!

Someone taps me on the shoulder. I turn and see Chiara and her friend, Daniela. Unbelievably they'd joined in. I'm glad she's here.

At 6.30 on the dot a torch is thrust at the hem of Carnival's multicoloured cloak. The crowd pulls back in one great wave. Flames engulf the effigy, and a burst of hot bonfire air overtakes us. The

children run away from the railings as gusts of wind blow smoke clouds about. All up in smoke. The flames flash and flicker, and Carnival burns quickly — like the Befana in Sant'Eraclio, reduced to a jangle of wires in minutes. And as quickly as he burns, the crowd breaks up, and toddlers begin rubbing their eyes and crying. This sacrificial burning of the old feels almost over before it had time to finish just being. As we leave the square, there's an elusive quality about what has just happened. *Ignis fatuus*, will-o'-the-wisp flames.

We head for the warmth of the bar. It has become even colder now that the fire has died down. And Julian is hungry.

¢

'See you tonight for the masked party?' asks Caroline, bundling her *bambini*, Clarissa and Georgia, into the car a few minutes later.

I hesitate.

'I guess I should go, at least once.'

'Yes, you should! I'll come over to your place in a few hours, to pick you up.'

Once back at the Millhouse Gregor is in barbecue mood, and cooks up spicy Trevi sausages and pork chops on the open fire. The meat is mouthwateringly good. We've discovered a farm down in the valley with a shop on the premises. Every Wednesday the farmers slaughter a cow and a pig, and appear to sell every part of the body, including pig's testicles and penis, which proves these don't always end up in the sausages, which are one of the local specialities. At the farm you can buy fresh milk, free-range eggs, and cheeses such as salty pecorino and ricotta. Gregor, a one-time semi-vegetarian, has eaten more meat this week than in the previous year, for Umbria is a meat-eating sort of place. Those pork chops and potatoes cooked with freshly picked rosemary are perfect on a winter's night.

I sit on a stool and ask, 'Are you and Jenny coming to the masked party with me and Caroline?'

Gregor grins sheepishly. 'Och, no. Jenny bought me one of those plastic devil tails, but you'll never see me running around with that on!'

Jenny walks over to him, and taps her foot. 'That's what you think! Come on Gregor, we're not in Scotland now — no one even knows you here! It's now or never! And I need you as my devil-double!'

Gregor shakes his head slowly but firmly. He repeats that he has no intention of putting on any stupid mask, any stupid tail, but after facing our united front gives up. He really has no choice. The two of them disappear to cover their faces in bright red paint, and attach horns and sharp little red tails. Meanwhile, I gel my hair and string gold thread through Chiara's jet-black Mortitia wig from the Addams Family. Then I slip on a dress: long, nondescript and black — but shiny. That will do. Like Julian in the afternoon, I make good use of gold beads and chains. I place a small rubber snake in the wig, a red spiralling form that winds its way through the rich black. This morning in the tobacconist's I had spotted a plastic python — it now slides around my throat and down my back. Tomorrow morning it will join Julian's bug and spider collection, and slither down the staircase in his bedroom; tonight, however, I need all the help I can get to metamorphose into an Egyptian princess — Cleopatra, preferably — but the woman gazing back from the mirror appears more gypsy than queen. *Pazienza*, patience! I paint a thick black line around my eyelids and a beauty spot on my right cheek, just for luck. That will do.

Caroline arrives around nine, hidden under a great mass of red curls; more *femme fatale* than clown. We share a lot of embarrassed giggling and some spumante before setting off.

In Via Roma, just past the theatre where Carnival parties occurred until recently, there are groups of masked revellers; and they could be absolutely anyone, so well are they disguised. There's a lot of laughter, but also a hint of something less benign. My face suddenly feels naked under the black fringe, with my eyes and mouth exposed — a declaration of femaleness, while most faces are covered. Suddenly I

wish I had hidden more, like everyone else. I wish I had hidden my face! Eyes behind white masks stare out at me, and I suddenly remember how it used to feel among the women of Alexandria. Often, only I displayed face and hair, a modest femaleness. The other women covered their hair and limbs. Memories surface — of not knowing who the other is, of powerlessness.

Of course, no one else feels like this. Gregor has cracked some joke, and Caroline is bent over laughing. We step inside the bar where the party will be held.

It's small-town stuff, a middle-of-the-road band squashed between the billiard tables, huddles of local Albanians shuffling around the door — not made to feel blatantly unwelcome, yet never encouraged to join in, they are destined to remain on the edge all evening. Why hadn't they masked themselves? There is nothing small-town about the costumes, however: from elaborate, ornate Venetian Dame to cannibals carrying plastic limbs, huge furry bears, one-eyed pirates and a multitude of red-faced devils; then glamorous female soldiers, a smattering of priests, nuns, black-and-white minstrels and, last to enter, a man-size baby in an oversize pram, great hairy arms folded across a massive chest, a pink dummy in his mouth.

Caroline and I pull up a couple of chairs next to his pram, and order some more *prosecco*, more sparkling wine. We give the giant baby a glass, which he gulps down greedily before resuming sucking his dummy.

Then we join in the dancing for a while. The mood is joyous, and people who have never met before are dancing together.

But as the night moves on I feel the oppressive dead weight of those young men by the door (like sitting down to breakfast with Giancarlo one morning in Cusco, Peru, while hungry children stared through the window), and find it impossible to ignore. Why hadn't they worn masks too? This had been their chance, after all, to turn the cards around. That's what Carnival is for, after all!

For me, the party is over, almost before it begins. I want to go home. The best part was the preparation.

¢

14 February, Valentine's Day. Valentino was also born in Umbria — but further south, in Terni. It seems only the Umbri and bizarrely, the Japanese, know that Terni is the birthplace of this saint. Japanese tourist agencies have found a sort of synergy between Christian religion, romantic love and culture in the figure of Valentino; the *Corriere dell'Umbria* announces excitedly that negotiations are under way with major tour operators for a series of 'lovers' pilgrimages' from 'the land of the rising sun'.

Julian wakes early, takes great care in dressing — best jeans, gelled hair again, black boots polished to a high shine. He has spent the evening making a card crisscrossed with bright red hearts for his favourite female classmate, and has purchased a mini-packet of Perugia's sublime offering for lovers and chocoholics the world over: Baci Perugina. He says he must get to school early so as to place the card on her desk. As an afterthought he places some of my old costume jewellery in a decorated package, and takes that too.

When he comes home after school, he tells me that she ate the chocolate but refused the fake jewels.

He sighs, 'I think I picked the wrong girl.'

Meanwhile, Chiara has made a card for herself — 'From Chiara to Chiara' — and has presented herself with a big box of chocolates, which she eats slowly, sensuously. 'Just in case, Mamma', she tells me, licking her lips.

¢

Julian and I are making our way up the stairway that leads to the piazza, when we run into an old woman who lives along the alley. She grabs my arm and mutters some strange tale of robbers breaking into her house and — she makes the sign of the Cross — hitting her

husband on the head with some garden implement. Then she declares that the 'robbers' had entered from our garden, through the opening in the wall by St Costanzo's chapel. She hints that they may have been the young Albanians who've been giving me a hand clearing the pathways in the last few days.

I tell her that it's very unlikely they are involved, and enquire whether she has reported the case to the local police.

'Of course, *certo*. That's the first thing I did.'

We say goodbye, and as we walk away she hisses back at me to take care. 'Pay attention!' she calls out, wagging her finger, 'they are dangerous! *Pericolosi!*'

'She is really spooky, Mum', whispers Julian, holding my hand tighter, 'and she looks like a witch with that really big nose. There's even a wart!'

But secretly I am worried. Robbers coming through our garden, entering through the hole in the wall? I must ask the workmen to brick it up. I decide it's probably prudent to talk to the Marshall, the *Maresciallo*, myself, if in any way we are involved. But when I visit the police station later in the morning, they look at me blankly. No one in the place knows what I am talking about. There has been no report of such a crime in the last few days, they tell me, shaking their heads, then ask me to let them know if I hear more.

By pure chance I meet the old lady's husband in the piazza a few minutes later, and ask him if he feels better.

He looks at me blankly. 'Better, Signora? I am very well, Signora. Why do you ask?'

My suspicions are confirmed. Walking back home, I wonder why exactly she had wanted to frighten me. Is this a way to get the hole blocked in? Why didn't she just ask? I'm angry at her scapegoating the Albanian workers; they don't need her poison. Maybe there are just too many foreigners around for comfort. As we walk back down to the Millhouse and pass her front door, I steel myself against her haggish hexing and feel Julian's fingers grip my hand tightly. I hope

there are no more potential harpies and furies hiding in the alleys of Trevi, waiting to pounce on me or anyone else who doesn't quite fit in.

<div align="center">¢</div>

As the weeks unfold, my eyes grow more and more attuned to the coloured palette of earth and sky. Silver-grey in the green of olive trees, blue tingeing the hilltops when white snow melts; warm umbers, charcoal greys and bistre, touches of sanguine in the rocks at sunset, a cloak of sepia spread over everything on dull afternoons, for way up here above the Via Flaminia there is an absence of synthetic artifice.

Against this backdrop it is suddenly San Remo Festival time again; another annual ritual and the traditional refuge for Italy's most sugary pop songs. This event is now taking Italy by storm for the 40th time. A radio commentator describes it as very 'Oll-i-vood'. I read in one paper that if the future of popular music were to be judged from the San Remo proposals, it would be a valid reason to request political — or cultural — asylum abroad. All week the newspapers regurgitate gossip from the *platea*, the stage, as popular archetypes (the Italo-American showman; the big, busty, blonde bombshell with dark glasses and eight bodyguards; the media-hungry hangers-on) jostle each other before an enormous public, sitting spellbound before television screens across the land. Fourteen million a night, in fact.

It feels so far from our Trevi epicentre.

<div align="center">¢</div>

Since being here I've dreamt so many times of earth and animals, and of burrowing into the very earth outside my door, into the soil of Trevi.

Last night it happened something like this:

I dreamt that after entering the swirling, downwards spiral in our garden, I could not find the tunnel and had to dig, until I came upon

a small open space, a dirt cavern, but moist, the sort of place a fern might grow were there enough light.

I found myself face to face with a female fox, suckling her four cubs. Instinctively, I crouched down before her and pleaded with her to be my guide. She slowly shook her head, smiling with concern.

I felt absolutely safe, deep in the earth beneath the olives, accepting everything she said; we communicated through an intense eye contact. Her penetrating gaze met mine, our eyes locked together, creating a powerful current of energy along which 'words' pulsated. She revealed that she was busy with the cubs and had no time to spare; it was not possible to follow me back to daylight just now, but yes, I was safe, and although I would be above ground and she below, we were bound together, by this meeting. I understood.

She nodded towards a dark corner where a little brown dog lay watching me. The dog sat up, and told me that if I required guidance he would be there. He said we had met before. I thanked him, aware that time was up, and bent over to pick up a twig as a talisman, for it was somehow crucial that I take something back. We said goodbye. The female fox was still smiling gently as I began to climb up, squeezing through the tight opening and into the bright bleached light.

Above ground, I realised to my dismay that the talisman had fallen from my hand. Time was running out and instinct warned me not to turn back, for I would be stuck inside the earth forever. After crawling out, I lay on the dry grass wiping the dirt off, enjoying the warmth of the sun on bare skin, yet regretting having lost the talisman. And then I heard a bark. The jaw of the little brown dog appeared through the hole, with the twig in his mouth. Sitting up I leant over to him. He told me that he must not leave the hole, and dropped the tiny bit of wood on the ground. And then he disappeared as quickly as he had come.

I picked the twig up and raised it, as far as my arm could reach, towards the sun.

March

WE ARE GLUED TO THE RADIO as news arrives from nearby Albania. It becomes more and more dramatic, building up towards a crescendo. Unknown places become familiar, for all the wrong reasons — Valona, Saranda, and Fieri. The names are beautiful on the lips of news-readers, yet they are tinged with tragedy.

I meet Orion, a member of the local Albanian community, up at the bar, standing amid a bunch of young Albanian men who look so sullen, visibly oppressed by the knowledge of belonging to an underclass, perhaps for the term of their natural lives. They are waiting — for work, for news from home, for things to change. When they smile, their smiles are defensive. As they while away interminable days in the piazza, some of these young men challenge the natural reserve of the Trevani with insolent gazes. Many stare at the local girls as if they were ripe for the picking, infuriating local parents who are used to thinking of their town as perfectly safe, and leaving men such as Orion a hard task — that of keeping the lines of communication open between the new arrivals and the native-born, for there's an invisible boundary between the *extracomunitari* and Italians. I remind Trevi friends that we Australians are also *extracomunitari*, from outside the European Union — but, as every-where, a bank balance and a touch of worldliness make all the difference.

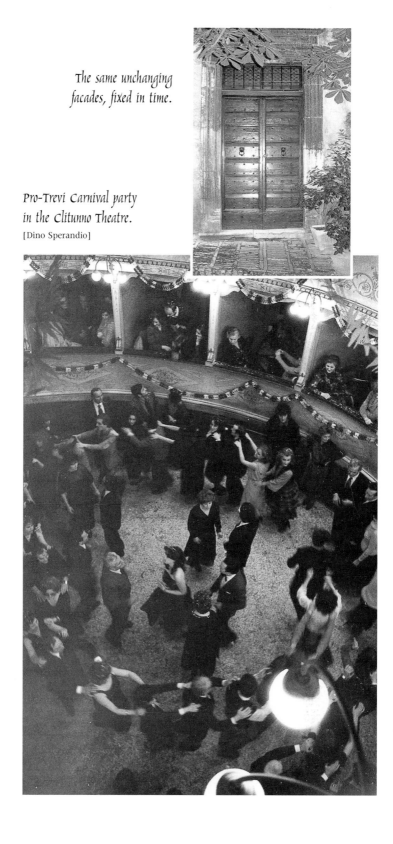

The same unchanging
facades, fixed in time.

Pro-Trevi Carnival party
in the Clitunno Theatre.
[Dino Sperandio]

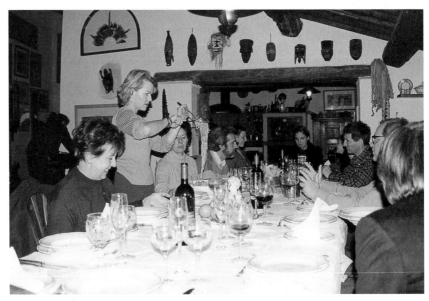

The Millhouse is becoming a port of call. [Chiara Izzo]

Giancarlo (left) and friends playing billiards in the Circolo di Lettura.

Viriginia with Caroline. [Giancarlo Izzo]

Cloister of the Pinacoteca.
[Vincenzo Giuliani]

Andrea outside the pottery.

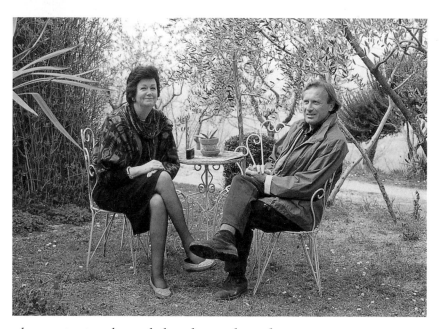

Glasgow art critic, Clare, with the architect in his garden.

Rodney, the Italian scholar from Melbourne, and Graziano, an actor.

A little corner of Paradise in the Zenobis' hidden garden.

Food-gathering on the hillside.

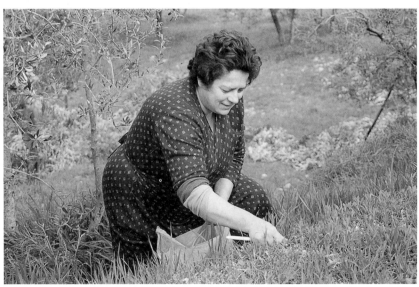

Orion comes from Valona, the southern port strategically placed for international arms dealing and contraband. At least his family hasn't invested in the pyramid banks that recently collapsed, and the money he'd worked so hard to save is safe. That's a huge relief. But he's worried about his family. He is confused. Where should he be? Here in peaceful Trevi, his home for the last four years, where he finds no peace in these days of reckoning — or home in Albania, with family and friends, and guns pointed against tanks? The question is familiar, for we heard such concerns voiced frequently, especially among strong young men, Croatian, Serb or Bosnian, when we lived in Yugoslavia. I remember a hospital near our Belgrade house that became a dumping ground for returned soldiers during the war. I would drive past it nearly every day on my way to the shops at Beograd Centar. As time unfolded, the sight of maimed boys in wheelchairs staring at the cars whizzing by became familiar. They sat by the edge of the road breathing in the car fumes, in their eyes the realisation that strength and youth were never to return, but had been truly stolen from them by warmongering fathers. The hospital was overflowing with human residue.

And it strikes me, talking to Orion on this chilly but sun-drenched morning, that many of the weapons of those recent uprisings could well have passed through the port of Valona, his beloved hometown, especially after the 1992 sanctions were decided against Serbia. Then, Valona had become a haunt of the Bulgarian, Greek and Turkish *mafiosi*, fertile territory for arms dealers and money launderers.

Being a mere 60 km from the southern Italian port of Bari, cultural ties between Italy and Valona are not casual; the histories of the two people are woven together through wars and migration, as in all Albanian towns. In the past decade the fake-blonde dancing girls and glitzy wheels of fortune of Italian television have invaded the inner sanctum of threadbare Albanian homes, brutally punching even more

holes in the national psyche; so many believe that Rome is a Latin Dallas, temptingly near. Young and old sail across the Adriatic, clinging to leaking boats, hoping to strike gold.

¢

Jenny and Gregor have slowly begun merging into the landscape; somehow they even look less foreign, as if they have learnt unwritten codes of behaviour and appearance. And they are happily productive, churning out drawings reflecting their identities as artists and travellers. The marks materialising on the white paper hint at a recognisable, yet somehow different, Trevi.

Jenny develops a series of small images based on the fourteenth-century pigeon tower slightly to our east, which culminates in a poignant self-portrait in which she carries the tower away. Fragments. Jenny loves fragments.

¢

The thermometer on the wall beside the computer rises at last to all of 14°C — the moisture trapped within the walls has perhaps begun drying out. My teeth have almost stopped chattering; I must be getting tougher.

Beyond the walls the air smells of early spring. I can't wait to see the tiny flowers sprout from rocks and to sniff blossoms on the fruit trees, some of which are already budding.

Giancarlo and I sit on a recycled roof-beam by the vegetable patch, and I observe that it is almost worth the bitter cold to feel such deep pleasure at the changing of the seasons. Just below us on the narrow road a slow parade of old women passes. Each is carrying something on her back; some of the women are almost hunchbacks. They have been out gathering wild asparagus and *rapunzoli*, a sort of radish, with which they concoct delicious salads.

Matilde Gasparini appears every few days with wild dandelion

leaves, which we steam and eat with olive oil, lots of lemon and a touch of garlic. I have taken to walking every morning for an hour or so — a strange habit to the old people, whose toughness comes from a life of working outdoors. They observe me with puzzled looks as I stride past them along dirt tracks between the olive groves. I make it my business to greet them with a '*Buon giorno*' and a smile. And they always smile back.

Like other newcomers, I have to remind myself constantly not to glamorise the figure of the *contadino*, the archetypal Mediterranean peasant, a frequent slip. They might be out here in the fields, but for sure their houses have all the mod cons, and they drive shiny automobiles rather than rusty *macchine*. Yet still, there is a wider idea of the *contadino* as a repository of the general values of a culture, and as such not confined exclusively to the rural sphere. One finds that in writers such as Carlo Levi. For him, *contadini* are all those who 'do' things, who create, who love, who are satisfied. If you look at it like that, artisans, doctors, mathematicians, painters — most of us, potentially — are also *contadini*. And a fundamental, surviving characteristic of *Italianità* is the timeless movement of hands at work, making beautiful things; hands that express the value of a culture, which, often unconsciously, has placed in high relief simplicity, functionalism and elegance. Making plants grow. Making *la salsa*, or cooking wild asparagus. Creating some of the world's finest shoes, leather bags, fast cars, carvings, marble tabletops, constructing a perfectly tailored suit. Years ago recognition of this innate gift of transforming the ordinary into the extra-ordinary pulled me irresistibly towards Mediterranean shores.

As I stride along between the olive trees and watch gravel disappearing underfoot, I wonder what is still true and what is not. For something has gone wrong in the last decades; there's no way around it. A case of too much, too soon? Before, did most people understand on some unspoken level the innate value and beauty of

things? Of stone, plant, song, a day's work? Was there more *rispetto*, more respect? Even here in Umbria the down side of affluence is presently pushing its loud-mouthed way into the foreground, embodied in the mindlessness of so-called *nuovi barbari*, the new barbarians. They are the ones getting a lot of newspaper coverage presently, they are said to hate books, hate learning — they just want to have a good time, full of *divertimento*, distractions. They are a sizeable portion of the 80 per cent of twenty-year-olds who consider reading an activity fit only for desperadoes.

But there are precedents. I'm reminded of Goethe's *Travels in Italy*, written over two hundred years ago. A Bolognese captain, a *capitano*, travelling with Goethe (obviously very worried about the writer's mental state and deeply concerned about his frequent silences) expressed a similar attitude. In the end the *capitano* felt compelled to warn Goethe that a 'man shouldn't think too much — thinking makes one grow old — a man shouldn't dwell on one thing, for he will go mad; he is far better off to have many things, a *confusione* inside his head'.

It seems that 80 per cent of Italy's youth would agree with the *capitano*. Goethe would have a hard time today and be seen as a misfit, his music lost behind the shouting of more brittle, streetwise voices.

We've got the *capitano*'s confusion all right — and in the here-and-now even he might have found it too much.

ç

More friends from other places begin dropping in. The Millhouse is becoming a port of call. From Brazil our old friends Margarita and Rafael have rung to say they will be in Rome and will be driving up to see us. It is seven years since we said goodbye in Brazil. Since then Rafael has served as mayor in the southern city of Curitiba, where we once lived; it is now known as the ecological capital of Brazil. Exuberant, oversize Rafael spends much of his time at international

conferences on urban planning, and this week has been in Rome explaining recent developments in Curitiba. He's like an enthusiastic schoolboy; that's part of his charm. Behind the smiles, however, is a man of culture and experience.

They arrive at the Millhouse one wet Saturday morning, their generous, well-dressed bodies bursting through the front door. 'Dear Virginia, Giancarlo! *Che bello!* Together at last!'

The room is suddenly full of them. We kiss both cheeks. Margarita smells of Chanel. They bustle about, exclaiming, observing everything. I am lit with joyful, Brazilian warmth.

'My dear friends. *Queridos!* There is so much to say. Where to start! Ah, I have brought you a book! Our book!' Rafael exclaims in Italo-Portuguese, plonking himself down on the leather sofa, and patting the cushion next to him for me. 'Come! Sit down and have a look.' I do as he says, feeling as if we have never been apart. He places the book in my lap, and I open the front page.

This is his book. I can see that. The large typeface of the preface is already totally in tune, reflecting Rafael's *joie de vivre*, his hungry, urgent determination to bring beauty into the lives of the citizens who voted for him. He points to the first page.

'Read this! This is my philosophy!'

'Let us invade the city with books for weapons and lighthouses for sentinels!' I look up. 'Lighthouses?'

He lights a cigar. 'Lighthouses of knowledge, *farols do saber*'. He blows the thick smoke out, and begins explaining that they're part of a series of ambitious urban developments. 'You'd hardly recognise the city now! Everything is changing so much.'

'Everyone tells us that in letters. Go on!'

'*Entaio*, so then. These *farols* are based on the ancient, quasi-mythical lighthouse in Alexandria in Egypt — once one of the Seven Wonders of the World. We merged the idea of the lighthouse together with the other famous monument in Alexandria — the Library. I don't

know if you know, a new library is presently being built by UNESCO on the same spot.'

I nod. 'Of course I do. Remember, Rafael, we used to live in Alexandria in the early 1980s. It was already being talked about then. Giancarlo and I used to sit on the terrace and look out over the corniche and the port where once that very lighthouse had stood.'

For three years in the early 1980s Giancarlo and I had been posted to Alexandria, and had lived in the former summer residence of the Italian Royal family, the Savoia. Although badly in need of repair, its furnishings faded and candelabras covered in fine sand, none the less the residence had been a magical place in which to wake up each morning. I remember spending the first months walking around the city with E. M Forster's *Guide to Alexandria* in hand. In winter the Hamsin winds from the Sahara would fill the reception rooms with fine sand and I would barricade myself indoors. It now seems so far away, sitting here in Trevi.

Margarita is still standing by the window, gazing out towards Spoleto. Giancarlo brings her an *aperitivo*, and she comes and sits down near Rafael, smiling indulgently at him while he tells us about his work as mayor. His voice is pitched high with enthusiasm. '*Bom*, good, let me tell you more. We have built a small library in a lighthouse in every suburb. So far, there are about fifty; still thirty or so to do. They are all pre-fabricated, identical, and immediately in place became familiar sights, like totems — safe places for people who might not have thought of themselves as book-lovers. Each contains 5000 books, reading rooms and computers with Internet. Then, above, on the third floor, there is a beaming light and a guard, so that single people, women and children can feel safe leaving the building late at night.'

Margarita breaks in. 'We are trying to create a culture where people become familiar with books, with new technology. You know our problems of illiteracy in Brazil, and the power of television in the lives of people there. We need to work against that.'

'Not only in Brazil, believe you me', Giancarlo exclaims. 'So you merged two great monuments of classical Alexandria and Western civilisation — the lighthouse and the library. Brilliant! Cavafy, the Greek Alexandrian poet, would have approved — you know, the words about the barbarians coming.'

'It's amazing how many connections there are. Between Curitiba in Brazil, Alexandria in Egypt, and even little Trevi, here in Umbria', I add. 'Trevi's been involved in books in unexpected ways too — you'll like this, Rafael! Back in 1470 the fourth printing press in Italy was set up here. It's thought to have been the very first publishing co-operative press in Italy.'

'*Que meraviglia!* You would never think — and what did it publish?'

'Not surprisingly the first works were Franciscan.'

'And now? With such a past! What do people read?'

I shake my head. 'Not much. There's a library staffed by heroic volunteers down in the valley. But people here — in all of Italy for that matter — are not great readers in general.'

Margarita puts her drink down. 'Perhaps you could say this is a very visual culture, not unlike Brazil.'

Rafael interrupts her. 'Margarita, then what they need is a Lighthouse of Knowledge here in Trevi — the first in Italy — connected via Internet with other libraries all over the world! Just think, with all these medieval towers! In Trevi the lighthouse might be reborn from one of them; that's a very Italian solution, after all! What a use for the new millennium! There are so many abandoned bell-towers in these little towns. Maybe there is one here.'

'There is.' I think of the thirteenth-century bell-tower in the piazza coming alive again, in proud defiance of the *nuovi barbari*. A tower, connecting past, present and future.

We are still talking about it an hour later over pasta and an excellent Montefalco Sagrantino wine in Maggiolini's restaurant. A relentless Rafael pontificates with heartfelt fervour and hardheaded

pragmatism. 'It's cheaper to build libraries than prisons.'

Over coffee, Giancarlo and I pore over the images in Rafael's book, which we had taken with us, recognising so much, yet at the same time amazed at how much the city had developed. I want to go back! For a second, life here in Trevi feels jaded and tired, but I banish such thoughts. They serve no purpose.

Together Giancarlo, Rafael, Margarita and I wander Trevi's narrow alleys, and I guide them to the little alcove above the Duomo, wherein kneels a modest marble carving of St Emiliano, the most touching of all the monuments I have spotted inside the medieval walls. Why do I love the statue so much? It is unassuming, lost in prayer as we pass below, as tourists and Trevani walk by, mostly unaware of its existence. It is cemented down to avoid being stolen by art thieves — a big problem in Italy. For me, it embodies the unassuming charm of Trevi.

'*Ah, si!*' sighs Rafael, standing below and gazing up. 'Beautiful. Peaceful.' Then he turns to me, frowning slightly. 'But are you happy here? I mean, it's a stunning place but don't you yearn for change, for modern things too? We love Italy, come back all the time, but there is a resistance to change.'

'Oh, Rafael, of course! Don't you think I know?' I take his arm. 'Come. I'll see if I can get the theatre open for you and Margarita. That was "modern" a hundred years ago, and was restored a few years back — and what a jewel!'

<center>¢</center>

Soon after, I'm invited to dine with another local family and their friends — some of whom are to become trusted friends over time — in a *cantina*, a cellar in part of their vast home in the town centre. It is a Tuesday, and Giancarlo is in Rome; sometimes I tire of going out alone.

I ring the bell, and enter from street level. There is no hint of the generous spaces within, or of the surprising rooftop gardens, just a

small wooden door, then a neat row of stone steps leading up to an internal courtyard. I climb up to the landing, and step into the closest I've ever been to an enchanted garden. A little corner of paradise, I think, a *paradiso* — like *paerodaeza*, perhaps, the ancient Persian for park or enclosed garden.

Once inside the house, I am told that the Roman walls in the room date back two thousand years, and would have been built by slaves or soldiers way before Costanzo was martyred in 175 AD; over time they have been incorporated into the spreading township. Walls like this are said to still exist in a number of Trevi homes.

The head of the household is the bubbly, eighty-year-old *avvocato*, a lawyer, still full of the love of life. I soon discover that Trevi owes much to him, for he has spent years researching and writing local history. In the assembled group a few faces are familiar. I see Franco, the *avvocato*'s endlessly busy son-in-law — the one who had found out about Costanzo for us. He invites me out onto the terrace, and we gaze down upon the northern lights of Foligno. Behind me is the courtyard, and then the thirteenth-century bell-tower of the Duomo rising behind a cluster of roof tiles and chimneys. The courtyard garden and terrace resemble a rabbit warren — full of inviting nooks and crannies. Only gurgling waters gushing from an urn-shaped fountain break the silence. The garden is shaded by palm trees, imported by a family member from the Italian colony of Abyssinia back in the 1930s.

I am welcomed like a long-lost friend, and yet I feel quite shy. We sit around a circular table, which the *avvocato* declares proudly he had designed so that everyone could talk to everyone else — an indication that he has no need to prove his position as a patriarch by sitting at the head of a traditional long wooden table — and begin this most friendly of meals with a hearty soup of farro, once a favourite amongst Roman soldiers. Farro is a hard grain cereal that has recently become popular at chic dining tables, along with other staples of the local

cucina povera, traditional peasant cooking. I discover that most Trevani do not remember eating farro as children thirty or forty years ago, but in the last few years it's become very popular when introducing guests to local traditional cooking. The Romans called it *far*, and with barley it was among the first cultivated grains — and probably the very first in central Italy. In fact, from its name the Latin word for flour, *farina*, originates.

White and red meats follow the farro, and spicy Trevi sausages cooked on a spit in the huge fireplace. I have never seen a spit like this one — operated by a stone, which gradually descends as the spit turns. And it occurs to me that I have not come across a vegetarian in Trevi yet, although surely someone must be happily surviving on farro, rice, pasta, and fresh vegetables; but traditionally Umbria is a land of hunters, of wild boar, pig, goat, fowls and pheasants. Until recently, meat was not often eaten by local people, and most meals were modest — a typical family dinner might have consisted of soup and salad, a boiled egg and a piece of fruit. To refuse meat on special occasions would have been unthinkable.

We sip the fullbodied red wines from Montefalco, a thriving wine-growing area. Umbrians, and indeed most Italians I meet, are never gluttonous at the table, but the most Italian of organs, the stomach, is accustomed to being treated well, and will not take second best. Everyone eats with gusto, but portions are never inflated. Goblets of wine are interspersed with glasses of mineral water. People's spirits are naturally high. Alcohol in Italy does not serve the same social function as in northern climes, and it is rare to see an Italian who has drunk too much. Toasts are proposed, and as the evening unfolds the men burst into song — mountain songs, followed by Puccini arias.

When I arrive home well after midnight, I find that Matilde Gasparini has left us a big plate of mouth-watering *frittelle*, a sort of fried pastry, which she's prepared for the feast of St Giuseppe, her husband's feast day. The fritters are made by kneading together flour,

egg yolk and sugar with a generous swig of rum. The mixture is then left to rest for ten minutes or so, before being rolled into a sheet, cut into strips and shaped into ribbons. Each piece is fried in lard, drained and sprinkled with sugar. Matilde tells me later that some women use honey instead, and turn up their noses at anything less.

It feels good to be wrapped in this neighbourly kindness, to push aside all displaced feelings for a while.

<p style="text-align:center">♀</p>

Julian's allegiances slowly shift: touched with artist's fever, he has become a devotee of Jenny and Gregor, rushing home after school in time for picnics, walks to the pigeon tower, painting expeditions. They make a happy, energetic little trio as they walk down the road, knapsacks bulging with drawing supplies.

Chiara is fully occupied with homework, acquiring language skills and new friendships, so I am pleased when Clare, a friend and Glasgow-based art critic rings to ask if she can visit. She's been invited to Venice for another blockbuster exhibition and is taking the opportunity of staying on a few extra days. I love feeling that our lives in other places can converge here in Trevi, and I tell her I'll be happy to have her.

A few days later I drive to Foligno station to meet her train; it is past midnight and she looks tired and drawn after a hellish day of confusing timetables and missed connections. But it doesn't take her long to revive, for a good night's sleep and the early morning view of the valley are balm for travel-weary souls.

We agree to explore hidden corners of the town together over the following days, although predictably we find ourselves spending hours discussing Scottish artists in the Bar del Circolo over *cappuccini* and *cornetti*, croissants.

Yet we do fit in a few local spots of interest between coffee breaks. First stop is the Pinacoteca — the museum beside the church of St

Francis. In Italy every town seems to want a Pinacoteca, yet as often as not paintings hang in dingy rooms off some town hall, and statues by minor masters gather dust in corners. In Trevi this new museum has been opened in another wing of the complex of the downsized school where Chiara goes. Rita, the young curator, is very welcoming and guides us through the rooms.

'It's a small museum, part of a network in Umbria called Sistema Museo,' she tells Clare in excellent English, 'not just for *turisti*, but for local people to become aware of their own history. The paintings and objects displayed here date from the *trecento*, the fourteenth century, until the last century, mainly paintings on canvas and wood, and some frescoes confiscated from local churches and monasteries during Napoleon's invasions.'

The paintings, mainly of the Scuola Umbra, are well displayed — half a floor has been removed to allow viewing of a restored work of Dello Spagna, who was a significant artist in central Italy in the Early Renaissance. We stand with Rita on the upper floor, and look down on the painting.

'It feels like we're in a *cantorium*, a choir stall, up here', says Clare.

Rita nods, 'Yes, that's true. And you know, it's an appropriate comment, for in the church next door — the Church of St Francis — there is the organ and *cantorium* — have you seen that yet?'

I shake my head.

'*Va bene*, I'll show you. We are trying to raise funds for its restoration. It is very old, one of the oldest in Europe, while the *cantorium* dates from the beginning of the sixteenth century.'

'So just how old is the organ?'

'1508.'

'And do lots of people know of it? Do you have many visitors?' asks Clare, astounded to find all this in the one spot.

'Over winter it is quiet. Very quiet. But last October, when we opened, we had a few thousand. It is a question of timing, like most

things. Predictions are that in the next few years artlovers and pilgrims will be flocking to this part of Umbria for the next Anno Santo.'

Clare frowns. 'Why's that?'

'You don't know about the Anno Santo? It's very important for Christians, and occurs every fifty years. This time around it will coincide with the third Millennium, which is quite an event, don't you think, even if you are not a believer! And nearby Assisi is such an important place for Christians, most of whom will come up along the Flaminia, from Rome to Assisi. They are already talking about an extra eight million tourists in Rome in the year 2000. Can you imagine that? Extra! And I hope it means that afterwards Umbria will be a little better known, so there will be a flow-on. So what can we do, except try and be ready? And all of this coincides with a revitalised interest in the figure of St Francis, and not only on the part of the traditional faithful.'

Francis is perhaps the most contemporary saint, one aware of the interconnectedness of all creation and earthly creatures. It's not hard to imagine him wandering over the hills and valleys of Umbria, experiencing the earth beneath his feet as a living entity, responding to instincts thousands of years old and still with us today — the earth as Gaia, to use William Golding's term.

All sorts of names are given to Francis. In the last year I have heard him described as the first authentic ecologist, and then again, in New Age parlance, as a sort of shamanic figure and healer. Francis has been patron saint of ecology since 1979. As well, he has long been patron saint of Italy and, according to a recent poll in the Catholic newspaper *Avvenire*, number one in the 'hit parade *dei santi*', with a massive 54 per cent of all votes, followed by St Anthony of Padua, with just half that number.

Rita tells us that the first Franciscans are said to have arrived in Trevi in 1213, in the company of Francis himself — over 1000 years after St Costanzo. The Trevani all came to hear the little man preach,

and one of the sermons was said to have happened in the cloister of the Pinacoteca.

It was a time of deep collective insecurities: Italy was torn by fratricidal struggle, city set itself against city, while civil and ecclesiastical authorities contended for power. It must have been revolutionary for the village people to hear Francis proclaiming that all are brothers and sisters: rich and poor, saints and sinners, brigands and prisoners. In the thirteenth century, when low status was accorded to beasts of burden and other creatures of the animal realm, this revolutionary way of perceiving the dignity of all life forms must have pulsated through the collective psyche like an electric current.

According to local legend, when Francis stood before the Trevani preaching, an untamed ass wandered among the crowd, braying loudly. It is said that Francis turned towards the beast, and said, 'Brother ass, be still and let me preach to the people who have come to hear me'. To the wonder of all present, the ass lay down and remained silent until the end of the sermon. In memory of this the Trevani built the Church of San Francesco in the fourteenth century, above the earlier Romanesque Chapel of Santa Maria. For a short time the church had been renamed after Beato Ventura, a hermit from nearby Pissignano who was buried in 1310.

But already in 1354 major works of renovation are said to have begun. The town council ordered all citizens to donate a cartload of wood to feed hungry kilns producing calcium oxide, an essential binding material in construction; four years later the inhabitants of north-facing Matigge owning beasts of burden were ordered to transport a cartload of rocks each up to Trevi. Agreement on such matters was reached in a general assembly. In bad weather, when the outdoor piazza could not be used for large gatherings, the inside of the church functioned as the arena to discuss issues of major importance; often with as many as 600–700 citizens, who showed agreement or disagreement by a raising of hands.

Due largely to Franciscan teachings, in the fourteenth-century organisations were created in Trevi to treat what we now call social problems, although documents existed from the thirteenth century testifying to the existence of hospitals, hospices and a leprosarium. A public bakery came into being, along with confraternities, societies of lay people, heavily engaged in charity works.

Between the church and the Pinacoteca is the cloister. It is decorated with frescoes of the life of St Francis by the Umbrian painter Gagliardi, painted around 1645. The frescoes, never great works of art, are not in a good state of conservation. Some illustrious citizens seem to have regretted the neglect, however, for a number of lunettes were repainted in the eighteenth century by a little-known local painter, Antonio Birretta de Trebio. Under each lunette flutters a gay ribbon of cherubs against a light-blue background, upon which the names of noble benefactors are inscribed: Valenti, Luzi, Salvi and Tulli. One of the more endearing images is of Francis praying in Trevi's piazza, and, of course, there is the obligatory scene of him preaching to the birds.

Directly below the frescoes lie heaps of rubble, workmen's tools and all the rigmarole of a building site. Rita tells us that the museum project, the Museum of the History of the Olive, the first private museum of its type in Italy, is far from complete, still only a few steps beyond the planning stage. The sound of drilling and clouds of dust emanate from some underground spaces.

Rita introduces Clare to the architect, who is inspecting the building site. He tells us it will be completed before too long; in fact, later this year if all goes according to plan.

She looks around dubiously, but I'm not so sure. There's some proven alchemy between building materials and Italian architects; I had seen proof of it time and time again. On chaotic building sites at the proverbial five-minutes-to-midnight where chaos reigns, nerves are stretched like taut wire and voices raised, suddenly abracadabra!

all is resolved. While the unsuspecting slumber, there's a last-minute waving of wands; scaffolding disappears, revealing walls are painted to perfection. As day dawns, state-of-the-art light fittings are installed, and floors polished to a high shine. Then long tables are set up, while all through the afternoon waiters prepare for another grand opening. By evening the spumante will lie obediently on ice awaiting the popping moment, and platters of prosciutto, tartines, olives and canapes offer themselves up in collective sacrifice.

Rita leads us across to the auditorium on the far side of the cloister, and gestures for us to enter. It's like a beehive, full of dusty workmen.

'This room has had many past lives — not long ago, in the sixties, as the town's cinema. I used to love coming here with my friends — we all did.'

The architect, who had followed us, quietly mentions that it is to be completed in three days for the inauguration on 8 March, International Women's Day. Disbelief is palpable. Looking around us, I have to admit it's a stretch of the imagination, hard to take seriously, even if the workgang slaves away night and day.

Clare catches my eye. I shrug. A few minutes later, as we walk towards the bar, she bursts out, 'They can't possibly finish that auditorium in three days. Come on!'

'Hmm. We'll see.'

'No, you'll see. I'll be gone, unfortunately. Back to blustery Glasgow.'

'Can't you stay on?'

'If only', she sighs. 'I've got so much to write about for the *Herald*. They'll be getting impatient. And I'd like to write something about Trevi in one of my articles, as well', she adds, as something of an afterthought. 'They are pretty active here for such a small place. Lots of energy.'

ç

On Clare's last day in Trevi, elections are held for councillors for the local tourist and cultural organisation, the Pro-loco. We both go along to look; for me, it's a chance to cast my first vote as a local citizen, while Clare wants to look inside the town hall where voting will take place. It is the only truly significant building in the main square, first documented in the thirteenth century — *'In palatio comunis dicti castri'* (In the town hall the laws are made). The Comune, the town council (the fundamental unit of the local government), is the modern outcome of the medieval state, and still Trevi's focus.

The *palazzo*, the palace that houses the Comune, may have been renovated twice in the fifteenth century; its present facade and sombre interior date back to the 1520s, although some further alterations occurred after the 1703 earthquake.

Given the town's population, a reasonable crowd has gathered — around forty or fifty — although it's obvious that few Trevani under the age of thirty feel any connection with the organisation. Clare is pleased she came as she observes the walls: painted on the ceiling and the vaults above and around us are the names of all the satellite hamlets of Trevi: Matigge and Santa Maria in Valle, which look northwards towards Foligno, Bovara and Pigge on the southern slopes, and nestling in the hills above Trevi the small community of Coste.

Of the mandatory fourteen councillors, four new members are appointed — a film-maker who divides his time between Trevi, Los Angeles and Rome, and an architect returning to Trevi from Rome with his wife and small children. It seems members are eager for new blood. There is a strong core of ten or so people who organise all the traditional celebrations, food feasts and medieval re-enactments. These are the volunteers who attempt to propel tradition into the here-and-now. But in the provinces that view of 'culture' often extends no further, to the endless frustration of more forward-looking Italians. None the less, without the Pro-loco organisations, there

would be fewer Befana-burnings, carnivals, street processions and outdoor feasting.

Clare takes a long look at the room, and then whispers, 'I'll wait back at the house. This is going to take absolutely ages, I can tell. And I won't understand a word. Glad I took a peek, though.'

I nod, 'See you soon'. I find a chair and sit down, feeling terribly conspicuous and wishing Giancarlo were here. There's plenty of murmuring and discontented sighing among the crowd; pleas are made for renewed links within the community, an interconnecting of the traditional with a more contemporary vision. There is evident tension behind the words, and I suspect some easily bruised egos — the dynamics of any small town.

Clare leaves at sunrise the following morning. I drive her down to the desolate little station at Borgo Trevi and run along beside the train as it pulls out; still so much to say. It feels deeply wrong when my friends leave, however affectionate my feelings are for Trevi — like I should be going with them. Standing there by the railway line I feel so foreign. The train disappears down the track, and I turn and walk back to the car.

Thankfully, the mood passes quickly enough — there is too much to do: the quickest cure for homesickness and wanderlust is a dose of hard physical work, an antidote to rootlessness. I have decided to put painting on hold for a bit longer, and continue working on the house. All the little things left undone! There is no point in forcing things, not just yet. There is a discipline in waiting, I discover, yet I ache to stand before a white sheet of paper, a blank canvas. But there is still so much to do.

It is still early — just 6.30. Chiara and Julian, Jenny and Gregor, are still sleeping the sleep of the innocent. I yank on my old boots and a leather jacket, and go for an early wander in the garden. It's all dewy, like everything had just been born. There's an embryonic flower-patch needing attention by the chapel walls; I could get stuck into that. Rays

of cold sunshine are poking through the clouds, and I notice with pleasure that the wattle trees next door are beginning to flower, in time for tomorrow's *Festa delle Donne*, International Women's Day.

I dig away for a while, and then go back inside, wake the kids, turn on the radio and have another coffee. Chiara has tuned it into a local commercial station, Radio Subasio, so I'm immediately blasted with *Festa delle Donne* publicity, supposedly honouring womankind, but really an old trick to keep the girls in place for the next 364 days of the year. On some levels Italy is still distressingly *maschilista*, sexist.

For days now, commercial radio and TV tempt the (female) viewer with offers of sparkling new washing machines, presenting them as some travesty of devotional offerings. Then there's an endless choice of male strip shows at local clubs between here and Perugia for ladies let loose one night of the year. It appears to be highly effective mind-control — armies of beautiful and not-so-beautiful women are apparently desperate for a glimpse of forbidden male body-parts, and happily turn up in droves to all-girl parties, let off for the night by indulgent partners and whining, spoilt children. No doubt they think it's a relief to do the ogling for a change, for Italian news-stands bulge with images of breasts and perfectly tanned buttocks every day of every year.

Italian women have a reputation for being difficult to fathom. I have heard many foreign women cast upon these shores bemoan the fact they could only connect on a most superficial level with their beautiful Italian counterparts. I can sympathise, even if I'm lucky to have found some female soul-mates in Italy. So often one has the uncomfortable sensation that it is all so illusory; the chatter, the smiles and the arm-in-arm strolling, the familiarity. For many women it seems there is a tacit understanding that at the end of the day it is really the men that matter.

Months back when Mike was here, he commented that there was a sense of men being expansive and friendly because they had so

much more space than the women, who sometimes struck him as jealous guardians or jailers of their own private purgatories — the dark side of the provinces.

According to the radio, all Italy's women will turn dewy-eyed watching their men shower them with love tokens and wishing them *'Buona festa, amore'*. It looks like there's absolutely no sexiness in female brainpower, at least for the time being. I endeavour to instil in Chiara the awareness that not everything that women have fought for can be reduced to boxes of chocolates and bunches of flowers.

In Trevi the restaurants are organising a series of girls-night-out menus. Rita offers the only local alternative. Over at the Pinacoteca she attempts to inject a bit of substance among radio proclamations and wattle sprays. The day must be honoured, but she takes a different path and combines it with the opening of the auditorium — somehow, the architect has kept his word and it really is ready.

Posters have been put up and invitations sent out to attend a lecture on the life of one of the few documented female characters in the history of Trevi: La Contessa Gertrude Prosperi, who died 150 years ago. A formidable woman for her time, she had entered the Benedictine convent of Santa Lucia, which stands a hundred metres or so from the Millhouse in the hamlet of Piaggia. It's not surprising that the most famous historical female from the town — or anywhere in Umbria — should have been from a religious order, for there had been little space for much else than the nunnery for generations of women, unless they wanted to be mothers and wives. I suppose there must have been some truly brave and exceptional women who just left, defied convention and disappeared to the city.

During the lecture I listen to the enthusiastic description the *avvocato* gives of Gertrude:

> tall of stature, of grave and majestic bearing; of pleasant and cordial nature, which instilled an affectionate trust. Just to gaze upon her

provoked a respectful reverence. Hearts were drawn to her while her thankful heart was drawn to helping others; sensitive and compassionate, this made her lovable and loved. Her manner was lively, relaxed, affable, sincere and without affectation. She had earned the affection of those good people, both inside and outside the cloister, who knew her.

The front row of the auditorium is filled with Benedictine nuns from the same convent. Is life very different for them now? Last century each nun was obliged to contribute economically to her personal upkeep, so that the ladylike business of lacework thrived among the less wealthy. The convent was constantly visited by lace buyers and, as the exquisite lacework became more and more profitable, there remained little time to pray; it was finally declared there was too much contact with life outside the convent enclosure, and that mundane issues were impinging on convent life. Consequently orders for lacework were severely cut back. And today? Are the nuns still engaged in any handiwork to bring in extra funds, as in the Contessa's days? It would seem not, or on a very reduced scale.

Sheila, an Irishwoman who has lived most of her adult life in Italy, is seated in the row before me. My mother would describe her as a real doer, with a heart of gold. She's an absolute goldmine of information on all things local, I've discovered, and is less partisan than many of the Trevani. We greet each other over spumante after the lecture, and she mentions another closed order of nuns who spent some years here in Trevi.

'They had come from Rwanda, and lived at the San Martino convent on the north face of Trevi, towards Santa Maria in Valle, where I live. By the way, have you seen the Perugino fresco over there?'

'Not yet, Sheila. I keep meaning to.'

'You should. You would love it. There's a fantastic view of Foligno

from the fifteenth century, and from a distance it really hasn't changed that much', she says breathlessly. Sheila always appears in a bit of a hurry. 'Anyway, I used to adore their masses at the church — so rhythmic, the drum-beat Sanctus and Gloria, and the strange lilting African Latin. Have you ever heard it?'

'No, I don't think I have.'

'Oh, it was wonderful. When I took first-communion children there for their retreat — you know I help out with that, of course — they were fascinated by those black beings with very pink hands and singsong Italian. As you can imagine, the kids couldn't really believe that those frail-looking creatures had been in the midst of that dreadful Rwandan bloodbath only a couple of years earlier.'

I sip the spumante. 'On one level, probably the nuns couldn't either — after having been catapulted over here, I mean.'

She nods in agreement, and adds wistfully 'You know, you live and learn such things even in trouble-free Trevi. I missed them in a way when they upped and left San Martino. I still do. Even though they were a closed order, there was always some excuse to bump into them, usually in the cloisters.'

¢

Chiara and Julian have another day off school — yet another local saint's day. The early morning sun, burnished gold, promises a cloudless day, so with Jenny and Gregor we decide to make a holiday of it, have a picnic and a trip somewhere. Jenny has stocked up on *panini*, slices of suckling pig, salad, prosciutto, and pecorino cheese. We pack the kids into the car and point it in a northerly direction. Our destination is the Alberto Burri Museum in Città di Castello, a forty-minute drive from Trevi. Burri is Umbria's most famous twentieth-century artist.

Driving up the Flaminia I tell Jenny and Gregor some background information on Burri's life: that he had studied medicine at Perugia

University before World War II, and had been a doctor during the war years until interned in a prisoner-of-war camp in Texas around 1943. That was where he began to 'paint'. His first art materials were found lying around the prison — old sacks, bits of wood and iron. Afterwards, when talking about the dynamics of his 'painting', he said that as a prisoner he was not permitted to practise medicine, and turned to painting, which then gave him a new sense of purpose.

Jenny breaks in, 'You must find that interesting from the art therapy point of view?'

I nod. 'I do. I mean, it's another way of understanding him, and this manifestation of inner necessity in a time of loss. It is useful as a beginning, sure. But he went much, much further than that, so that in the end the therapeutic argument would be a mere drop in the ocean. He took up fulltime painting after the war; and in the early 1950s began working in the way that would soon make him famous. He became totally committed to his art, to its development.'

'It must have been so liberating for him.'

'Perhaps. He was courageous though, and must have understood the connection with Italian art way back to the quattrocento. He is totally Umbrian as an artist after all, despite the fact that most people here know little about him unless they are specifically interested in modern art. Here it seems everyone knows the past, and yet few bother to make strong connections with the present, to see continuums. But I'm digressing. Anyway, the work after the war was really new. Think of Rome in 1952, when he first showed his *sacchi*.'

'What were they?'

'Old burlap mail sacks, which became central images rather than the supports for paint, as they had been in prison camp. The sacks were varnished, torn, burnt, an interplaying of elements which never, ever disguised the original material. I remember seeing some of those

works reproduced in artbooks, or art magazines in the 1970s, when I was an art student in Australia.'

Gregor scratches his head. 'We haven't heard of him in Scotland, have we, Jenny?'

She shakes her head. 'I don't think so.'

'Oh, listen, I'm sure now the name is familiar it will come around again. That always happens. Anyway, after showing in the States in the early 1950s — and exerting a strong pull on artists such as Robert Rauschenberg and Jasper Johns, by the way — he exhibited at the Biennale of Venice in 1957. That propelled him onto the international stage.'

We arrive on the outskirts of Città di Castello, and leave the Flaminia.

'Let's just visit the tobacco factory this morning — that's where his later work is, isn't it?' asks Jenny.

I nod.

'No cramming!' Jenny declares.

There are few, if any, other visitors. Most tourists, even those with an interest in their own century's art, are on the whole unaware of the importance of the museum as they drive down the Flaminia. It is a pity, for the museum is enormous, with oversized spaces, a bit like a hangar. We pay, set out viewing the works together, but soon enough lose each other as each follows a personal rhythm. Julian becomes the thread that ties us all together, as he runs from one room to another, keeping track of our movements.

At a certain point Jenny and I collide. She turns to me. 'It's overpowering. The work *and* the setting. A good mix. His work is like a gigantic jigsaw, where nothing is pure chance or simple research for the sake of it. What a mind!'

'Just like Primo Levi said, the creative act is one of making connections. That's pure Burri.'

There are two buildings housing Burri's major works in Città di Castello: the earlier at Palazzo Albazzini, opened in 1981, while the

second collection, much of it created for the specific site, in the massive tobacco-drying factory on the outside of the town. It had been his studio until a few years ago, when he died of emphysema. It is a fantastic museum, but little visited by tourists, for there is so little publicity about its existence. Umbrians really know how to hide their treasures.

After the visit we find a sunny field and unpack the lunch. Julian has brought his soccer ball, and for a while Gregor joins him in a game. Then we open a bottle of Montefalco Rosso and settle down to a long chat, which begins with Gregor's questioning of his own working methods. His enthusiasm for Burri's work is refreshingly humble. For Gregor it seems there is a reverberating shimmer between Burri's surfaces and his growing awareness of the nature of both the abstract in images and the figurative in organic forms, which he then picks up in his own drawings. Like artists throughout time, Jenny and Gregor have spent hours tirelessly discussing this desire to work with images.

The pecorino is good, crushed between lettuce and crusty, round, *rosetta* bread rolls. I chew away, hungrily, with Chiara's head in my lap, as Gregor talks of intimate things for a painter, and of recent memories of his studio at the Edinburgh School of Art.

'Scotland seems light years away. I don't know what it is most, but I think it's the light.'

He pours another glass of dark red wine, which Umbrians call *vino nero*, black wine, and sprawls untidily in the grass.

'Ah, this is the life! And I don't even feel guilty! It's funny though, since I've been here in Italy I've felt like writing as well. First time. But then it's the first time I'm not able to speak the language.'

Jenny breaks in. 'But what about the year you spent in Germany!'

He props himself up on one elbow. 'Och, Jenny, that was different. First of all, I knew the language and, thinking back, I never ever felt the compulsion to write. As far as I can remember, that is.'

'Oh, I know what you mean', I answer. 'First of all, it's that connection between image-making and writing. For me, my daily conversation with the computer in English has become a moment when I touch base again. Every day, if possible. I must hear my own language, or at least see it on the computer screen. Otherwise I start forgetting where I come from!'

Jenny pours the last of the wine. 'Is that so bad?'

'Well, it feels like losing one's grip. You know, before I came here I wanted a house to feel "at home". And now I need my own language for the same reason!'

'A very contemporary ritual, isn't it?' said Gregor. 'Not the writing, obviously, but doing it on the computer so you can constantly slot in memories, flashbacks, unlimited associations.'

'The amazing thing to me', observes Jenny, 'when you think about it is, that is, is that all over the world displaced people like you can reconnect with a first language, whatever it be, and see the words appear on the screen, and take comfort from that! Like a continual conversation with one's origins.'

'Aha', I screw up my nose. 'But Jenny, do you see me as a "displaced person"?'

'Yeah, in a way, I suppose I do. Happily displaced, but still a bit of a fish out of water. Like millions of other people, mind you, so nothing to worry about!' She chuckles. 'At least you lot have got an excuse for being confused!'

We all laugh, but Chiara laughs the hardest. I ask Gregor, 'So you've been writing too? Keeping travel notes on Trevi, a diary, what?'

Gregor looks shy in that I-don't-want-to-be-noticed way the Scots have. 'Och, a bit of everything. I'll show you, if you can be bothered, when we get back to the Millhouse.'

'Be bothered? I'd love to see.'

Hours later in the kitchen he sheepishly places some sheets in my hands. They are covered in his characteristic minuscule script. At the

top of the page I read 'Building a wall in an artist's studio — a deconstructive dialogue.'

'You know what that's about, I guess?' he asks me.

Building a wall — of course, the woodpile! I begin reading the paper scrawled with Gregor's words, describing making things, working with wood; woodpiles, fire and buzzing things, Umbrian things.

The wood scorpion now sleeps
in the arch of my right foot,
the community in the woodpile whisper
as I choose logs to light the morning fire.
The convent bell calls
quarter to the hour.
8 o'clock. Dawn casts a shadow,
 lengthening
across the wall to daylight.
Unswung, the open window becomes
a monolith of light!
The early morning mist
laps up the olive terraces,
The cypresses descend — 'Pastoral'.
Bumblebee buzz of a moped cuts up
the moment bluntly.
The pot belly hisses
recounting words of women passing,
on afternoon walks.
Dogs gossiping across the valley from the hilltops,
cave canem — beware of idle gossip!
The jackdaws jump off the tower, crying.
The bats pipe at dusk.
Orion defends lunette through another night.

The men still stand in the square
as the old 'postman' leaves the church,
whistling on his rounds.
We see ourselves reflected.
We listen with our eyes.
Our first wall.
Our first Dialogue.

In exchange for the room rent-free, Jenny and Gregor had agreed to do some of the heavier jobs around the place, including stacking a great untidy pile of wood brought down from the mountains and dumped by the roadside a few days earlier. I occasionally peer in as Gregor and Jenny work away, stacking the hundreds of logs higher and higher against the back wall of the studio. At a certain point Gregor decides it doesn't look quite as it should, and to Jenny's understandable dismay, sets about dismantling the lot. There's a job to do, and he has to do it a certain way. 'But Gregor, it's just a woodpile', Jenny groans.

When finally complete, standing two metres high, the woodpile appears inviolate — something too complete to dismantle — a happy collision of art and life. Immediately, impossibly permanent.

On its completion Gregor stands back and admires the neat rows stacked against the white rock. 'Looks like a Mario Merz to me, or someone like that.'

'Oh Gregor', Jenny sighs, smiling, but with a touch of exasperation.

The woodpile is destined to impermanence, for the nights are still cold, with the occasional frost. So without the flickering flames in the fireplace, it would be impossible to sit and talk the hours away each evening. We start lifting logs from the top layer, carrying them upstairs to the kitchen fireplace. A layer of the perfect woodpile soon disappears. Then another, and another.

ℭ

Another week passes, more logs disappear, transformed into heat and smoke. All too soon Jenny and Gregor depart, though they don't want to go. Backpacks bulge with sketchbooks, and they fly with little enthusiasm back to wet and windy Scotland. They promise to return, for the charms of Italy have bewitched them too.

Julian misses them so much when he arrives home from school. His young gypsy life has meant so many meetings with as many sad partings. I can't fill the gap, although I spend many afternoons drawing vast Trevi-to-Montefalco panoramas with him, just as they had. When Giancarlo arrives on Friday night, Julian runs to him and nestles in his lap. He needs men in a house mainly of women, and Gregor had temporarily filled up an empty place.

¢

A few days later the strangest thing happens. Jenny would have loved it.

The architect rings and tells me that a number of 'mummified' bodies have been found under the Church of San Francesco where the olive oil museum is being set up, and invites me to visit before the police arrive to padlock the doorway.

'I thought you might be interested.'

'I sure am. Mummified! I'll come straight up.'

The architect says the corpses were found under the apse of the church by the workmen. Until late last century this lower space had been used as a cemetery, regardless of the fact that a law had already been passed obliging all corpses to be buried outside city walls.

A small, subdued group of people is gathered there when I arrive. The architect ceremoniously leads us all into the crypt-like spaces off the cloister. It smells of ancient rock, and there is a strange sense of *déjà vu*. And then it dawns on me — it's the same place I had dreamt of all those months back. In my sleep I had entered a tunnel, then come upon the Church of San Francesco; yet at the same time the

roof was lower, and everything was smaller. So it was this church, directly beneath San Francesco. It really does exist, then.

In my dream I had come across four monks at a lectern. Now there are no wise men, but a pile of skulls in the corner, exposed and defenceless.

'Those ones were just thrown down through a hole in the church, poor things', someone exclaims loudly. Everyone else is whispering.

In the next room a row of partly broken-up wooden boxes is laid out. There are a dozen or so of them, of varying sizes, ghostly in the filtered light. As we approach there's a fluttering of hands hastily making the sign of the Cross. I step close to one box, and peer inside. It's an amazing sight — a corpse, which really does appear mummified, dressed in a white tunic with an embroidered cross, a cloak of light-blue wool wrapped around bony shoulders. A voice in the crowd whispers that the clothing indicates that the man had been a member of the confraternity of the Sacred Heart of Mary, very active in Trevi last century. Next to him lies another male figure in a long skirt, the design of which indicates membership in the confraternity of the Stigmata of St Francis.

On both, the skin is still visible, stretched tautly across bones. I stare at the feet, still protected by thick knitted socks, tied together, lovingly, with a little bow. Someone did that over a century ago. Someone overwhelmed by loss, a loss still palpable. It's blindingly clear that we are part of a continuum, life and death and rebirth and death again, over and over.

'But they are amazingly well preserved', I blurt out, too loudly. 'How?'

'Signora, there is a theory that it might have something to do with the nature of the soil — calcareous rock with very little humidity.'

'We will see soon, for experts from the Anthropological Institute of Florence University are arriving tomorrow morning', adds the

architect. 'Perhaps they will be able to give us the answers after they have the results from the clothing fibres that they will test.' He then says that last century some corpses were moved from other churches, including the cathedral, and placed in boxes in layers here, adding that up at the cemetery, not far from the Millhouse, bodies in a similar state of preservation were exhumed years back — their extraordinary state of preservation due to the same soil structure. But they had been buried again almost immediately, without the interference of scientists.

¢

The news from Albania becomes more and more dramatic.

The Italian government declares a temporary state of emergency, to last until early summer. There is fear that many of the Albanians flooding ashore on the Italian coast in the last weeks are escapees from the suddenly empty prisons — pimps, gunrunners, dope-dealers. Few remember that those very prisons are also home to many political prisoners. When pictures from Albania flash across the television screen during the evening news, I notice that there are no women or girls with Kalashnikovs to be seen. While the fighting goes on, the women stay indoors or search for food to feed their men and children. Many wait, just as they always had. Or they try to leave, for countless women and children cling to the boats arriving in the ports of Apulia in southern Italy.

The threadbare lives of many Albanians are tearing apart. The get-rich schemes have failed, and suddenly the downtrodden, last-class Albanian neighbours are far too close for comfort. Here in Italy we are forced to witness their grinding poverty, and it is perceived as an obscene threat to a jealously guarded wellbeing.

Along the Adriatic coastlines where the boats arrive daily, bookings for summer holidays have already fallen by a hefty 80 per cent. There's rumblings of a new psychosis — that 'we' will be invaded,

swamped by these shabby creatures from across the Adriatic, as if millions had arrived rather than a mere 10,000. When a packed boat sinks about 60 km from the port of Brindisi, and about eighty people, including twenty children, are swallowed up by a pitiless sea, desperate survivors speak of a huge Italian military ship ramming the side of the boat. There's to be an inquest.

We avert our eyes: no one wants responsibility for this human flotsam and jetsam. It reminds Italians of worst-scenario futures, or bad dreams from the past. The ex-president and media magnate, Silvio Berlusconi, cries publicly on TV after visiting survivors. He offers to 'adopt' three families — adults and children. The little children look at him adoringly when he promises them new toys.

April

IT'S HOMECOMING TIME for the birds of Umbria. From dawn to dusk blue tits, starlings and cooing pigeons ceaselessly twitter away, as if catching up on all the latest after their winter travels. These small, fluttering creatures of the sky, however, are not to be taken for granted. Over the centuries the Umbrian bird population has more often than not ended up in someone's cast-iron pot. Foreigners travelling through Umbria were often horrified by this tendency to eat everything with wings. There's a good example of that in the letters of an intrepid Englishwoman, Helen Mabel Trevor, who visited Italy to pursue her love of painting late last century. With her travelling companion, she spent some months in Assisi in 1886, sitting under loggias at her easel each morning before the sun began scorching city stones. When not busy sketching, Mabel engaged in charitable acts, tea parties with other British travellers, and long rambling walks over the surrounding countryside. And she soon discovered that

> there is one great drawback to Italian country life, and that is the almost utter absence of birds. The countryside is so silent. The Italians eat everything that has life, down or up to a titmouse. One day when I was ill, our landlady sent me a whole string of goldfinches. I sent them back in horror! They were delicious, she said. How the nightingale manages to escape this omnivorous people I do

119

not know, but he does. Perhaps because he does not stay long enough. One of these sweet birds joined our picnic the other day, and discoursed most eloquent music during and after our repast somewhere over our heads in a mulberry tree. I took note of the performance then and there in my sketchbook for your benefit and mine. It is to this effect: that the nightingale's is not a song; it is a wandering variety of sweet notes and turns and shakes, very leisurely uttered from a deep throat, muttering slowly to itself and stopping long between, as if recalling some sweet sounds once heard and half forgotten, like a performer who searches out an air with his fingers on the piano in the dark and does not care whether he finds it out or not, so that he gets harmony.

As I sit here watching the words appear on the computer screen, I become keenly aware of the similarities between end-of-millennium newcomers to Umbria and 'grand tour' travellers from previous centuries. Sometimes the connection feels so strong, partly because many of those travellers were also writers and painters, and left personal documents that form part of the basis of every foreigner's life here.

My fingers skip across the keyboard in time with Van Morrison singing in the background. This is as close to happiness as I get. Painting, gardening, writing, and listening to music. Stepping outside.

Then the computer screen goes black. I stare at it for a few seconds, and wait. Nothing happens. Without thinking, I close the terminal, a reflex reaction. I wait some more, conscious of nervous heartbeats, then switch the computer back on. The Trevi file has disappeared. I do a search — and find nothing. Where is it?

In a mild panic I ring my computer-whiz friend, twelve-year-old Antonio, who begins directing me over the phone, telling me where else I might look within the computer's vast inner realms. I follow his instructions. Still nothing comes up. Where is all my work? It has to be there somewhere, Antonio assures me. It can't just evaporate. I

can't find it anywhere, and begin to panic even more. Everything else we have ever done on the computer is still there, reminding me of other times — half-written letters, games, invitations, art therapy papers, and the kids' schoolwork from Scotland. But the only file I want and need has been swallowed up, spiralled off somewhere else. I realise that my hands are trembling. Antonio senses my nervousness through the phone line from here to his place and tells me to calm down, we'll find my story. He hops onto his pushbike, and is with me in a record-breaking five minutes.

He begins tapping at the keyboard, searching inside the machine, a determined look across his face. Julian comes in and turns on the television, but I snap at him and tell him to go and do his homework, anything else. Antonino begins sighing, scratching his head and muttering. '*Boh!* It's really gone.'

He turns to me, his voice accusing, 'But I can't understand how you did that'.

'Did what? *Che cosa?* I didn't do anything.'

'Well, at least I hope you put it all on floppy disk.'

That's what I don't want to hear. I hadn't put the words onto a disk for weeks. I feel the heat rushing to my face. 'Actually, I haven't done that for a bit', I mumble. Exposed by a twelve-year-old. This can't be true, soon I'll wake up and realise it's just a bad dream. All these hours and hours of work, and now for a minor detail most of it gone. *Non è possibile!*

But I'm not asleep. When I pinch myself, I feel the pain.

It seems that I am back at the beginning. My story. Our story! What will happen to my memories now? And do I actually have enough energy to start all over again? I stare at Antonio, at the computer.

After another half-hour, he stands up, still repeating, 'I don't know how you could do that'.

I go with him to the door, despairing. 'What can I do?'

'I don't know, Signora. What can I say? Ask someone else to have a look — a real expert. But I think it's gone. Really gone. Goodbye.'

I want to slam the door behind him, but it's glass. I close it gently, watch him riding down the gravel driveway, pebbles flying around the wheels. Julian reappears and switches on the TV to the Simpsons speaking Italian. I pass the rest of the day in a haze.

The night comes. I watch television with the kids, something I never do. I am sick of losing things — places, homes, friends. Now this. And when I go to bed, I dream that the file has been kidnapped by another writer in Trevi, who, discovering what I am up to and, consumed by jealousy, has found a way to steal my words. I wake and stare up past the wooden beams, at nothingness. It's only a silly little dream, but it unsettles me, for it's a petty, small-town dream. I pick up Giancarlo's soft pillow next to me, and thump it hard.

I feel a bit better in the morning. Surely my story will turn up. Antonio is right when he says it can't just 'evaporate', after all. I've worked for years with this computer — she's more trusted ally than machine. And someone I could always speak English to, just like I'd told Gregor a few weeks back.

I march towards my desk and turn the terminal on. I scan the files, and with a heavy heart see that none called 'Trevi' reappears. The computer's memory is tightly interwoven with mine, and by losing hers she has betrayed me. Where do we go from here? Is it really time to start again? To forget the loss, to pick up the threads?

While Chiara and Julian are at school, I consider my predicament. I'll find a computer expert in Foligno to come over and check it out. That ought to do the trick. And then what, if it still doesn't come back?

I make a coffee and sit on the terrace. Well then, I'll just have to put it behind me, count my losses as Mum would say, and get on with things. I can try looking at it from the other side. A fresh start, perhaps. But I cannot convince myself. I just want my words back.

There must be reasons why this is happening, if there is a reason for everything. Or at least, there must be some way to turn it around. Time for a little lateral thinking. Immediately I think of the chapel in the garden. Perhaps the moment has come to pick up the threads of the St Costanzo story, which I've been neglecting. Months have passed after all. I'm spending so much time sitting here in front of a machine while the chapel waits silently, asking nothing, its foundations sinking more and more into the soil. It is real, solid, while I occupy time and virtual space with disappearing words.

I put on my crusty old gardening boots and go and sit on the slope outside St Costanzo's walls. Dark rings of blackberries are sprouting everywhere, like a crown-of-thorns encircling the chapel. I grab some gardening tools and slash the blackberry spikes pushing through all the iris bulbs. The Etruscans and possibly the Umbrians too, refused to eat the blackberry fruit. Along with black figs, wild pears and blueberries, they were called *arbores infelices*, earthly representations of the Inferno. Strange to think of that — the fruits of hell all around our heavenly little chapel.

I will have to start writing down everything from scratch again. Everything I can remember about the beginning.

¢

This morning I look up the Yellow Pages and find the phone number of the Church of San Costanzo in Perugia, sure enough in Via San Costanzo. Would the Padre have some information for me, and did he know of our chapel?

'The Padre's not in, Signora', breathes the ancient female voice down the phone. 'It's hard to find him. He's always out in the parish helping his parishioners. A busy man, *occupato*. You'll have to try again, tomorrow, *domani, Signora, domani.*'

'*Va bene*, very well, Signora. *Domani*, tomorrow.'

It will be weeks before I call back.

123

§

Just before Easter I meet the Sindaco, the Mayor of Trevi, on my way
to the newsagent's. He has just returned from a medical conference
in Sydney, and is full of compliments, sincerely felt. All those words
Europeans use to describe Australia pour forth: dynamic, energetic,
young, a melting pot, sophisticated, exciting.

He exclaims, 'I had no idea that it would be so much like that'. He
seems to look at me differently, as if the pieces have fallen into place.
I feel exposed in the bright morning light.

'What, do you think I was made to leave?' I am joking, but there's
a hard knot inside.

He shrugs, 'Who can say? But how do you feel when you go back
home for visits? Sydney and Trevi are really at opposite ends, no?'

'Carlo, when I go home I feel like Rip Van Winkel. That's as close
as I can get. Each time we fly into Sydney, it's as if a decade has
passed, rather than a mere year or two. Everyone looks so cosmo-
politan, and there are so many different-looking people.'

'So you think here, almost everyone looks the same, *uguali*?'

'Not exactly, but like fruit from a select number of trees. Umbria is
generally like that, you have to admit. And time is different here. It's
not fast. It's still cyclical in a way that's surprising to outsiders. It
takes a while to get used to.'

He nods, and I add, 'I'm beginning to understand when I hear
someone say I could never go back now. I've been away too long. I
hope it doesn't happen to me, but I know what they mean now.'

'*Si, capisco*, I understand. Will you join me for a coffee?'

We walk into the bar, and Carlo declares, 'Now this is a real Trevi
gathering. It was strange to see all those Italian bars in Sydney —
some of them even have the old men'. He looks around.

'I'm sure my father is in here somewhere. Have you seen him this
morning?'

I shake my head.

'You know him though?'

'Oh yes, I see him up in the piazza. And once, in a dreadful storm, he came down from Bar Roma to help us, when we were left without lights. He's a great electrician!'

'I know. His parents were very simple people, *contadini*. He's proud of me now, flying off around the world! Short black or cappuccino?'

'Cappuccino, *grazie.*'

'Shall we sit for five minutes?'

We find an empty table, and he continues, 'I never wanted to let my father down. If I got anywhere in life, if I studied at school, it was so as not to disappoint him. I could not bear the responsibility of disappointing him.'

I sip the cappuccino. 'Like a question of honour.'

'In a way you could call it that. I just couldn't let him down. That generation had a tough time, with the war, with the Germans here in Trevi — my father was one who suffered under them. Did I ever tell you the story of my father and the shoes?'

'No, I don't think so.' I light a cigarette, although it is too early in the day for my first cigarette. 'Tell me. What happened to your father?'

'Oh, it's so long ago. It was all over a pair of shoes. As you can imagine, during the occupation, there was a flourishing black market. And a good pair of boots was a precious commodity. These particular boots were sold by a German soldier, no doubt for a ridiculously in-flated price, to my father and a friend whom everyone called Microbo.'

'Microbo?'

'*Si, si,* Microbo! He was very small and insignificant to look at. But he was really clever, and sly. Like a germ! Selling the property of the German army was a great crime, and the soldier ran grave risks, as did Papa and Microbo. You can imagine. They then resold the boots, making a bit on the side, to another man who lived down in Piaggia — near your place, actually. All went well until one day. A

junior officer passing by noticed the boots and asked the man why he was wearing German property. The man said that Papa and Microbo had sold them to him.'

'With friends like that–'

'Exactly. So of course Papa and Microbo were cornered and taken to headquarters. It was under where Conti's supermarket is now, opposite the Bar Chalet. My poor father! From 6 o'clock that evening until the next morning they were interrogated every two hours. The officers wanted them to explain how they got the boots in the first place. The two men refused to answer. They were very brave, and they had agreed not to give anything away. Microbo, who was at least ten years older than my father, had reasoned that if they talked they'd be in for it anyway, so the best policy was to not give in.'

'They must have had an alibi?'

'I don't know what sort of excuse they invented. Probably just that they had found them somewhere. Microbo had Papa's coat on through the whole ordeal, for he had complained of the cold so Papa had lent it to him. But really it was to protect his shoulders from the thumps, the punches and so on. I told you he was sly! So Papa got the worst of it.'

Carlo leans back in the chair and crosses his arms.

'So the beatings went on all night. Then at dawn they were taken outside and faced with lines of soldiers — the only ones to have such shoes — and forced to walk slowly before them, in order to identify the guy who sold them. Both men saw the soldier, whom they had in fact got to know quite well over the preceding months. I remember Papa said the guy was so pale, for he knew he stood a good chance of being sent before a firing squad. But Papa and Microbo shook their heads, frowned, said they recognised no one–'

'No doubt to the soldier's immense relief!'

'And were beaten for the very last time and set free.'

'Your grandmother must have been relieved. It could have been worse.'

'Much, much worse. Returning home, as fate would have it, who did Papa run into but his old mate — you know, the one who'd dobbed them in. And my mild-mannered father who wouldn't hurt a fly punched him in the face, pushing out his two front teeth!'

Carlo glances at his watch.

'And that, Virginia, is the end of the story. And I must get to the town hall for a meeting before I go to the clinic, I'm running far too late.'

He stands up and stretches. 'Say hello to my Papa if you see him!'

<center>¢</center>

The weather is perfect for long lunches indoors. A late snowfall dusts the hills behind Trevi, while all through Umbria winds blow clouds across the sky.

The Halley-Bopp comet is highly visible in the north on the eve of Easter Friday, when the old celery planters, the *sedanai*, sow the seeds of celery plants that will be eaten next October during the celery feasts. This celery planting is an ancient tradition, but now there are only three or four traditional *sedanai* left. While these frail old men toil away in moonlit fields, a group of local teenagers performs the Passion of Jesus in a series of *tableaux vivants* up at the Duomo. Compared with many of the Umbrian Easter celebrations — for it seemed there was a Via Crucis in every hamlet — the Trevi happening is a modest affair; but then it has only been going for a couple of years. Simple but effective lighting is used to cast strong shadows across their young, athletic bodies, which are draped in brilliant white cloth — pure Caravaggio. That innate sense of beauty once again. What do Italians have in their genes that I missed out on? At least my kids have got it, thanks to Giancarlo.

Stock still, the young, muscular bodies are beautiful, like dancers. Even at a distance you can see the concentration written on each finely structured face. It's odd to think that tomorrow morning

these same kids will be congregating outside the pizzeria, boredom plastered across perfect features, mumbling in dialect about motorbikes, engaging in small-town gossip. Most of them appear astoundingly apathetic about life outside their Trevi 'island', and would never consider going off to discover the world if it meant choosing between that or a spiffy new car. Not for them group apartments, part-time jobs in pubs, dreams of India or Mexico or Bali. '*Stiamo bene qui*', they declare, 'we are comfortable here'. And that's enough. For most. There is little curiosity

Over Easter, the Trevani congregate around vast tables groaning with food. On the morning of Easter Sunday, there they are all back in place outside the pizzeria. After the aperitif in the piazza — a chance to see and be seen — there will be the traditional Sunday concert in the Teatro Clitunno followed, naturally, by more family gatherings. Sometimes I ache for an extended family too, to fill in all the gaps.

Is there anywhere else in Europe where you can still find such a cult-like devotion to food, to families? I listen to the animated discussions going on around me, all concerning the imminent feast. In past generations it had been the custom for the women of Trevi to wake early, and to walk to church laden with baskets of food to be blessed for the Easter breakfast: home-made salami, cheese pizza and sweet bread pizza. Those foods are still seen at the table at Easter lunch, but nowadays there is no dawn pilgrimage.

With the arrival of Easter, just as the first tourists from the north began drifting back, we put the clocks forward an hour onto summer time. I am glad to see the strangers, cameras slung on shoulders, striding along the Panoramica in their sensible walking shoes, pointing lenses at our jumble of houses. Most find the town as charming as we had done two years ago. They call it authentic. It's reassuring, as if their being here confirms our choice, although they view it as a holiday place, never a place to live a life in.

We are somewhere in the middle, being able to see Trevi from the inside and out, no longer newcomers, but still very foreign. It's not a

bad position to be in — I enjoy more freedom as a foreigner, can break more rules and still am more or less accepted.

<p style="text-align:center">❢</p>

Giancarlo and I plan a series of spring outings — partly to keep the kids busy, and partly because it would be too easy to stop exploring the countryside nearby. On Easter Monday, Pasquetta, the wind drops enough to contemplate a day in the mountains. All over Italy the custom has been to spend this one day of the year in the countryside, laden with the obligatory supplies for a picnic, or to join the nationwide pilgrimage into restaurants for elaborate luncheons. All the better, then, if the restaurant is in the country!

We have heard a lot about Cancelli, a little village between Trevi and Foligno, hidden in the mountains. There, a painter called Maurizio Cancelli runs a restaurant called the Inn of the Two Apostles. Geppino, a friend of Giuseppe the architect, says that Maurizio's family has lived up there since Roman times, and perhaps even longer. He adds that the area around Cancelli is also fascinating if you know how to 'read' it, and suggests we all go up in the four-wheel drive, have a look around, and then lunch in the inn. We agree.

So Chiara, Julian, the architect and his boy Leo, Giancarlo and I pile into Geppino's Range Rover, and set off along hidden bush tracks leading to Cancelli. The mountains are densely covered in oaks and birch trees. After a few kilometres we leave spring behind and drive over the odd patch of snow. It is in these mountains that pilgrims once walked from village to monastery to village, back in time when the valley was a massive, partially-drained marshland and most activity was at hilltop level. It is said that here, on these mountains, the hardy Umbri first set up camp in the Iron Age.

We park the jeep behind the hamlet of Cancelli. Geppino leads us to a flattened area where he points out evidence of a Bronze Age settlement, a *castelliere*. A sloping mound encircles the top once layered

with stone walls; Geppino spots tiny fragments of fired clay, which have lain here for perhaps 3000 years. He tells Julian that while walking alone just by here some years ago he discovered a small bronze snake. Julian begins searching.

From up here the panorama is an exhilarating 360 degrees, and, complete with gale-like winds, it is reminiscent of the Scottish Highlands.

Geppino asks us to imagine how it might have been 3000 years ago. The Umbri settlers would have lit fires that were safeguarded and kept alight by the priests, and with the flames signalled warnings of dangerous beasts roaming across the valleys.

With strong binoculars we spot evidence of other *castellieri* on other hills. Without Geppino's excellent guiding, we would have remained oblivious to the past written so clearly across the landscape. New vistas open up, parallel times. We then drive to another rise, just behind Cancelli village, where the ruins of an early Italic temple still stand. On these hills the high priests offered sacrifices to an inspirited earth, their great mother. It's not difficult to conjure up images of those men and women walking along ridges of oak and ilex, constantly on the lookout for fierce mountain beasts on the prowl, for wild foods. Woven tightly into the legend of Cancelli is also the story of Maurizio's family; said by some to be direct descendants of these settlers, a straight patriarchal line from that time to the present.

The winds grow more blustery and the clouds darken. We take refuge at the inn.

Easter Monday lunch is a set menu; good solid country food that hardly anyone eats any more. Scores of people have appeared from nowhere. The place is packed, so we squeeze into a cosy corner by the fireplace. Maurizio brings great serves of steaming potato gnocchi, followed by omelette with truffle sauce, traditional spring lamb, and then wild greens picked that very morning on the hillside. To finish it all off, we follow with fruitcake, coffee and liqueur. The restaurant

is filled with noise. Maurizio takes a moment's break from his customers and tells us the legend of the Apostles Peter and Paul sheltering in Cancelli — hence the name of the inn.

Legend tells that, because of the generosity of the Cancelli clan towards the apostles, the oldest male member in each generation was given healing powers — the laying on of hands. Over the centuries, almost two millennia, the gift has been carried down from father to son. Geppino wondered if it might even be traced back to pre-Christian times, back to those mysterious high priests of the temple, and later have been incorporated into Christian beliefs.

Maurizio's father, an old man now, is presently the official Healer. In order to safeguard the gift, it is said that the Cancelli family must reside all year round in this isolated hamlet — or else their powers will disappear. So Maurizio, his wife and children remain, while most of the other villagers have long gone, returning only for summer holidays. The family speaks little of the old man's gift, although he is visited by numerous travellers, mainly Italian, in search of cures for both body and soul.

After lunch we look for Maurizio's father. We find him standing by the roadside with his walking stick, looking every bit the *contadino*. Geppino asks him if we might look at the church. He nods, and hobbles off to fetch the keys. Chiara begins complaining about being bored, and of wanting to go back to see her friends in Trevi. The old man returns. He leads us all into a crypt-like space under the main church; its dark walls lined with *ex-votos*, votive offerings, from previous visitors. On the altar someone has placed two kitchy representations of Peter and Paul. The old man points to some of the votive offerings with his walking stick, and he mutters that a few are very old, but most have been left by people that he has cured. He then points out a recent photo of a young man from Trevi, who suddenly regained his voice in that same tiny room after years of being mute. It was taken only five years back.

'Do you know him?' I ask Chiara.

She looks closely, and slowly shakes her head.

Geppino, the architect and Giancarlo have begun climbing the staircase into the main church. Chiara and the children follow. I ask if I might stay behind and submit to his healing treatment.

The old man nods, leads me into the corner, and asks me to face the wall. He stands behind me and places his hands lightly along my legs and back, muttering *sotto voce* all the while. I can't catch the words but it makes me think of butterflies flitting about. Prayers or incantations. It only lasts a minute or so. He finishes off by making the sign of the Cross, running his hand first down my spine, and then across my shoulder blades. My skin tingles. He gives me a holy card to Peter and Paul, and instructs me to pray to them.

Afterwards I watch as he repeats the same movements on another woman surrounded by a gang of overfed, fur-coated friends, all loudly declaring their scepticism, chattering all the while, the woman shaking with laughter. The old man concentrates on the task, taking absolutely no notice of them. I feel angry for him, for his age makes him vulnerable to my eyes. What are they here for? Yet he seems not to care.

As we drive away from Cancelli, Julian and Leo spot two hawks flying overhead. Wild grouse hide in the undergrowth, where forgotten tracks crisscross the hills. Geppino asks if we still have any energy after the massive lunch, for he has something else to show us. We say yes. 'Just one more ruin', says Geppino, 'a well-kept secret.' The Range Rover bumps along barely visible tracks. Geppino knows the country well.

After ten minutes we come across another ruin, towering over the treetops near the little village of Manciano; the old abbey of St Stefano, roofless now, invaded by forest. Inside the walls a small family of birch trees is growing — thriving, it would seem. They lean against the remains of a simple apse with an arched crypt below.

Nearby, a hunter's cabin is camouflaged by leafy branches, just like at a Boy Scout camp, enveloped in an eerie silence.

No church bells chime from this abandoned abbey, although if I close my eyes it's easy to evoke the sound of bells pealing across the Manciano landscape. We listen instead to the melodies of birds twittering despite the cold, their song occasionally broken by gun-shots.

<center>℘</center>

Later in the evening we all go up to the Church of San Francesco for an Easter concert — an attempt to raise money for the restoration of the organ, and the last organised event for this season. Rita tells me that the town council has given the first 20 million lira towards the project, but triple that amount is required.

A youth choir and orchestra from Wales are to perform. I stand at the door talking to friends and watch the musicians set up. They look unbelievably peaches-and-creamy, fleshier than the young Trevani, and much more serious. There are very few of the town's youth in the audience. No doubt the music teacher in the school next door has not thought to mention the concert to his students, for the supposedly music-loving Italians are often the last to take advantage of opportunities to actually hear any real performances. There is not the same devotion to choral music, youth orchestras and music-for-pleasure here as in other parts of Europe, and no such things as school choirs or bands.

Carlo, who works in the Museum, informs me that an early form of the organ existed in Byzantium, but it was in the Middle Ages that the Catholic Church first introduced the instrument in Europe. The Trevi organ was commissioned by the Franciscan monks in 1509, and built by a gentleman in neighbouring Montefalco, a certain Mastro Pietro di Paolo, for the sum of 80 florins. He must have laboured away tirelessly, for the organ was mounted and played during the Christmas

celebrations that same year. It was so enthusiastically received that the town council actually employed an official organist from 1528 until 1695. The organ has been modified during the centuries, but the central organ pipes are still original, making it the oldest in existence in Umbria and one of the oldest in Europe. Its wooden case juts out jauntily from the wall; along the choir stalls below, a passing parade of saints is depicted: little-known characters like St Didaco alongside the household names such as St Chiara of Assisi, St Catherine of Alexandria, the ever-present St Emiliano, and Italy's number-two hero, St Anthony from Padua.

I sit down with Giancarlo and the children in a front pew and wait for the concert to begin. Julian has come along, so we must sit close, otherwise he will lose interest. The organ is to our left, while directly before, and above the altar, hangs the large crucifix that Geppino had also mentioned at lunch up at Cancelli. I am gazing up at it when Geppino arrives. Julian sits near me reading a Mickey Mouse magazine, *Topolino*, a hugely popular Disney character throughout Italy.

Geppino sits behind us. 'Did you have a rest? We did a lot of walking!' he whispers in my ear.

'Enough. A hot bath did the trick. That's the crucifix you were talking about, isn't it?'

'Mmm. *Si, si.* I love that crucifix. It is so full of meaning.'

A steady stream of instruments is being lifted from well-travelled cases, but we still have plenty of time. Julian has begun fidgeting. I lean over to him. 'You can go outside if you want to. I saw a couple of your friends just leave.'

'Can I go to the video games in the bar?'

'One go only. Then run back. OK?'

'OK. *Ciao, Ma.*' Julian scurries off, free at last.

Geppino takes Julian's seat, and continues softly, 'I know I'm hardly breaking new ground, but I'm interested in how the greatest artists in the Middle Ages or early Renaissance drew inspiration from

ancient universal wisdom. The cross here is as good an example as we'll find locally.'

'Really? In what sense?'

'Oh, as if there were a chain connecting the centuries, expressed through the artist. The "information", if you want to call it that, was then expressed through the symbolism in the actual images. It is that, I think, that continues to vibrate very, very subtly around us.'

'But if I understand you, you're talking about a very limited number of works, Geppino.'

'Absolutely. In Trevi, I suppose for me there are two works of art that represent what I refer to as the Initiatic Soul: this crucifix here and one of the altars in the Church of St Emiliano. When I look at these two works, I can perceive the nature of both the artist and myself — as if we have a place in the grand plan of things.'

'So tell me then, apply that to the crucifix. Go on, the orchestra won't be ready for a few more minutes!'

'*Va bene. Allora.* I'll tell you the way I see it. To start, take a look above the central image of Christ on the black cross. Can you see at the very top a round disc shape, a medallion, containing an image of God? And just below the medallion there are two angels — one white, the other red. On the right side of the cross there is St John in a red mantle, while on the left you see the Virgin Mary in a black mantle. They both figure against a gold background. Then at the feet of Jesus kneels St Francis. Both he and the base of the cross rest on a stone. Inside that stone, onto which fall drops of Christ's blood, you'll see a skull. God is represented in the medallion. He is the Christian First Beginning. The medallion around him is the circle representing the Universe, just like the wheel — a hyperbolic symbol with God in the centre. It incorporates all of humanity, so obviously his Son as well. Then there are the angels. I think they represent Creative Will; you could call it the will to work. That this work is alchemic is suggested by the colour of the angels: red for Power and white for Spirit. The

Virgin's mantle is black, for example: it signifies mourning, but is also the alchemic colour for Nature, the great Mother. I like to think that she is Isis, spiritual mother and at the same time Nut, corporeal mother of the ancient Egyptians.'

'Then there is Christ — he's the central image.'

'Yes, of course. Christ: Death and the unrevealed. Can you see that he is at the centre of the vertical axis of the cross? He is directly between God the Father and that stone below, which has the skull inside. The way I read it, the stone symbolises spiritless matter, which will be fertilised by the love of Christ, in the form of drops of blood, a holy fire.'

'And the skull?'

'A sort of Holy Grail, perhaps? It's like the head of a Celtic titanic god!' He takes a breath. 'Then look at that red blood falling onto the stone containing the skull. It's a Christian symbol for great burning — a holocaust, really. Whereas in Paganism it could represent a mythic cosmic bull, streaming blood onto the earth, fertilising the beginning of humanity.'

'The orchestra is ready, by the looks of it. That must be the conductor,' I glance around, 'and Julian's not back yet. I'll have to go and get him. But before I go, what about St Francis there?'

'I don't know. For me there is a big question mark around his figure, kneeling between Christ and the stone. He is certainly a symbol of holiness, like a transmitter of what I call mystic perception between the Absolute and humanity. Ah, here's Julian', Geppino stands up. 'Julian, I'll sit behind again. I just kept your seat warm.'

Geppino steps back into the pew directly behind us. As he sits down and the music begins, he leans forward and whispers, 'Ah, St Francis. Who knows? I find him a strange subject to be situated right there — he doesn't quite fit into the grand design. Probably he is there because the church is named after him. *Sai com'è*, you know how it is.'

ζ

Ivana, who has children the same age as Chiara and Julian, calls in one afternoon for coffee. Finally there is someone with whom I can discuss parenting, Italian style.

'There are so few children in Italy now', she jokes, 'and soon they'll be declared a protected species. The supposed Big Mama of all *bambini* has really given up in the last decade or so.'

Back in the 1960s my mother had been already considered a rare and exotic breed for having had five children — with red hair and freckles as well — but thirty years on, fewer and fewer children can be seen in playgrounds throughout the country.

Statistics make Italy the leading country in the world for low population growth, with approximately 1.17 children per couple. And it's the first country ever to have more people over the age of sixty than under the age of twenty.

The problem with having children in Italy is exacerbated in big cities such as Rome, where you have to be a bit of a masochist, martyr or hard-line urban warrior to cope with the logistics of carting your kids around congested, child-unfriendly streets.

Often in Italy you must be prepared to have your skills as a mother challenged constantly, with all the best intentions, by aunts, sisters, friends, doctors and chemists, shop assistants, mothers and fathers, and anybody you might pass on the street. It isn't too big a leap to say that you'd be looked at critically if your little darling was not spotless, elegant and sweetly scented at all times. There are still unlucky toddlers, for example, who are forbidden to run in summer — for fear of sweating and consequently catching cold — and toys, pushers, bedroom furniture, clothing and shoes must be the very best, designer labelled — or else your friends might suspect you are negligent as a parent.

As a mother, you may have a job outside the house to pay for all the goodies, but you must also maintain a gleaming home and be constantly at the beck and call of your 'big *bambino*' — husband —

who is hard at work trying subconsciously to turn you, his wife and lover, into his mother. Meanwhile, you must simultaneously remain madonna-like before your new little baby. And whether it is subconscious vendetta or not, you'll bring up the little one to be just as mamma-dependent as your husband.

Why? In a way I suppose there is power of a sort in the quasi-genetically-coded manipulation — but over the years, watching this suffocating pampering of Italy's future adults, I can't spot the compensatory pleasure.

Some of my Italian friends do not appear to perceive their offspring as separate entities, but rather as perfect new bits of themselves, to be controlled and smothered in something called love that often looks like something else to me. Its worst manifestations are to be seen in the obsession with toilet training (with rigid timetables), in not getting dirty, falling over, missing out on any new toy, or showing at any times an emotion bordering on boredom. The result is often a pouting, petulant child and a stressed-out parent, who most effectively projects disdain for non-glossy things onto the offspring. Remember mud pies, grazed knees, scratches, dirty jeans? They are rare in Italy.

I feel sorry for these reined-in little people, and I have to pull myself up at times when I become more concerned with the state of Julian's jeans than the state of his spirit. It's an easy trap to fall into, especially when subconsciously there is a wish to 'fit in'. And that's what the average Italian child must do all the time — fit into a world of adoring adults who are astoundingly tolerant on one level, but never think of encouraging their little angel to develop an alternative children's world, full of discovery and the wonder of things.

In the provinces there are still extended families who take the weight off the new mother, and the pressure to be constantly perfect hasn't been so successfully internalised by potential parents. I got a whiff of this the first time we visited Trevi, when I spotted the

beautifully situated playground, quite deserving of the name, with lots of brightly coloured swings, climbing frames, a flying fox and, unbelievably, a sandpit! It was something that most Roman children would only dream of, and parents here allow their kids to play together without over-supervision. Everyone is much happier, and you see more children around, riding bikes, rollerblading, playing soccer and having fun — doing kids' things.

But it appears that the general subliminal message in Italy is that, if you want to hit the big time and own lots and lots of shiny objects and pretty clothes, you'd better wipe out the inconvenience of that other form of human life known as children — they could seriously hamper your style. It's a lot more down to earth here in unsophisticated Umbria, although Chiara, for example, is the only one in her class who doesn't have a television in her bedroom.

To help me unravel local attitudes and habits, women like Ivana are invaluable. She's a petite, energetic woman in her late thirties — one not afraid to pull up her shirtsleeves, and always eager to help out where she can. Ivana is full of curiosity about other people, about parallel lives in distant lands.

We set ourselves up with cigarettes and coffee on the terrace. Then Ivana pulls a paper package from her shoulder bag and hands it to me. She smiles, 'Virginia, I have brought you a gift.' I take the bag, open it, and exclaim, 'It's a sausage! No, no, a salami!'

'Yes, of course, but home-made by my father-in-law, Novemio. Why don't you get a knife, and we'll taste it?'

'Yes, *va bene.*'

I bring out a knife, a chopping board and two plates. We cut a few slices and each take a bite, and agree that the taste is very different from shop-bought produce.

Ivana continues:

'You know, you notice the taste difference for a few reasons: maybe because we still make it in the traditional way, or because of the

seasoning, or even the food the pig was given to eat. My parents-in-law still rear pigs and feed them beets, cornmeal, leftovers from the kitchen, and mix them with semolina, flour, acorns and chestnuts into a mixture we call *pastone*. It's an entirely different approach to large-scale animal farming.

'My dad used to keep a pig too — until ten years or so ago. When I was a child, I found it entirely natural to watch it being slaughtered, and to see the adults preparing all the different pork food items — to tell you the truth, for me it was a kind of celebration! I remember the only ugly moment was the actual killing — they'd catch the pig, tie it up on a raised bench, and slit its throat with a big knife. As the blood poured out, it was collected in a big bowl, and stirred constantly so that it wouldn't congeal. Otherwise, it would become too hard to make *sanguinaccio*, a sort of sweet salami that you probably have heard of.'

I nod. 'Giancarlo's mother, Maria, made it for me once in Naples. I didn't know what it was until I had eaten it all up, but I enjoyed it at the time, even though the calorie content should have put me off! Maria mixed together sugar, lots of chocolate, cinnamon, glacé fruits, milk and flour, with pig's blood. I have to say that it was my first and last blood pudding. It was served at the time of Carnival, although Maria did comment that a long time ago it was a part of the Christmas and New Year dinners, and, if I remember, was served with rice.'

'I don't know. You know how recipes change so much from one area to another in Italy! I haven't tasted a Neapolitan version, but the recipe we use in Trevi requires that we wait till it firms up, cut it, and fry the slices in the saucepan', says Ivana, then continues:

'You know, even though the scenario I have described to you sounds a bit cruel now, I remember I didn't feel at all sorry for the pig; not like the other farm animals — lambs, for example, maybe because pigs aren't what you call cute, are they? Although come to

140

mention it, I used to stand and watch them for hours! I never went too close to the pigpen though, because Mamma had told me how dangerous they could be. She told me that, if I fell in, the little beasts were capable of eating things like me alive — which had really happened! At our place a pig was always slaughtered in the week leading up to Christmas. Once dead, it was immediately cleaned with boiling water and then the hairs were removed from the skin by burning, because the pig's skin and rind is used in all sorts of different preparations as well. Things have changed a lot since then. These days the method for killing a pig is more humane: it is shot and dies instantaneously, before having its throat slit. And I have seen they use a kind of electric device now to burn the hairs off the skin.

'My father-in-law killed two pigs last season — one just before Christmas and the other a month later so that we could have both fresh meat and sausages over an extended period. Maurizio and my brother-in-law always help Novemio. And then there's the butcher, Alfredo, who is called in for the slaughter, and to help them cut it up. Well, he's not actually a butcher, but works as a barber — he does this in his free time! Listen Virginia, shall I go on? This all started with a piece of salami! Do you want to know more?'

I respond, 'It's certainly not what I thought I'd spend an afternoon talking to you about, Ivana, but I am fascinated, really. Remember, I am not from here — it's all new to me.'

Ivana smiles, 'Not only to you. A lot of these things are being forgotten here. Even so, in a way it's not easy to talk about these procedures. I feel so self-conscious using terms like slaughter and quartering. It makes me sound cruel, crude, when I have always experienced these things naturally. To me, a pig's death was, and is, a part of life, although that can seem strange as we sit here and talk this afternoon. Anyway, where were we? Ah, yes, the pig is then hung on big hooks and quartered, with the help of the barber-butcher

Alfredo. It's left to mature for a couple of days, and then the preparation of the different cuts begins. Around here we say *si spolpa il maiale*, we skin the pig.'

'And then?'

'Alfredo dissects the whole animal, and the pieces are grouped: meat for plain Trevi sausages and for liver sausages, for salami, prosciutto, for pork steaks and local dried specialities like *lonze*, dried pork fillets, and *capocolli*, salami made from the cured and salted pig's neck. Then there is the *pancetta* — what you call bacon — and pork ribs. And with the leftover meat, those bits near the bone and some rind we make *coppa*, entrails in gelatine, which I find delicious. You wouldn't think so from how it is prepared! You have to boil everything up — bones, rind, and bits of meat. If you look when it's being done, you'll see it floating in a sea of fat! Then the mixture is drained and the bones removed, it is seasoned and put in a cloth bag with a big weight on top to squeeze out the juices. The entire business is time-consuming, but when it finally dries out and firms up, you take the cloth away and the *coppa* is ready to eat. Maurizio's mother, Iolanda, is an expert at making it, and lots of other things as well.

'She even collects the *strutto*, an oily, solid substance we use in cake-making and in frying — it takes the place of oil in some homes. That reminds me, in the Middle Ages the Benedictine monks used to have a special room in their monasteries to prepare the *strutto* and the lard — it was called the *lardarium*. The days when the animal was slaughtered, at the beginning of winter then as now, were called *tempus de laride*, lard time! They let the lard rest until Easter time before using it in recipes, more or less what we still do with the dried meats. Iolanda also cooks the tongue and the trotters; she doesn't waste anything! Only the lard isn't saved nowadays.

'I must confess I hardly know how to do any of this for myself — maybe because our parents always did it for us, because I am so busy at work and don't have enough enthusiasm. But I feel sad that when

they are too old to continue, the skills might be lost, and we won't have access to the real thing anymore.

'Both of my children, Nicola and Valentina, have experienced it first hand; I am really glad about that! As a matter of fact, they help out sometimes, and it's not an easy job. They both really enjoy making the sausages and the salami. It's important to work really hard and concentrate if you want a good result. You must use good-quality *budelli* — you know, the intestines — which have to be bought and cleaned very thoroughly. As the sausage meat is churned out of the grinder, it is seasoned with garlic, salt and pepper, before being squashed very gently into these "bags", and tied in a tight knot. The important thing is to do the last bit without letting any air in — otherwise the sausages can explode!

'Even more important than the seasonings is the drying-out period, and for that the sausages and salamis must have the right conditions. At first the sausages need a dry, warm environment to help them firm up. They must be moved to another dry place, but this time it needs to be cold and without currents — that way they dry out well. The salami are different. They go straight into the storeroom, and some old folk like Novemio rub them with ash to preserve them. Although it makes them a bit dirty on your hands when you cut them, I think the ash really gives the salami a special flavour. You can taste it on this meat, no? I remember when my father hung his meats that they didn't always turn out as he hoped, and that was because he didn't have all the optimum conditions in the storeroom. Poor thing! He tried everything: ashes, burying them in tubs of semolina, but he could never get them like Novemio's.

'The *capocolli* and the *lonze* have another set of requirements: the meat pulp is put under salt for ten days or so, then washed, dipped in wine, and dried. Then it is seasoned with pepper and garlic, stuffed into the *budelli*, and hung in the storeroom.

'And the prosciutto — well, there is a lot of care and attention

lavished on them! They stay under salt for ages, about a month or so, it depends a bit on how big they are. Then they are washed, dipped in wine, dried, flavoured with garlic and pepper once again, especially near to the bone — so the pest of a *moscone*, the blowfly, isn't tempted to have a taste — and hung in the store room with the other produce.'

Ivana stubs out a cigarette and looks at her watch. '*Dio mio!* Look at the time! I have to get back to the office! Anyway, it's probably just as well, otherwise I'll tell you all our secrets. You know talking about this has made me want to do it myself, before all this hard-earned knowledge disappears. And, if you like, next time Chiara and Julian can help out with Nicola and Valentina.'

<p style="text-align:center">¢</p>

Towards the end of the month, the architect invites us to a *festa* for his *nonna*, his grandmother, Signora Caterina Bettini, who is celebrating her first century — and at the same time as the rare appearance of the Halley-Bopp comet, which is cause for even more celebration. The house is packed with friends of the family, wellwishers and wall-to-wall elderly folk chatting away. One by one they pay their respects to Caterina, or Ninetta as she is affectionately called. She seems to be enjoying herself, wrapped up neatly in a shawl as blue as her eyes. She sits by the blazing fire beneath a Warhol's Marilyn Monroe, a rather incongruous sight. She seems to recognise everyone, and asks her guests about their families, smiling when they tell her all the latest.

'*Auguri*, all the best, *brava*, well done! In just a few years you'll have lived in three centuries! Look after yourself, and I'll take you for a walk in the new millennium', exclaims a coiffed signora, taking her hand.

Ninetta smiles warmly, but as if she is indifferent. That might be the secret of her longevity.

Later when we go to retrieve our coats hanging in the corridor, we

pass a makeshift altar with a small wooden crucifix in the middle of a large, white room. In my ignorance I imagine the room always like that — a sort of family chapel. They must be very Catholic.

The architect roars with laughter when I ask him about it. 'No, no, That's just for today, for the mass. Before the party the Padre was here saying a private mass for Ninetta. She never leaves the house now. She's still doing well though, although as you saw she is terribly frail. You know, until just a few years back, till she reached ninety-five or so, she had always cooked our family meals. She made tagliatelle by hand. *Buonissimi!* I miss that!'

May

EVERY FRIDAY MORNING the *mercato*, the weekly market, comes to Trevi. The *mercato* is a small-town event, but all the food is fresh and locally produced — a welcome alternative to the squat, square supermarkets sprouting along the Via Flaminia below, selling out-of-season fruit, peanut butter and tomato ketchup.

On Friday mornings, if the sun is shining, the car stays at home and I walk up to the piazza. If it's still early — around 8.30 — the amplified voice of the fish vendor, serenading the town's homemakers from a crackly megaphone, follows me as I climb the steps near the Gasparinis', where the white lemon geraniums, emitting a soft smell like citronella, are already in full bloom. From the very top of the steps, near Guardian Angel Way, I can just spot his white truck zigzagging through the olive groves spread out below. Like a contemporary town crier, his voice announces, 'Donne, Ladies! Don't know what to cook for today's lunch? Well, now your problems are over! *Si, si!* Yes, *finalmente*, your friendly fishmonger is back again with loads of fresh fish — *trote, gamberi, cozze, anguille,* and *sogliole!*' The words, evoking the distant Mediterranean, reverberate through the foothills and momentarily drown out birdsong.

The fish vendor is a Neapolitan and is as *verace*, as genuine, as the fish he sells. I don't know what his name is, but to me he's Gennaro,

named after St Gennaro, patron saint of Naples. It must be hard for him to be landlocked. Maybe that's why he's taken to trading in creatures from the sea, exotic maritime bodies — to remind him of home. Gennaro is always among the first to set up his stall at the end of the market square, just by the lentil-seller who drives down from the high plains of Castellucio, way beyond Spoleto — the latter is a chubby man with a creased and stubbly face, who sits patiently all morning among sacks of potatoes, *cicerchie* (a cross between lentils and chickpeas) and pots of creamy honey.

Further on, among crates alive with the reds of juicy fruits and the greens of leafy vegetables, the curly-haired greengrocer holds court. Invariably, there's always something of a queue before him, stamping feet and rubbing hands to stay warm in winter, sighing deeply and fanning themselves with newspapers in summer. Italians have an almost religious devotion to all edible things, verdure in particular, and in Trevi the produce on offer is discussed with the same intensity as the latest political manouevrings.

Strategically positioned between the old and new piazzas sits another white van displaying, at the front, a large pink *porchetta*: roast pig of tender meat and salted crispy skin, slices of which are served in a crusty bread roll with added salt, and ideally eaten still warm. Beyond that, trailers of parkas, ex-army gear, jeans, kitchen utensils, stockings, and racks of designer underwear, rub shoulders with gardening tools laid out on the bitumen, like some seaport bazaar way down south.

Last, but not least, stands Signor Vito amid the gorgeous patchwork of blossoms that make up his plant stall. Because this is Umbria, he also sells trays of vegetable seedlings, which are popular items with the little old men permanently gathered about him. Like an old-fashioned general practitioner, Vito offers advice to all Trevani whose baby vegetables may be suffering from growing pains. Tossing aside any newcomer's remaining shyness, I barrage him with gardening

questions, for he makes it sound so easy. Our south-facing land is subject to a relentless sun beating down on a cracked and crumbly soil, and we need help — lots of it. Months back Vito had sold me the hardiest rambling rose bush a novice gardener could ever wish for, which already twists and curves its way across the stone walls of the house. Ablaze with oversized blood-red blossoms since March, it is much admired by the signoras strolling past every evening.

Piazza Garibaldi, the home to Friday markets, has always been central in the life of the Trevani. For centuries it was a large catchment basin for precious rainwater, for hilltop dwellers in Umbria have constantly suffered from water shortages. As in other Italian towns, local women gathered in the square to launder at the public *lavanderia*, the wash-house, while menfolk would lead thirsty donkeys down from the mountains to drink. Apart from an occasional drought, there was a fairly constant supply of fresh water, but with no functioning drainage system. Inevitably the waters stagnated and disease followed, especially in summer. The situation improved dramatically in the nineteenth century, when a modest fountain-cum-wash-house was built. No evidence of that remains, but the piazza still undergoes sporadic renovations. Plans are presently under way for an international architect to redesign the square, add to the greenery, and create underground parking spaces.

Piazza Garibaldi immediately became a point of reference for us, as for every new arrival. It was an important focal point for the children too. Some weeks ago Chiara returned from school declaring tearfully that the *fontanella* — a modest little fountain from the 1930s — had been ripped out from its spot in the middle of the piazza. 'It was all smashed up!' she protested, adding that it could have been transported to some other place had there been time to get organised, for it had served the Trevi public well, and quenched many a traveller's thirst. For Chiara it had immediately become the rendez-vous point for young people. From her first days in Trevi, new friends

had always told her, 'Chiara, *ci vedremmo alla fontanella*, let's meet at the fountain'.

My cooler, well-travelled self has no doubts about our reactions to the shattering of the cement *fontanella* being evidence of misplaced sentimentalism, an overreaction indicating emotional fogginess towards all things local, something I loathe in foreigners who choose to live in Italy, and dread succumbing to myself. Time and familiarity will soon rob us of this. Besides, it seems another far more beautiful fountain is to take its place.

Are tears spilt over a block of cement from the 1930s, *l'età fascista*, wasted tears, when so much of real value is being neglected? Most hardheaded Trevani would say so, for Italy, burdened with an imploding mass of monuments, churches, pictures, statues and palaces, has difficulty establishing priorities; so many buildings and objects that in other countries would be cherished — if not for aesthetic value, then at least for their part in a community's story — are quite coldly, and perhaps justifiably, sacrificed to the gods of time.

And then, on altogether a different level, there are the art thieves to contend with. This year it appears there have been a series of successful daytime raids on some of the more isolated chapels in the area, and the few remaining paintings and carved wooden pews are under constant threat. The Capuchin church up by the main cemetery has recently undergone some brazen daytime raids, and at this rate will soon be empty of any remaining objects. And we worry about a cement *fontanella!*

Back to Piazza Garibaldi. Far on the other side of the square, against the northern walls, rises another fountain, unnoticed by most visitors because of its distance from the shops and main carpark. It is known as the horses' fountain, the Fontana dei Cavalli, and is composed of a niche resting on the central *vasca*, the basin, supported by brick columns. At the top a relief of the coat-of-arms of the Trevi

Comune has been sculpted: a three-tiered tower. Two more recent minor basins flank the sides.

I like to sit on the side of the horse fountain and sketch. It's a good viewpoint, for on the left, past the primary school one has a clear view to the southern side of the square. At a certain point one's eyes come to rest on a stretch of stone wall that hides an imposing villa and the remains of its formal garden. The villa dates from the beginning of the seventeenth century, and languishes sleepily behind hefty iron gates and high stone walls, but one can still clearly see the tops of the trees — lime-trees and horse chestnuts cast shadows across the walls, while laurels and cypresses peep over the rooftop. Within the park encircling the buildings, I imagine that the sweeping vista towards Spoleto must be similar to that from my bedroom window further down the same patch of hill. Such homes as this brought a note of refinement to the countryside, and were often conceived as replicas of the family's town house. Within the spacious rooms of this particular villa, frescoes decorate the ceilings; the best-preserved on the main floor depict Old Testament stories, allegorical figures and family crests. The garden has been emptied of ornament — petty art thieves having helped with the distribution of stone inscriptions, statues and balustrades around the Umbrian countryside. Now only a couple of horses graze there, helping to keep the grass down.

Like many other great houses in Italy, the villa experienced a succession of owners before being purchased this century by the Bohemian College, who painted delightful fresco views of Prague and other loved Bohemian cities across the facade; happily, they have held up pretty well over the decades since. Then just after World War II, the fine buildings were passed into well-oiled Vatican hands, and became known as the Villa del Vaticano. People still call it that, although recently it became the property of a local boy-made-good, who, it appears, has completely forgotten all about it. Although still exuding a tired and haughty charm, it patiently awaits better days, and is a

*Crucifix in the Church
of San Francesco.*
[Dino Sperandio]

*The organ and cantorium,
Church of San Francesco.*
[Dino Sperandio, with permission
from the Trevi Town Council]

Watching an Easter procession in nearby Foligno. From left: Caroline, Virginia, the painters Riccetti and Innocenti, Giancarlo and Paola, a teacher from Foligno. [Chiara Izzo]

All dressed up — and everything's cancelled: Chiara (centre) and friends in medieval dress. [Domenico Pistola]

Looking down at Bar Roma from the Town Hall. [Dino Sperandio]

Nonna Caterina,
one hundred years young.
[G. Bettini]

Giancarlo's prize crop of FAVE,
broad beans.

Slicing up the locally
produced prosciutto in
the delicatessen.

Painting lesson for Julian. [Jenny Temple]

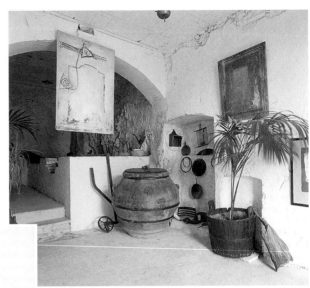

Inside the Millhouse. [Dino Sperandio]

THE SEAT OF ENDLESS WANDERING
in Norrie-Toch Gallery, Scotland.

Paintings drying in the studio near the olive press. [Dino Sperandio]

somewhat poignant, and useful, reminder of Trevi's more dignified past. Rumour has it that the town council will buy it back.

I stand in line before the vegetable stall and examine the beans, fennel and ripe fleshy eggplants. Everything looks good to me. I find myself side by side with one of the women I have met down at the little library in Borgo Trevi. Her name is Anna. We chat sometimes when I take Julian there to help him with school projects. I'd like to tell her about the Brazilian libraries (the Lighthouses of Knowledge), but she's intent on finding the choicest peaches and plums, concentrating hard on the task at hand. She looks up, and we exchange a *'Buon giorno, come stai*, how are you?' She comments on the fine weather, on the children of course, and on how busy she is. Then she puts her bulging leather shopping bag down and asks me how I really am, whether I feel settled in Trevi, *ambientata*, used to it. I am surprised by the question, for I'm not used to saying how I feel — not openly, here in Trevi anyway. I smile at her and look around. It is warm, spring is in the air: a perfect blending of smells, soft warmth and Latin temperament guaranteed to make any foreigner feel that Italy is truly home. It would be churlish to complain. So I answer that 'Yes, I am more or less settled in'.

She leans her head to one side and smiles, as if she doesn't really believe me. Once again, I feel exposed in a way only overtly willing, over-enthusiastic foreigners do. Perhaps she is right not to believe me entirely, and senses the ambivalence — the constant weighing up of the gaining and losing.

One must be patient when buying vegetables in Trevi, forget supermarket time. Finally it's Anna's turn, then mine. She waits for me while I pay, then suggests morning coffee. Together we head towards the Bar Chalet and find a couple of empty seats under the trees. We talk of this and that, *dell più e dell meno*.

Then Anna repeats, 'Are you and your family really settled now, do you think, Virginia? It must be so strange for you! I have always

lived in the same place, I can't imagine moving somewhere else! How do you say it in English? Have you found your feet?'

Found my feet. Mapped my ground. I screw up my nose at painful memories of feet not wanting to touch the Umbrian ground surface, yet they are private thoughts, so I smile as I reply. 'How appropriate an expression in my case! I think so, but I don't know if I'm just saying that to reassure myself — or you!' She smiles at me, and I take my first sip of cappuccino, as usual not hot enough — unlike most Italians, I like my coffee *bollente*, boiling hot. Someone taps me on the shoulder. It is Rosella, who works in the town council offices — I've met her often enough there while renewing family documents. She is the daughter of the *avvocato*, the one who writes books on Trevi's history.

I look up and exclaim, 'Rosella, *che piacere*, what a pleasure! Got time for a coffee?'

'Just for a few minutes. I must get to the bank; there's sure to be a queue!' She settles back in the chair. '*Buon giorno*, Anna! So, what are you two up to? You both looked so intense from the distance, I was curious to know what you are talking about!'

Anna murmurs something about having annoyed me by trying to find out how I really feel about Trevi, about being too curious.

'You're not annoying me, and you're not too curious!' I protest, laughing. 'There is so much I could say, but would I believe my own words? It's not easy to explain. As soon as you're here, it's as if you forget where you were before. I know I'm living less and less in my own head each month, and more and more with my feet on the ground, which is a very good sign. And the kids are settling in just fine.'

'Are you happy with so little?' asks Rosella, disbelievingly.

I hesitate, light a cigarette. 'N-no, but perhaps yes, for now that is. Really, Rosella. I feel reassured about my choice, after some serious second thoughts. That's already a huge bonus with this gypsy life of ours!'

Rosella raises her eyebrows. 'If I seem sceptical, it's because I sometimes feel so out place myself here — like a stranger rather than a local.'

'You?'

I'm surprised, for Umbrians are nothing if not private about such feelings. Anna lights up as well — a sign she's settling in for a long talk — and nods slowly, sympathetically.

Rosella continues, 'Sometimes I think back to when I was a child, living where I still live now. I had a special friend, Marina, who sat next to me at primary school and then again at the school where your Chiara goes now. For years, one of our rituals involved doing our homework together, either at her house or mine. Do you remember that, Anna?'

Anna nods.

'I remember clearly that we'd walk each other home, skipping, jumping, dawdling, dreaming, and giggling over nothing. When we'd reach her door, Marina would tell me she would walk me back to my place, and then, of course, I'd do the same, just like kids all over the world! This would go on until it got quite late, and we really would have to tear ourselves away for the evening.'

Anna leans back in her chair. 'I remember the voices of our mothers calling us from the little balconies, and how their words would blow away like leaves in the breeze, and we children would go on playing.'

Rosella nods.

'This particular little ritual was repeated day after day, month after month, season after season, so that as children the short distance from my street to the square where Marina lived, was as familiar to us as our own kitchens and bedrooms. Inside and outside were all some sort of big sitting-room.'

'Or *campo giochi*, playing fields, perhaps.'

'It must have been like that for a few years, and then one day

Where the cypress rises

Marina left. That was a sad day, I can tell you. *Tristissimo!* Her family moved to the city and to new friends.'

'Poor Rosella. You must have felt betrayed!'

'And jealous, of course! I was stuck here in Trevi, with the same old narrow paths and corners, where, from then on, it was as if nothing ever seemed to change.' Rosella pauses briefly and looks up. 'Yet, thinking about it I can't even say that I know those streets well, I mean in all their details, despite this long-term contact. Sure, I've walked down them countless times, but once I stopped being a child, once Marina left, I always tried as hard as I could to think of other things. To tell you the truth I still feel so oppressed when I find now, for example, the same charcoal graffiti in the very same spot on a particular wall as when I was a child! Back then, the marks I saw about me were full of mystery, of dark, hidden potential.'

'I remember that feeling, especially before I could really read!'

'It was kind of wonderful, but now I know them all too well. Look, there's one that fascinated me as a child; years ago I discovered it refers to a local cyclist long since dead and buried.' Rosella turns to me, 'These are innocuous things I'm talking about! And yet I feel so antagonistic — it's crazy, *pazzesco*, isn't it? But secretly I can't help feeling irritated by those unchanging traces on the wall!'

'Oh, how you exaggerate, Rosella!' ventures Anna, stirring her spoon slowly in the empty coffee cup.

'It is silly, I know, but I can't help it! There's another doorway, for instance, which I walk past all the time. It irritates me in the same irrational way. It's always closed, but a musty smell creeps through the cracks, and every time I get a whiff of it I feel like I'm stuck in a groove. Sometimes even the scent of spring flowers can have the same effect as that old, damp smell — even the wisteria or the same ornamental roses that I would pick to take to my class teacher when I was little. And the buildings! The same unchanging facades, fixed in time, with their severe windows overhung with Latin mottoes.'

'They look so beautiful to me.'

'Oh, you don't need me to tell you how beautiful they are, but I almost feel threatened by them. It's more like a prison sentence seeing them every single day, and so I try not to look up as I walk. Unfortunately, what I can't avoid, and feel I know like the back of my hand, are the fixed positions of the men who sit with inquisitive, prying eyes that follow you as you cross the piazza. You must have noticed them as soon as you arrived in Trevi, Virginia — or any other provincial Italian town!'

'Of course, but they seem harmless enough.'

'Every morning they seat themselves down in the same spot, *immobile*, around the edges of the square. It's so territorial! And they look like they've been there forever, don't they?' Anna quips, and stubs out her cigarette with emphasis, grinding it into the ashtray.

'Fathers die, sons grow older and take their places. But the faces are always, always, the same. It's true!' She glances at the men sitting at the table across from us, and raises her eyebrows. 'Nothing really penetrates a reality as sterile as that!'

Rosella's description of the town is unexpected, as is Anna's ready agreement, for from the outside one would assume them to be so in tune with local rhythms, with this constant perpetuation of the present.

Rosella seems to read my thoughts, and shakes her head slowly. 'It is not like you foreigners think at all. Sometimes I make a detour when I leave the house in the morning, just to avoid this infuriating, totally predictable encounter with people and buildings! As a repetitive pattern it really unsettles me, makes me nervous. If there's enough time, I choose a much longer route; a twisted, contorted way to reach the newsagent's, for I go by the little stepped alley rather than across the piazza — you'll know it, Anna, where all the jasmine blossoms tumble along the walls. Or else I walk all the way around, by the outer walls of Trevi; there at least I have the relief of the view, that view towards Foligno and Assisi.'

'I wouldn't go to all that effort, even though Trevi can make you claustrophobic, that's true', says Anna.

'That's not all I do! Some days I leave home well before eight, like a real early bird — you should see the swallows flying and chirping in the trees above the Bar Chalet at that hour! On other days, I sneak out later than usual.'

'Anything, anything, to avoid all those faces, Rosella!'

'Exactly. And as soon as I have a day off work I make a beeline for Rome. The air might be more polluted, but I can soak up the images, store them up as an antidote to the daily experience awaiting me here, where I open my eyes every morning to the very same day — like time is stuck in a groove.'

¢

Chiara is going on a school camp tomorrow morning — up north in the Dolomites — so I've convinced her to spend this warm Sunday morning with me, which means abandoning piazza and friends for a few hours. She has agreed to come with me to see an art exhibition in Todi. She is not too happy about it, but finally says yes, just this once. Chiara knows I feel that occasionally it might be a good idea to resist the magnet-like attraction of Piazza Garibaldi and step into the world outside. It is a delicate issue between us.

We drive past Montefalco, and on through rolling hills. Todi rises before us. This is supposedly a much trendier part of Umbria: lots of artists hidden in these hills, many foreign part-timers seeking refuge or inspiration ensconced in a landscape that can be almost too beautiful, too perfect. A few years back Todi was judged by the University of Lexington in Kentucky to be the most habitable township in the world, which paradoxically sent property prices soaring and out of the reach of most. According to the study, Todi contains all the attractive characteristics essential for a high quality of life: a well-preserved environment, pleasant climate, good food,

efficient services, historic traditions and beautiful architecture, moderate prices, the mild manners of the Todini themselves.

The tourist traffic has beaten us already; we park well outside the medieval fortifications, and stroll up steep alleys until we come upon the central piazza. It is alive with daytrippers and foreign tourists drinking coffee at tables recently dusted down and placed gaily in the spring sunshine. There is a strong whiff of summertime, of life *al fresco* — Chiara feels it, and instantly brightens up. We sit down in a cafe, and order coffee and *cornetti*, then engage in some serious people-watching. The piazza exudes a dignified and austere air quite different from that of Trevi: more confident, more *città*, citified, and contains a strange mix of lily-white tourists and angelic local faces straight out of a Piero della Francesca painting. In fact, the teenage waitress looks like Piero's extraordinarily moving *Madonna del Parto*, his 'Pregnant Madonna'.

After a few minutes we track down Todi's only real contemporary art gallery just off Piazza Garibaldi, behind a group of imposing civic buildings from the thirteenth century. I am hungry for contemporary images. We step into the cool white rooms. There are some familiar faces, mainly from the small art world of Perugia. Someone shakes my hand and I immediately get dragged into a conversation about gender and creativity, for this happens to be an all-woman show organised in America; just as quickly, aware of Chiara's resistance to the conversation, I plan our escape. I understand her, and don't want to go over the same old things either. Too often in Italy it seems there's so little space to face such issues openly; it's always a double-edged sword, for all that — the gender stuff — is supposed to have been dealt with, well and truly buried. Despite having been partially rehabilitated by postmodernism, the F-word, *feminismo*, had long been declared *passé* — but one has just to flick through most Italian art magazines to realise something might still be amiss, for women are still thin on the ground, at least those of my generation. Yet it is

changing among younger artists — there, women are placing themselves well and truly in the foreground.

A local painter introduces me to a foreign artist who lives near Perugia. I try not to stare enviously at her fine porcelain skin, while she earnestly declares that she paints *masculine* things. Just what does she mean by that, and why did she need to tell me, I wonder. It reminds me that in Italy I am often told that I paint like a man, which sets up ambivalent and highly-charged responses. It is intended as a compliment; but why must I be assimilated into a lineage of male forebears for my work to be validated? I sense a happy mix of cross-Atlantic energy and plenty of animated talk around the drinks table — that's the place to be. The room is flooded with soft Umbrian light, so that it reminds me of a film set, hints of Bertolucci.

I follow some other guests, and stroll outside with my glass of *prosecco*. From the terrace there's an outstanding view of valleys, ridges, and rolling hills, seemingly close enough to touch. Maybe it's just my mood this morning, but I feel vaguely irritated by all the beauty — too much of a good thing can be tiresome. Like a naughty child, I imagine painting an iconoclastic dirty-brown smear right across the picture-postcard-perfect scene spread out before me, and immediately feel better. I think back to my recent conversation about Trevi with Rosella and Anna. Maybe Rosella needs to rub out some of those charcoal graffiti outside her house, and add some new graffiti of her own.

When we arrive home in the early afternoon, Giancarlo has left a note on the door saying that he and Julian have gone trout-fishing down at the Clitumnus, that shady spot a few kilometres away where once the little mud-god Clitunno lived beneath the crystal waters. Chiara, unshackled at last, seems to sprout wings, and flies off to her adopted tribe, members of which can be seen floating around Piazza Garibaldi at all hours, like charged, yet somewhat aimless particles.

Taking advantage of the lull, I finally drive to nearby Poreta to visit

Rodney, another Australian who has planted himself deep within these hills. He's been inviting me to come and see his place for weeks. Rodney is in his early thirties, his strong sculptured face and body the object of many an admiring glance, for he embodies the classical ideal of male beauty. In the last few years, while the majority of his contemporaries have sought diversion in discos, he has studied intensely and sought an authentic base in tune with his particular interests. I suspect he has found his little pot of gold, his Umbrian paradise, and I am curious to see for myself. Unlike most foreigners Rodney has settled in Umbria full-time, for he, like me, does not view Italy as therapy. Presently, he's only partially restored the stone walls and outbuildings that make up his property. He greets me warmly and invites me to sit at his little reconstructed terrace.

'I still get a buzz sitting here, seeing all my handiwork! It's like a drug, isn't it? All this fixing up and pulling down and restoring. I think we all feel like guardians in a way, breathing life back into forgotten walls, abandoned rooms.'

I hesitate. 'Yes, but one has to be careful not to overdose, or to turn it into a fairytale. Not that I've got anything against fairytales, mind you. On the contrary. But you know what I mean.'

Rodney nods slowly when I blurt out that sometimes I feel the urge to rebel against the very things that brought me here, like this morning in Todi — the sublime landscape, the soft pink glow of the evening that makes everything look like a fresco from the fifteenth century.

'Take this morning in Todi, Rodney! I wanted to shout "That's enough! *Basta, BASTA, BASTAAAAA!*" across from the terrace! Sometimes too much beauty can dull your senses. You have to be careful, don't you think?'

He grins. 'I think I know what you mean. And not just careful of beauty! It reminds me of a few years back and a place I nearly bought. I'd been renting in Perugia for two or three years then and had started a degree in early Italian and Latin literature. I knew by then that the

time had come to buy a house somewhere here, in the country. First I looked north of Perugia, you know, around Umbertide and beyond.'

'Almost Piero della Francesca country.'

'Well, not quite, but overflowing with his devotees — especially British!'

'And Germans, and Americans, and–'

He waves his hands dismissively. 'OK, OK! Anyway, I searched the place for months, and one day discovered yet another old mill in a tiny glen. It still had the old wooden wheel, which was turned by the quietly flowing water underneath, which in turn trickled down to join the Tiber below. And I immediately thought it was just too perfect. And then, of course, I became suspicious, and wondered why no one had snatched it up before.'

'There had to be a catch. What was it?'

'There was. This pretty wild-looking squatter, with child in tow came out, and shooed me away; he must have sniffed my interest.'

'Or else you were just the last in a long line of foreign house-hunters turning up on the poor man's doorstep!'

'Maybe! Anyway, he yelled in strong dialect that he would never move out, with or without the law to protect him! The message was very clear, and I bolted.'

That was ten years ago, when Rodney was still very young. Then, some years later, his mother visited from Melbourne. She fell in love with the area around Spoleto — this area — and begged him to look for a house south of Perugia. He agreed to take a good look, and slowly but surely the area opened itself to him. Rodney soon felt that the location was perfect, and that same year struck up a friendship with a local family in Spoleto whose family tree went way back to the tenth century, to a noble family of southern Italian origins. They were about to purchase an eighteenth-century hunting lodge on the outskirts of Spoleto, and asked Rodney if he would consider joint ownership. He'd get half the top floor, great views and a rooftop terrace — and the

price was right. There was the advantage also that he would have charming neighbours, and the bonus that the Signora loved cooking for family and friends. What they all neglected considering were potential disagreements with their *vicini*, the other neighbours living on the adjoining land.

Soon he and two of the male offspring of the family were the grandiose but still unrenovated old villa. Now, as Rodney describes that short-lived period of his life — another fading fairytale of parties, big family meals, walks in the hills and the long, snuggly winter afternoons spent studying for his exams by an open fire — I think he still misses it.

'There was one time I remember particularly, the eve of my Latin exam, for which I had been frantically studying for a year — and that last night I was really wound up. Terrified! I had been going over and over the program for weeks, running through Horace's odes before turning out the light. That night I lay there aware that it was to be the last time, the time of reckoning was upon me, and with any luck I'd pass the exam, take a week off study and enjoy the Italian summer. I think I had just dozed off when I was woken up by a light penetrating my closed eyelids. It was a strange light, right there in front of me, not more than 10 centimetres away in the pitch black of night. And then I realised — it was a firefly! Like most Australians, I'd never seen one before, let alone been woken up by one. I felt instantly reassured that all would go well in the morning, for it struck me as a good omen.'

'And was it?'

He smiled. 'Yes, very much. In the long run!'

'And then, what about the house?'

'Then, inevitably perhaps when I look back now, the neighbours came into the picture and things started to go wrong; basic misunderstandings, the inevitable clashing of different worlds. At least I'd got through my exams before all the mess. It all started

because the neighbours had always used the driveway of the villa to arrive at their own front door so as not to sacrifice any of their vast vegetable plantations, yet at the same time insisted that we not walk in certain parts that were legally owned by us. Can you believe that?'

'Oh yes. I hear stories like this all the time!'

When Rodney got wind that things were turning sour, he started to waver in the conviction that this was the haven he had searched for, both for himself and his dogs, Tarconte and Tagete. As things deteriorated over the winter, the younger of his hot-headed housemates decided rashly that the *contadini* next door should be taught a lesson, and quietly set about planning a vendetta and whispering over the telephone. And sure enough, a few mornings later, a gaggle of council officials arrived from Spoleto with bulldozers, and set about grimly ploughing into the ancient, illegally jerry-built sheds, while the neighbours stood by, momentarily powerless, but swearing bloody vengeance.

As the sheds fell to the ground, crunched by the machines, tension rose to fever pitch, but no words were exchanged between the warring parties. From then on the decline was rapid, for the momentum of hate set in motion reached a tragic finale in a mere twenty-four hours.

'The very next morning the two brothers woke me, and told me quietly to follow them into the second kitchen space, recycled as a large kennel for Tarconte and Tagete. I twigged that something was very wrong, and rushed through the corridors towards my much-loved pets. And there I found the pair of them lying on the floor, stiff, with froth still fresh in their mouths.'

'Oh Rodney! That's like the Muriel Spark story in Tuscany with her dogs. Didn't they get poisoned?'

'I don't know about that. I still find it hard to talk about mine, let alone others. Anyway, a few days later the vet informed me that they had swallowed enough strychnine to kill a horse. As you can imagine, that was it for me. All the magic had been swept away, and I was left

with a sickening sense of defeat — and of loss. Everything was poisoned.'

Rodney knew he couldn't stay any longer. As soon as he could, he moved out, sold his share back to the family, and spent the next months in a tiny flat in Via del Duomo in Spoleto. Whenever possible he would set out on foot to scour the areas around Spoleto for 'his place', from south of Spoleto right up to the 'Coste' of Trevi — a large triangle if you look on the map — and preferably with no close neighbours. Essential requirements? A 'positive' history and, as an option, the site of some religious endeavour.

Rodney turns towards me, his strong features outlined by the setting sun, and exclaims, 'It sounds now as if I was looking for another abandoned Romanesque church! But you know, I think I found something even better. I don't have to tell you that around here the best way to find out what's for sale is to go for the key people. And all know who they are.'

'The barman and the local parish priest, or so most foreigners say.'

'Exactly, *bravissima!*'

'Elementary, Rodney!'

'Sure, once you know. Anyway, somewhere I met this English teacher — appropriately called Otello — who introduced me to the local priest of Poreta, this tiny village on the slopes here under the castle. The priest was called Don Dante, which for an Italianist like me is–'

'*Il massimo*, the greatest!'

'Yes, *cara*. Don Dante had just finished saying that there was nothing for sale in the whole area when he stooped in his shaky old tracks and exclaimed, "*Aspetti, forse*, hang on, perhaps that old ruin called I Cerri, that place called the Turkey Oaks".

'I Cerri had once been a microscopic hamlet above Poreta, and belonged to a one-time Milanese turned Cistercian monk, who was deciding whether to transform it into a retreat or sell it. After about

a month of haggling, I convinced him to transform his villa down south on the Island of Pantelleria into his refuge, and to let me buy this place. The deal was done, and I became the proud owner of a pile of stones that had been abandoned for almost twenty years — just like you and Giancarlo in Trevi!'

I privately came to the conclusion that Rodney had been a lot smarter than us, whatever he might say. We tried to do everything at once, a concentrated fix-it-up job that blew the bank balance, while he was taking this slowly, bit by bit, stone by stone, year by year. But then Rodney doesn't have a family, he is freer, can take his time, I think to myself. The truth is more complex, connected to my characteristic impulsiveness cohabiting with a strong desire for order, for things to be finished so that Giancarlo and I can get on with the day-to-day business of living.

¢

Chiara comes back from the Stelvio National Park aglow with tales of snow-covered peaks, wild deer and flying foxes, and the strange accents of the northerners. 'And you think the Trevi accent is hard on your ears!' she exclaims, parroting the lilt of the Trentino–Alto Adige locals. In Trevi it has been raining relentlessly, while northern Italy freezes under a thick blanket of spring snow, so that poor Chiara has been obliged to borrow warmer clothes from friends. I feel like the negligent foreign *mamma* again, unprepared for the climatic fickle-ness of Italy in May. And then the rains disappear, the waterlogged valley dries out, and this morning we awaken to suddenly find the fields below ablaze with wild poppies — a great red carpet spread out beneath the Millhouse, just like that!

Red for sacrifice, vital energy, the juice of life. I gaze down on the sea of grasses generously sprinkled with countless Seurat-like red dots, and imagine jumping, floating, falling from my window into that sea of moving colour. Later, when I jog down into the valley and

stride past those same stalks quivering in the breeze, I experience the essence of impressionism, its sense of dappled glowing movement; my understanding of Cézanne and Monet shifts, for it has suddenly become real to me. But it's not just poppy-time; all around, underfoot, there's a party going on. Such a gathering of spring wildflowers, trailing pink blossoms and minuscule yellow-and-purple budding things. Wild fennel, asparagus, sage, camomile and comfrey. Then hedgehogs, toads, snakes and tortoises make tracks through the grass, marking territories after winter slumbering. We live so much on the surface of things, and here in Trevi I've become so aware of another world, a world beneath my feet, and I begin to tread more carefully.

¢

The weeks unfold. Spring moves on towards early summer, and the evenings grow longer and balmier. On one such evening Julian and I stroll down the dirt track not far from the Millhouse, and sit at the other end on a rise near the Panoramica. From there Trevi looks her perfect jewel-like self, and all is right with the world. It's hard to imagine the cold we felt just months before, the damp, the mists and drizzle. It all seems so far away — not just a different season, but a different location altogether.

'It looks like a place in a postcard', observes Julian solemnly. He is eager to spot some *lucciole*, fireflies, for his little classmates have told him they have been spotted on some back roads in the last day or two, and this seems to be one of the main topics of conversation in his classroom this week. He rattles off some amazing facts on them and lesser insects, knowledge recently acquired from bug-books. He informs me that the best way to find fireflies is to look for evidence of snails, a favourite food of firefly larvae.

'It should be easy then — I mean there were plenty of snails around Trevi, judging by the number of snail hunters around after a rainfall', I tell him.

'Let's walk a bit then, Mamma, back in the direction of Trevi, and see if we can spot some.'

The purple sun sets late in a pink, pink sky over Montefalco. We retrace our steps along the track, now enveloped in a gently falling curtain of darkness. Gravel scrunches underfoot, satisfyingly crunchy. Julian wraps his arm around my waist. As night falls, the first fireflies flit about us, darting under olive trees, along the walls of the convent of Madonna delle Lacrime.

I remember reading somewhere that Pasolini had been worried that the fireflies would lose their magic and disappear forever with the arrival of pesticides, no longer to flash brightly on early summer nights. Not around here, apparently. Giuseppe Gasparini has promised me I'll see many more than ten years ago, because, he says, people are using far less pesticides around Trevi than a few years back.

The fireflies' flickering lights, emitted from the bottom of their stomach, send out a message for potential mates: here I am, come and get me! As it grows darker, the dirt track is suddenly bordered by hundreds of lights, like a multitude of Tinkerbells. Julian casts a wide-eyed glance about him, and softly chants the children's song they sing at school, '*Lucciola, lucciola, vien da me, ti darò il pane del Re, pan del Re e della Regina; lucciola, lucciola, vien vicina!*' (Firefly, firefly, come to me, I'll give you the king's bread, bread of the king and of the queen; firefly, firefly, come closer!).

'You know, Mamma', he whispers *sotto voce*, 'in Trevi some of the kids say that if you put a firefly under a glass before you go to sleep at night, in the morning you'll find a coin. But I don't think it's like that now. All you'll have really is a poor, dead firefly.'

ℭ

With the warmer weather, the moment has finally come to reconstruct my special private space, my ever-returning sanctuary and refuge. Time to set up the Trevi studio!

I haven't rushed into this; there has been much to resolve before returning to this other world of images, of dynamic interplay between heart, hands, intellect and the flat surface 'out there'. Between the me and the not-me. If I had recreated the studio space too early on in this story, I might have found myself seeking refuge there rather than coming to terms with the spirits on the upper level of the Mill and buzzing around the chapel in the garden. I might well have locked myself away in my own secret hideaway, to experiment with visual alchemy; but if golden images had materialised they would have been falsely brushed with chimerical fool's gold, and the marks drawn out of white surfaces subliminally frantic, unresolved — for it would have been too soon.

One morning I race downstairs and fling open the huge double doors; light floods in. Against the rocky back wall, still ordered and systematic, stand the remains of Jenny and Gregor's woodpile. In the middle of the room two imposing brick columns rise from stone floor to ceiling, to resurface on the second floor of the Millhouse where they then stretch upwards and touch the roof. And right between these columns a local handyman has been engaged to construct a false wall: my painting wall. Bottles and tubes of colours, boxes of drawings, of paints and brushes line another wall, waiting. I feel as if I've been on a long voyage, and am coming home at last, for the studio has always been another home away from home.

Such a pleasurable addiction to my workspace probably began in childhood on sunny afternoons in Melbourne, back in the early 1960s. Mum would place an old wooden easel on the paved area behind the back porch, which was immediately transformed into a playroom. I can still conjure it up: my younger sister Fiona and I would splash non-toxic water-paints across sheets of butcher's paper collected at the corner shops, along with the daily loaf of bread and the obligatory liquorice straps from the milk bar — a special treat for 'being good'. The highlight, the fun part, was when we'd plunge our hands into

the paint-tubs, right up to the wrist; we could almost taste the colours, the wetness. We'd lift dripping fingers out, heavy with drops of live colour, and position our palms slapbang in the middle of an empty sheet of butcher's paper, pressing down into the white expanse, leaving our handprints behind. My first paintings were like rock paintings. Thirty years on, the impulse to leave a handprint in the corner of a canvas can still be strong.

My first grown-up studio, after art school, was in Alexandria in Egypt. It overlooked the waterfront with its row of wind-blown palms stretching right along the shoreline, and sat high above the loudspeakers calling the faithful to prayer and the rickety-rick of the crusty old trams in the square. (I have kept little of the work I did there, and years ago, in Brazil, all the drawings from Egypt, Rome and art school sketches were mistakenly thrown out by the packers.) My studio in Egypt was huge, and, intimidated by the newness of everything, the noise, language, the sophisticated Alexandrians left over from some belated Belle Epoque, the smells and the lack of breathing space, I used only one tiny corner, and a little desk where I did small, intricate, arabesque-full watercolours and pencil drawings. Rarely did I venture onto canvas and out of my corner; too much space must have been threatening.

The function of all my studios has always been multi-levelled, ever-expanding. A safe place, facilitating environment and therapeutic space. Atelier. Playground. Workshop. School. The locus where masks may be laid aside, temporarily.

Part of our travelling and resettling has always intertwined with weeks of searching for a workspace for me — an often tedious process requiring loads of stamina, hours and hours of real time, and the ability to recognise frustrating dead-ends early on. After leaving Alexandria in 1986 and settling in Rome, I had tirelessly walked the streets of our new neighbourhood with Chiara in her stroller, asking if anyone knew of any possible artist's spaces — a bit like Rodney in

Poreta, although the image of mother and child would have been less convincing, given the stereotypes of our time. Weeks later I was led to the *studio d'arte* of a local sculptor near St Peter's Square, where I worked for a year in a cramped side room next to the spacious roofed-in quarters of the Maestro. I must have been timid back then, for I vaguely recall burying myself in that room, the radio my preferred company, as a stream of clients paid him homage. My stay there was brief enough — in fact, I couldn't wait to leave.

A year later, when we uprooted to bigger accommodation in a more upmarket part of Rome, my studio emerged like a grubby chrysalis from a garage beneath the apartments. By then, I wanted lots of space, and yearned for my studio in Egypt, but finances dictated that I must wait. Inquisitive neighbours would peer in suspiciously while paint dripped and dribbled down canvases. I'd stand back, watching and waiting, aware of their eyes burning into my back. On bad days I fantasised about throwing pots of ochre paints at their shiny new cars, or aiming cadmium red at their taut, permanently suntanned faces. Instead I would turn to face them, smile, take a great gulp of polluted Roman air, and say '*Buon giorno*'.

In Brazil I worked in a modern sunlit zone with floor-to-ceiling windows overlooking a smooth green lawn; a home to fluttering reams of paper depicting wandering figures against a palimpsest of spiralling, symbolic forms. Soon after, in war-torn Belgrade, my studio was a true haven in a world gone mad — a place of harmony, outwardly calm and balanced lest I lose my grip, but overflowing with secret references. And for years afterwards, in no-nonsense but unexpectedly generous Scotland, a place of catharsis. A chance to finally exorcise the violent demons — to fully process the reds, flowing rivers of blood, and the memory of an only-apparently-distant Balkan war. *Rosso*, the red of blood-loss. And black, the black of mourning.

In Edinburgh the time was ripe to finally etch, mould, scratch, squirt and draw the story of what had happened in Yugoslavia, both

within me and outside. It was then that I started putting script together with images. Often words were repeated obsessively across the surfaces of paper and canvas like mantras, over and over again. Looking back, the scripts were evidence of private fears, for I had learnt in Belgrade that the war was not something out there, something belonging to others. It was inside us all, and the work reflected my fears. It took years for me to paint it out, to shake off the taint of war that clung so tenaciously, and made me feel that I was always slightly dirty inside.

One typically windy Scottish day, while working happily in my studio, I remember becoming suddenly aware of an old chair in the corner. It was always there, but rarely noticed. In Brazil it had become one of the odd bits of studio furniture following us from one country to the next. And there it stood — patient, ignored. That morning I observed it as if for the first time, and stepped towards it before crouching down beside it. I felt the wood — warm, unassuming pine. My hands, like the hands of a blind woman, began travelling along the contours, reading the dips, hard edges and ridges as if it were a map — or already a painting. It cried out for paint. I reached for my brushes. Over the following days it was transformed into a different chair, and became 'The Seat of Endless Wanderings', finally covered in minuscule script: the words said 'I am tired. I need to rest. I want to sit down. I want to go home.'

After appearing in a series of exhibitions the chair is still here with me as I set up the studio in Trevi, covered in a great dusty bag in a corner of my studio, as perfectly unassuming as four years ago in Scotland — back in a corner, waiting. It is comforting to see it here again, for it is yet another thread connecting past and present, and is extremely useful, for, like a witness, it makes the imminent trans-formation of this old storage space into studio space real. As if this small, inconsequential chair has become my mirror, and reassures me that I am still an artist.

In order to reacquaint with each other I peer under the plastic cover, and touch the painted black pinewood once again, running my fingers along the overlays of white script, rereading the lines. The words are so harsh: potential utterings from the mouths of the dispossessed, whose faces haunted me in Yugoslavia, who peer out from the television sets at night and visit me in my dreams. The tired faces of those who walk on endlessly, their few possessions slung over stooping shoulders.

I'm so tired. I want to sit down. I want to go home. I need to rest. I'm so tired.

¶

The setting-up of the Umbrian studio coincides with meeting other artists, for slowly I am becoming acquainted with arts-related people living in the area — both Italian and foreign. Like a spider's web, the art community makes space for you, however tempered by Umbrian diffidence individual members are. There is naturally some hilltop-like suspicion of outsiders, yet once inside the web, another expanding world appears, full of interesting characters. I am willingly ensnared, although, as with all things, there will be a dark side, a flip side: jealousies, one-upmanship, factions. Franco, a Spoleto painter and sculptor, hints at something else when he says that foreign artists who come to Umbria grow lazy — not about art making, but about personal success; that they stop caring about how others see them with all the 'inner work' that goes on.

'Inner work?'

'*Si*. They often feel that they become better people. *Capisci*, do you understand? But at the same time their work suffers, you know, in career terms.' Franco tells me he's seen it time and time again.

That may be connected to the fact that Umbria is a long, long way from major art centres such as London and New York, but, like other supposedly peripheral places, it has had its fair share of artists who

keep the creative juices flowing. It appears, however, that Umbrians do not treat their homegrown contemporary artists as well as they should, being slightly wary of such dubious activity in the here-and-now; a bit unfair, considering that artists, artisans, saints and visionaries of the past are key players in the flourishing tourist industry that is the region's life-blood.

There are pleasant surprises, however, for one who cares to look beneath the surface. We are kept busy on weekends with openings all over the region and in Rome, and I have begun visiting other artists' studios — wildly different or comfortingly familiar places. Slowly, some faces became more familiar, more open than others, and friendships can begin. After a number of meetings, Antonio, an uprooted Neapolitan artist living in Foligno, invites me to visit his studio in the town's *centro storico*, its historical centre. He works in a large *cantina*, a cellar, built in the sixteenth century. When I step into his workspace the air is cool and smells of stone, oil and wood. I am inspired by the sense of order and the craftsman-like respect for materials, so different from the sense of struggle that often pervades my workroom.

Antonio also introduces me to one of the best wine bars in Umbria: the Baccho Felice in Via Garibaldi just near his studio. It's a great little place. The two rooms are very cosy; a sort of woody Umbrian-*trattoria-meets-French-cafe*. He introduces the proprietor, the round and curly-haired Salvatore, a dedicated drinker with a reputation for being a knowledgeable wine merchant and connoisseur. We find a table in the corner and raise our glasses as Salvatore joins us for a chat, telling me that he arrived from Sicily years ago, is more or less happily settled in Foligno now, after fourteen years, and relentlessly educates willing victims on the enjoyable business of wine tasting. He is very choosy about his clientele, preferring empty seats to what he calls the 'wrong' people, for wine is his passion, and he is unforgiving about those who treat it as anything less than sacred, scathing towards the *barbari*, the

172

barbarians, who dip almond biscuits served on a side plate into their wine glasses, thus confusing tastes. He declares that such behaviour is acceptable only with Tuscan *tozzette*, the almond biscuits, and Vin Santo, a fortified dessert wine, but with any other wine it is an insult to Bacchus. I'm glad I didn't fall into his trap, for I surely could have, thus instantly becoming *persona non grata* in this idyllic corner of Foligno. It's all slightly intimidating, and I feel I have passed some sort of initiation. As Antonio and I drag ourselves away, promising to return, Salvatore hands me his card on which is written:

Build yourself a spacious airy cantina,
Liven it up with lots of lovely bottles,
Some standing up and some lying down.
For they'll be your true friends
Through Spring, Summer, Autumn and Winter evenings,
Whilst you'll spare a thought for those with no song or melody,
With no women, no wine, who might live on ten years more than you!'

I promise Salvatore we'll be back, but vow next time that Giancarlo would be coming too.

¢

The days become even longer, and we begin spending more time outdoors. One afternoon, while sipping white wine on the terrace, I ask Giancarlo, 'Why don't we open that door through to the chapel — before it gets too hot to do anything at all out here? The two Giuseppes — you know, the architect and Geppino — said they would help.'

Giancarlo glances over to where the ancient walls snuggle in the trees. 'Good idea — try to remember to ring them next week. If they feel like it, I suppose we could do it when I come back next weekend.'

I ring a few days later, and the two Giuseppes agree. The architect

has an electric drill, so we make an appointment to get working the following Sunday afternoon. The opening of the chapel is to be followed, predictably, by a big meal with a few other local friends. A symbolic act. I invite English Caroline, Rodney and Graziano as well.

When Saturday afternoon rolls around, Caroline is the first to arrive. She's organised a babysitter, so is free all evening. We sit on the hillside as the two Giuseppes and Giancarlo take turns with the powerful drill, forcing it through the thick walls so that one by one the rocks fall. We watch from the sidelines.

'Oh, it's so good to have some time off! What do you think you'll find behind there?' Caroline asks, stretching out on the grass like a cat.

'Caroline, nothing. Well, not nothing. Dirt. There are two metres of trapped earth in there. Two centuries of sediment. Hadn't I told you that?'

She shakes her head.

'After the chapel was deconsecrated, for centuries it was used as a water deposit for the people on this side of the hill. At least that's the official line. Apparently they opened a hole on the north wall so that all the rainwater from Trevi would be trapped inside.'

'So now it's full of compacted earth that came in, bit by bit, with the rainwater?'

'Exactly. Maybe under the earth there's still the remains of an altar. I hope so. But the frescoes are all gone, obviously, with all that humidity, although at the very top there are still some vague outlines. You can see them if you crawl inside from that same hole and stand on top of the earth. It's safe. Feel like trying?'

'No thanks. Not today anyway, not in these clothes.'

We hear a car engine, and she peers down the hillside. 'Hey, is that Rodney's old car?'

'Looks like it.'

Rodney and Graziano pull up in the driveway. They come supplied with bottles of spumante, and a mysterious parcel of wrapped papers. Rodney waves up at me.

'Got something for you! Something to make you happy!'

Caroline and I look at each other. She raises her eyebrows. 'Expecting anything in particular?' she yells above the sound of the drill.

I shake my head, and shrug. 'I've no idea. Let's go and meet them.'

We hurry down the garden path, holding onto the wooden railings in the steep patches.

'I've been doing some research for you in Perugia, *cara!* I've done a little work on your saint here, and I have a few bits and pieces you might like. *Voilà!*' He kisses me on the cheek and gently places the sheets in my hands. 'This should keep you busy for a while at least.'

I'm excited by the gift. 'Thank you, Rodney, really!', and shuffle through the photocopies. On the top of each page is printed Biblioteca Sanctorum. Caroline peers over my shoulder. I squeeze Rodney's hand in gratitude, for this is entirely unexpected. Then, spumante underarm, he and Graziano make their way up the path towards the chapel and the other men.

I stand at the bottom of the path and leaf through the pages, although I know I should wait till later when I have more time. From these papers it is immediately clear there are two Costanzos in Umbria: another Costanzo from Fabriano and then Costanzo from Perugia — he's our man.

I look up. 'Just let me read this bit, Caroline. I'm dying to. It'll only take a second. Then I'll come up.'

I take the top page:

COSTANZO, *bishop of Perugia,*
Saint and martyr,
According to legend was taken before the Consul Lucius and savagely whipped, then enclosed in a burning oven from which he

was later rescued unharmed. Thrown back in jail, he converted his jailers to Christianity. They then helped him escape. Taking refuge in the home of a certain Anastasio, he was once again arrested.

After many trials in the prisons of Assisi and Spello, he was finally beheaded near Foligno in an area known as the 'Trivium'.

The saint did have a church built in his honour which was demolished in 1527, in an area outside Foligno known as the La Campagna di San Costanzo: the Countryside of San Costanzo.

After his death, it is thought that his body was carried to Perugia, and buried not far from the city in an area known as the Areola di San Pietro, where the first cathedral of Perugia was built, dedicated to the great apostle. Over the cathedral was built the present-day Church of San Costanzo, consecrated by Viviano, Bishop of Perugia, in 1205.

San Costanzo is thought to be the first bishop of Perugia, and, given the serious nature of the ancient traditions surrounding him, it is most probable. His martyrdom definitely goes back to the first centuries of Christianity.

The Perugini adopted him as one of the protectors of their city, and the cult of Costanzo soon spread far outside the confines of the Umbrian region. In 1781 his remains were recognised officially by the church, and in 1895 were transferred to the new altar in his church in Perugia.

I stop there. That's enough; there will be time to read later. I take the bundle of paper into the house and place it in a drawer, grab my camera, then run back up to the chapel. This is one moment I must get on film.

I peer through the lens, focus on the architect. He is frowning, and sweat drips down his face. 'These stones are huge, they feel like they're cemented in', he calls over to Giancarlo. 'But all this was constructed as a *muro secco*, a dry wall. They sure knew what they were doing back then. We'll never finish today, drill or no drill.'

He wipes away the sweat with the palm of his hand. Giancarlo and Geppino stand by, Giancarlo ready with a hand-pick to prise away the stones once the drill has loosened them. Behind the architect dirt flies in all directions. The stones are truly embedded, refusing to abandon their position as sentinels.

I click the camera at the moment a large blue-and-green butterfly flies out from somewhere behind the rocks, as if just born. The architect gives the drill back to the Geppino, then stretches and yawns.

'*Madonna Santa*, that's enough. Otherwise I won't be able to stand up tomorrow.'

Geppino keeps up work for another half-hour. His face becomes redder and redder, sweat dripping down the sides. The drill reverberates throughout his limbs — I can see the muscles straining under the force of the vibrations. Still only a few rocks give way. But it's a start. Geppino places the drill by the lilac bush and stretches. He washes his hands in some bottled water placed on a wooden stool standing in the grass. When he's finished he takes a cigar from his top pocket. 'That's better. Much better.' He folds his arms. 'But it needs a lot more time and effort. More than you'd think just looking at the doorway, eh?'

'But you can see some of the dirt behind — and you did break through, after all — I saw a butterfly come out of one gap in the wall!' I tell him cheerfully, as if I'd been sent to rally the troops.

He nods, and looks across at Caroline. 'Now, where is that spumante?'

'Are we giving up for the day? Should I have another go before we stop?' Giancarlo asks.

Geppino shrugs. 'Who knows? If you feel up to it. As far as I'm concerned, that's enough. *Basta*, enough! The sun will be setting soon.'

The architect folds his arms, and surveys the scene with

satisfaction. 'We got some of the heftier blocks out. Probably all of them. The worst is done, Giancarlo. It's much more than a start, if you think about it.'

'*Si, si, va bene!*' says Geppino, laughing. 'But let's stop. Giancarlo, there's no point in going on now while the others drink all the spumante and you do all the hard work.'

It is agreed. Tools are downed, the sun sets in a blaze of purple-pink, and the evening ritual of food, wine and conversation begins in earnest.

<center>¢</center>

Rodney's unexpected gift has reawakened my curiosity about Costanzo. I make up my mind to visit the basilica of San Costanzo in Perugia before my interest level dips again, before everyday life, the so-called *tram-tram*, takes over. So some days later I drive over to Perugia with Aurora, a new friend.

I met Aurora one night a month or so back up at the Teatro Clitunno, although I had noticed her well before that. It would be hard not to. Ten years or so younger than me, she is dark and glossy, with penetrating, soulful black eyes. A great spinner and weaver of stories, she considers herself a semi-recluse, and lives alone in the hills behind Trevi, which is unusual behaviour for a woman around these parts. Her father and mother had been among the first weekend country dwellers from Rome to buy up in the area; that had been back in the early 1960s. Then they both died in a tragic car accident twenty years later, on a particularly dark stretch of the Via Flaminia, while trying to avoid a motorbike. They had left the little hill cottage and garden and a big city apartment to Aurora and a younger brother — a bigwig in advertising in Milan, or some such thing. At the time of the accident, she had been an art-history student at Rome University. After the tragedy she began coming up to the Trevi cottage more and more frequently to continue research on Perugino, the great Umbrian painter (it was she, for example, who told me to visit one of his best

<center>178</center>

works, of which I knew nothing: the San Sebastian fresco in the little town of Panicale, on the other side of Perugia). Inevitably, perhaps, Aurora began to spend more time here than in Rome, so that the cottage, full of her parents' memories, became home. Her studies over, she moved up more or less permanently. I'm still not sure how she actually lives — an inheritance perhaps, plus a bit of freelance lecturing and leading highbrow American study groups around Assisi.

Soon after we met she declared with refreshing candour that she wanted us to be friends, and I was only too happy to fall in with her, for I quite often feel my relationships with Italian women are limited; many seem to have a completely different concept of what a friendship with another woman can be like. Maybe, I thought, Aurora would be different; maybe she'd be like my real friends, those ones you can say everything too. I'd always had them, but missed them here in Trevi — with most local women I feel I can go so far, exchange intimacies in the piazza, but that's about it. In that sense I still feel myself an outsider. And, despite our differences, Aurora and I have a lot in common. Being an art historian, she is fascinated with the story of our chapel in the garden, the story of Costanzo — a man she declared she would have enjoyed meeting.

Driving along the Flaminia she comments, 'At least those old guys, those saints and martyrs, had a bit of spunk. Nowadays, *uffa!* It's Mamma this, Mamma that, *sempre colpa della Mamma!* Always Mamma's fault!' She pauses, stares out the window at the architectural horrors along that particular stretch of the highway. 'Look at that!' she exclaims as we passed the massive new commercial centre outside Perugia, 'A temple to the greedy money gods. *Che disastro!* Like a great wound on the landscape'. She sighs. 'But back to the men. We women have made them like that, you know.'

I snort, 'You are joking, I hope! Do you want to take the blame forever, or let the boys grow up? Come on Aurora, make up your mind!'

'Easier said than done, *non è vero*, isn't that so? Seriously though,

it's back to the old "nature-or-nurture" debate. And our men do seem to suffer from an unhealthy dose of overnurturing. My brother is the same, and to some extent it sprang from the nature of my mother. What I don't understand is why it's not the same in other places? Or, maybe, deep down they're all the same.'

'Giancarlo's not like that, and he's as Italian as you, don't forget!'

She waves her hand dismissively. 'Giancarlo's a rare bird, you know that as well as I do.'

'Not that rare. What about all the men here who cook, and cook well. It seems every time I go out to dinner in Trevi it is the men who cook!' I add somewhat lamely.

'But for each man like that, think of the multitudes who never do anything! What's that expression in English — rose-coloured glasses? *Si*, I think you are wearing rose-coloured glasses sometimes when you talk about Italians. You know, in the seventeenth century travellers to Umbria rarely noticed the people — the peasants were just a quaint backdrop on the "grand tour". Nowadays you foreigners, you *stranieri*, still come and see what you want to see. And most of the *stranieri* who come to central Italy see cypresses and ruins to restore, and faces from frescoes, and pots of geraniums and basil, and–'

'OK. I know. *Mea culpa*, it's my fault.'

'No, I'm not attacking you; I know you've had your share of the other stuff, and I'm sidetracking. But sometimes I feel we'll always be those charming, crazy Italians, which other races love, but don't take seriously. Really. Open your eyes. Most Italian men are jealous, and very spoilt! At least I think so. Take my last boy friend, Luigi. Now he's a prime example. He was an absolute angel to look at. You would love him — straight out of a Fra Filippo Lippi. At first he didn't mind me having a life of my own, truly he didn't. And I like my freedom, need it, wouldn't give it up for any men I've met so far, and I've met a few in thirty years — all types, all nationalities, all shapes and sizes, believe you me. But Luigi didn't feel jealous of my desire for freedom, and over time I realised it was because he never felt the same need.

He just had no idea what he was missing. *Per carita!* For heaven's sake! Looking back, although I wouldn't admit it at the time, he just wanted comfort, and comfort meant Mamma to iron his shirts, tidy his room, cook meals, and a lover-whore for the nights. Over time I would have had to fuse into those two female archetypes. *Santo Dio!* Holy God! But I wanted a man with a capital M. All I got was another Peter Pan who never wanted to grow up.'

'What happened to him?'

'Oh nothing, he's still floating around Rome. When I talk about him, it still feels raw. I guess I still love him in a way. But I have made a hardheaded decision that it's better to stay single, enjoy my men, then send them home at night to their real mammas. Truly! Much, much better.'

She takes a loud breath, which ends as a sigh. 'It's sad though. And you know what scares the hell out of me? That deep down I don't trust myself — I mean, my own nature. Maybe I am just like my mother. If I manage to have a baby some day, a boy especially, I'll smother him in all that excess *amore*. It has happened to some of my friends, despite all their resolutions to be different. Maybe also because they nearly all have just one child — who knows, but they smother them. Maybe deep inside me, under all this self-assurance, this desire for freedom, lurks a mamma just like that waiting for her chance to come out. *Boh!*'

We reach the outskirts of Perugia. While concentrating on Aurora telling me about the problems she had with Luigi, I'm also trying to find my way to Costanzo's basilica. I have no map — in fact, I rarely use them in Italy. I know I'll get there sooner or later, for my habit is to stop somewhere en route and ask locals the way, which always drives Giancarlo crazy. As he keeps reminding me, most adults use *carte geografiche*, roadmaps. I argue that there are so many one-way streets in Italian towns, lots of narrow side alleys and impossible corners that are a perfect metaphor for the complex workings of an Italian brain; and that to understand how to get from A to B and back

again, my best bet is to quiz a local at the traffic lights. It seems to work, after all. I always reach my destination, don't I?

'Don't you use a map?' asks Aurora.

I shake my head. She laughs. 'You're like me then! I always ask someone. I think it's much easier. The maps never show the one-way streets, for one.'

I like Aurora more and more. Today, however, we don't even need to ask, for at a certain point on the way into Perugia she spots a little road off to the right with a signpost reading Via di San Costanzo.

'Virginia, turn right here. *A destra!* There it is! San Costanzo's Way!'

I put the indicator on, and swing over. '*Brava!* Now, that was easy!'

'*È destino*, it's fate', she mutters *sotto voce*, as if she knows something I don't. I glance over at her, but she's staring straight ahead.

We drive slowly up the hill, and spot the church at the end of a leafy avenue. An imposing structure, it is well kept, with a very proper garden. And the hard-to-find priest is actually standing outside chatting with a young couple. It appears their visit is almost over, as the man stands by the open car door, keys in hand. Probably planning a marriage, by the eager, soft-edged look on their faces.

I pull into the parking space. 'Good timing! We're doing all the right things today! You can't imagine Aurora, just how many times I have tried to talk with that priest there on the phone. I always get the housekeeper, who sounds typically possessive, and she always tells me, "He's not here, Signora, he is doing his duty, his *dovere*, you know, parish work".'

'You see, it was meant for you to meet him like this. Go on, go and get him before he disappears again!'

I quickly step out and walk towards him, my feet scrunching white pebbles underfoot. I stand at a polite distance, smelling some roses still blooming in ceramic pots.

He looks over and waves. '*Momento, Signora, momento.*' I glance back at the car. Aurora is reapplying her pale lipstick in the mirror. She always looks fantastic.

The couple climb into their Fiat, and the priest walks towards me. We shake hands.

'*Padre, buon giorno!*'

'Signora? What can I do for you?'

I explain as briefly as I can the story of buying the Millhouse and the little church that came as a bonus in the sale; of the legend that St Costanzo was decapitated on the Costarella of Trevi rather than in the city of Foligno. He listens carefully.

'Padre, which version of the story do you think might be correct?' I ask earnestly.

'Signora, these are legends lost in time. Near Trevi, Trivium, and Foligno–' He shrugs. '*Mà!* None the less, the story of your chapel is fascinating — I didn't even know of its existence, which is surprising.'

Aurora joins us, and shakes the priest's hand. She adds eagerly, 'No one does, except a few scholars and odd-bods like us. One day you must visit, Padre. We would be honoured, wouldn't we, Virginia?'

'*Si, si, naturalmente.*'

He smiles at her. 'Of course, of course', then lifts some keys from deep inside his robe. 'But now, if you wish, we can visit this church briefly. I don't have long I'm afraid, but I'm sure you understand. I am a busy man, and yet I am touched you have come all this way to visit me. *Avanti*, come this way, please!'

He leads us inside. Once Romanesque, the church was rebuilt, enlarged and 'modernised' last century, no doubt to the dismay of many present-day art historians, Aurora included. Sure enough I can sense her disappointment, feel her wincing. She whispers, 'Somehow I think we got here too late'.

The dreadful restoration work was finished in 1898. And as if to rub salt in the wound, we're greeted with the obligatory electric candles and garish madonna-with-electric-halo, icons of our time.

'The holy remains of St Costanzo are up here, in that case, together with an ampoule of his blood', the priest whispers, adding, 'They were officially recognised in 1781 and placed there, under the main altar.

And on the side are also the remains of Leviano, his faithful follower.'

We try to look impressed, but I'd secretly hoped for something smaller, on a more human scale; in fact, for good old intact Roman-esque. *Pazienza*. I should have known better. It has none of the charm of our chapel in Trevi wherein stone, hints of fresco and knotted trunks of ivy have been fused into one over centuries.

The priest hands me a little booklet as we prepare to leave. It is for children, and is illustrated with cartoon-like images in coloured pencil. 'We've just published this. Take it, take it, Signora', he insists, pressing it into my hands. 'It may be of some interest.'

I thank him, and leave an offering in exchange.

Later, on the way home, Aurora opens the little book and leans towards me. 'Do you want me to read it aloud to you now as you're driving? To tell you all about our man Costanzo?'

'Yes, please! Go on then — but don't leave out the boring bits.'

'*Si, si va bene*, very well, if you don't interrupt me. I'm an art historian, remember!'

And so Aurora begins:

The Story of St Costanzo — Saint and Martyr

St Costanzo was born in the year 140 AD in Perugia. His father was known as Opizone, from the noble Barzi family. His mother was a noblewoman, a Dalregio. When Costanzo was born, the land was governed by the Emperor Marco Antonio. The Pope was Pio the First, and the Bishop of Perugia was St Sallustio. Prefect of the city was the Consul Carisio …

Costanzo's mother and father were Christians. They educated their son not only in the humanities, but also in the virtues of the faith: love of prayer, help for the poor, and chastity.

Costanzo was twelve when suddenly orphaned.

Great was his suffering, but he proved to have inner strength and the immense comfort of his beliefs. He entrusted himself to Mary, mother of God, and to Joseph.

Then, he found another father and older brother in the figure of the Bishop, St Sallustio, to whom he opened his heart and spoke of his desire to enter the clergy.

When around fifteen, Costanzo first wore the sacred robes and promised to serve the church.

He put himself willingly under the authority of Sallustio, who lived in semi-clandestinity in the church of Saint Peter, for those were dangerous times.

Sallustio advised Costanzo to give his land to the peasants, for they had been so faithful to his beloved parents. Costanzo did as he was bid, keeping only a small field for himself on which there was also a hut, called the Areola.

This was in the very spot where today we find his church.

When Costanzo was around twenty, Sallustio died. The new bishop, whose name has been lost over the centuries, is thought to have ordained Costanzo around the year 165.

Costanzo tried to be like the apostles in all his actions.

It is said he was quite jolly, dignified in his habits, beyond reproach in his behaviour.

When the new bishop died but a few years after, Costanzo was his natural successor, despite being only thirty years old. At first he refused, saying he was not fit for the task.

Later, with the blessing of the Pope, he accepted.

Costanzo doubled his evangelising, converting many pagans to the new faith, and performing miracles. In such an instance a woman called Astasia was brought to him.

For many years, she had been blind and suffered from eye infections. She believed Costanzo could help her. Astasia knelt before Costanzo, and was instantly cured.

Another time a nobleman called Cresenzio, paralysed from the waist down, was carried to him on a stretcher. It is said that he, too, got up and began to walk, his lameness cured.

Then, in the year 175, the fourth terrible wave of persecutions against Christians occurred, ordered by the Emperor Marco Aurelius. Lucius, the new Consul, arrived from Rome to help the Prefect Carisio flush the Christians from their hiding places.

Costanzo was the first to be arrested, in the house of Cresenzio. Together, they were brought before the tribunal. Lucio and Carisio tried in vain to corrupt them, offering titles, gifts and honours. It was then decided to take them to Spoleto, where the Emperor Marco Aurelius was to be found. On the way they spent a night in the prisons of Assisi. There, Costanzo comforted the other prisoners, two Christians called Concordio and Ponziano.

The next day, the 29th of January 175, the soldiers took Costanzo from the prison and marched onwards down the Flaminia. Cresenzio was abandoned. They passed Spello, where the Christians came out and walked on with Costanzo to Foligno, where they arrived in the early evening. Once there, the soldiers began plotting to kill Costanzo. Perhaps they were afraid of being harassed by more Christians overnight, and wished to escape. One of them grabbed Costanzo by the hair and cut off his head, planning to carry it to Spoleto on his sword. The actual location where this terrible deed took place was said to be at a place called Trivio Folignate.

Sadly, it is not known what happened to the sacred head of Costanzo.

At dawn the next morning, word had spread about the terrible events.

A certain Leviano, a rich and good man from Foligno, gathered up the body of the saint. With the help of his servants, he laid it on a stretcher. It was then carried back to his native city by way of the hills and forests. In one such area lived four bandits, one of whom had become blind in a skirmish. Having been informed of the passing of Costanzo, he was overcome with divine fervour, and went forward to touch the robes of the Saint.

Miracolo! He instantly regained his sight. The three other bandits, witnessing the scene, were most deeply moved and vowed to live as Christians from then on.

They offered to carry the body the rest of the way to Perugia.

The evening of the 30th the tired little group neared Perugia, and could finally see the Etruscan walls before them. Leviano decided not to continue into the city that night, but to lay the sacred body to rest in a little hut on the outskirts. Unbeknownst to him, it was the Areola, Costanzo's actual hut.

The bandits went to beg food in the surrounding huts, from the peasants who had been so faithful to Costanzo's parents. Hearing of the tragedy, the people came armed with bread, candles and torches of fire, paying their final respects to the martyr.

Soon all the Christians of Perugia had been told of the death of their bishop.

They arrived in great numbers at the Areola.

Leviano realised that he had brought Costanzo back to his true home. It was decided that he should be buried on that very spot. Leviano sent his servants to purchase a sarcophagus of heavy stone, wherein he laid the body to rest.

Carved onto the lid was the name CONSTANTIUS MARTIRE.

From that day, it became a place of worship and of prayer for the Perugini.

After the peace of Constantine in the year 311 and the end of persecutions, a stone church was built on the holy spot. Finally all the faithful could worship without fear of reprisal. The sarcophagus was placed directly under the altar, along with the coffin of the faithful Leviano.

Centuries later, in 936, Costanzo's remains were exhumed by the bishop Rogerio who wished to donate some saints' reliquaries to the bishop of Brandenburg, to be housed in that city in the Church of Saint Stephen.

The cult of Costanzo spread widely: to Orvieto, Assisi, Arezzo, Ancona, Foligno and Gubbio. Outside of Italy, St Costanzo was revered in England and Germany.

Aurora shuts the book gently. The road runs on under our wheels.

'I wonder if he is still famous in England — I mean, famous as far as saints go', she murmurs, after a moment's silence.

I shrug. 'I don't think so. But who knows? It's not the sort of thing you talk about really, is it!'

'Hardly. Not in England, anyway. It's a curious story. But then we're not talking about Mr Average, are we?'

Aurora pauses thoughtfully, and cocks her head to one side. 'Your little chapel was built not that long after his remains had been exhumed, according to what I just read. That's around the time the cult began to spread, isn't it?'

'Yes, it would seem so. I can't help imagining something earlier up on our little slopes though, some wooden hut, for example. Can't you? Who knows? Probably even since his death. That's eighteen hundred years ago!'

She nods. 'I know what you mean. I suppose it might have been a place of pilgrimage and prayer since the earliest days of Christianity. And it does have a strong sort of feel to it — as if energies have been gathering there over a long, long time.'

'It feels like that to me too. And that the energy is still there, somehow. I mean, when I am up there alone, I feel it so strongly.'

She nods. 'Me too. Maybe we should just be happy with that, and stop all this searching. Sometimes, to maintain the energy, you must leave things alone.'

I look at her. 'Maybe. But not yet, Aurora.'

June

THE FEAST OF CORPUS CHRISTI IS celebrated on the first Sunday of June, and throughout Umbria carpets of flower-paintings are traditionally recreated along the alleys and streets of medieval hill-towns. Every year thousands of tourists come to sightsee, but essentially it remains a home-grown affair. The beautiful town of Spello, just 15 km from here, has one of the most famous festivals. It's called the Infiorata (the Flowering).

Trevi has a more modest festival of its own, and over the last two days I've noticed a passing parade of women, including a smattering of nuns, collecting great bundles of plants from the roadside. Wheat and barley stalks, yellow gorse, sweet-smelling camomile, pink and red rambling roses, wild fennel, and all varieties of wildflowers are then emptied into large plastic bags and carted off to a cool cellar in the town centre. All this must take place in the forty-eighty hours before the feast of Corpus Christi, for it is essential that the colours are still fresh when placed into the pattern.

Yesterday, Saturday, I came upon the crouched figure of Maria Pia busily filling plastic bags with long whitish grasses sprouting by the roadside. She invited me to help sort through the assorted plant life in the afternoon.

'There's never enough of us, and believe me, it's fun being all together for a few hours! We'll be in the *cantina*, the cellar, of the

189

Melonis, down by the museum — maybe you know the place? It's just another big old door from the outside, but inside there's a courtyard like something from Romeo and Juliet. It's worth seeing in any case.'

In fact, I did know the place. There's a tiny square — the court-yard — beyond a hefty green *portone*, the front door, with an old well situated slapbang in the middle. And beyond that, a beautiful stone staircase leading to the first floor.

I told Maria Pia I'd come if I were free.

I persuaded Julian to come up with me, and soon after lunch we walked up to Trevi, followed instructions to the house, and knocked on the massive green door. An elderly woman called for us to come inside, where a dozen or so women were already busy at work — in fact, most looked like they'd been at it for days, perched on rickety old chairs or wooden boxes, perhaps glad to be away from the demands of their men for the day. I gave the woman in charge a box of rose petals that Julian and I had 'stolen' from Ugo and Ute's rosebush a short while before, and enquired how I could be most useful. She handed me a bag of wild roses still clinging to tiny branches, and pointed to a stool where I should sit. I sat down and began the task of plucking each pink rose petal from its stem. Spread out before me on the floor lay a golden cloak of vibrant yellow gorse flowers. I was to make a similar pile beside it.

It was all very relaxed, for there were smiles all around — quiet, reserved Umbrian smiles — and an easy acceptance of our participation — but no exchange of names, no handshakes. This no longer surprised me.

Julian, suddenly aware of his maleness, bade a hasty retreat. He told me he'd be in the piazza, probably playing soccer with some of his friends, and disappeared.

I looked about me. A young woman stood up and stretched. She'd been chopping up great sprays of fennel, and needed a break. She

took her cigarettes from her bag and offered me one. I shook my head, for I'm making a half-hearted attempt to give up smoking.

She lit up, then began telling me that only a few years ago the prepared flowers had not been arranged into pictorial representations on footpaths, like nowadays; rather, handfuls had been strewn along the route the procession was to follow. In the last twenty years it had become fashionable to design complicated religious scenes or copies of famous paintings, which were then outlined with chalk on the ground. Then from early afternoon on the feast day, the flowers — ancient symbols of fertility — were arranged into often highly complex representations. She added that, while the ritual in Trevi was comparatively simple, over in Spello it was a far more ambitious business. There, even the bark from trees was dried months before; flowers were ground to make richly coloured powders, and all manner of foodstuffs (coffee beans, lentils, pasta) were ground up, and included in the designs.

I marvelled again at the ephemeral nature of this. Something gone as quickly as it came, like so much of collective Italian ritual, but cyclical, returning, manifesting itself again every year. There was a courageous quality in all of this: no searching for personal glory, an acceptance that nothing lasts, that beauty is often captured in small moments, and that, in the end, everything fades.

The hours passed quickly. At 6 o'clock I had to leave, frustrated that I hadn't managed to peel all the roses from the branches — the bag seemed almost as full as when I started three hours earlier, like the parable of the loaves and fishes. It was time-consuming work, and some of the women would be there all evening, after having risen from their beds before dawn to pick. It was agreed all around that it was a *peccato*, a great pity, that more people weren't directly involved. But then again, I thought to myself, it was all very much behind-the-scenes stuff. I wondered if all the people who might potentially want to get involved actually knew about all this activity.

Before I left, Maria Pia told me that the following afternoon the petals would be carried up the street in baskets, and then the task of placing them over the gesso line drawings marked out in the morning would commence. As the procession begins at 6 p.m., that would leave just a few hours to complete the work, assuming a good number of willing helpers. I knew that Julian and Chiara had been roped in to help another group working in Piazza Garibaldi, but I told Maria Pia I'd be only too happy to come.

¢

This morning I wake early despite it being Sunday, and throw open the shutters. The sky is overcast, threatening heavy rain. A breeze is blowing — not the breeze of spring mornings melting into summer, but something less benign. It looks windy and chilly out there. I shiver and wrap my dressing gown tighter. If the weather doesn't pick up, the afternoon procession will be a washout. But the Italian sun is sure to make an appearance later on.

As the morning unfolds, the weather turns nasty. Great billowing clouds roll across the valley, hiding the mountains from view. Sure enough, before long raindrops pelt against the windowpanes. I think of the months of preparation for the Infiorata in Spello; the lovingly-prepared carpets of flowers will be sliding sorrowfully down slippery side streets, and the crowds of tourists will have gone home.

And here, in Trevi? We decide to drive up to Piazza Mazzini to see how things are anyway, and to have a coffee at the bar.

Forlorn little groups huddle under porticoes, wrapped in raincoats, tapping umbrellas impatiently against the stone footpaths. There is a lot of quintessential Italian shrugging going on, constant sighing and repeating of '*Pazienza!*' We have a *cafe macchiato*, buy the newspaper, and go back home to the Millhouse. There's nothing else to do except wait, so I go down to my studio.

192

Giancarlo begins cooking a big slice of local pork from the farm, which he first fries in olive oil and then lets simmer in red wine for an hour or so. The recipe is called, appropriately, '*Porco Ubriaco*, Drunk Pig'. Soon the house is full of the heady smell of frying meat and garlic, evaporating red wine and rosemary, winter smells that go well with the rain that falls incessantly all afternoon and into early evening. Towards 6 p.m. we drive up to the square anyway, just in case an alternative venue has been found in the meanwhile. On the way up to the cathedral we come upon a young girl, dwarfed by an oversize umbrella, scattering petals along the waterlogged route which, in theory at least, is to be followed by the procession. She comments, forlornly, that a scattering of petals is better than nothing. and points at the few chalk marks still not washed away. Yet minutes later it proves pointless, for the priest decides to keep the congregation within the church. 'It's just too wet', he announces, and many of the assembled are old and frail. Outside, the delicate blossoms strewn along the alleys are soon washed away, floating past wet feet, slipping and sliding down into the piazza to be immediately squashed under the uncaring wheels of cars and *motorini*, mopeds.

At the entrance to the cathedral we run into some of the women from yesterday's working bee. One woman grabs my arm, and exclaims, '*Pazienza, Signora, pazienza!* It will be bigger and better next year, when the sun shines and more people join in the fun. Just think what pictures we will make then!'

¢

In Italy there are a number of mysterious customs guaranteed to throw those of us who think they know a thing or two about their adopted home. And by foreigners I'm not just talking about barbarians from the north, or Antipodeans from farflung corners like me; even someone from Lazium or the Marches will get a few surprises in Umbria.

I find myself often enough in that position. One hot morning soon after the flower washout, I cast aside tights and, with a sense of wellbeing, of relief, slip on a pair of open sandals, anticipating lazy months ahead, imagining the welcoming cool inside the house. There will be early-morning swims up at the pool, long afternoons in my studio, swallows flying overhead — *la dolce vita, la bella stagione*, the sweet life, the beautiful season — and not a day too soon!

But first things first. Shopping. I park the car in Piazza Garibaldi, and head for the delicatessen for, among other culinary delights, a tub of homemade truffle sauce — my daily fix for the last month or so. In the corner of my eye I catch sight of a red-haired woman from Bovara, who lives in a beautiful villa near the ostrich farm (from which a very particular prosciutto is made), waving at me across the square. I walk over to her, and she takes my hand.

'*Brava, ti sei tolta le calze!* Well done, you've taken off your tights!' she exclaims loudly.

I nod, amused at the attention she gives to such a minor detail and her thinking it worth commenting on. But in the shops a few minutes later I notice other women glancing at my pink-and-white toes peeping from under leather straps. Sure enough, before long I find myself furtively casting eyes downward to see if I can spot any other naked feet. I finish the shopping, slowly move towards the front of the queue, and then–

'Ah!' exclaims Layla at the cash register, '*Ti sei tolta le calze!* You've taken off your stockings! That was a good move!' The women behind me peer down at my feet. There is some murmuring, but I can't catch if it constitutes approval or disapproval.

Later, in the pharmacy, the chemist informs me that seasonal coughs and colds, the *grippa*, the flu, are often caused by feet being exposed prematurely in the season — before the earth underfoot has been baked hot and dry by the sun.

'You should be careful, Signora', she warns with friendly concern.

I think of all those bare dimply thighs in mini-skirts in Scotland; pink flesh alighting from buses in sub-zero temperatures. They had cared little enough for the *grippa!*

Little rules, a minefield for foreigners. Today's apparently insignificant demonstration of how different we still are takes me back thirty years to my childhood in northern Italy, where I broke an unwritten law one hot day in early June, and suffered the anguish that only a child can feel when they overstep almost sacred boundaries. That morning I had appeared at school in a sleeveless dress under my starched, white cotton smock — the *grembiule* that all Italian children then wore to school. My schoolfriends had been mortified on my behalf, especially Emmanuela, my best friend, who always tried good-naturedly to initiate me into local ways. It was still not officially summer, they had explained in shocked, censorious ten-year-old voices, and under my smock I was sleeveless. I had felt the flush of hot shame rising in me, for I had not followed the rules. By being uninitiated in provincial codes of behaviour, I had gone far too far.

And, even worse, I realised that day that my mother was more of an outsider than me, and was not to be trusted in such matters, however pure her intentions: 'It's so hot this morning, dear; why don't you put on one of your summer dresses or you'll be uncomfortable' — thus exposing me to the ridicule, or pity, of everyone else. I didn't want to be different then, and I wanted a mamma who did things the way the other mammas did, who knew the rules, who fitted in — who was *Italiana*, and thus would care as deeply about conforming as her ten-year-old Australian daughter.

¢

The Sunday before Italian schools close down for the three-month summer break, the Trevi swimming pool finally reopens. As far as I'm concerned it should have been open weeks ago but Italians, and

Umbrians in particular, have a different attitude to getting wet. I wake the kids early despite it being Sunday, for the place is sure to be jampacked by mid-morning, and I'm hoping to fit in some up-and-down lap swimming before the naturally boundary-less local kids plunge in.

We arrive at five past nine, well supplied with blockout for fair skins, although I've changed colour overnight with the help of some fake tan. I don't care what the fashion is, there's nothing more vulnerable, more naked than the translucent flesh I've inherited from my Irish ancestors among a mass of young golden bodies. I've opted in the last few years for the pale-and-interesting, ozone-aware, black-one-piece look preferred by my peers in Australia but there's a limit, especially on the first day before the sun does its magic on the really white bits.

The pool is so quiet when we arrive that for a moment I wonder if it really is opening day. Then I see the long and lanky limbs of the lifeguard, the *bagnino*, through the bamboo fence. He is shifting umbrella stands around. Reassured, we keep walking past the grey concrete walls of the gym and through the glass doors to the ticket box.

Italian public swimming pools tend to be a lot more glamorous than pools in other countries — this is a council pool, remember, not an upmarket private club. Positioned on a hill above the town, it has a glorious view over the Duomo and bell-tower. There's a well-stocked bar with tables and chairs placed under a tarpaulin strung between the bar and the gym next door. Potted palms are placed at intervals. Naturally there's a lucrative game room for the young and the addicted. The ugly concrete walls behind have been painted a gay yellow and green, and covered with bamboo.

There's another *bagnino* near the front desk. He looks up, and comments, 'You're here early', as he hands over the entry tickets, which are definitely overpriced — but then here there's not the habit

of plunging in for a quick dip, or a half-hour of laps squeezed in before work. Here, if you come to the pool, you come for the day.

'I'm early because it's the first day, so I thought we'd beat the crowds. It's so hot, I bet people can't wait to jump in.'

The *bagnino* gives me an odd look, then smiles, 'But nobody ever comes on the first day. There won't be many people at all! Not many can face the cold water, and anyway there's a bit of a breeze coming up. You can have the pool to yourselves now, if you want to go in.'

A bit of a breeze? The air is oppressively still, at least as far as I can tell. Not a leaf moving in the olive trees.

We change, then set up camp under a striped blue-and-white umbrella near the outdoor shower. I dive straight into the water, and come up tingling all over — but not before donning the obligatory swimming cap that makes me look like a round-faced Irish nun. Why, oh why, are Italians fixated on the smallest, oddest things? 'This is to stop hairs getting into the filters', the *bagnino* had informed me with an air of authority. What about all the other swimming-pool filters all over the world? Wearing one of these little caps is guaranteed to make any woman feel particularly unattractive. The advantage is that it makes me take to the water fast, before I can be spotted by the *bagnino* and his friends; and I swim, swim away the months of cold, the snow, and the rain. I swim, up and down in a straight line, swimming towards something, some goal.

As the minutes pass, a few brave Trevani arrive, mainly bleary-eyed parents with young children who no doubt had been up for hours anyway. Slowly but surely, a few join me in the water. No one else does laps. No doubt I must appear very boring, swimming up and down like that. Through my goggles I stare at the patterns on the bottom of the pool below me and reflect that I've always been hopeless at staying put, but rather am always out to get some-where — even if just to arrive at the end of twenty lengths of the pool. I climb into pools all over the world, and all I do is 'do' laps, trying to

find a straight path to follow, some direction even under water. Up and down and back again until I arrive back at the beginning, right where I started.

In contrast, most Italians are completely anarchic in the water, preferring to play, to splash, to swim underwater in circles, or just to sit on the edge — cap-less, goggle-less and quite beautiful — and people-watch. The Trevani are still relatively down to earth, so that it turns out to be a friendly enough place, where people come to flirt, fool around and play.

I keep swimming up and down, leaving the winter behind me, until suddenly — BOOM! — it sounds like a cannonball has hit the water. I lift my head out, trying to comprehend what on earth is going on. Huge loudspeakers have been placed at the edge of the pool and are blaring out some harsh techno number. It's half-past nine in the morning! The noise cuts out the sound of birdsong and reverberates through the sheet of water. The *bagnino* looks like he's the only one who wants it as he claps his thongs together, and does a solitary dance. I try to keep swimming, but the peace has been shattered by the arrival of screeching synthetic sounds penetrating every nook and cranny in my head. The eleventh commandment, perfect for the end of this millennium, even in this quiet corner of Umbria: where there is peace, let there be *confusione*.

I'm angry, furious even, and swim towards the edge of the pool. Something has to be done, now. The *bagnino* is nearby. Better to try the mild, sweet approach first. I call over to him.

'*Scusi!* Do you think you could turn the music down, please? It sounds like late night in a disco; a bit hard to take at this time of the morning!'

He frowns, shakes his head. 'That's as soft as it goes. And the people want it.'

I look around me. What people? Those two mothers with their toddlers on the other side? The man over there under the umbrella reading a newspaper?

'What people?'

'*Tutti, Signora, tutti* — everyone.'

I force a laugh. 'No, not everyone. Not me.'

He sighs. 'Signora, we can't keep everyone happy.'

I take my time to answer. 'Listen, *ascolta*, how about just keeping it off first thing in the morning? It sounds even louder when the pool is empty! I can even hear it under the water. It must cost a lot of money to keep it going for the few of us who come so early.'

He gazes down on me, and I become aware that I must look truly ridiculous in this stupid striped bathing cap, but I'm starting to feel territorial and for a brief moment don't care how I look. I just want the noise to stop.

'It's so beautiful, so peaceful here. If I wanted disco music I'd be lying on one of the pay-beaches at Rimini, not here on a hilltop in Umbria! Can't you consider just starting the day without it?' As I tread water I call out, 'People can always put on a Walkman or bring a radio if they can't stand the sound of the swallows or the splash of water for an hour or two!'

He laughs sarcastically, as if I don't understand anything. A woman walks towards him. She is Zoe, a young woman from Berlin, a set designer and part-time Trevana. Unbelievably, she comes to my rescue, 'She's right. I can't hear myself think! Can't you turn that thing down — or OFF?'

The *bagnino* is getting nervous, for he's outnumbered now. 'But the people like it!'

'But the people aren't here now. There's just a few of us, and we hate it!'

I swim back, happy that I'm not alone.

But by the pained expression on his face, it's clear that the *bagnino* doesn't understand either of us. He just doesn't get it. In fact, he feels sorry for us! 'The people' are somewhere else while he's stuck with these marginal, unhappy creatures, quite obviously incapable of

'having fun'. He shakes his head sorrowfully, but does not turn the music down.

I swim a few more laps, then give up. It's useless. I pull myself out of the pool with as much grace as can be mustered, rinse my hair under the cold shower and find a grassy corner as far from the loudspeakers as possible. I put my hands over my ears and try to concentrate on my book. I am furious, and powerless. The Trevi of swallows, of stone walls, church bells, and car horns tooting in the distance is buried under louder, crasser sounds. There's a Pino Daniele song playing, and even though I love his Neapolitan jazz rock, the timing's all wrong. I decide to go home, despite the free morning I'd given myself.

'I'm going!' I grumble to Chiara, who has found some of her classmates. 'Keep your eye on Julian, will you? You'll be OK without me. Ring me when you want to come home.'

She nods, and continues talking with a school friend who has bravely turned up.

I collect my gear and head for the changing room, peel off my costume, shower under hot water and coat my skin with moisturiser, gently kneading the soft white skin of my fleshy stomach and breasts. Not too bad for forty, I decide kindly — so long as I don't compare the quality of my Irish skin with that of twenty-year-old Italians, that is. The problem is that I have a tendency to forget I'm not twenty-something, or even thirty-something, unless confronted with my reflection before a mirror. How different the history of the world would have been without mirrors!

A group of women, laughing and joking, enter the changing room. I glance at them, suddenly aware of the freshly-painted graffiti near the taps in the corner: '*Tutti Albanesi appesi* — Hang all Albanians'. My mood darkens.

On the way out I smile politely at the different face behind the counter, a blonde woman with a pair of Fendi sunglasses to die for.

She calls after me, '*Arrivederci Signora! A domani!* See you tomorrow.'

I hesitate. It's worth another try, after all. Nothing ventured, nothing gained. I turn back, lean on the counter and smile sweetly. 'I'm not sure I'll be back tomorrow. Maybe you really could consider holding off with the loud music for an hour or two in the morning — you know, until the people arrive. It would be good to know that there's a specific time when those of us — and there's a few of us, I'm sure, if they don't stop coming — can have a morning coffee, read the newspaper, swim, talk to our friends without having to shout above the loudspeakers! What do you think?'

She peers through her dark glasses, shrugs, and her red lips slowly curve into a helpless smile. She emits a sound which is as quintessentially Latin, as non-committal, as open-to-all-eventualities and simultaneously as fatalistic as those cunning gods of antiquity could ever have invented:

'*Boh!*'

Ah, ha. So that's it, then. I know exactly what she means, and I know there's no answer. Just you try standing up against two thousand years of 'Who knows, maybe yes, maybe no, it's not my problem'.

I throw the wet towel on the back seat and drive down the hill, stopping briefly at the tobacconist's to pick up the photos of the opening of Costanzo's chapel. In the shop the woman gasps, her expression caught somewhere between amazement and horror.

'Signora Virginia! Your hair is still damp — you'll catch a cold!'

I attempt a smile, but it comes out crooked. Patience! 'I know. I've just come from the pool.'

'Already! So early in the season. *Che corraggio!* how courageous! But be careful, you never know.'

'Of course, Signora, I will. Truly. But it's 30 degrees out there.'

'*Si, si*, but there are air currents. You can't be too careful.' She gives me a motherly smile, and hands me the photos.

I place the money in her hand, step out onto Via Roma and take the photos from the envelope. Damn! This is not my day! Another cosmic trick. *Che fregatura!* Chiara had been taking photos of her school friends again, and somehow they are superimposed onto all the snaps of the chapel. My faithful, battleworn Olympus must have got stuck. That had been a day never to return, an important day in the history of the house. We'll never repeat that moment when we — or rather, the architect, Geppino and Giancarlo — had broken through the rocks and begun releasing the compacted earth behind.

Why can't Chiara just leave my things alone?

Back at the Millhouse, I await their arrival back from the pool. As soon as Chiara walks through the door I confront her with my anger and frustration. 'Who pays for this, how many out-of-focus snaps of your friends do we really need, why can't you leave my camera alone, or at least ask me?'

'I don't know what you're so angry about!' she retorts. 'You're exaggerating! Most of the other photos look OK. It's just those five of papa and the others up at the chapel that got mixed up with my friends' upside-down faces.'

Something clicks. I hesitate. 'That's not the point, Chiara', I state emphatically, then spread all the photos across the tabletop. It's true, after all. The rest of the roll — the inside of the house, the day-trip to Urbino — is fine, give or take a few light problems. And then I look at the images again as if for the first time. It's odd. What I'm looking at are a number of ghost-like heads, upside-down, superimposed over other shots of the chapel door — like trapped spirits escaping. Strange coincidence, to say the least, for legend says that the holy man had been decapitated right there. My heart misses a beat. Too many connections, coincidences, which seem quite absurd, or far too obvious. Too literal. What's going on?

I don't mention anything to Chiara, although she notices my change of mood, and sensibly sneaks off to listen to music in her

room. I put the photos slowly back in the envelope, remembering back to that day last January when I'd picked up the newspaper to read 'It's St Costanzo's day'. Another coincidence? My heart is missing beats again, now as then.

I stand in the middle of the kitchen, not knowing what to do. I feel confused. I know, I'll ring Aurora. But when I dial the number no one answers. Then I try ringing Rodney. He'll understand. Again, no one is home, and I don't want to leave a message on the answering machine. Should I ring Giancarlo in Rome? I decide against it; his secretary will only repeat that he's at a meeting.

I go to my desk, switch on the computer, and begin writing. What should I make of this? I feel an intense need to empty myself. I drum my fingers on the leather desktop. Time passes, and my heart finds its right rhythm. Nothing has actually happened, after all, I tell myself. Like most artists I'm far too ready to find connections, for the creative act is one of constant threading and intertwining, a professional defect. I'm just doing my job a little too enthusiastically. But I can't help feeling somewhat disoriented, as if I'm immersed in something bigger than I am. I hesitate a minute, ring Aurora's number again. She's just come in, so I tell her what's 'happened'. She says nothing, but is listening intently.

'All that business about truth being stranger than fiction', she says slowly, as if weighing each word, then adds, 'But, *attenzione*, don't tell too many people'.

'Why not? '

'*Scaramanzia*, tempting fate, perhaps. Deep down, I think we're all a bit superstitious, don't you? And for heaven's sake, don't write it in your book. Ever.'

I giggle nervously. 'I was just putting it on the computer, actually, if you want to know the truth–'

Her tone is disapproving. 'I see. That machine plays too big a part in your life, if you ask me. I don't know, you artists, you all live too

much in your heads! But I sincerely hope you don't imagine putting it in your book, or diary or whatever it is! Photos of disembodied heads and upside-down to boot! No one will ever believe you!'

'You don't think so? I wonder?' I pause, 'But you know, Aurora, I don't think that concerns me. I mean, I'm not out to convince people of anything, am I? I'm just telling a story, more or less. Really.'

'Oh, really?'

'You sound sceptical.'

'You don't say! But that's not it, not exactly. Concerned for you, maybe. I always worry about my friends, you know that. Like a mamma, remember! And you have to admit it is a strange story; and we know nothing of the forces around us, do we? Or the forces within us. How do you say in English — truth is stranger than fiction? And are you really telling the truth when you say you don't need to be believed?'

'Really and truly, cross my heart!'

'Hmm. *Vedremmo*, we'll see.'

We make plans to meet in the evening for a gelato, once the temperature has cooled down.

'*Ciao*, Aurora, and thanks.'

I replace the phone on the hook, and turn my attention back to the computer; suddenly everything feels flat and empty. Perhaps Aurora is right, and I am being foolish. I pick up the envelope and flick through the photos one more time, while reflecting on Aurora's words. She's right, I suppose, about knowing nothing of the forces around me, if there are such things. These are the moments I must keep my feet on the ground, the moments when I sense other times co-existing.

My head's splitting. I turn off the computer, go into the bedroom and curl up on the bed. Even I will respect siesta time today. I close my eyes and dream of Costanzo, who is definitely displaying a mischievous side.

§

For three weeks attention is focused on Spoleto, the gateway to the eastern part of Umbria and home to the Festival dei Due Mondi (the Festival of the Two Worlds), which starts on the 25th with a major concert in the cathedral. It coincides with the blooming of thousands of sunflowers along the Flaminia, so that the short drive from Trevi to Spoleto is as visually arresting as any image I might see at the actual festival.

I love the feeling around festival time, and often spend late afternoons with friends at the Tric-Trac Bar, in Spoleto's Piazza del Duomo. Such moments make me feel that so long as there is life in the piazza Italy will never lose its charm. We chat, people-watch. I often see the famous founder of the festival, Giancarlo Menotti, with his son, Francis. They are usually surrounded by a gaggle of imposing, bejewelled women who create a seemingly impenetrable wall around the maestro, fluttering like nervous butterflies. He walks slowly, frailer than last time I saw him at dinner in Scotland, where he spends much of the year. He is, after all, in his late eighties, but not about to give up his considerable power.

A chamber group is playing on the other side of the square, and soft lights are switched on so that everything is discreetly floodlit. The cathedral containing Fra Filippo Lippi's frescoes shimmers behind a foreground of sparkling, well-heeled Spoletini and their international guests, like angels in an earthly paradise. Festival-goers are discussing this year's programme, internal politics, and where to go for dinner. Voices rise, drop again between the *squillo*, the shrilling, of the obligatory cellular phones. It's easy to sense the flip side of provincial jealousies and power games — but I push all that away. I want just this perfect surface, for the piazza is one I love deeply, despite it being so cold, so forlorn and such a wind trap for much of the year. Yet in summer it glows.

Spoleto Festival projects a relaxed, cosmopolitan image perfectly in tune with the pace of the town, although the locals say they get fed

up with the tourist takeover. Yet deep down most Spoletini are proud of the event, and would miss having their habits shaken about for a few weeks of the year; they would miss seeing the likes of Joachim Cortes and Luciano Pavarotti stepping out among them. Although predominantly inward-looking and provincial, over the centuries the city of Spoleto has been constantly visited by pilgrims, writers, explorers, painters and poets en route from Assisi to Rome: the likes of the romantic painter Elisabeth Vigée Le Brun, J. M. W. Turner and Percy Bysshe Shelley, who thought Spoleto the most romantic city he had ever laid eyes on. Others disagreed. John Ruskin, for example, visited Spoleto in 1841 and found it a disappointing place — but then he was ill with fever and arrived on a windy day, which quite brutally transforms this one-time Duchy into a lonely, end-of-the-line sort of place.

One of the big hits at this year's festival turns out to be the Australian male dance group called the Tap Dogs, originally from Newcastle, who exude an overwhelming masculine vitality that has the Italian girls swooning in their seats. It is suddenly very chic to be Australian.

July

ALL OVER ITALY the struggle against mindless noise rages on.

Daily battles are fought on beaches, in the piazzas, and at night in the narrow streets and discos; anyone strange enough to find it bothersome is observed with deep suspicion. Suddenly, to my dismay, I've become one of them. But it's not just a few eccentric foreigners who find noise pollution unbearable — this summer it's a major topic in the newspapers and among opinion-makers.

Theories have been put forward as to why the 'cult of no-limits' has such a following (including that the constant beat of drums recalls a mother's heartbeat inside the womb). In Italy split-your-eardrums noise is not confined to raves or discos — you'll find it on the beach, at your local pool, at noon as much as at midnight.

Although we Australians have earned our reputation as a rowdy lot, I need my boundaries between quiet and not quiet, between a peaceful morning and a party — between rest and play, funda-mentally. And here, sometimes, it's as if my mind is being taken over by sounds without context — and it all jars so violently with the harmonious nature of the Umbrian landscape. It is so out of context, after all.

I read in one newspaper that newborns hate loud noises, whereas older children often display a natural dislike of boundaries, loving to shout, to be in the midst of confusion, to test the limits and joyously

invade adult space and time. But what about when one actually comes of age and still doesn't realise how invasive such noise can be? Is it because most young adults still live with their parents in Italy, where perhaps they never have real private space, so don't want anyone else to have any? Are they taking it out on the rest of us, years later?

Whatever the reasons, there's a lot of strong emotion floating around Trevi about the 'Noise'. People living near the Trevi pool have begun to complain — loudly. Even if I still feel like a *strega*, a witch, as I repeat my request every morning that the sound be turned down lest my eardrums split while I am lap swimming, I'm revelling in the sensation that a large minority is finding its voice, whatever Marco, the now-deeply-tanned lifeguard, might say — for he never fails to inform me that I'm the only one who complains, while everyone else loves it.

'*Solo lei, Signora, solo lei*', he complains whenever he sees me, as if to say, 'Just who do you think you are, coming here from far away and telling me to turn the volume down! *Stranieri!*'

The problem is, when I lose my temper, I forget all that business about not really belonging.

<p style="text-align:center">ℊ</p>

Graziano's mother dies, after years of illness and pain. She's not old, but has been sick from her early forties — in and out of hospital, constantly subjected to this or that treatment. The rest of the family have suffered with her, year after year. Graziano and his brother ended up staying close to home. Graziano, for one, would undoubtedly have encountered more success in the theatre world had he left Umbria, but he chose to stay.

Chiara and I go along to the funeral, despite never having met her, for Graziano asks us to be there.

It is held at 4 o'clock in the afternoon. The day is oppressively hot.

<p style="text-align:center">208</p>

Steam rises from the bitumen; yet, despite the heat, the coffin is carried by family members from the house to the church, followed by a silent procession of friends and relatives. We follow the crowd inside; there are hundreds of mourners. All Borgo Trevi must be here. Great wreaths of flowers are being placed around the coffin.

We stand at the back by a column, and I can just make out, way down in the front row, Graziano's white-shirted back, bathed in sweat, grief-stricken, tense from holding in pain. I have no handkerchief, and unexpectedly find myself moved, and taste the salty tears running down my face. A woman passes me a tissue, which is immediately drenched in tears.

Why is this happening to me? I hear the priest's voice reciting the funeral prayers, the soporific slow chant of the crowd, and observe the fluttering of the women's fans in the hot, still air. The voice of the priest drones on and on, like a spell. He is talking about the gift of being *madre e sposa*, a mother and wife. His voice is like a fly buzzing in my ear and I wish I could flick it away. I begin to wonder if he actually knew Graziano's mother, for if he did how could he talk about her like this? How is it that so many priests have come to possess the same timbre of voice, intonation, total lack of human expression? He goes on and on about the exultation of suffering, of lessons to be learnt, all the while inciting us not to forget the suffering, the sacrifice, of Jesus on the Cross. My head starts to ache. I can feel anger welling up, knots forming on the inside — perhaps turning on myself for failing to cross this unfolding cultural divide — or for understanding too well. I hesitate. Is there something I can't grasp, some nuance in the language that might explain the priest's apparent coldness? Is my command of Italian letting me down?

My spirit rebels that a lifetime could be reduced to this limited description, this mumbling of clichés. I feel fiercely protective of Graziano, who deserves so much more, for it seems there is no recognition that the suffering and the people are real, that this

moment also defines a life, becomes a crucial part of the memory of who she had been. She will also be remembered for this. It seems a betrayal, but perhaps I am giving too much importance to words. Italians often say that we English-speakers do.

My heart hardens a little more against a church that could do this in the name of love. Here and now I never want to hear another priest, for I do not belong here. Tears continue to trickle from my eyes hidden behind dark glasses, while the air is full of dignified sorrow. A voice rises within me and asks, insists, 'Can't you just go along with things?'

The service is nearly over. An old lady faints in the unbearable heat and is carried outside. The priest begins circling the coffin, swinging incense burners that emit puffs of ancient, heady smells, of musk and myrrh, as if releasing pure spirit. A group of women shuffles towards the altar, and, like a choreography, in unison their heavy arms lift the great wreaths from the shiny parquet floor. The women move towards the door and are immediately followed by the silent crowd. A few close friends remain in the church and surround Graziano, his brother and father, kissing and embracing them. Graziano's face is mask-like, twisted in pain. Yet he manages to nod and thank each one for their words.

Once outside, the coffin is placed in the hearse. The procession then begins winding its way through the township of Borgo Trevi, under the Flaminia bypass and towards the cemetery a kilometre or so away. Chiara and I walk along silently, arm-in-arm. I feel relief once the oppressive atmosphere of the church is behind us and we leave the narrow streets and move towards the cemetery. The heat hangs in a haze about us, but the evening light is clear and casts deep shadows across the fields where, until a few weeks ago, sunflowers dazzled with their golden glow. Chiming bells from the cemetery peel out across the countryside, like sweet soul music wrapping itself around the cold, hard core of my heart. Way up front, we see the flower-carriers as they

enter the high cemetery walls. I'm so thankful Chiara is with me, or I with her, hearing myself tell her that when I die I don't want any priests seeing me off; just beautiful music, green grass, blue sky above and lots of jokes about my foibles. She squeezes my arm. 'Oh Mamma, you're such a pagan deep deep down, aren't you?'

As we all cram into the cemetery I get stuck in a corner, not quite sure what's going on. I suppose everyone wants to say a last goodbye as the coffin is lowered, but we stand back, never having known her. Chiara and I quietly leave, among some other mourners making their way back to their automobiles. How sensible the Irish are at times like these with their whiskey, their fond remembering, and their wakes. We could do with a stiff drink, I reflect.

Back at the Millhouse, Giancarlo asks me how it went. My eyes fill with unexpected tears again; I brush them away impatiently. 'Oh Giancarlo, it was all wrong! The priest let them down so badly — he was so cold, so formal. There was nothing about her, her life — nothing! Just all this stereotypic stuff about having been a good mamma, a good wife. She no doubt was, poor woman, but she was many other things too. Surely! I never want to see another damn priest, as long as I live!' Then I remember the wonderful, brave friends we had in Brazil who were also priests, and lower my voice, 'Well, at least not these sort of priests, anyway. God forbid that I should die here and have to go through all that.'

Giancarlo looks at me scornfully, and crosses his arms. 'As usual, you are so ungenerous. What do you expect? Don't you understand it's just tradition?'

Sometimes Australia feels like Mars, or Venus, or Saturn. Light years away. I stare back at him.

'Ungenerous! Well thank you! And what exactly do you mean by "just tradition"?'

'Don't you understand some things are just like that?'

'And don't you understand these are real people? That's why I'm

so shocked, if you want to know. I happen to care about Graziano, even if we haven't been friends for long, and that service was a betrayal!' I hear my voice rising. It is better not to talk about this. Dangerous territory. There's no point, and I'll never learn to just let things be. Cultural differences. We'll never see eye to eye, even if we came from the same country, I think bitterly. It is beyond my grasp why, despite Mediterranean warmth, expansiveness and constant flouting of rules and regulations, the average lively Italian could accept such impersonal sterility, such coldheartedness. I didn't get it, couldn't get it. It went against the grain. Just tradition!

All evening, at the dinner table with our part-time neighbours, Ugo and Ute, I avoid talking to Giancarlo, who doesn't like these outbursts of spontaneous feeling. I feel like the enemy, casting bad spells, and no amount of good food or wine can make it better.

Yet, on reflection, not everything can be explained away as a 'cultural difference'. I remember the story of a friend of mine, an Italian, who could not come to terms with the denial she saw in her own situation, which went something like this:

Once upon a time, in another place where the sun bleached everything white from April till October, there was a family of two brothers and two sisters. One day the younger sister died after a long illness; she was grown up, had moved to another, bigger city, and after some years began to sicken.

The remaining three decided that it would be wiser not to tell their elderly papa, for the shock might well kill him.

'But he has a right to know!' protested the wife of the older brother, even though she knew it would be better to say nothing. But the words came out, inevitably.

They turned towards her. 'Papa is old, and can't travel that far any more to visit.'

'Maybe, but that's not the point, is it? He needs to mourn.'

'*Cara*, these are *affari nostri* — it's really none of your business. Papa need never know. How can we tell him and cause him so much pain? It might kill him.'

Inside, the wife rebelled. 'But she was his daughter. He loved her! You must let him grieve with you.' She stared at her husband, adding, 'He's not a baby'.

They all stared back at her, not unkindly.

A long time passed.

Years later, when the old man asked how his daughter was — for he had known that she was ill all along, they told him her health was much the same, *cosi, cosi*.

'Don't worry, Papa, when it's not so hot, when it's not so cold, when Christmas is over, before the new year, after Easter, after summer we'll go and visit her. Soon.'

Days came and turned into dark nights, summers to burnished autumns, and all the while the old man grew older and waited.

He asked less and less about his girl whom he never saw, the daughter who never telephoned, who never asked for him to visit her, who had almost ceased to exist in his memory.

Somewhere deep inside he knew each time his children hid the truth from him, to save him pain, so he tried to forget. He sat and waited — suspended in time, in bittersweet memories. Sometimes when he forgot not to think, he caught himself wondering what it had all been for, and with a great pang in his heart, listened to the chirping and calling of the children playing in the narrow streets down below.

g

Our neighbour, Matilde Gasparini, is back in hospital, having a series of check-ups. Giuseppe Gasparini is well fed by his daughters, but you just have to look at him to see he misses Matilde terribly. He pops in every so often with bottles of cold-pressed oil, fava beans and capers

from his orchard. Early in the morning, while most of Trevi is still asleep, Giancarlo and he are already up on the hillside discussing gardening matters. They both have the habit of rising at the crack of dawn to tend their beloved vegetables. All this tender loving care means that by mid-July we have a bumper crop of zucchini, lettuces, endives and rocket spread out on little patches under the olive trees. But Giancarlo's pride and joy are the tomato plants, already heavy with fruit, especially the San Marzano variety. These are perfect for pasta sauces — either cooked or fresh with basil.

During the summer I tend to sleep a bit later in the mornings, not having school timetables to respect. This morning I wake up even later than usual — around 9 — throw on a kimono and head for the kitchen, for coffee. Giancarlo is there already, reading the newspaper.

He looks up. 'I've been up in the garden since 5 o'clock. It's starting to get hot now.'

I yawn. 'Why don't you try to go back to bed for an hour or so? You must be tired — we didn't get to bed till after one.'

'No, not yet. Later, after lunch I'll have a siesta. I want to try something first.'

'Something? What exactly?' I take the espresso machine from the stove and pour some coffee into my cup. 'You want a drop?'

He nods. 'Just a little. You know, I want to try drying some of my tomatoes. We've got such a crop. It's simple. Mamma used to do it when I was little, after the war. Sun-drying. I was talking about it to old Giuseppe Gasparini this morning, but he says we're too far north. I think there's enough sun here, don't you?'

'You'd think so. Still, old Giuseppe should know what he's talking about–'

'Yes, but Umbrians don't have the tradition of sun-drying behind them, do they? They tend to stick to what they know.'

That is true enough. 'Well, it's probably at least worth a try', I agree. 'Nothing ventured–'

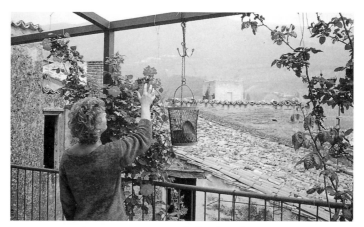

Maria Pia gathering some extra petals for the Infiorata. [M. Falcinelli]

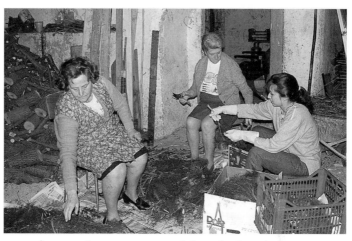

Feast of Corpus Christi: preparation of plants for the Infiorata.

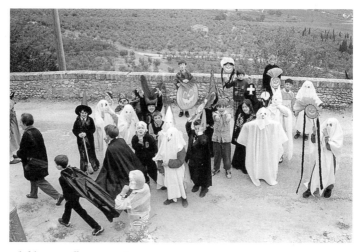

Children's Halloween party, Trevi.

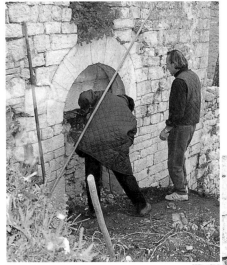

Geppino and the architect checking out the walled-in entry to St Costanzo's chapel.

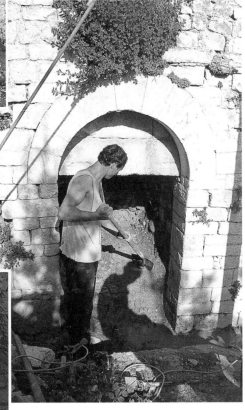

Opening the doorway of St Costanzo's chapel.

Julian inside the chapel.

Chiara sheltering under the jasmine by the front doorway.

As close as I'll ever get to home. [Patricia Clough]

ALL SOULS SHOE BOX, *installation details.* [Armando Gregori]

Setting up the FIELD OF LEAVES *installation in Perugia during the earthquake.*
[Ryan McCluskey]

'Exactly. I've already picked a couple of baskets of the best, and I've laid out some of those slatted wooden crates — you know, the ones for storing olives. They'll do the trick. The air passes through them. And I've been thinking, with the worst tomatoes, I'll just make the everyday sauces.'

'Mmm. Sounds wonderful.' I sip my coffee slowly. I know what this means. Giancarlo will be wanting help while I've been planning a morning in the studio.

I gaze out the kitchen window, like I do every time I sit here. 'You want some help, I suppose?'

'Just with cutting up the tomatoes, maybe. It'll only take an hour or so.'

This Italian devotion to preparing food is awe-inspiring — eternal, atavistic — and Giancarlo is a living testament to that. And to think, before we came here, I had never really believed him when he'd say that all he really wanted was a bit of land to grow vegetables.

I stand up. 'Just let me go and shower. Then I'll come.'

I stay under the streaming water for ages. Oh well, there goes my morning! Art or life, life or art. There's always this tension. But what Giancarlo is doing is also an art, and a highly useful one at that, with life, Italian style, threaded through it. And when he's around I tend to go along with things anyway, as really we have precious little time together.

As I wash the night away, I think about all his childhood stories of life down south near Naples. It might seem odd to outsiders, but so many of them have to do with tomatoes.

At his parents' house there's still a wonderful photo in a silver frame of his family out in the tomato fields. It must have been taken in the late 1940s, when Giancarlo was still a toddler and the smallest of the five children in the photo. He looks a bit like Chiara did as a small child, with a mass of curls crowning a cherub face. He stands in the foreground, slapbang in the middle, clutching his grandmother's hand. She stares out from above and slightly behind,

thin after the war years, severe yet gentle-looking. Three other women stand by her. One is Giancarlo's mother, Maria, who must have been in her thirties. She appears a little fleshier than the others, the only one not dressed in black, and attempts a smile. It must have been hard to feel happy then: her family had lost most of their possessions during the war. Behind the women, standing stiffly before a wooden fence, are two thin-faced men in white cotton shirts. They have positioned themselves well apart, as if wanting to separate themselves from the womenfolk.

It looks like they're all in the midst of a luscious tomato patch, and if the camera lens could just stretch a bit further, Vesuvius would appear, a smoky hint of itself in the background, simultaneously tempting and threatening.

It's an image that is so raw, so essential. It belongs to another time when there was nothing superfluous — just sun, thin, hardworking bodies and the tomato plants taking root again, like the very people themselves after the upheavals of war.

Over the years Giancarlo has told me more than once how important the tomato fruit has been to his family and to all the families in the south. Sometimes I imagine their veins run with the juices of San Marzano tomatoes rather than the red blood of more northern people.

In Giancarlo's childhood home the kitchen was the centre of all human interactions. There the women spent most of their time, major decisions were made and visiting friends were invited to sit at the kitchen table rather than in the sitting room. Life revolved around cooking and eating. And the heart of that cooking was, and is, the tomato plant, so that in a way the tomato is the bright red, fleshy core of the many little towns spread throughout the region. Like a big juicy heart, the nectar of the Neapolitans.

Fifty years have passed since then, and we have gone almost full circle.

To reach the stage of drying and turning them into *pomodori secchi*, sun-dried tomatoes, Giancarlo has first planted around fifty San Marzanos, lovingly watered the roots whenever the soil dried out — which is nearly every day on our slope — and discarded unwanted branches, the so-called *feminelle*. After just two months the plants are laden with fruit, and he's a proud man, for his moment of glory has arrived.

I dry my hair; put on tracksuit pants splattered with paint, a singlet top and a wide-brimmed hat; and go up onto the terrace. Giancarlo sits at a table on the terrace, choosing which tomatoes will be dried, which boiled and peeled to make *pelati*, bottled tomatoes, and which will be blended for the *passata*, the sauce.

He glances up. 'It's a pity Italian families are getting so small. You need a gang to do all of this.'

I laugh. 'Tough! You'll never get Chiara up here, or Julian, for that matter. Anyway, it's hardly worth worrying about, just for two unwilling workers.'

'*Si, si.* I know.' He frowns, holds a tomato in his hand and stares at it closely, like a surgeon. 'So, this one — for boiling, or for drying?'

I sit down on the wrought-iron seats brought over from Scotland. 'You tell me.'

'For drying.' He puts it on the table, alongside another twenty or so others. They look so plump, so juicy.

'Did you bring a knife?'

'No, I never thought–'

He lays out the fruit in a line before him. 'I knew you wouldn't. Never mind, I came prepared.' He picks up a shiny kitchen knife lying in the corner; I hadn't noticed it till then, although the blade glistens in the morning light.

He leans back in the chair. 'Now, in the disappearing world of the *contadini*, my oldest daughter would be sitting to my right. Let's say that's Chiara — an unlikely event, I know! She would cut the chosen

fruit in two. And you, supervising her, would then take each half and quarter the ones to be used for *pelati*–'

'Like some sort of pre-industrial production line, I suppose.'

He pauses a second, glances up at me, 'Exactly.'

'But now?'

'Ah, now–' He rests his chin in his hands a while, and stares at me, expressionless, as if his thoughts had gone off in another direction; then shrugs, and begins chopping again, a half-smile still upon his lips.

<div align="center">ℊ</div>

We adopt a stray dog, and christen him Hot Dog. Julian declares he must have a surname and chooses Costanzo, after our very own live-in saint. Really it was Hot Dog Costanzo who adopted us by just turning up one day and steadfastly refusing to budge. The vet down in Borgo Trevi told me she thought he might have belonged to the people who had the lease on the swimming pool last year and had run away with all the money to Mexico.

Hot Dog turns out to be the only dog I've ever met who never barks, and he adores us unconditionally. I think he's had a rough time in the past. One day he manages to creep through the makeshift barrier on the garden path and dig another great dusty hole in the new patch of Giancarlo's thriving radicchio plants. This is a serious crime. I immediately buy new seedlings, far smaller than the others but I hope Giancarlo won't notice the difference. Then I search for an old piece of wood to transform into a semi-permanent gate. This must be done before Giancarlo returns on the weekend and discovers Hot Dog's criminal tendencies.

While I'm replanting I remember the resident tortoises — what if Hot Dog finds one of those? They've been here for decades, perhaps centuries, and are a protected species. I decide its imperative that I call the carpenter. The gate must be totally dog-proof, a professional job.

<div align="center">ℊ</div>

July

There has been no rain. The plants will need lots of water from now on — even the agave are looking parched and ragged. But the house is refreshingly cool inside. All that rock really does the trick. We spend hours lying on the sofas listening to music while a soft breeze rustles through the olive groves. And every evening, the red sun sets like a great juicy tomato over Montefalco, just as it did summers back when we first stepped into the Millhouse.

It is good to rest inside, to have a roof over our heads; to gaze up comfortably at the ancient tiles supported by massive chestnut beams — as if everything, finally, is in its right place.

August

AUGUST IS TRADITIONALLY the month of siestas, for *dolce far niente*, for pleasant idleness, followed by long evenings sitting in the piazza sipping cool drinks. The hills around us are parched, bleached of colour, for there has been no rain for weeks. The only time I feel truly alive, truly awake, is early in the morning when I jump into the cold water up at the swimming pool. The music is still loud enough to shatter eardrums and Marco-the-lifeguard still pouts and sneers at me as I pull myself from the water after forty lengths, but I'm putting fitness before principles. After that, it's indoors till evening. In the garden, scorched plants wilt against the rocks. All the greenery has turned brown, except in the courtyard where the geraniums, protected by an overhead vine, continue to flower.

After my morning swim I stop in the piazza for essential supplies — fresh bread, ricotta, pecorino and prosciutto — and am home by 10.30 or 11, by which time the sun is already fierce. The Millhouse is wonderfully cool and relaxing inside. Julian is usually just waking up, like the rest of Trevi's children, while Chiara has already disappeared with her friends.

Most days I head to the studio where it is cool enough to work, and remains so all summer. In fact, my studio is the best place to be! I've fallen into a routine at last, which is essential if I'm to 'get somewhere' with my work. It's so good to smell paint, smudge

pastels, and push my pencil deep into paper again. I work with the great wooden doors open to let in the light of late morning, bare feet cool against the ancient brick floor. Sometimes neighbours pass along the road, chatting quietly, taking their dogs for walks; some peer in. Unlike years ago in my Roman studio I quite like it now, even when I'm working, for it makes me feel I live in a very human place, despite the sweeping vistas and the sense of more-than-human space.

About 11 o'clock each morning, Monday to Saturday, the postman, the *postino*, passes on his *motorino*. Despite email, the *posta eletronica* — a lifeline on our Trevi 'island' — I still love snail-mail letters. I don't write enough myself, and am tempted to post off bundles of 'Life in Trevi' circulars to friends just to stay in touch. There are good days when it doesn't matter if mail arrives or not; others when the *postino* beeps cheerfully and I run outside to take the cherished letters from his hands — dispatches from friends in faraway places. I sit on a log against the wall and soak up the news, basking in the sun and in the affection written between the lines. This is soul-food. Of course there are bad days too, when I await the postman and he drives straight past — then I have a nagging feeling that all efforts to stay in touch are quite useless and I'm stuck, forgotten in this farflung outpost.

This morning a letter arrives from my mother, from wintry Ulladulla, south of Sydney. She is brushing up on her Italian, preparing for her visit to Trevi with my father in September. She sends me a *racconto*, a short story, written in her Italian class, which she thinks I might enjoy. I sit on the log and read it to Julian, still pyjama clad, his faced smudged with Nutella — the addictive chocolate paste much loved by Italian children.

IL PICNIC

One Sunday in the long ago spring of 1967 — when we lived in Varese in northern Italy — my husband Hugh decided we should visit Milan for the day.

'*È una bella giornata!*' I exclaimed. 'Let's take the children on a picnic.'

'Where, to Milan?' Hugh looked at me as if I were mad, *pazza*. 'Where on earth will we be able to eat a picnic? Don't be crazy, Pat!'

When we arrived in the city we went first to the galleria to window shop. Just as well it was Sunday and the shops were shut. *Quante belle cose!*

Then we visited La Scala in the nearby piazza. A guide took us around. I loved standing on the stage — so big, big enough for eight hundred performers if I remember well. After that we went to the duomo. A magnificent example of the Gothic style with its white marble facade, towers, turrets and countless statues. After St Peter's in Rome it is, I think, the largest in the world, with space for 40,000 people. As I write this, I wonder if that is possible. Surely they mean 4000!

We took a lift to the rooftop, wandering here and there admiring the view, when all of a sudden I stopped in my tracks.

'Look, look!' I exclaimed to my husband, the children, and anyone else around. 'The perfect picnic spot!'

In a far-off corner, among turrets of winged creatures overlooking that great smoggy city, sat a family with aluminium table, striped deck chairs, a beach umbrella, masses of glorious food and a bottle of vino — having a picnic!

I put the letter down, and put my arm around Julian. 'Are you looking forward to seeing your grandparents, Jules? They'll be coming at the end of next month!'

He rests his head against me; eyes closed in the bright light. 'I'm glad. Otherwise I might forget what they look like. And we can go on our own picnics!'

I smile at him, secretly thinking 'In this heat? Never!'

§

This afternoon Julian makes his first confession — one of the Catholic sacraments. This is a major rite of passage here in Italy. In the last few weeks a group of eight-year-olds has been drilled daily by the priest, and like the other parents I've delivered my son punctually to the Church of San Giovanni at 4 o'clock each afternoon. I am touched by his enthusiastic fervour, and simultaneously appalled at my own rebellious inner child, whom I must force, kicking and screaming, through the great doors of the church, where Giancarlo is already seated with his sister. I see they have thoughtfully saved me a place. Giancarlo waves to me, and I join them.

So much ambivalence. As I sit in the pew watching the children take their places, I try to reason it out. Sure enough, I want my boy to follow his own desires, and for him this is all part of fitting in, but I feel light years away — in fact, I had a hard job escaping from the worst aspects of the Irish version. Yet I must not project my ambivalence onto him. This is my problem, I tell myself sternly, my problem, not his.

I observe Julian sitting third in a row up by the altar. He is scrutinising something on a sheet of paper with the intensity of a map reader.

I feel restless — no, claustrophobic. I pick up the photocopied sheets on the pew besides me. Presumably this is what Julian is reading too.

It begins with the Exam of Conscience, the *Esame di Conscienca*:

IO SONO IL SIGNORE DIO TUO
(I AM THE LORD YOUR GOD)

YOU WILL NOT WORSHIP FALSE GODS

Have I prayed every day, morning and evening? During the day do I remember God? Have I let other things take the place of God? Do I believe in horoscopes, the number thirteen, the number seventeen, black cats, red horns, and horseshoes? Have I been disrespectful

towards the clergy (the pope, bishops, priests, monks and nuns), towards sacred places (the church, the cemetery) or sacred things (sacred vases, robes, the sacraments)?

DO NOT SPEAK THE NAME OF GOD IN VAIN

Have I sworn using the name of God, the Madonna, and the Saints? Have I made unnecessary or false promises? Have I kept my promises to God?

REMEMBER TO HONOUR GOD'S FEASTDAYS

Have I been to mass on Sundays, and attended other important religious events? Did I behave myself during the celebration?

HONOUR YOUR FATHER AND MOTHER

Have I obeyed my parents, teachers, religious instructors, and the priest? Have I been respectful? Have I helped my parents when necessary?

DO NOT KILL

Have I been violent with my brothers, my family? Have I hit them? Have I made fun of them, called them names? Have I been helpful at school, to old people? Have I forgiven those who have offended me? Have I asked forgiveness when I have offended others, been unkind, made a mistake?

DO NOT COMMIT IMPURE ACTS

Have I thought impure things? Have I looked at indecent pictures, bad programmes on television? Have I used swear words, used dirty language with my peers? Have I behaved impurely alone or with my friends?

DO NOT STEAL

Did I take something which doesn't belong to me? Did I destroy the property of others, or ruined something belonging to the community?

DO NOT LIE

Have I told lies to get out of something, or worse still, to lay the blame on others? Did I trick my companions in their games, at school, at home? Did I hide the truth? Have I kept my word?

DO NOT DESIRE THE WOMAN OF ANOTHER

DO NOT DESIRE THE PROPERTY OF ANOTHER

Have I been jealous of other people's things?

I feel distinctly squeamish. Get me out of here — no, get my boy out of here! Black cats, red horns? Acts of impurity? Desiring another's woman? Why do we do this to kids? With this sort of cultural conditioning I'll never mould him into a new man, a man for the third millennium. The odds are most definitely against me, and I don't like it.

I nudge Giancarlo. 'Just how did we end up here, doing this?' He looks at me as if I'm a Martian, and shrugs uncomprehendingly — at me more than the question. I'm being foreign again. My sister-in-law, a sophisticated woman, smiles at me indulgently.

After the readings each child takes it in turn to confess to the priest. When Julian's moment comes I strain to see him in the shadows behind the altar. He appears to be shaking his head a lot, and afterwards tells me the priest went through the entire list of sins.

'I didn't really have much to say, I don't have that many sins', he happily confides in the car as we all head up to the mountain hamlet behind Trevi where there's a celebratory dinner at the pizzeria with all the other parents, aunts, uncles, cousins and grandparents — and the children spend the evening boasting to each other of the presents awaiting them next year when they celebrate their first communion.

§

In summer each little town in Umbria finds a reason to hold its own local festival. Trevi is no exception, with a series of nightly events called Trevi in Piazza. Preparations have been going on for months.

Borgo Trevi, 2 km away, has to have its own little festa too, as do the tiny hamlets of Collechio and Bovara. The sounds of keyboards and accordions churning out middle-of-the-road evergreens float up late at night from the valley. Then on the other side of the valley, across in Montefalco, local events come under the heading of 'The Monte-falchese Summer'.

In Trevi there's something for everyone: folk dancing from China, theatre work by local schoolchildren, classical music on Tuesday evenings in the cloisters of the Pinacoteca, flag-throwers, fire-eaters, street parties and food feasts. One night Chiara's schoolmates put on a repeat performance of a Pirandello piece with the help of Graziano, who is working intensely despite the recent loss of his mother. One of the organisers tells me that each year there's a heated discussion as to whether it would be better to host fewer events in the Trevi festival. The idea, of course, is to raise the general standards, as in nearby Bettona, where high-quality theatre and classical music are presented once a week, rather than less-challenging entertainment nightly. But by the look of it, general consensus in Trevi is for filling up the piazza every night. The big hit each year are the local theatre pieces in Umbrian dialects — humorous, fun entertainment for all — while anything experimental or vaguely challenging is guaranteed, not surprisingly, a very limited public.

We are told that every August there are a couple of not-to-be-missed events on the calendar: the Cena in Piazza, a full dinner served under the stars in the square for around four hundred people, and a week or so later, the follow-up Dolci in Piazza — sweets in the square — where traditionally each family brings along a pudding, cake or biscuits to share with others. In the past huge trestle tables were apparently positioned across the square, laden with homemade *crostate*, *torte*, and *rocciate*, but European community health regulations have put an end to all that; present rulings require that the calorie-laden cakes be made professionally, and so, in recent years, the

women have grown accustomed to arriving armed with money rather than glorious examples of traditional family recipes. It's considered to be a great loss that home baking is no longer acceptable, and we hear lots of muttering that '*Non è come prima*, it's not like it used to be'.

The night of the dinner in the square we make up a group of ten, and book a table at the Pro-Trevi office. Richard and Fiona, two friends visiting from Australia, join us, plus our neighbours Ugo and Ute, Irish Sheila, and a theatre couple from Britain who have recently bought a place on the north side of the hill. We meet up amid a noisy, bustling throng, as the evening coincides with a *mercatino*, a small bric-a-brac fair, in Via Roma. I've never seen Trevi so busy! As we make our way through the crowd I spot another foreign face, that of Anne, unmistakable with her platinum-blonde hair, tall, casual but elegant, standing behind a table laden with porcelain and art deco costume jewellery. A teacher married to an Italian artist, Anne seems to be one of the few full-time Americans in the area. She has been in Umbria since the early 1970s.

'Hi Virginia!' she calls across to me in her soft singsong New York voice, which floats above the babble. I fight my way gently through the sea of suntanned bodies, smart clothes and glossy black hair. Anna told me once that she had started collecting as a hobby, but now sets up at all the local fairs, for it can be quite a money-spinner on a good day. She is one of the organisers of the collectors' *mercatino* down in Pissignano, a little village and castle by the Clitumnus Springs, where she and Afranio live with their two grown children. The Pissignano fair is held on the first Sunday of every month, summer and winter, and has become an important appointment event on the local calendar, although one must get there early, for it's popular with the Romans and the Perugini.

It's a long, long way from New York to little Pissignano, where Anna has now lived longer than any other place. Yet she is still the *Americana*, an outsider who is perhaps granted more liberties than

local women are — for example, being able to have a stall at the fair! For most Italians of her social group, such behaviour would be considered a no-no, although even that has begun to change. 'I know I'll never be completely accepted, as one of them that is, but I can handle that', she once told me. 'Being an outsider has its advantages too, you know. I can push the limits of normal "signora-like" behaviour. I usually meet less resistance and criticism than an Italian woman would.'

Pissignano is like small towns everywhere, as far as Anna's concerned. In small towns there are no secrets — that's the downside. The reassuring aspect for foreigners is that you need never be totally alone if you don't want to. Just open your front door and one of your neighbours will be there to help you. At least that's the way Anna tells me she sees it.

I reach her stall and examine the table before me, sparkling with jet-black necklaces, art-deco brooches and wacky 1960s bracelets.

'You can't take some time out and come to dinner with us?' I ask her.

Anna shakes her head, so that the platinum-blonde hair moves in one soft wave under the street light.

'No. Thanks, but I'll be here till midnight! Lots of people come to look after dinner, and it's already so busy, isn't it — for Trevi, I mean!'

'You're right.' I kiss her on both cheeks. 'I'll be off then. The others are waiting. But I might be back after a few glasses of wine for one of those bracelets!'

I wind my way back to Giancarlo and the others. We reach the medieval square where a gaggle of the more industrious Pro-Trevi members, transformed into surprisingly elegant waiters for the night, are putting the final touches on the tables. Bunches of fresh yellow flowers sit on starched white tablecloths; wine glasses glint in the soft candlelight. It's not what we had been told to expect — we had envisaged something more rustic. This is proving to be a serious attempt at elegance.

As usual there's the same statuesque woman collecting the money as at every other fund-raising event. She's doing it before the dinner begins, which is probably a good idea. She nods when Sheila compliments her on the professional look of the table settings.

'It's a new thing for us. We felt like a change after all these years. *Sai com'è*, you know how it is!'

'Why, how was it before, exactly?' I ask Sheila.

'Much more like the night of the Dolci in Piazza, which you will see next week. Big tables covered in checked paper cloths, you know, those red-and-white ones like you sometimes see in restaurants.'

'Much more a street party — for everyone', added the money-collector, smiling at me.

'Last year there were 330 people', Sheila continues, 'That's a lot of mouths to feed!'

'This year we made it a little more expensive; we're trying to make it more special, more chic. But there have been some complaints already that we've betrayed the original spirit. We'll see!'

We thank her, and are led to our table. I'm secretly disappointed. Like my Australian friends, I was hoping for total immersion in popular culture. We had wanted to be participants in a big collective *festa*, throw ourselves into the spirit of Trevi at its mid-summer best. But my friends think it's wonderful anyway. I can see that all the tables are reserved, however, so I suppose the organisers can be satisfied. Tonight's dinner is to be prepared by Massimo, a Trevano who had learnt to cook in the kitchens of the famous Cocchetto restaurant in the 1960s, and has risen to become head chef at the Senate. His father had been owner of the Cocchetto, a Trevi restaurant that had become one of the most loved in Central Italy. I notice very few children. Chiara and Julian are missing as well, Chiara to hang out at the Bar Chalet over a plate of gelato, Julian to rollerblade with his mates along the *passeggiata*, which, moreover, seems to be a favourite haunt for *innamorati*, Trevi's young lovers.

The date for the dinner coincides with the Night of San Lorenzo, the night of the *stelle cadenti*, the falling stars. Legend has it that on this special night, if you gaze at the heavens long enough, you'll be rewarded with a glimpse of shooting stars plummeting to earth. Here, they're called the tears of San Lorenzo, after yet another martyr and saint. Popular legends say that Lorenzo was decapitated in the year 258, although in the annals of hagiography it is said that he was burnt at the stake — so that the shooting stars are nothing less than the sparks flying from the flames. The scientific explanation is another: all year small meteorites and cosmic dust cross the earth's atmosphere where, on impact, they burn up. Owing to the particular position of the earth and atmospheric conditions in the first days of August the phenomena is simply more visible.

During our dinner in the piazza, however, the stars all stay in place above us, and the night passes by in a haze of good Montefalco wines and cheerful conversation.

Julian arrives on his rollerblades at about 1 a.m., and tells me that he has been sitting in the playground with his friends, waiting for the stars to 'drop' all evening. He pulls impatiently at my jacket. 'We counted five, Mamma, me and Giulio!' he whispers triumphantly, his eyes glowing like two bright stars themselves against the dark brown of his suntanned skin.

Later, from the little balcony at the Millhouse, I stare into the distance, and count two *stelle cadenti* falling over Spoleto. I make a wish, and feel what I can only describe as intense happiness. It is summer, we have new friends, I am working constantly in my new studio, and the time-consuming business of renovating is thankfully over. The children seem perfectly at ease in this environment. My feet are back on the ground, and tonight it feels about as close as I'll ever get to home.

September

THE HEAT CONTINUES. I feel wrapped in it, and begin to imagine winter fires ablaze. And, with September, sudden earth tremors are occurring with alarming frequency; last week constantly for five days and nights, so that we now understand why the builders had insisted on anti-earthquake safety measures during renovations. At sunset the sky appears intense and brooding over Montefalco, with a great purple fireball of a sun spinning in the sky. Numerous porcupines, insects and bats, seemingly seeking refuge indoors, have visited the Millhouse. The other morning I found a baby porcupine that had managed to tangle himself up in a roll of masking tape in my studio; I had quite a task unravelling him, and turning him free again. Do all these earthly creatures sense something strange in the air, I wonder.

Do they know something we don't?

When the earth shudders ominously, the entire length of the Millhouse heaves and sighs like a ship riding the waves, before settling down quite comfortably once again — so far, without a hint of damage.

Surprisingly, I'm not really anxious about this; if anything, I'm overawed by such demonstrations of nature's forces at work. At bedtime, none the less, I've taken to wearing silk pyjamas just in case we ever are forced to make a quick getaway. No one is catching me out! I keep any private fears private, as no one else seems particularly

preoccupied by Gaia's restless shuddering beneath our feet. No one else in our house, that is, except perhaps the porcupines!

I discover that Trevi has always known earthquakes. In fact, we discover it's an area known for quite intense seismic activity. There are records of terrible damage as far back as 365 and 444 AD, which caused the massive reduction of the waters of the Clitumnus River down in the valley; then again in 1496, 1592 and 1689–90. In 1703 there was a bad quake at 1.30 in the morning, which is said to have further diminished the flow of water in the valley, and damaged the facade of the Renaissance basilica known as the Madonna delle Lacrime, just below the Millhouse. There was serious damage all through central Italy that year, and thousands of people died; it finally led to the Pope declaring a moratorium on taxes for the next five years. Earthquakes have occurred with alarming frequency since then, but generally Trevi has suffered less damage than towns such as Norcia, Bevagna and Spoleto.

Looking back, we realise many of those gaping cracks in the walls of the unreconstructed Millhouse could have been earthquake damage. We never thought of that at the time. Still, the building has managed to stand up for six hundred years! Not a bad record, Giancarlo tells me reassuringly.

Today the paper reports that Foligno has had a grand total of sixteen minor tremors in the previous twenty-four hours, registering 4 points on the Mercalli scale (which is only used in Italy) or around 2.5 on the Richter scale, and at Colfiorito, a mere valley and mountain away, terrified locals are sleeping in tents. They speak of a mountain behind the small town of Cesi, near the Umbrian–Marches border, slowly sinking into the ground, causing the earth to heave and shift in compensation. The newspaper says that in Cesi everyone is convinced that over the previous thirty years the mountain has sunk up to 50 metres. They say all these things are linked, that they are bad signs, and protest that no one in officialdom is listening to their warnings.

At the Road of the Mills things are quite calm, a lot calmer than in Cesi. It is fascinating — and only minimally threatening for now — to sense these subterranean vibrations, for each tremor seems to exist in a timeless space, creating a sort of gap between the underworld, the earth and the sky above; a still point where time stops and everything is strangely, momentarily, silent before the earth groans and shudders.

Because of the unseasonable heat, the local pool is still open to the joy of lap swimmers, sunworshippers and schoolchildren who will soon be back in class. And, even better, Marco, Umbria's least-*simpatico* lifeguard, has finally got the sack, so I can lie unharrassed on the lawn by the pool, feeling smug and satisfied that I was right all along. Rumours abound that he beat up his girlfriend, and that she recently spent a night in Foligno Hospital.

The girl at the front desk of the pool nods and smiles when I comment on the friendliness of the new lifeguards.

'*Dio mio, Signora*, My God', she shakes her head, 'you can't imagine what I have been through with him. I treated him so well, fed him whatever he wanted, looked after him as best I could', she shrugs and raises eyes to heaven, beseeching. 'And in the end, he wouldn't do anything — just sit and eat. *Pazienza!* We're much better off without him, don't you think?'

'Yes, I do', I reply, the intense pleasure of vendetta hovering about me.

Everyone else seems cheerier too. No one misses the muzak once the loudspeakers disappear and are replaced with the cheerful sounds of children laughing, splashing water, and birds chirping from treetops. A smaller sound-system is placed near the bar, away from the pool. It beats a crowded beach any day. Sinuous golden-brown bodies bask in the late summer warmth. I still wear my widebrimmed hat and black one-piece, and try not to wish for the smooth, elastic skin of Latin women. If only the summer would never end.

The main topic of conversation by the poolside, in cafes, in shops,

and no doubt along the stretches of beach where *paparazzi* roam in search of prey, is Princess Di and Dodi al Fayed's dramatic annihilation in a Paris tunnel. The Italians hover between awe and scepticism at the British response, and unanimously agree that such outpourings of very public, yet contained, collective grief would be impossible here, in this land of egocentric individualists. As the London crowds grow bigger, and queues to sign the books of condolence longer, I read that the first sightings of Diana's ghost are declared by a tiny smattering of foot-weary mourners, while patiently standing in line for hours to leave their signatures; hallucinating, perhaps, in the very unBritish heat. The tragic princess is said to have been sighted among them, sadfaced, carrying white lilies.

'Aha, I was expecting this', muses a friend up at the pool, massaging coconut oil into skin taut over muscles, *'Non cè mito senza rito'*, which I roughly translate as meaning there can be no myth without a (previous) ritual.

He goes on. 'Those people, they've been doing the ritual for days now, on such a grand scale, while the news of Diana's death has already penetrated to the furthermost nooks and crannies in the world. In the past this entire pre-mythmaking would have taken so long. But now, it can happen overnight! And already someone believes they have seen her ghost! Imagine! It used to take years!'

He chuckles away to himself and adds, 'I don't wish to sound cold-hearted, but you just wait a few more years — they'll be saying she didn't really die, but masterminded all this just to get away from the *paparazzi*, and is snuggling up to Dodi on some forgotten island in the Pacific. Or maybe surviving in splendid isolation atop some Himalayan mountain, or even living in the Amazon with native Indian lepers, to whom she has sacrificed her glamour, beauty and wealth. You just wait and see!'

Towards the middle of the month Chiara and Julian prepare to go back to school, no longer outsiders after three months in the piazza

and by the pool, but reborn as 100% Trevani, with newly-acquired accents and a vast vocabulary of dialect that drives me absolutely crazy — so harsh to my ears, so lacking in poetry, so that even I, loyal as I am, admit I can understand the Tuscan disdain for the speech of the less-refined Umbrians. I catch myself saying, 'I don't want you speaking like that in this house!' where only a few months ago I just wanted them to fit in. I make new house rules so as not to get irritated by the dialect, which represents, after all, assimilation; something that I hoped for so desperately when we first arrived here. Suddenly, that seems light years ago. I declare that English will be spoken at the dinner table, so as to keep those language skills up, but knowing deep down that it's much more to avoid hearing my beautiful, physically-poised Chiara sounding like a drunken peasant.

¶

Over towards Montefalco, the grapes hang richly ripened on the vines, taking on a deep blue-purple typical of the mature fruit. As I walk through the few grapevines established in the valley directly below us, I see that the plants have all recently been stripped by a bunch of sturdy Trevani and Albanian guestworkers. The pickers start at sunrise and finish around 11 a.m. when the heat makes physical labour too uncomfortable, sometimes to reappear after a long siesta, then work through until sunset.

It's a time of great comings-and-goings at the Millhouse. My fifteen-year-old nephew, Ryan, arrives from Sydney. He has saved up the money for the trip himself, which Chiara's Trevi friends find unbelievable. Then Aurora disappears on her annual late-summer, six-week trip to Greece, just one day before my parents, Pat and Hugh, arrive from Ulladulla, via Paris.

The next morning Chiara starts a new school in Foligno. Her time at the middle school in Trevi is already over; here, at the age of fourteen, they are all streamed off into highly specific areas of study.

After much thought, she's decided on the Liceo Linguistico, where the emphasis is on languages — four hours of Latin a week, French and English, and, of course, Italian language and literature. Nearly the same as the Liceo Classico, without the ancient Greek. Perhaps these are the students most likely to keep Italian booksellers from closing down in the next few years.

Chiara is elated to be heading off on the bus at 7.15 a.m. with her friends from the piazza, bound for Foligno, 9 km away. I am less enthusiastic about a school that starts so early six days a week. These are not the hours I like to keep, being quite fond of late nights.

On the first day of school I leave Pat and Hugh sleeping, and drive her up to the piazza at a quarter to seven. We find the square buzzing with activity: the supermarket, bars, cake shop, butchery and newsagent, all set up for the day's trading. Signor Allegretti, Trevi's butcher, tells me he's been up since 4 a.m., while his wife adds that they've been doing it six days a week, fifty-one weeks of the year for the last eleven years. She shrugs, and adds that she wouldn't mind a break — but who would service the town's need for good-quality meat, especially fennel sausages, if they were to go on holidays?

The Allegrettis close for three hours in the middle of the day, then reopen until 8 p.m. And then they have to clean up. It reminds me of the family-centred Italian migrants I've met around the world, such as the Italo-Scots who started with icecream vans, then cafes (much loved by Scots still too young for the pubs), and finally graduated to restaurants. Now, their young nephews and nieces come over from Italy to work during the summer, earning cash as waiters while learning English. These Italians work incredibly hard, often seven days a week, year after year, but are immensely proud of their achievements and richly decorated homes.

Chiara and I head off for the Bar Chalet for *cappuccini* and croissants. Chiara gobbles hers nervously, then pecks me on the cheek,

and with a '*Ciao, Ma*' runs off to join her friends at the bus stop. On my way to the car I notice a few Albanian men sitting around outside the bar, hoping for a day's work. I run into a friend of Vladimir, who had helped me in the garden months back

'Where is Vladimir? I still owe him money for some work he didn't finish, but he disappeared!'

The young man attempts a smile. 'Eh, Signora, the police got him. They sent him home. He's back in Albania, trying to organise his documents so he can come back. He left in a hurry.'

'Oh, *mi dispiace*, I'm sorry to hear that.'

'Me too, Signora. What can we do? He'll be back soon, though. I'll tell him you were asking after him.'

I walk back to the car, thinking that Vladimir could have taught a thing or two to the rest of us, with his soft, gentle ways. Turning, I see Chiara climbing onto the bus. I feel proud of her, standing tall, self-assured, eager to begin this new experience, despite the fact it is her seventh school, counting *scuola materna*, childcare, back in Rome.

I drive back down the hill, feed Hot Dog his mincemeat-and-pasta breakfast, wake Julian up and help him into his jeans, pick up all the new schoolbooks he forgot to put in his bag last night, coax him into eating a little breakfast, before hopping into the car again and zooming up to the *scuola elementare* with him.

Julian's teachers, Clelia, Giuseppina and Gabriella, are all at their desks, welcoming back their pupils, for they follow the same class of children from first to fifth grade, moving up as they do.

I am immensely relieved that school has commenced, for although the summer has drifted by effortlessly enough, three months is a long time to be without a routine. And I desperately need space to get on with my work — my painting, my writing.

I have been invited to take part in an exhibition in Perugia, '*Presenze:* Foreign Artists In Italy', and must complete the work for that, a series of boxes containing 'relics' of the soles of shoes. And for

the next few days I'll be showing Pat and Hugh around, helping them get their bearings.

Then Lucia from the town council has asked me to organise an exhibition of Australian artists living in Umbria for the October festival. I like the idea, and enjoy meeting the other artists, two of whom are new to me. The exhibition is to be held in the cloister of the Pinacoteca, so there's much liaising to do with Rita, the curator of the museum. But that's another story.

And for one marvellous week, I do manage to re-establish a work pattern and an intense connection with visual images returns.

¢

I wake in the night with a jolt.

The Millhouse feels like a boat tossed by stormy waters. The whole place is vibrating, shaking so much it seems we'll all go crashing through the floor. Next to the bed, the wardrobe rattles as if possessed by poltergeists.

I leap from under the bedcovers, aware that somewhere in the background Julian's frightened voice is calling me. Then, just as suddenly, the thumping and shaking subsides, leaving me strangely calm, indifferent. I turn on the light and go in to reassure Julian, but he just stares back sleepily, turns over and begins snoring gently. And that is all I care about too — sleep — so that I won't be overtired in the morning, for there is another busy day ahead. I lie down again, and look at the clock: 2.35 a.m. I close my eyes and pull the blankets back over my head. But I cannot relax. I toss and turn until dawn, wondering if it is only my imagination, or if the earth really continues to rumble in a nervous and menacing manner.

At 7 a.m. my alarm goes off as usual. I throw on an old kimono, pull a comb through unruly curls, then drag myself into the kitchen to make coffee. I feel really tired. I can hear Chiara singing along loudly with the Spice Girls as she showers. Just as the

coffee rises in the espresso, she appears in the doorway, but doesn't mention the night's upheavals. Perhaps she heard nothing. I do not ask.

Within minutes I'm dressed, and we are on our way up the winding road to the piazza and bus stop.

At the bakery the woman shakes her head slowly when I order freshly baked *cornetti*.

'There are none left. They were all bought as soon as they came out of the oven — they didn't even make it round here to the shop! Nobody slept after the earthquake, the *terremoto!* I'm so afraid, my house is old and it won't be able to stand up to other shocks like that.' She wrings her hands. 'Is everything all right down at *casa tua*, your house?'

I stare at her for a moment, then nod numbly, and walk out into the bright late summer light. There are groups of people huddled together talking, the way they always do in the piazza, but suddenly I am aware of many more than is usual at this hour. Chiara and I enter the supermarket, where another nervous group busily discusses the intensity of the shock — 8 on the Mercalli scale (5.5 on the Richter). So my imagination hadn't been playing tricks — it had been quite a shake. And I hadn't even checked the house! Looking around, the realisation dawns that these people, these hardy Umbrians, are truly frightened.

I hide my growing dismay, and decide to go back to the house to ring Giancarlo. Chiara kisses me goodbye, gets on the bus with her friends, but no sooner do I reach the car and put the key in the ignition than there she is before me again, thrusting her schoolbag onto the back seat and shouting, 'The driver says school's cancelled, but we're going to Foligno anyway — to see what's going on! Don't worry, we'll be back in a couple of hours!'

She gives me no time to respond before sliding off into the gaggle of jeans and designer gym-shoes.

I drive back home at snail's pace, looking for cracks in the road, my hands shaking on the steering wheel. Yet everything looks just the same. The olives rustle in the slight breeze; Montefalco still peeps back as the road twists through the fields. But it all feels different, as if suddenly shifted onto a different plane, just like that. It feels dangerous.

Will the house be damaged, I wonder, with cracks hidden behind the beams that hold up the roof? Our roof?

Back home, I run inside to inspect all the damage, brace myself for gaps in the still-newish plaster, wishing all the while that Chiara was here rather than traipsing about under those creaky old buildings in Foligno. What if there were other shocks of that intensity while she was in Foligno? Why couldn't I impose my will, why must my family be scattered over central Italy and Rome at a time like this?

But inside all is perfectly calm, perfectly normal. My eyes creep over the walls and across the wooden beams running the length of the upper building, then scan the skirting boards and sparkling tiles in the kitchen. No damage. At least, nothing I can pick out. Maybe all that money spent on anti-earthquake measures was worth it after all. Then the phone rings.

Giancarlo is on the other end, ringing from his Roman apartment, alarmed after hearing the latest radio reports.

'I nearly choked on my coffee!' His voice bellows down the telephone line, across the hill-towns and valleys separating us. '*Dio Mio!* Are you all right?'

I make light. 'It's nothing, just a jolt. Everything's normal.'

'That's not what it sounds like on the news.'

I reassure him, while feeling once again that my grip on events is tenuous. But looking around me, everything appears as always. Cleopatra the cat curled upon the red velvet sofa; Yugoslav kilims scattered across the floor, gold-and-brown cushions glowing in the thin morning light. A calm, restful place. A refuge, really, I reflect. I tell Giancarlo once again not to worry, we are safe.

The clock says 7.30. Time to wake Julian for school. I open his graffiti-covered door, decorated with the Simpsons, 'Viva Albania', 'Enter at your own peril', and step inside, where I'm temporarily blinded by the morning light. I blink. All the furniture has shifted, the teddy bears on the shelves slumped over, action men in a tumble on the floor; as if all the toys had come alive at midnight, partied, and hadn't got back into place before the clock struck one. And his bookcase! Books everywhere, strewn across the floor. As Julian washes and dresses, we talk of other things. I wait, but he seems to have forgotten everything. So much the better, perhaps. My head is beginning to ache, anyway. Lack of sleep. So much to do. After breakfast, I drive him uptown, feeling tired, irritable, wishing I didn't have to go to Perugia to set up my artwork in a couple of hours, wondering how long till Chiara returns, feeling angry at her, at me. She should not have gone.

Outside the *scuola elementare* a sea of chattering parents congregates, excited children running around, neatly dressed under their smocks, schoolbags gaily tossed aside, and above them, standing on the stairs, the headmaster and teachers. The school will be closed till further notice. Maybe a day, maybe a week. No one knows, but the safety of the building cannot be guaranteed, for there might be some structural damage. All this a week after the long summer holidays finally ended. When are these kids going to learn anything? I stand around in the square feeling foreign, commiserating half-heartedly with other parents.

And then, out of the blue, Chiara reappears. 'We took the next bus home! Mum, you should see things in Foligno! The bell-tower is crooked; there are bits of *coppe* from the roofs all over the roads, and they say the school is badly damaged. People slept in their cars all night, and they say lots of people can't go back into their homes. And there is no school tomorrow or Saturday', she adds, smiling blissfully.

I decide to avoid thinking for a while, and take them both home to Pat and Hugh, now sitting at the breakfast table with Ryan, who is overjoyed that in Italy it is holiday time for his cousins again, although they are all shaken by the night's events.

Too much to do, too many people. I ring Antonio in Foligno to see if he will still be coming to Perugia as agreed. Today I am expected to take my work there for the exhibition — the 'Foreign Artists in Italy' show. Antonio had offered to come along and give me some friendly, professional advice. But his voice is flat when I locate him on the mobile phone.

'*Cara*, I don't think I should move from here this morning. You know our house has got some cracks, and my studio too. We slept in the car last night. Poor Mamma. I am taking her to friends in Bevagna while we check if the damage is serious or not. Let's talk this afternoon'.

I wish him good luck, but have still no inkling of the way his life, and the life of many other Umbri will change in the next few weeks. I feel no more than a passing concern for his family; it does not occur to me that the cracks will prove serious.

Chiara and Ryan offer to come along instead of Antonio and help me set up, while Pat and Hugh decide to take Julian to the museum in Montefalco.

By 10 a.m. we are on the highway, bypassing Foligno, heading along the highway in the direction of Assisi. After a few kilometres I realise how many ambulances, screeching sirens and police cars there are everywhere. Had people been injured in the night? Chiara tunes into the local radio station, Radio Subasio, but it is carrying on with the usual bland drivel, innuendoes, crooners and transnational pop.

As we pass Assisi on our right, at a certain point the road dips dangerously. Chiara grabs my arm. 'Mum, it's another earthquake, isn't it?'

I shake my head, only half-believing myself when I answer that it is just a dip in the road. We're imagining things — I hope. I drive on into Perugia, listening to Chiara and Ryan's banter, their singing along with the radio crooners, soon forgetting the brief moment's fright. We enter the city walls and pass the Perugia Hospital, then proceed towards the pavilion where the exhibition will be held. As I'm parking, a special news bulletin comes over the radio. A voice announces that part of the roof of the upper basilica of St Francis in Assisi, which had stood strong and upright for 700 years, had caved in at 11.40 a.m.

'Mum, that's when we were driving past!'

'So much for a dip in the road', adds Ryan.

My blood goes cold. For a second Chiara and I just stare blankly at each other. The voice says there are no more details yet, but news will be given as it arrives.

I want to pinch myself, wake up from the nightmare. The basilica of St Francis, permanent home to frescoes by many major artists of the late thirteenth and early fourteenth centuries, damaged? The roof fallen in? Not even wars had done that. A treasure trove of frescoes by Cimabue, Lorenzetti, Martini and Giotto, great masters of the early Renaissance, and a priceless source of reference for future artists.

We sit in the car, dumbstruck, awaiting further information. The voice returns, informing that the basilica has stood firm, although several interior vaults have collapsed and it appears that priceless visions of angels and saints, the work of Giotto and Cimabue, have crashed to the floor. I think of Cimabue's portrait of St Francis, which is said to have been painted according to eyewitness reports of what the small man really looked like, and the gravity of this unfolding scenario becomes apparent. Chiara and Ryan are silent as the voice announces that four victims are lying under rubble, fragments of frescoes and roof tiles. They had been checking the structure after last night's quake.

My stomach is churning as it sometimes would back in Belgrade during the war, when everything threatened to crumble around me; it has a habit of doing that when I'm unsure of my footing, of what steps to take and who to trust. The voice on the radio goes on to report that the area from Nocera Umbra, down through Assisi and across to Foligno has been hit, and that some of the roads are closed. I think of Giancarlo in his office in Rome, of us in Perugia and Julian with Pat and Hugh in Montefalco — and I cross my fingers that the house will still be standing. I want to go home, but instead run inside the exhibition hall, looking for someone to talk to.

What should I do? Go back to Trevi? Set up as planned? There are other artists standing around — some Germans, and an Iranian woman. They appear relaxed, unconcerned. Is that because they don't know what's happening, or because they have decided to carry on regardless?

I decide to set up as quickly as I can, for we must get back to Trevi. Ryan helps me lift boxes from the station wagon, and carries them inside. I persuade Chiara to gather up some bags of early autumn leaves from under the oak trees by the building; they'll serve for my floor piece. Sometimes the best solutions are those closest at hand, and for my installations I often rely on what appears as a support at the last minute. Then I set to work feverishly, creating a field of leaves into which I place the wooden cases in a checkerboard fashion, like the Corpus Christi flower carpets of early June. The boxes contain the soles and leather straps of shoes (my own and those of close friends and family) among dried flowers, newspapers, shells, painted footprints, laces, earth and sand — the soles of shoes, entitled in Italian '*I Passi*', The Steps.

I laugh nervously at Chiara, who kneels beside me patting leaves into place. 'If there are any more quakes, the whole thing will start sliding, walking across the shiny floor. Outside the boundaries of my allocated space, my territory!'

'Oh Mum, don't! You're supposed to reassure me!'

Minutes later I thrust a card with the title of my work at one of the assistants and nervously bundle Chiara and Ryan into the car once again. I am terrified of getting stuck midway if the highway is closed. We pass Perugia Hospital again, and get stuck in the confusion of cars going in all directions. The radio voice informs us that Foligno Hospital is being evacuated, which explains all those ambulances everywhere. After twenty minutes or so, we get through.

Once out of town, the Via Flaminia is dotted with police cars and Red Cross vans, interwoven with everyday traffic and with late-summer tourists in fast cars, some of whom are probably unaware of the unfolding drama, caught in some other 'good-time' holiday parallel as they zoom down the *superstrade*, the motorways. Ryan, spread across the back seat, observes them critically.

'They'll realise soon enough that something else is going on, that they'll be getting more holiday thrills than they had bargained for. Unless they just keep driving till they run out of petrol, and don't read the newspapers. Just think, they might never know if they don't speak Italian and are driving when the tremors hit!'

I nod. It's true enough. A million thoughts flood my mind — of children, school, whether Pat and Hugh are worried, whether Trevi has been damaged; then, whether I should have put those autumn leaves around my boxes in the show. Would all those leaves soon be strewn around the exhibition space, crunched underfoot by cynical onlookers, scattered around the room by a trembling earth?

The road is open. We arrive home, and everyone and everything is safe. I set about making prosciutto and mozzarella sandwiches — it is very uncharacteristic of me to seek refuge in food preparation. Pat and Hugh, who arrived a few minutes earlier, tell us that they were in central Montefalco when the second big shake-up occurred.

'You should have seen it!' exclaims Pat, her words tinged with the fear of the morning. 'I was standing in the piazza, looking for the

signs to the museum with those Benozzo Gozzoli frescoes you told me about, when everything began to move — even the lamp-posts were wobbling so much I was sure they'd fall down. I clung to your father. I thought great cracks would appear underfoot and I'd be swallowed up! Then an old woman rushed out of a building, crying, crossing herself as she shouted *'Madonna santa, Madonna!'* She pauses, and adds, 'That should be the end of that, shouldn't it?'

I keep slicing tomatoes. 'I sure hope so.'

The pressure is building up. I am beginning to feel like a volcano. I decide to ring Giancarlo. His secretary passes me on to him with her usual polite *'Buon giorno, Signora'*.

Then Giancarlo begins shouting down the phone at me, *'Che sta succedendo?* What's going on there? I've been trying to ring you for the last hour. No one can get through. Are you all OK?'

I hear myself reassuring him. 'We're fine. The house is fine. We are all together.'

'Shall I come up?'

I pause. 'No, there is no need, really. We don't need the extra weight', I joke.

He doesn't laugh, but tells me that he's been taking anxious phone calls from Washington, Scotland, and a number of close friends in Rome. No one can get through to us. I am touched, but I really need to talk about the basilica in Assisi, and about my doubts concerning the leaves around the boxes.

'Do you think I made a mistake, Giancarlo? I mean, using the leaves? Oh God, maybe I should go back and change it all!'

'Oh listen, you're not thinking straight. Don't be so stupid! Who cares about the leaves, for God's sake? It's best not to go anywhere. Tell me, are there any cracks in the walls? Did anything break?' He hesitates, then adds, 'Just as well we followed all the building regulations'.

'You're telling me. It looks OK. I'll go and check downstairs. I'll

ring you later if there are any problems, or if you can't get through —
about 6 o'clock, OK? And don't worry.'

After lunch Pat and I decide to head uptown to take Julian to
Eraldo, the barber, for an overdue haircut — it's an excuse to hear the
latest. I need to know from the Trevani how serious this is. It's all
new to me. We climb back into the car, and Pat turns to me, 'You're
just like a local, aren't you? You've begun gravitating towards that
square up there just like everyone else rather than turning on the
radio!'

At the barber's the conversation is animated. Chiara and Ryan join
us as we wait for Julian to take his turn. Chiara lays down the law. 'We
mustn't sleep at home tonight, Mamma', she proclaims. 'No one is.
All Trevi is sleeping in cars in the piazza.'

All Trevi sleeping in the piazza? *Santa Madonna!* I take a breath,
then nod cautiously. 'Darling, our house has just been restored. It's so
strong, and it's built right into the rock. We are as safe there as
anywhere.'

Chiara shakes her head knowingly. 'That's not true. Emmanuela's
mamma told me our house was dangerous because it's so old, and
she was born here.' She gives me a withering look, 'I'm not sleeping
there. No way. Let's bring the car up here, please Mum!'

The thought of Ryan, Chiara, Julian, Pat, Hugh and me sleeping
cramped in the two cars in the middle of Trevi is worse than any
earthquake as far as I'm concerned. And what about my *bella figura*?
Do I really want the whole town to know what I look like first thing
in the morning?

Through Eraldo's window I spy Geppino doing his emergency
volunteer work for the volunteer Civil Protection organisation, giving
welcome advice to nervous and worried townspeople. He'll be my ally,
I'm sure. I run out to the *fontanella* and join the animated little group
gathered under the fig tree; for the first time I notice that even in
Trevi the leaves are changing colour. Autumn has arrived, then.

To my relief, Geppino agrees that our house is probably as safe a place to be as anywhere, that we have good reasons to stay put. Chiara looks sceptical, then angry.

'You just don't care', she cries, turning on me.

Irritation sets in. 'I decide, and I decide for all of us! Of course I care.' I stop, count to ten, then add softly, 'Don't make this any harder for me, darling'.

We go back into the barber's, still arguing; Pat tries sticking up for me, while Chiara launches a few more missiles. At a certain point Eraldo, no doubt acutely aware of the lack of a father figure in our menage, intervenes.

He faces Chiara, and kindly advises, 'Listen to your mamma. She's right, poor lady. That mill has not only stood for centuries but on top of that has just been restored.' He pauses as if weighing his words. 'You are safe there', he reassures her, adopting a milder, fatherly tone. 'It's the people in the really old houses in the *centro storico*, the historic centre, who have problems. There will be tents set up for them up near the sports centre. But you stay put with mamma.'

Chiara glares at him, but says no more. Friction remains high between us. By now, I am so tired, apprehensive, and secretly fearing other shakes.

Back at the Millhouse Chiara and Ryan ask me if, after dinner, they can go up to the piazza to see their friends, all of whom will be sleeping in cars, too afraid, and too sensible, to stay indoors.

'Why don't you go now? I don't want you out after dark tonight. I need to sleep, Chiara. And I need us all together; otherwise I'll be worried sick.'

She glares at me, eyes flashing. 'You don't understand anything. There's no one there now. They're all at home, having dinner!'

I snort. 'I thought you said they're all to scared to go indoors, it's far too–', and then I stop. That's enough. Hugh eyes us, but wisely says nothing.

We need to do better than this, this bickering, this careless flinging of words.

I am feeling *spaesata*, rootless, that nowhere is safe.

<div align="center">¢</div>

I sleep. For hours and hours. When I wake, my mind has cleared.

The schools are all shut until further notice, so the kids spend their morning at the bar, at the playground with their friends, giggling excitedly about the way things have panned out. I ring friends in Foligno: Antonio, whose house had proved uninhabitable, is spending the morning beneath a cracked ceiling packing away family possessions. I speak with his mother, a hardy Neapolitan widow who dedicates her time to looking after a spotless house and numerous offspring. She is devastated. She tells me that for the meanwhile the family will go to stay with relatives near Bevagna. 'And then I don't know', she wails. Her world has fallen apart, just like that. Antonio sounds dispirited, *disanimato*. He has to cancel his imminent exhibition in Mexico, which has been prepared with such care. They must start searching for a flat to rent. There is little I can say.

I ask if he has news from my Brazilian friend Andrea, a ceramist who also lives in Foligno, for no one is answering her phone. He tells me she has moved out of the ancient *palazzo* where they have a flat, and is camping downstairs in the pottery with her husband and little girl.

'Here in Foligno all the old buildings have some cracks — some more, some less. They all have to be checked by the building experts. So most people are sleeping outdoors. People are really scared.'

All morning phone calls arrive from friends around the world: from Brazil, Australia, Scotland. Out there it must have sounded as if all of Umbria was on its knees, as if there wasn't a building left standing, which puts everything back in perspective. I remember who has thought to call, sometimes the least expected acquaintances, and

despite myself am aware of close friends who remain silent; probably they haven't heard.

Caroline, who lives on the other side of Trevi with her two young daughters, rings and together we have a good laugh. It's a way to relieve the tension. She tells me how she's spent the afternoon and evening driving from one hotel to another checking on her clients, British holidaymakers.

'I expected them to be panicking, to want to go home, to be shocked by the turn of events, by all the bumps, rattles and shakes. Instead most of them were over the moon.' She mimics them, 'Oh, how very kind of you to worry. But we wouldn't dream of moving. It's WONDERFUL to see Assisi without all the crowds! And the weather — just perfect! So much sun! We're all having an ABSOLUTELY MARVELLOUS time.' She takes a breath, and adds, 'Is it the stiff upper lip, are they the sensible ones, or are they just plain balmy? It's weird.'

I chuckle. 'They're just functioning in the "good time" zone, Caroline, and once you're in there, it's all perfectly logical. They're on holiday, remember — and it's all prepaid!'

It seems all the world 'outside' is glued to the radio and the news emanating from Umbria as the dimension of the quakes becomes apparent. Towns like Nocera Umbra, only twenty minutes away, have suffered extensively. Virtually everyone there has left home. We brace ourselves for future quakes. There are scores of so-called aftershocks in the following days, most too weak for us to feel.

Perhaps the earth is settling down again.

At the end of the month the exhibition opens in Perugia, but the schools remain shut.

October

As the first days of October unfold, it becomes clear that the business of living will take a while to get back to normal, and that as usual the people with the least have suffered the most.

In Trevi, all the town council's plans to have Australia here as guest country for the October festivities have been put on hold: a fax is sent to the Australian Girls Choir regretfully telling them that we must await better times. Trevi families who had offered to billet the girls obviously and understandably don't want the extra responsibility now. Many need the extra beds for relatives, or are sleeping in tents themselves as a precautionary measure. The town council is checking buildings for safety — a steady flow of signals of damaged buildings keep the *technici*, the building technicians, busy.

I seek advice from Rita at the Pinacoteca: Should we cancel our exhibition of Australian artists? Deep down, I would love a break, at least until the kids get back to school.

She shakes her head vehemently. 'We must go ahead. The invitations have all been sent, we'll just create more confusion if we start chopping and changing now. The building is safe. The only problem might be the public, but by then surely things will have settled down. We've still got a week. Surely there will be no more shocks!'

On one level everything seems to be getting back to normal, but even in apparently unharmed Trevi there are real problems. Number

251

one, for us, is school. News arrives that the *scuola elementare* is to stay closed for another ten days, maybe longer. Ivana up at the town hall tells me that students will most probably be bussed down to the old school in the valley, at Borgo Trevi. She suggests I ring the city police in Foligno for news about the secondary schools. I try and try. The lines are busy for hours, but I persist. When I finally get through, the tired voice on the other end says, 'All schools are closed till next week, Signora. Ring on Monday for further information.'

'Of course, but I heard that the Liceo where my daughter goes was badly damaged, that–'

The voice is tired, running out of patience. 'Signora, many people are saying many things. The buildings must be checked. Good morning.'

Giancarlo, who has been up here for a few days, and I decide the time has come to move in with a bit of self-help. I organise morning lessons for Chiara and Julian at home. After the long summer break, after a short spell back at school preparing for the year, now this. *Basta!* Enough! I want a bit of routine, of stability! It's four months ago that the summer holidays started, since Chiara and Julian did any serious study, and I don't want their brains turning to jelly. I invite some of Chiara's classmates to come along, but they do not see the point.

This evening Brazilian Andrea and her husband Nicola invite me to call in on them in Foligno. I park the car in Piazza San Domenico and head for the Street of Artisans, Via Arti e Mestieri, where they live — a narrow alley that we call 'little Napoli', for it is always chock-a-block with people sitting around on footsteps, washing hanging from lines overhead, children on bikes.

Where is everyone? There is nobody here, *nessuno*. All the lights are off, the shutters drawn, no washing, no bikes, no women sitting on outdoor chairs, no cigarette smoke, and no laughter, *niente*. And suddenly, dread stirs within me, for there are few feelings as

vulnerable as being alone in a deserted city. I quicken my pace, for I feel exposed and defenceless. At the end of the alley there are a couple of stray dogs rummaging through a garbage bin. They sniff the air as I pass, then decide to ignore me. Just as well. I reach the garden, knock loudly on the gate. Andrea opens, smiling as usual, welcoming.

'Andrea, where is everybody? It's deserted!'

'Everyone's gone, Virginia, everyone — they're all in tents, or with relatives. There's just us left!'

I step inside her studio, transformed into makeshift living quarters. The beds have been brought down, the radio, fridge, television, gas stove. It looks joyful, playful, with the old lace curtains as dividers between the porticoes, with hand-painted ceramic plates, goblets, vases and jugs lining the shelves.

I squeeze her arm. 'I can see you've had your magic wand out, touching everything!'

Andrea claps her hands together, and laughs. 'I love beautiful things. Even if it's just for a week or two, it must feel right.' Then her face darkens, and she whispers, 'Just so long as it doesn't rain.'

I look at her bright smiling face, and I love her generous spirit, her openness and simplicity. Nicola is already hovering over the gas burner cooking up a feast, which we sit down to eat with Salvatore, who turns up after a meeting of local shopowners at his wine bar, which, he announces, will reopen for aperitifs tomorrow, even though his flat above is uninhabitable. Nicola claps him on the back, and says, 'Bravo, Salvatore, bravo!'

Then Antonio arrives. He is despondent, has spent the day house-hunting, and is worried about his elderly mother. Rents have gone up overnight in Foligno, he tells us. He is sad that the Mexico show is off, but as the evening unfolds Andrea's good spirits and a bottle of Australian cabernet cheer him a little. There is no other talk than *terremoto* talk, and indeed there can't be, for it completely conditions the present. Everyone has his or her personal drama to

exorcise. Andrea's daughter watches Topolino (Mickey Mouse) on television, seemingly oblivious to adult conversation. But at a certain point she pipes up and declares she hopes the earthquake is not going to come back.

Hours later Antonio walks me back to the car. In these cold and empty streets he also feels that it is no longer a place to wander about alone. We stop, and look around — at the closed windows, the drawn shutters, the empty washing lines.

'*Futuro primitivo*', whispers Antonio.

I spy a doll dangling from the line; her hair attached to an old wooden peg, abandoned. She looks like she'd been given a wash just minutes before the first big shake sent her young owner fleeing. Antonio sees her too, and whispers, '*O Dio*, just like a Dario Argento film.'

¢

The hot sun beats down relentlessly at a time in the year when the earth should be cooling down. The rock face hidden behind giant *agavi* in the garden emits rays of heat at dusk and old people shake their heads and say this unseasonable heat is *strano*, strange. *Tempo di terremoto*, earthquake time.

The popular notion that a certain sort of weather precedes earth movement goes back a long, long way. Aristotle, for example, working with the elements of air, earth, fire and water, imagined masses of air or gases contained in subterranean cavities and heated to the point that they must escape, leading to the shaking of the ground. He put forward the idea that the atmosphere becomes heavy, stifling, because air has been sucked into the underground cavities in larger amounts than usual.

Over time folk wisdom came to dictate that the stuffiness that accompanies high humidity is a portent, a warning of coming tremors.

The old people say the earth smells of sulphur. For the people in

tents and caravans the sunny days are a godsend, for they dread the coming chill. Others say such heat in October will bring more bad luck, that things shouldn't be like this.

There are many aftershocks, which weaken already damaged structures. People are tense, taut, and ready to pounce. We are becoming instinctual, aware of imminent danger, like animals. Twice I've been standing under steaming water in the shower and the world has begun to vibrate, and I slide on the slippery tiles; and in bed, watching the light bulb hit against the sides of the lampshade, I feel we're stuck in a brief moment outside time.

This morning a schoolfriend of Chiara's rings and announces, 'Tell your Mamma we all have to go into Foligno, to meet outside the school building. The teachers are going to explain where we are to go for lessons next week. Ask her to take you now, the earlier the better.'

I have my doubts about this — but then again, it just could be true. Best to go. It is wise never to dismiss the grapevine, for it's often the only source of information. I leave Julian at home with Claudia, their teacher-away-from-school. Pat and Hugh have already headed up to the piazza for the weekly October market — a bigger version of the Friday market — and Ryan is still fast asleep, snoring loudly. I tell Julian we won't be long.

Once in Foligno we see that most of the streets around the school have been cordoned off, and the main piazza, Piazza della Repubblica, is out of bounds as a precautionary measure. The bell-tower has partly collapsed, and the facade of the town hall threatens to detach itself. Rubble is still strewn around; the atmosphere is *disanimato*, as if the city's soul has been wounded. Foligno was bombed badly in the last war, and a hint of what that must have meant to the people pervades the town this morning. Faces are tense; conversations all centred on recent events.

There is no one at the school. Just some volunteers from the Civil

Protection organisation standing around looking bored. It doesn't surprise us that the phantom meeting is not on, but I can feel frustration mounting. I must learn to control this, for it changes nothing except my blood pressure.

We go off for cakes and coffee in a side-street bar. I vaguely register that I am eating more than usual, comfort food, as if the extra weight will ground me. I'll regret this one day — hopefully soon, before the extra kilos move in for good. Then, as we are leaving I run into Andrea parking her bike, and we agree to meet up in the evening at the Baccho Felice wine bar.

In the afternoon there's another wave of tremors felt as far south as Rome, although the epicentre is once again around Colfiorito, a little town on the Umbrian–Marche border not far from here.

At 7 o'clock we drive back into Foligno. As soon as the sun goes down the temperature drops ten degrees, and it is suddenly autumn; we wrap ourselves in woollen jackets. The streets around Via Garibaldi are cordoned off. It seems like all of Foligno is out of bounds. We park around the corner, and walk past piles of rubble. There are the now familiar red-and-white plastic strips delineating no-go areas under many of the houses. Young men in uniform from the volunteer Civil Protection organisation have replaced the Foligno youth. Then, in the distance, we see a cluster of Folignati beneath a statue of the great hero of Italian Unification, Giuseppe Garibaldi. Salvatore has moved the wine bar outside, and placed a table laden with savouries, *pizzette*, *biscotti* and a magnificent magnum full of Ferrari spumante in the centre of the square. He is there, wildly gesticulating, always a source of concentrated energy, wherever he is. He tells me that after the last few tremors he's not chancing taking his faithful customers indoors, but neither would he abandon them. We mingle with other customers at Garibaldi's feet. It is wonderful to see how the people have appropriated public space in which to enjoy each other's company, when private spaces are out of bounds.

With a flourish Salvatore opens the great bottle of bubbly, makes the sign of the Cross, and proclaims in priestly tones:

> *Nel nome del pane,*
> *Salame,*
> *E del vino bianco*
> [In the name of bread,
> Salami,
> And of white wine]

The little party breaks into loud laughter and cheers him on.

I spot Andrea and Nicola; she looks tense and tells me that their patience is running out, that they yearn to move back into their apartment, but with the latest tremors they've decided to stay in the pottery and see how things pan out.

There are few familiar faces, but it feels like we're all old friends. I hear stories of more homes no longer habitable, and feel almost guilty that we have been so lucky. There's a man with a red flashing light on his chest who smiles at me, so I ask him why he wears the light. He winks and says it's to identify him as a *terremotato*, an earthquake victim. He asks me if my house is safe. I nod. A different, temporary culture is developing, defined by those who have suffered, who have lost something as a result of this movement beneath our feet.

As the get-together turns into a party, Salvatore once again raises his glass to Garibaldi's statue, stands below him on the stone plinth, and addresses the great Italian hero:

> *Giuseppe, tu hai la spada ed Io il bicchiere*
> *Dimmi, qui metterà apposto questo quartiere?*
> [Giuseppe, you have the sword, and I the wine glass.
> Tell me, who will restore this neighbourhood?]

Giggles and hoots fill the air while Garibaldi's immutable, moustachioed face gazes down. The last drops are squeezed from the

257

magnum, and Salvatore rushes back to the wine bar, returning with more modestly-sized bottles sitting on a sea of ice. We push some lire through the top of the demijohn, which someone has placed in the centre of the table, and then agree to wander back to the car: home to Julian, past the ever-present police squads, broken tiles and empty streets. Chiara and Ryan are slightly tipsy, walking arm in arm along the road singing a Janet Jackson rap update of an old Joni Mitchell song that is so popular at the moment: 'Don't it always seem to go, that you don't know what you've got till it's gone … Don't it always seem to go, that you don't know what you've got till it's gone–'

They giggle, repeating the words softly over and over. 'Underage drinking', growls Hugh, but he's smiling. We're all thinking about the words. I wish Giancarlo were here.

ç

The newspapers are full of heated discussions about reconstruction priorities. Members of the clergy announce that people must come before the monuments, and that prefabricated housing is a top priority, for soon the temperature will drop and the *terremotati* will begin to feel the chill of winter.

Sunday, the feast day of St Francis. An old woman in Assisi is interviewed on television and asked how she plans to spend the day. 'I'll pray to our Saint to stop the earthquake', she answers, then adds defensively, 'but this mess isn't his fault. There's only so much he can do, *più di tanto non puo fare*. He's trying his best.'

The fifteen monks left in the basilica pray to St Francis also, beseeching him to help them live in solidarity with the people most directly affected by the quake. Most of the numerous churches in Assisi are closed as a precautionary measure, and as usual word of mouth effectively informs the churchgoing faithful of alternative services being held. The paper describes it as being like the time of the catacombs. Little-known chapels open their doors, such as the

thirteenth-century Church of Santa Margarita, and that of Santo Stefano. But there are none of the usual crowds, for there is still a great fear of gathering together, and conversations return obsessively, cathartically, to the earthquake.

Sunday is also sightseeing day. Kilometre after kilometre of Alfas, Mercedes and Fiats — daytrippers, sightseers out to inspect the damage before lunching in a favourite restaurant — can be seen on the road to Colfiorito, which has suddenly become a scenic viewpoint. The drivers and their passengers are described as *turisti della catastrofe*, catastrophe tourists, out for a day of cheap thrills, getting in the way of aid workers and Red Cross staff, and stopping the traffic to photograph crumbling roofs, empty streets, and the rows and rows of emergency blue tents erected by units of the Civil Protection organisation.

Aurora told me, not long ago, that 'Italians are great homemakers, attached to their houses, to their gardens, to their cherished objects. The house tells the world who you are, and how you have arrived there. *La nostra casa è la nostra anima*, our house is our soul.' Her words make such sense now: 'We are not nomadic, we attach ourselves: in fact, often we choose not to know other things so as to invest in our four walls, these containers for all that we are, which should represent security. Can you imagine what it feels like when it all collapses around you. Then, you are nothing!'

I wish she were here now, to put her perspective on all this. I hope her house is all right. No doubt, she must have some relatives who will have materialised from heaven-knows-where to check up on things for her.

It is a strange mixture of the normal and the out-of-the-normal at present. In Trevi October's traditional cart race and medieval re-enactments have been cancelled, relatively recent annual events that involve the entire town and that appear to be taken most seriously. There's much dismay, as people have spent all year preparing the carts and costumes, and this year's runners have been getting fit, for these

are the popular events that still define the identity of many of the townspeople. I remember I had heard so much about the Ottobre Trevano before I came to live here. We'll just have to wait for next year. Everything, and everyone, feels flat.

The last-minute preparations for our exhibition are keeping me busy: constantly checking on the development of the catalogue, the painting of the cloister, which has gone on despite all these upheavals, the framing of the works. Almost all other exhibitions planned for the month have been cancelled, or postponed until spring. But I am unsure if this is the way things should go. Antonio from Foligno takes a break from househunting, and grumbles, 'I've been up in Trevi and everything's shut, even the Flash Art Museum. And today I really felt like switching off, seeing some art. Everyone's so depressed, I need an escape, just to forget the earthquake for a few hours.'

I hope there will be a reasonable turnout for the opening next Saturday evening, and that the decision to go ahead as planned is not misread as insensitivity but more a case of 'the show must go on'.

¢

The heavens have finally opened, and a great blanket of rain soaks the dry, cracked earth. For the thousands of people sleeping in tents the nightmare worsens.

On top of this, about 1.30 last night, the earth rose and swelled again so violently that it was felt all the way down the Via Flaminia, the shudders sneaking their way into the high-rise apartments in Rome. I awoke to great convulsions, and as the apparently interminable movement subsided I felt my own body tremble uncontrollably, as if the shock waves had got under my skin. I almost fell from my bed, switched on the light with shaking hand, and then somehow stumbled into the kitchen. Chiara and Julian slept on.

This time I felt shaken to the core. I stood in the kitchen, trying to control the trembling. Ryan appeared from the guestroom downstairs,

rubbing his eyes, pale and sleepy. Looking at him, I wondered why none of us ever rushed outside for safety as we've been told to do. After all, these new beams could fall and crush us. Nothing is secure. Nothing. Yet instinctively I felt protected, sheltered within these walls, despite fears of being swallowed up by the earth. Was I protecting the children enough, however? What would happen if even stronger convulsions were to occur? In my heart of hearts I suppose I didn't believe they would, although by now all securities were being scattered and a sense of vulnerability was becoming pervasive. It was far too catastrophic to contemplate.

I sat with Ryan in the kitchen, alert despite my tiredness, at that point feeling — there's only one way to describe it — absolutely terrified. My eyes filled with tears, until a great rush of salty water ran down my face, tumbling from my eyes. My body shook uncontrollably as if expelling all the shocks received in the last fourteen days. I sobbed to Ryan, 'I want to ring Giancarlo, but I'll wake him up!'

My young nephew smiled gently across the table, and said softly but firmly, 'I think if you feel this bad, in the middle of another earthquake, he really won't mind being woken up'.

Ryan then dialled the number for me. Pino, Giancarlo's flatmate, answered immediately, for he had been awoken in Rome, 150 km away, by the same tremor. As soon as he heard my voice, he said, 'Ah, Virginia, there has been another quake, I know. I felt it here. I'll call Giancarlo.'

Giancarlo's voice was soothing as he calmed me down, asked after the children, told me he'd come up the next evening and stay a couple of nights. During the brief exchange I felt my body relax, my heart stop thumping, the tears dry up. I needed him to take the weight from me.

'Try and go back to sleep now', he said gently, before wishing me goodnight.

As I put the phone down, Pat came up the stairs. She stared hard

at me, nodded her head in a motherly sort of way that I remembered from my childhood, and announced 'I think I'll make us a cup of tea'.

A cup of tea! I followed her back into the kitchen where we sat until around 3 a.m., drinking cup after cup of Earl Grey — something I would never have managed by myself, a ritual that I had forgotten here in Italy. It was good to feel looked after. As my terror subsided we made small talk, joked with Ryan, repeated over and over again how we had each experienced that shake-up. I peered through the window outside into the night. It was still pouring. Across the narrow road, my neighbour Ugo was standing under an umbrella in his doorway, staring out into the roadway, waving up at me frantically.

He shouted over: 'Are you all right? My son just rang me from Rome. He was sure we'd have had real damage this time!'

'We're fine — but Ugo, enough's enough! All those people in tents, and the buildings in Foligno, in Assisi, in Nocera, when will this stop?'

We swapped a few words — strangely, there wasn't much to say — and as I asked him to dash over for some tea I remembered we were all in our pyjamas, my face tear-stained, my hair dishevelled. This is not the way I want to be remembered, earthquakes or no earthquakes. Perhaps he read my thoughts; anyway he refused the offer, saying he needed to go back to bed. Instead, we wished each other goodnight.

'*Facciamo le corna*, touch wood it's all over! Let's try to get some sleep.'

I lay awake till dawn listening to the local radio, for once I was alone again my panic returned. There was no possibility of sleep overtaking me. People were phoning the radio station from all over Umbria, describing scenes of panic but thankfully little further damage. Tomorrow would tell. The rain continued to pelt against the tiles, and thunder to roll off distant hills. I tossed and turned. Every so often the earth trembled and sighed as if also trying to resettle for the night.

¢

In the light of the new morning I feel incredibly fragile — or brittle, like I might snap. Looking at the face staring back from the bathroom mirror, it appears that too many sleepless nights are beginning to take effect. I splash cold water from the tap over my eyes, my nose, my lips. I must wake up, get Julian to school. I stumble back into the kitchen, put the coffee on. Then, minutes later when I open the shutters of Julian's room, and begin, parrot fashion, my habitual morning call to him, the sight of a great river of muddy water flowing down the rock face on the other side of the driveway greets me. I blink. Piles of mud have formed on the road below, so that it is almost impossible to drive up Via Costarella in a car. I slam the shutters closed again. That's all we need.

As I sip my espresso, I reflect that last night's incessant downpour was the first consistently heavy rain since St Costanzo's door was opened, way back in May. So all that water obviously still entering the chapel, through holes in the roof and a little side entry, now had an escape route through the reopened doorway. Unbelievably, the rock-hard sediment inside had turned to mud and was being swept out in the downpour! That meant a hell of a lot of rain had entered the chapel. St Costanzo! While Julian eats breakfast, I ring the town hall and tell the male voice on the other end what's happening down here. After all, in a few more hours the road will be completely blocked. The man tells me they have already been advised by our neighbours and will be sending someone over to check it out shortly.

When I take Julian to school, I just manage to squeeze the car past the mounting piles of mud on the road. Within an hour or so, the whole road will be blocked off. A brown river of earth from our chapel flows all the way past Le Lacrime Basilica and towards the valley. It is an odd sight, this river of muddy tears, and makes me wonder if St Costanzo is up to something. Then, when we arrive at Julian's school, the gates are padlocked. We find a handwritten sign saying '*Chiuso*

per terremoto' (Closed because of the earthquake). I should have guessed. We drive back home, but are forced to leave the car at the end of the road, and wade up through the mud. The escaping earth from the chapel is cutting us off! As we pass the Gasparinis' house, Giuseppe puts his head out and tells me bulldozers will be sent shortly to clear the road. He asks me if the house was damaged in last night's quake. I shake my head, and tell him we're fine.

I can't stand thinking about this any more. There is work to be done. I ring the cultural attaché at the Australian Embassy in Rome and tell her I am still unsure whether to go ahead next Saturday with the exhibition. For one thing, will anyone come? Is it safe? I wonder if she thinks I'm exaggerating — it must all sound so odd to outsiders, and I suspect she can detect a note of hysteria in my voice, yet she is quite calm when replying that she hopes we'll go ahead. I hear myself reply that yes, probably we will. I put the phone down thinking but what if there was a really BIG quake, with Trevi, with the Road of the Mills, as epicentre? After all, there's always an epicentre. It's as if I have one foot in the here-and-now, dealing with daily issues, the stuff of life, and the other in some far less secure place. My heart is beating like a damn drum again.

Next I phone Lucia at the town council. 'What do you think?' I ask her. 'Should we still plan the opening for next Saturday?' Lucia's melodious voice answers yes, people need some things to go on as much as possible, and before she hangs up she adds, 'With all these never-ending tremors, we'll never do anything if we get too anxious. We've been forced to cancel so much already this October. All that hard work for nothing! At least the exhibition is under the portico at the cloisters, so it is half outside and that makes the public feel more secure. Let's do it!'

Next I decide to confront other urgent business: school. After all, Chiara still has no word as to where or when school will actually be from now on. The official rumour is that she may be doing afternoon

shifts in another building on the outskirts of Foligno, at least until Christmas. I spend an hour or so trying to sort out fact from fiction before accepting that it is a totally pointless exercise.

Chiara and Julian are still glad to have no school, especially while Ryan is with them. None the less I insist they continue private lessons in the morning. There must be a structure to the day. Their afternoons are spent in the piazza or on the tennis court. I fret about them not learning enough, for I don't want my children to be left behind. I have ridiculous images of the rest of the world sweating over text-books, but try to convince myself of the 'life experience' value of all of this.

What I really need is a workout in the gym — to cut off from all this mess. I get my gear, and make my way down to the car again, past the bulldozer clearing the road. That was quick, at least! Thank heavens it's stopped raining, and the sun is peeping through a tumble of silver clouds.

The gym is crowded, which is unusual for this hour. Safety in numbers? Letting off steam? The owner, muscle-bound, handsome and gentle, gives me a bright smile when I enter.

But no sooner do I start running on the treadmill than I am forced to stop. My heart is really going crazy. I am not imagining this. It thumps, flutters, and misses beats. It hurts. Sure, it's been missing beats for days now, but this is worse. I slow down to a walk, my hand on my chest. Forget fitness, I need a doctor. And, to make matters worse, my left foot has begun to itch again. Not much, but enough to get the alarm bells ringing in my brain. I am terrified that it will swell up and take over my life again, shooting painful messages up my spine about being in the wrong place, just like that recent summer, which feels so long ago.

The owner looks at me quizzically as I step off the treadmill. 'Signora, that's not like you! *Già finito?* Already finished?'

'Oh no, but I just remembered another appointment.' I try to laugh.

I shower slowly, dress slowly, then walk slowly to the car, and drive over to the medical clinic. My doctor is on duty this afternoon and there are a few patients before me, but it doesn't take long before I am next in the queue, knocking on his door.

'*Dottore, buon giorno!*'

He smiles, shakes my hand, invites me to sit down. '*Allora?*' he asks, smiling.

I am embarrassed when I tell him my symptoms. The words tumble out. '*Dottore, mi scusi.* I know it sounds quite silly, but I think I'm in danger of a heart attack! Can you take my pulse? My heart won't stop racing.' I attempt a laugh, but he sees the distress clearly. 'It hurts', I add nervously.

He checks my pulse, tells me to relax, to breathe slowly. I try, while he frowns in concentration. Then his face smooths out and all the deep lines uncrease.

'You won't have a heart attack, Signora. Don't worry! It is a bit fast though, I must admit. Are you stressed, overtired? Having disturbed nights with all these tremors, perhaps?' He looks up and smiles reassuringly, 'You're as restless as the earth!'

'A bit sleepless, actually. And nervous. Like everyone.'

He nods. 'Signora, you can't imagine how many people are coming to me since the tremors started, with heart palpitations, sweating, insomnia. You need something to calm you down.'

For some reason, I do not tell him about my foot. I feel if my heart stops racing, my foot will stop swelling.

$¢$

Julian is finally back at school, squashed into temporary quarters down in the valley, at Borgo Trevi. The Spoletina bus picks him up in the morning from the turnoff to the Road of the Mills. As he sits on the stone wall, Hot Dog by his side, and waits, he wishes he didn't have to go back to school while Chiara is still 'on holidays'.

But I can see he is much happier, more settled, once the essential boundary between work and play is re-established.

<center>₵</center>

Giancarlo has taken a few days off work, which means the weight of earthquake fever is spread between us. I pour all my energy into the Australian artists' show, dealing with the idiosyncrasies of one or two of the other artists, ever so gently giving instructions to the workmen busy freshening up the cloister.

This morning, two days before the opening, all five artists gather at the Pinacoteca to hang our work. It's such a beautiful morning, clear and crisp. Pigeons coo from rafters in the cloister.

First to arrive is Neil with his intricate Durer-esque etchings and mannerist oils, then Diego and Tony from the other side of Perugia. Diego's work is still clearly Australian, his bronze and wood sculptures presenting a steadfast and earthly attitude. He's obsessed with getting back to Sydney, working there for a couple of years, having had enough of his isolated Umbrian paradise, which sounds more like a prison when he talks about it. Mild-mannered Tony walks around the cloister, apparently choosing the best place for his work, then sits down on one of the workmen's seats and rolls a cigarette — something no one does here; perhaps it is considered less elegant. I sit down besides him, and he begins telling me about his childhood in a village in primitive Calabria, in southern Italy.

'That was back in the 1940s. There were no cars, not where I was. Or electricity, for that matter. And most of all, I remember the hunger. I used to say, "Mamma, I'm hungry". Poor lady! She'd look at me and nod, and say, "I know, I know. But, little Antonio, there's nothing else to eat today".'

He smiles wryly. 'Sometimes, some very special days, there would be an egg, and it was always given to me. But it wasn't often! That's why I'm still such a small guy, you know. Malnourishment. But then

<center>267</center>

my dad went out to Australia in the early 1950s, and we followed him a couple of years later, when he'd raised the money for all our fares. It's a long way from a mountain village in Calabria to Melbourne, I can tell you! They made it though, and have never been back.'

'Why not?'

He shrugs. 'Too painful, I guess. Mind you, I wouldn't mind if they came over and had a look at my house and the art studios, but they don't want to put a foot back here in Italy. They still remember the hunger, you know. I just can't convince them that Umbria in the 1990s is not Calabria after the war!'

As Tony watches Neil hanging his work, occasionally offering advice, we chat on about our peripatetic careers, the things we miss about Australia.

'Tell you what', says Tony, 'in the 1970s it was so much easier to sell artwork — oh, I used to sell a lot back then. We all did — I mean those who were working at that time. It's changed a lot, eh, for most artists! But at least it gave me the chance to save, and buy a place back here to spend half the year, when it's not too cold. I guess I'm lucky, really.'

I nod, 'You are.'

I glance towards my pictures lined up against the wall, awaiting hanging. My work has become more intimate — and it shows. Back in the early 1980s there were many more overt messages to be read in my drawings and paintings, reflecting events around me. And even more so, perhaps, in the early 1990s when I'd been in Yugoslavia, when that world had brutally fallen apart. That already seems a long time ago, no doubt because this world, this Umbrian hill-town, is so fundamentally different.

This series, entitled 'Open Books', completed in the cool of my studio last August, consists of ten mixed-media works suspended in black boxes. Like pages from a lyrical diary I hope they express something of the notion of vulnerability, of exposure — something

268

all artists face — for the very pages of these works are glued to their wooden supports and thus can never be closed; the vegetable-fibre pages, hand-made years ago in Brazil, will remain forever open and empty of script. Silent, empty, yet alive with potential.

Tony stubs out his cigarette. 'I guess I'd better get on with my hanging, eh!'

'Me too.' I stand there for a while, hands on hips, deciding on the order of the pieces for hanging. I am satisfied that they will look well beside the glowing luminous watercolours of the fifth exhibiting artist.

There have been some testy moments organising this show, but as the works are hung and the unflappable architect adjusts the lights everything begins to fall into place. I am hawk-like, watching out for imperfections and overhanging that might affect the overall look of the show. It must all appear effortless, with no ragged, loose ends. Tony helps Diego centre his large wall sculptures. My framer, a huge, strong man, arrives during his lunch break to hang my works, which are quite heavy; I take on the role of assistant, enjoying the luxury of standing back and observing as he lines the row of black boxes up perfectly. Somehow, in little Trevi, in the middle of earthquakes — or because of them — it seems all the more important to do our best. When the hanging is complete we open the boxes of freshly printed catalogues, and our larrikin-like group portrait appears on the shiny black covers. Everyone seems happy with the catalogue, and we decide to all go off for a drink at Maggiolini's restaurant.

¢

The opening goes surprisingly well, given earthquake fever. The paintings and sculptures look striking under the illuminated arches, and the weather spirits are behaving themselves: it's a perfect October evening. Someone's on my side, then! And there's been a big turnout, fleshed out even more by a cheerful contingent of Australians from

Rome, led by the art-loving ambassador. The foreigners drink Monte-falco wines, while the Italians choose Foster's beers in a perfect marriage of cultures. Afterwards we all pack out the local restaurants, toasting the end of earthquakes.

The next morning I oversleep. I've been dreaming about the opening all night, and of angels flying high over a cracked, torn earth. Everything is settling, and I'm beginning to appreciate all those celestial creatures in Umbrian frescoes; perhaps it has always been much safer up there among the clouds. So much for a secure base, for terra firma beneath our feet. One must find safety elsewhere, in some sort of internal home — an inner psychic space. I reflect on how glad I am that the pre-exhibition work is finally over, that in the end it all went smoothly enough. Going ahead with the exhibition was worth it after all. I have let no one down; and there was no wind, no rain, no irritating shakes, and the works looked good.

Giancarlo brings me this morning's newspaper, for he's already been up to the piazza, and a cup of coffee. Luxury. All is quiet, and then, out of nowhere, the earth resumes its deep rumbling. Suddenly I am wide awake.

Oh no! I hear glasses clinking, pots and pans in the kitchen banging together, Julian calling me.

Giancarlo's voice is calling out from somewhere, 'What the–!' and then, '*Calmi, calmi*, it's all right!'

Santo cielo, holy skies! Not again. When is this going to let up? My first thought is of the children, but they are safe. Once more, thankfully, unbelievably, the Millhouse suffers no damage. But elsewhere? Where was the epicentre this time? It must have been close, for the whole place was really shaken up.

I wonder about the tower, the so-called *torrino*, in Foligno — the one over the town hall. Shakes like this are bound to send it flying to the ground. That tottering little campanile has recently become a popular symbol of resistance in a city brought to its knees in the last few weeks.

I grab the phone and ring Antonio in Foligno — thank heavens he has a mobile phone; these phones have proved a godsend through all this — and ask him how it is in Foligno. He sounds quite calm, and says he's on his way out to have a look around. We agree to meet later in the day as arranged, for he has some antique doors and a ceramic slow-combustion stove to sell that vaguely interest me. Life goes on, appointments should be kept. Antonio is forced to free himself of non-essential belongings now that he and his mother are living in a caravan; but he has been given permission by the building technicians to re-enter and empty their medieval home of all their belongings. He tells me his mother is quite devastated, overwhelmed by loss.

'And you wouldn't believe just how impossible it has become to find anything to rent in the Foligno district. Prices have skyrocketed', he adds with a bitter laugh.

'What will you do?'

'I'm fed up, I really can't bear any more Virginia — if this doesn't stop, I'm leaving. It's too much.'

In the afternoon we meet up near the Piazza del Municipio in central Foligno — Antonio, his friend Francesco, Giancarlo, Chiara, Julian, Pat and Hugh. To reach Antonio's courtyard, we walk tentatively along Via Garibaldi, even more desolate than a week ago. The Baccho Felice wine bar is shut; the wrought-iron gate firmly padlocked. It's disturbing just how quickly a city loses its spirit once its citizens are gone, how it becomes seedy and broken-down almost overnight. There's no one in sight; just abandoned streets and buildings with signs: *'Pericolo di crollo'* (Danger of collapse).

Although the air still carries some hint of late summer, autumnal gusts sweep up rubbish lying in corners. We see a group of Folignati at the end of the alley. Like them, we position ourselves within view of the Piazza del Municipio and collectively gaze up at the tower. Black crows circulate above.

'They are saying goodbye to their home — *addio*, farewell', someone nearby whispers. We remain silent, watching the birds. Then I remember the bridge in Mostar, the Stari Most, which became a potent symbol during the Yugoslav war, or rather the part acted out in Bosnia Herzegovina. Although its bombing had been infinitely more terrible and impossible to comprehend for one whose mind had not been poisoned by an obsessive, cathartic desire for revenge, there are parallels to be drawn here today. In its own way the *torrino* has become a symbol of endurance, just like the bridge.

No one standing here will forget this scene; least of all Julian who stares up silently, occasionally blinking, clutching my hand.

Yesterday at 5.20 p.m. there was another terrifying quake: 8 on the Mercalli scale, 5 or so on the Richter. The epicentre moved from Colfiorito to the little town of Sellano in the mountains behind us; some buildings were quite literally knocked to the ground. Foligno once again was badly hit. Antonio described scenes of panic, and then sadness, as the tower of the town hall finally tumbled down at the very moment exhausted firemen were attempting to reinforce it with a cage-like structure of steel.

This evening the scene was replayed on television time after time, being, obscenely, great film footage. The little *torrino* seemed to explode, then spin off into space and break up, crumble, creating great billowing clouds of dust as fragments hit the roof, then the street below. The mayor of Foligno was filmed with tears in his eyes, declaring that the city's civic symbol had been lost, just days after the religious symbol of the cathedral bell-tower on the other side of the piazza had also crumbled. Two emblems of the city at opposing corners of the main piazza have now come to signify destruction.

This morning the sun shines brightly and there is no wind; just a few wispy clouds drifting over Monte Brunetti, coming to settle on the peak as morning floats lazily towards noon. After a flurry of phone

calls it is established that Julian's school will reopen once again, despite yesterday's tremors. There's no news about Chiara's, although rumours circulate that schools in Foligno may open towards the end of next week. I hope so.

¢

Ryan flies back to Sydney, to schoolwork and surfing — Giancarlo drives him to Fiumicino and sees him on his way. Then my brother Tim arrives via Paris with his girlfriend Felicity, laden with presents for us all: Yves St Laurent perfume for me, a Men-in-Black watch for Julian, CDs for Chiara, and, for Giancarlo, the world's smallest, shiniest fire-engine-red espresso machine. Tim has been planning this trip all year, hoping to partake of the medieval October festival in Trevi, but most events have been cancelled. So with the extra numbers — Pat and Hugh, Tim and Felicity — we're a fully-fledged Australian community on this Umbrian hilltop.

I give them the rundown on present conditions. They announce how glad they are to be here anyway, and chat on about all the walks they can do in the mountains, the car trips to Norcia, Perugia, Todi, Orvieto and Siena. We drink too much wine, but at this point I really don't care, and I can feel it helps me relax. Then Brazilian Andrea rings in the evening and tells me she is heading off to Milan to stay with friends for a few days, until things calm down. Her usually animated voice has a lacklustre timbre, for their home has officially been declared off limits. She says she'll ring as soon as she comes back. But I'm glad for her that she's getting away, for the pottery offers no protection against the colder weather. While she's away Nicola wants to build some temporary walls to keep the cold and damp out.

¢

Yesterday it felt like things were getting back to normal, and the business of reconstruction could begin. But few in Trevi dare to

declare it is over, for reasons of superstition. I realise too late what a major blunder I've made when commenting publicly in the piazza that the last tremor surely must have been the grand finale. A chorus of voices cries '*Facciamo le corna*, Touch wood', while simultaneously pointing fingers and jabbing at the air. Heads shake in disbelief, for it is considered unwise, stupid even, to tempt fate.

<p style="text-align:center">❡</p>

This morning, Sunday, Giancarlo is itching to get on with things in the garden, to turn the topsoil in the vegetable plots, to water the last of the thirsty tomato plants, so we decide to leave him out of our plans. Chiara could not be woken for she'd spent yesterday, 'Youth Day', on a pilgrimage to the Vatican among tens of thousands of flag-waving, screaming adolescents, all awaiting the Pope. Trevi's teenagers had left at dawn, suddenly all eager to be supervised by big and burly Fabio, leader of the local Catholic Youth Club. For most of them it was just a chance to have a day together, nothing more, nothing less. Chiara returned late last night exhausted and, she joked, with permanently damaged eardrums from all the screaming. I leave her sleeping peacefully, while the rest of us pile into the car and abandon Giancarlo, happily digging up what is left of his tomato patch.

This is Pat and Hugh's last Sunday here. I want to show them an unforgettable sight. We drive the 80 km through the hillside to medieval Orvieto — once Urbe Vetus — a beautiful city atop a massive tufa outcrop. It really does look golden in the morning light. We drive towards the town centre, find a half-empty carpark, and stroll uptown, past the tourist shops brimming with ceramics and alabaster statuettes, until we reach the cathedral. Its horizontal stripes of travertine and basalt are lit brilliantly by the sun's rays. This, and the Piazza del Duomo in Spoleto, are my favourite squares in all Umbria. The town is awash with prosperous tourists, but it feels quite a relief,

for mass tourism has abandoned the entire Umbria region since late September, and the tourist dollar matters around here.

I feel carefree and more relaxed than I have in ages — in fact, I too feel like a tourist, and behave accordingly, forgetting the messy business life can be at times. We sit on the steps of the Duomo and watch the rapturous faces around us gazing up at the unbelievably rich facade, the mosaics, and the statues. From this prime position the cast-bronze symbols of the Evangelists — the angel, lion, fox and eagle — watch over us as they have for centuries. Forget earthquakes, Italian bureaucracy, and closed schools. Here is the glorious world of *Italianità*, the best Italy has to offer, at its most sublime. I could forgive anything and anyone when I connect with this Italy.

Back in Piazza Garibaldi in Trevi this afternoon, the annual *sagra*, food feast, of sausages and celery is well under way. In previous years it has taken place in the medieval square, but no one wants to chance being hit by falling roof tiles, so the whole show has been transferred to a more open space. A series of trestle tables groan under the weight of massive celery stalks freshly harvested. Planted way back last Easter, they look like an invasion of sleeping green men, while beside them pepper plants add a touch of red. A massive central stall is the centre of attention as stocky male members of the Pro Trevi Association grill sausages, *salsicce*, on the coal-fired barbecues. Scores of *salsicce*, local pork meat seasoned with fennel, a touch of chili pepper and herbs, sizzle on the grates. The smell is rich, wintry and irresistible.

We line up to pay the modest 2000 lire each per sausage. Elegant, stately Vera from the Pro Trevi Association, dressed in creams and whites, takes our money while simultaneously handing out photo-copied sheets reproducing the words of St Emiliano, by now almost a local mantra: '*Trevi tremera, ma non cadrà*, Trevi will tremble, but will not fall'.

We buy a glass of local red wine to go with the sausages, and seat ourselves on a bench. The signoras parading between the stalls and

the Bar Chalet are all very proper in their sombre suits and little heels.

Pat eyes them and says, quite happily, 'I must be the only one my age in pants today', and sips the red.

I observe her, then look at the passing parade of stout elderly women. It's absolutely true; she looks so lovely in her new suede jacket, the collar turned up rakishly, seventy-eight years young, and I reflect that all those years of keeping fit, wearing gym shoes and keeping optimistic, of doing, have paid off.

I watch Tim disappear into the crowd with the video, and then, unbelievably, after days of stillness, once again the earth moves: not violently, but like a short, soft push-and-pull at our feet, at everyone's feet. The sounds of children's voices calling out for their mothers cut through the sounds of the afternoon, stray dogs bark in chorus, and for a split second time once again stands still, faces frozen in uncertainty. It is as if everything, in fact, is frozen for what feels like ages. Time is momentarily suspended. The moment passes as quickly as it came, the ground resettles, and a great collective breath is taken. Chiara breaks away from her friends and runs towards us, her beautiful face flushed, laughing nervously, and declaring, 'Stop the world, I want to get off!'

Tim reappears out of nowhere, and positively bounds back to Felicity, throwing his strong arms around her protectively, and asks, 'Are you all OK? Now that was what I call low-frequency sound. Extraordinary. The most fundamental noise I've ever heard!'

It's true. All through these quakes there has been a series of low and booming vibrations, that much I've been aware of. Apparently nearer the epicentre the sound resembles the tearing apart of great blocks of rocks, but here on the hillside it is experienced more like waves of thunder, cannonballs, explosions. The official line is that generally these sounds actually precede the first shock, the more intense sound then accompanying the most powerful shakings, slowly dying down so that the end sound coincides with the last tremor.

Pat giggles nervously, and hugs me while peering into my eyes, no doubt searching for those telltale signs of panic that have crossed my face too many times lately. My heart thumps giddily as usual, but I try not to give too much away. I wonder if she knows.

§

Lucky Giancarlo has been sent on a work trip again; this time to Dakar, capital of Senegal. He rings me from the Italian Embassy there to check that the 'Earth is behaving herself'. I find myself reassuring him, hoping that he'll have some time to tour the country, go fishing off the West African coast. It is hot and steamy in Dakar, he tells me.

Why do I pretend everything is all right when long distance and telephones are involved?

While he's away, the day of Pat and Hugh's departure arrives, just as the first autumn rains begin to fall.

Cold gusts blow yellow leaves from treetops. The birds are migrating south again. As we stand by my parents' Renault, hired weeks back at Paris's Charles de Gaulle airport, gazing up at the fast-moving clouds, I marvel at all the winged creatures flying overhead — perhaps from as far north as Scotland, answering to the call of warmth, of winter sunshine far south. Pat's eyes are filled with tears as she bundles herself into the car, and I wonder when I'll see them both again. Hugh hugs me tightly in his version of a bear hug, and growls in that way Australian men have, 'Just look after yourself'. I fold my arms and nod, my mouth all scrunched up in a ball, teeth clenched tight, and immediately wish I'd been able to give them more. More of me, more of Umbria.

§

I don't feel like doing anything. I don't want to write, work in my studio, cook, garden, walk, do the food shopping, look after things. All I really want to do is go away, far, far away, escape from everything

and everyone, or sleep for a few days I go and lie on my bed, open the local newspaper, and flick through the pages. They're full of earthquake news, or stupid beauty contests. I should go to my studio but I have no drive, even though once there I know the energy would begin flowing like it always does. The problem is that with all this upheaval it is harder to believe in the power of a simple drawing.

There's a soft knock on the door, and Felicity enters.

'Hi Virginia', she greets me gaily. 'I've brought you a good strong coffee.'

I smile at her.

'Oh thanks, Felicity, that's really thoughtful.'

I take a sip, and noisily close the rattly newspaper. My room is a bit of a mess really — clothes flung about, cupboards open.

'Sit on the bed, Felicity; you'll never find the chair in this mess!'

She glances about. 'I like it. The blue walls, like Greece really. And that yellow alcove. It's sunny, maybe even a bit like Mexico in here, with all those designs around the window and doors. Did you do all that?'

I nod. 'Can't seem to keep it tidy though. Some rooms are like that. My bedrooms always are.'

She shrugs. 'Looks all right to me. Mine's the same back in Sydney. There's something I'm dying to do, though, now I'm in here. Can I have a look through your clothes? That cupboard looks very, very inviting. It's been tempting me since I arrived in Trevi! I much prefer going through my girlfriends' clothes cupboards than their photo albums.'

I laugh, cross my arms behind my head on the big comfortable cushions. 'Sure, go ahead. You might be able to give me some advice. I think my standards are slipping from too much time on our Trevi "island"!'

'Don't be silly.'

She stands up and walks over to the wardrobe.

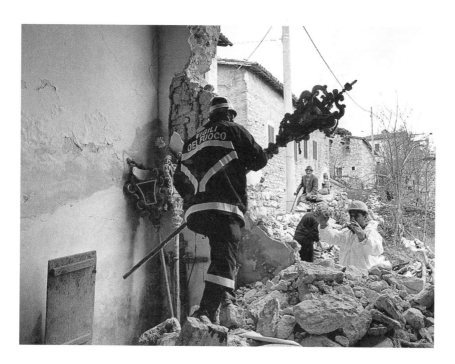

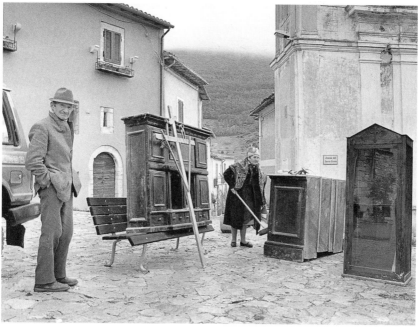

Earthquake in Umbria, September/October 1997. [Dino Sperandio]

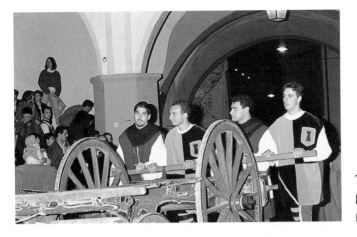

The boys at the end of the cart-race.
[Domenico Pistola]

Crowds cheering
the cart-race
in the October
re-enactments.
[Domenico Pistola]

After the cart-race, celebrations in the piazza. [Domenico Pistola]

Barbecue, Trevi-style, with local spicy sausages. [Domenico Pistola]

Salvatore from the Baccho Felice wine bar.

Street scene, Piaggia, Trevi. [Dino Sperandio]

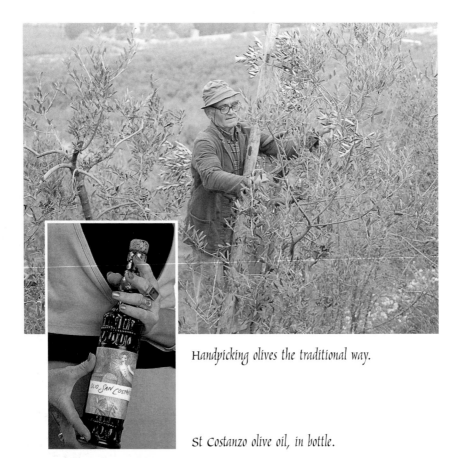

Handpicking olives the traditional way.

St Costanzo olive oil, in bottle.

Julian riding through the olive grove.

I watch her sifting through the rack of jackets, suits, skirts, and coats. My life, or rather, lifestyle, is written on each. Cocktail dresses, smart city suits, fitted pants. Classical. Easy to wear, but far from country. Public clothes, belonging to Life-before-Trevi. Life before jeans, lace-up boots, leather jackets; before there had been studio clothes and city clothes, work clothes and dressing-up clothes. I liked that. It occurs to me that maybe I'm beginning to miss the other clothes, miss the way they made me feel.

By now Felicity is half-hidden under my coats. She spies the old mink opera-jacket my Aunt Kath left me years ago before she died of emphysema. It had become a permanent fixture in my wardrobe, although I never actually wore it. Since living in Scotland and being exposed to the wrath of the animal liberationists, I had been uneasy about wearing fur coats anyway. Still, it wasn't as if I had bought it.

'Virginia, it's wonderful', she exclaims, turning towards me. 'Why don't you do something with this?'

I look up. 'Oh, that! It's a family heirloom. Don't you think it's a bit *passé*— I mean, really, look at the shape, Felicity! Definitely not the 1990s, is it?'

Felicity shrugs. 'Oh, I don't know. Try it on. Go on!'

I stand in front of the mirror, bundle into it, and gaze at the reflection. The jacket is most definitely not me — or anyone now, with its three-quarter sleeves, its old-fashioned collar. I pull a face. Felicity bursts into laughter.

'You could try something really different — I don't know, cut it all up, start all over again. It's a shame to have it just sitting there.'

Is it? 'Yes, I suppose it is.' I wonder how my aunt would have felt about this. Would she have minded? Auntie Kath had been a bit of a fashionplate after all, had loved clothes, had always spent a lot of money on herself, so she was probably cheering us on from her new home in the clouds.

'Let's take it into Spoleto, or Foligno, and see what can be done.

You know what Italians are like — miracle-makers as far as clothes are concerned. There'll be a furrier around somewhere. won't there? From what I can tell, they're all fur-crazy here in Italy.'

'Yes, I guess they're everywhere. I've never actually looked.'

Is Felicity trying to cheer me up? I feel very affectionate towards her. She must sense the pressure we've been under.

We agree to devote the afternoon to doing the Foligno shops. It's a pity that funds are a bit low, but we'll just have to be creative about it. I pack the mink away in its special bag, and put it in the car.

This might be the best thing for me — the Shopping Cure! After all, in the last weeks any non-essential desires have been severely shoved aside in post-earthquake chaos. My energy level is uncharacteristically low, and I suspect Felicity has decided I need a bit of pampering.

Along Foligno's Corso, the local kids are strutting about in their designer jeans, looking gorgeous as usual. It's good to see them back in position in their favourite haunts. Old men in woollen berets ride past on pushbikes, friends meet up and chat on every corner. Felicity, with her shiny black hair, short black skirt and black bomber jacket fits in perfectly. The cinemas are still all closed, but the atmosphere is more like that of months ago, playful, but in an austere, Umbrian way. Faces are still strained, but a sense of relief is palpable, although around the corner from the *corso*, the main street, the main square is still cordoned off. Many of the houses have been declared unin-habitable, and the churches will take years to restore.

We hunt out a furrier, a *pellicceria*. The shopfront window is exquisitely presented. The mannequins are richly, extravagantly wrapped for the frozen plains of Siberia with a multitude of skins. Despite the superb craftsmanship in the making, I'm still not convinced. I think I'd find it hard to go in and purchase one of those full-length coats, even if I did have the money. Italian women who decorate themselves in costly blankets of fox, mink, and sable often appear somewhat kitsch. It's not that cold here after all.

We stand peering through the window. I do not want to look like one of them, but, on the other hand, I've inherited this little mink and it's a shame to waste it. If I close my eyes, I can still evoke Kath's image, glamorous, smelling of Chanel No. 5, off to the Melbourne concert series back in the 1960s, the mink across her shoulders — and warm and soft she looked! When I was a child I longed to grow up to look like her. I still carry these memories of my aunt along with the fur resting, inside its bag, in my arms.

We climb up the stairs and enter through polished wooden doors. I lay the linen bag on the table before a matronly, but obviously efficient, signora. She glances at us from the corner of her eye, then takes the jacket from the bag, runs her hands across it, lifts it up, turns it around, inspects every little fold with expert eyes.

She nods slowly, murmurs, 'Well, it's not bad, not bad at all', and looks up. 'Where did Madam purchase this?'

I show her the tag. Collins Street, Melbourne. 'When?'

'About thirty years ago, I think.'

She glances up, and frowns.

'Yes, but not me, Signora, my aunt. I have it for sentimental reasons. What do you think?'

'It depends.'

'On what, Signora?'

She sighs, patiently. 'On what you want to do, of course', adding, in a more kindly voice, 'but it has been well looked after. *Complimenti*, good girl, *brava.*'

I smile, aware that I've ended up feeling like a good girl. Why are these women always more powerful, more womanly, than me? Why do I always feel like it is exam time? Why don't I call them good girls?

I hesitate, then announce, 'I don't want anything too serious, Signora'. I look at the full-length numbers in the window. 'I don't want to appear as if I'm trying too hard to make a statement. Do you understand, Signora? I just want to have a bit of fun with it. Perhaps

adding a collar and cuffs to another, much more casual coat — a leather coat, a suede jacket. Something *sportivo!* — I don't know, but something I can throw over jeans and immediately look well dressed, but not like I'm making an effort.'

'*Si, si*, I understand. But what about the rest of the mink? It's a shame not to use it all.'

Felicity, concentrating hard on following our rapid Italian, breaks in, in English. 'I know, Virginia — make one of those little fur vests that are all the rage now, like in this year's winter collections.'

I translate for the Signora. She looks approvingly at Felicity. 'That's a good idea, *bella*. I like that. I have some magazines — we'll take a look. And you use all the fur that way. Yes, yes, we can do this. It will be good.'

It will be good, but will it be expensive? I ask her in a roundabout, face-saving way, and am relieved by the answer. Local prices for tailormade clothing, or to remodel high-fashion items, are often relatively inexpensive compared to other countries.

That raises my spirits even more, and Felicity is almost as excited as I am.

'A mink vest — Virginia, please! Your Auntie Kath would be pleased!'

We walk out laughing.

On the wall at the base of the stairwell below, someone has just drawn a crucifix — with wings — in shiny black paint, and written underneath, *Per la mia città* (For my city).

The paint is still wet.

ç

Tim has inherited official responsibility for the vegetable patch during Giancarlo's time away in Africa; as a consequence he decides to spend time among the olives on our sundrenched slope, rather than sight-seeing with the rest of us. Just like Giancarlo.

He toils away happily, mixing sand and cement for the steps Giancarlo wants to build up to his tomato plantation. The hardy plants are slowly dying, after giving us a bumper crop all season. St Costanzo's church stands a little below the spot where Tim labours.

As far as I can tell, the chapel has not suffered further damage, no doubt having survived quite a few earthquakes over the centuries.

I've hardly spared a thought for it over these weeks — a case of 'people first', but now I see that the little fig tree before the portal has put on quite a spurt, despite our efforts to dig it out at the roots. I've never seen a tree grow so fast! And the grass is longer and thicker than elsewhere, like a carpet for angels. The dahlias that Giuseppe and Matilde gave me back in March are still blooming, along with tiny purple alyssums, which creep playfully along dirt patches on the rockface. Matilde says that the white-and-red geraniums on the windowsills should be good outside for another few weeks, before the frosts set in

Finally, miracle of miracles, Chiara is also back at school! It feels as if we've all finally emerged from a major battle, victorious — and in a way I suppose we have. The reopening of the schools in Foligno is a strong sign that order is slowly being re-established. For the time being, school hours are from 2 till 6 p.m., and will remain so at least until Christmas. No longer housed in the wonderful, decrepit old *palazzo*, Chiara's particular school has taken up cramped quarters in a more modern building some streets away. Next to the school a *tendopoli*, a tent city, is set up for those who have nowhere else to go. Life in these mass camping grounds has settled down into some sort of routine, a tedious existence for those awaiting rehousing.

Soon the tents will be replaced with prefabricated houses, called 'containers' here. The Via Flaminia has been jammed with great trucks carrying these mobile homes to Foligno, Colfiorito, Sellano and Nocera Umbra. At least they offer protection from the imminent cold.

Along the Road of the Mills we are thankful that life is returning

to normal. In the late afternoon I go walking with Hot Dog among the hillsides and along the Panoramica. We traipse over to look at the ancient tree of St Emiliano once again in Bovara; Hot Dog comes back covered in burrs, looking like a doggish imitation of St Sebastian.

Striding along the Panoramica, I stop for a while and gaze at Trevi in the distance. This year the foliage on the horsechestnuts, poplars and oaks around the town appears more vibrant than ever. Autumn is always a colourful spectacle in Europe, but this year a dry summer has been followed by a mild early autumn, which causes the leaves to become more intensely yellow, orange and red. And the olives are abundant, little splashes of dark purple nestling against clumps of silver-grey leaves. They say it's a good year for olives and for grapes. Some plump olives look almost ready to pick, but so far there's no evidence of the olive pickers with those big hessian bags on their backs.

As we near the Millhouse, walking the last steps along the Road of the Mills, a blustery wind blows up. It seems to come from nowhere. Hot Dog is excited, and barks at the scattering leaves. I look behind at Monte Brunetti, and to my surprise see that great black clouds cover the hilltop, moving towards me. There will be a storm, and it looks serious. My spine tingles. I run up the gravel driveway, the dog close at my heels, suddenly eager to get inside.

ℊ

If you stop to think about it, earthquakes are just natural events, after all — the shaking of the ground due to the breaking and shifting of subterranean rock under intense pressure. So is weather — bad weather, especially the sort of weather we've been having. In the end we are insignificant against nature's backdrop, perched here, quite helplessly I suppose, between the sky and the flatlands below.

The temperature has plummeted from unseasonably warm to unseasonably cold in the space of a fortnight. Heavy coats are taken

from under protective plastic, aired and hung on the coat-rack near the front door, like faithful sentinels.

Rain pours down, and snow sprinkles itself generously across the peaks and ridges of the Apennines — in October!

The papers and television brim over with images of the homeless of Umbria still living in tents. The daunting task of creating areas upon which container-cities might be situated, of clearing the land and connecting services, is far from complete. Of the 3000 promised containers, only 800 are already in place, so many of the earthquake victims are still in tents and extremely vulnerable to nature's vicissitudes. They don't need a wave of such wild weather.

The main issue has been whether people or artworks are the national priority, but now that the weather has turned nasty the either/or debate has been laid aside while quick solutions to housing problems are sought. Some families have been transferred into the hotels around Assisi, but many refuse to leave their villages and their vegetable gardens. These are people who identify closely with their land, their extended families and close-knit communities. They are not going anywhere.

I listened to such a man on talk-back radio this morning on a daily programme called 'Prima Pagina', where each week a foreign correspondent in Italy acts as host — today, the *Scotsman* correspondent from Edinburgh had a go. Most of this week's programme has centred on post-earthquake issues. To his obvious surprise, one of the telephone calls came from Romano Prodi, the present Prime Minister, who enquired what sort of set-up exists in Britain in the case of a national emergency.

'For example, how many tents do you have in stock in Britain in case of a natural disaster, of thousands of homeless?'

The correspondent admitted that he didn't actually know, before thanking the Prime Minister for calling.

'I try to listen every morning', answered the Prime Minister.

The next caller, hot on Prodi's tail, told of his five children and wife living in a tent in the snow, still awaiting their container. There, bulldozers are still clearing the site. So, he argued, why could the container not be unloaded into his *orto*, his vegetable garden.

'I could connect it up to the services myself — I know how to do these things', he told the radio announcer, 'and I've done much trickier things in my day. Maybe if he's still listening, the Prime Minister will take more of an interest and get things rolling up here, or let us get on with it ourselves.'

Up in the Bar Roma a couple of hours later I hear a couple of locals discussing the same programme. *'Boh!'* snorts one, 'I can't see why they didn't put the people into hotels first off — especially the children and old people. I mean, the hotels are half-empty at this time of year, anyway! Even if not in Umbria, what about the big ones along the Adriatic coast! It's the end of the season, no? They've taken so much time and money setting up the *tendopoli*, the tent cities, and now they have to find other places, further away, to put the containers! A double job!'

'But the people won't go! They don't want to leave their houses, their animals.'

'Si, si, but sometimes its a case of being cruel to be kind. I've seen a few hard cases myself in these past days — old folk who've dug their heels in, refused to budge. Now half of them will have pneumonia! If you ask me, they should have been under medical orders.'

The other man looks doubtful, but admits, 'You've got a point about the tents taking up all the space where the containers could be. I agree with that. *Santa Madonna!* What a mess!'

The two then stand up, and put their heavy-duty jackets on.

'Ma!' says one, shaking his head. 'That's just the way it is, I suppose. That's life.'

The other one sighs, and scratches his head, *'È una problema.* People don't know what's good for them, do they?'

'Sometimes you've got to push a bit — apply a bit of pressure where it hurts. Otherwise there's too such *confusione!'*

<center>ℭ</center>

Towards the end of the month the temperature rises a few degrees. We're glad of the warmth, and summer shadows have decided to linger a while longer before winter moves in. Then the day comes for Tim and Felicity's departure for Sydney. As afternoon slides into early evening, we sit in the kitchen having a last cup of tea.

Aurora, just back from Greece, comes screeching up the driveway in her old Fiat. Unbelievably, her house has not suffered at all in the earthquake. We have been so lucky, all of us.

She rushes in with a bottle of her new season's oil for Tim and Felicity to take back to Australia, Customs regulations permitting, and exclaims breathlessly, 'It's some of the earliest oil of the season! I wanted you to have it. They had to get the press working again over in Bovara, and tried it out on my olives. I probably should have left them another week or two, but you know what it's like — I couldn't wait! I'm like a greedy baby at the breast when it comes to Olio Nuovo!'

She opens her bag, lifts out a long-necked, green bottle and turns to Felicity, 'Here, take some to remember me by. If you can get it into the country — I've heard they're pretty tough down there!' she laughs, hugging Tim affectionately. 'But I like the idea of you tasting this at your home so far away, while we're back here in the heart of Italy, with our fires lit, with the snow on the mountains.'

Aurora joins us for a glass of farewell spumante, which seems in order, despite just having finished the tea. She grins as I hand it to her, and I think how fantastic she looks, like a shiny ripe olive herself. I think to myself how comforting it is to have her back in Trevi, for I know I'll miss Tim and Felicity badly for the first few days. It's not really that I feel left behind, or abandoned, but we've certainly grown

<center>287</center>

used to having a relaxed Australian way-of-being breezing about the place — first with Ryan, then Pat and Hugh, and finally Tim and Felicity. And the children, Julian especially, revel in this Australian connection.

As usual, my insides turn to mush while attempting to get the goodbyes over. We make them more a light-hearted *ciao* than farewell. After their car disappears along the Via Flaminia, Aurora puts her arm around me, and we go back inside. We drink another glass of spumante and listen to the Crowded House tape Tim left behind. Aurora tells me tales of her holiday in Greece.

Time floats on. I look at my watch — 8 o'clock. 'Aurora, wait here! I must go and pick up Julian from a Halloween party. I'm running late!'

I throw my leather jacket on, drive over to Bovara where the party is being held. On the way over I sight the first of the olive pickers in the fields. Their ladders are all in position, leaning up against the trees along the Panoramica.

Already olive-picking time. The year is nearly over, and there's still so much to do!

November

TODAY, SATURDAY, there's a wispy fog in the valley and the air is cool with just a little tang — perfect walking weather. It happens also to be All Saints Day, a yearly date when the numerous cemeteries around Trevi are packed with families from dawn to dusk. On this occasion visiting the tombs of deceased loved ones is a ritual and *dovere*, an obligation. Below the Capuchin cemetery, the olive pickers are out in force, filling their hessian bags with a fruit that has been grown here for well over 2000 years, although the first olive trees may have arrived in southern Italy from Greece even earlier than that — about 3000 years ago, around the time that the Etruscans of central Italy were developing trade with the Phoenicians. Olive plantations in the area of 'Trebiae' probably go back to Roman times. The sunny south-facing slopes surrounding the Millhouse, relatively protected from the Tramontana winds, must have seemed ideal to those early cultivators.

Olives are traditionally grown throughout the Mediterranean, from northern Africa, the Iberian peninsula and southern France to Italy, Greece and Turkey. Archaeologists think that perhaps it was the first cultivated plant, at least in the Mediterranean basin. The tree is a constant fixture in the landscape, almost a symbol for the Mediterranean, which generates a temperate and dry climate perfect for the fruit.

Aurora knows so many myths about olives, symbols of life and

peace throughout antiquity. She says that, before recorded history, the olive was more bush than tree, and that, even then, our distant ancestors ate the fruit.

Together Aurora and I take Julian and Hot Dog for another of our long, lazy walks through the olive groves.

'There are so many stories I could tell you!' Aurora says, taking Julian's hand in hers as we walk along the dirt track that Julian now refers to as the 'firefly road'. 'Stories about the olive tree. First the ancient Greeks, who have many versions of the origin of the olive — for them it was a sacred plant.

'Do you know Julian, some say that it was Hercules who brought olive seeds from the Crimea — then the land of the Hypborians — and planted them at the foot of Mt Olympus?'

Aurora knows of Julian's devotion to *Hercules*, the TV serial version, and all the new games based on his exploits. She sees he's immediately hooked, and continues brightly, 'Then, there's another version that Athena, goddess of wisdom, offered an olive plant to the people of Attica, whose love and devotion she was trying to win over. If I remember the story, she was competing with Poseidon, god of the sea — now he was another interesting character!' She looks at Julian, and asks, 'Shall we sit down a bit?'

He nods, and we find a rocky rise between some of the trees. Aurora continues, 'Anyway, Poseidon offered them a magnificent horse that had mysteriously arisen from springs flowing from the place where he'd pierced the waters with his trident. But Zeus, the father of all gods, awarded victory to Athena. He said that she had offered the people of Attica peace, whereas Poseidon, offering dominion over the sea, incited them to war. Goodness, if I think about it, there are so many stories! Shall I tell you more, but just about olives?'

Julian, his head in my lap, nods again.

'Let me see. Well, there was Aristeo, son of Apollo and Cirene, who

was a shepherd half-god, let's put it like that. He learnt how to cultivate the olive plants from the *ninfe*, the nymphs. They were beautiful divinities who inhabited mountains, rivers and trees, in ancient times — and indeed perhaps they still do, if only we still knew how to look! Anyway, Aristeo passed on the knowledge to all the people he met. In his wanderings he travelled as far as distant Phoenicia in north Africa, where the plants grew strong, bearing many lush, ripe olives. From there, it is said a dove carried an olive branch back to Greece, to the temple of Zeus and Olympia. Because of this, the olive trees at Mt Olympus are still considered sacred, and from them come the branches that are used to crown the victorious at the Olympic Games. In the same way, the olives of the Acropolis are also sacred.'

Aurora turns to me. 'Ah, that reminds me of something I read by Aristotle, who said that in antiquity whoever harmed an olive tree would be severely punished.'

'How severely?' I ask.

'Ha! It could even be the death sentence! In his time the law was still current, but I don't think it was enforced that often. And that reminds me of a story of a wealthy landowner at the end of the fifth century', she glances at Julian, adding 'before Christ, that is–'

Julian looks up, 'I know that.'

'–who was accused of the shameful act of having pulled from the earth a dried-up trunk of an olive tree. He, poor man, had his land confiscated, and was sent into exile.'

In the Old Testament the olive appeared frequently. In the story of Noah and the Ark, after forty days and forty nights it was a dove that carried an olive branch back to Noah, signifying the end of the great flood. It represented prosperity, joy, and friendship, and was described as a symbol of strength and wisdom; then the oil was used to purify and consecrate altars and sacred utensils.

The more down-to-earth Romans didn't ponder the origins in the

same way as the Greeks, but they did see it as a symbol of peace. For them, it represented innocence, physical and spiritual wellbeing. The branches were used to decorate temples. Noble warriors were crowned with olive wreaths, as were the betrothed, and especially important people at ceremonial funerals. The priestesses offered libations of olive oil to the gods and goddesses of the earth and of the harvests, while farmers oiled the blades of their ploughs with this precious liquid to ensure a good harvest.

The Romans used different words to describe the characteristics of the oil. There was 'Acerbum' extracted from green olives, 'Strictum' obtained from semi-ripe fruit, for external use, 'Commune' from mature olives, and finally 'Cibarium', a lower-grade extract from imperfect fruit, a bit like today's 'Olio di Sansa', to be consumed by plebeians and slaves. The demise of olive plantations went hand in hand with the collapse of the Roman empire and the successive waves of northern invaders, for the olive was a plant that required peace, long periods of maturation and care on the part of cultivators. Abandoned, the plants went wild, or all but disappeared.

During the Dark Ages, following the fall of the Roman Empire, olive cultivation survived in the fields and orchards of the great monasteries of the Benedictines, Dominicans and Franciscans. In the fourteenth and fifteenth centuries trade in olive oil once more became lucrative, and areas such as Puglia in southern Italy and Liguria in the north were home to a thriving industry.

The history of the olive tree has always gone hand in hand with economic developments. In the sixteenth century, for example, an unsettled period in Italy, production once more diminished, only to improve in the eighteenth century, when countries such as Russia, England, Germany and Belgium developed import markets. The unification of Italy was followed by a period of relative stability. Agricultural techniques improved, and in many areas plantations increased. By 1890 prices began to oscillate, and areas such as Puglia

and Calabria diversified crops, introducing grapevines, while in Liguria trees were destroyed to make way for cash crops.

According to what Aurora says, 140 years ago Trevi had about thirty functioning presses, connected to the *aziende agricole*, the farms dotting the countryside, most using the ancient means of a donkey or mule to turn the wheel. Ours was one of these, part of the property of a local noble family. Later last century some of the more progressive Trevani experimented with technological innovations such as steam heaters, *caldaie a vapore*, to speed things along; by 1888, of the twenty-two presses still in use in Trevi, six were mechanised. From these mills flowed an oil that was advertised as being 'picked from the plant at the end of autumn; the best of which are cleaned and pressed straight after harvesting'.

Since about mid-October this year, preparations have been under way for the picking. I have seen many of the fields ploughed, and made as level as possible. Although in Umbria handpicking is still practised, tractors have been out and about in the fields below, driving in concentric circles around each tree and breaking up the rocks. The practice is followed in areas where nets are hung to catch the olives, or where the fruit is combed from the tree. Handpicking is still general practice in pockets of Italy — in Umbria, around Lake Garda and the Veneto region in the north — but now many nets are placed beneath the trees to catch the falling olives. All the tools of the trade, the ladders, baskets, gloves and storage containers are checked each year before use, and a dry storage space provided should rain fall during picking time. Downstairs in the Millhouse we still have twenty or so wooden containers with slatted bottoms where olives were once stored before the pressing, the same system still employed today: if not wood, then plastic containers are used, the essential characteristic being that the bases are raised from the ground, to allow air to circulate.

ℰ

It is local wisdom that the best oil is produced at the moment in which the *drupa*, the ripe olive, passes from green or yellow-green to a purple red, while the inside is still a fairly light colour. This usually happens between the last days of October and those of early November. The quality of the oil is compromised if the time between picking and pressing is too long, and if during the interim the fruit is not preserved in perfect conditions. And then if the olives are picked late, many will have already fallen from the branches, or even worse, suffered from an early frost. It is said that waiting too long will also have a negative effect on the following season's harvest.

So if quality is your game, it is essential for the picking to be swift, and as gentle as possible, for olives that are not treated with tender loving care will not produce as fine an oil. Straight after the picking they are carted off to one of the local presses.

Italy is still the world's number-one producer of extra-virgin olive oil, thanks also in part to a nationwide effort to increase awareness among Italians of its nutritional virtues, and despite the fact that oil is imported also from other Mediterranean countries such as Tunisia, Morocco and Turkey.

The first weekend of the month is reserved for the 'Festa del Olio Nuovo' at one of the local presses, so on Sunday afternoon Giancarlo, the architect and his boy Leo, Julian, Aurora and Chiara decide to take a look. Outside the main building, a stall has been erected, and local girls are already busy supplying the crowd with great slices of grilled bread, *bruschetta*, spread with the unfiltered new oil, straight from the press.

The recipe for the *bruschetta* could not be simpler: bread, garlic, salt and oil. The new oil tastes sublime on the *bruschetta*, but would overwhelm most dishes — fish, for example. A subtler taste will come later, either for the filtered oil, or when this first cold pressing has had time to settle. That should take a couple of weeks. The *bruschetta* is washed down with glasses of *vino bianco*, the local Terra dei Trinci.

When our press was still functioning in the 1950s, apparently there was a mini New Oil Festival every year at the Millhouse. I have heard tales of *bruschetta* feasts, said to have been joyous family affairs, held in the room that is now my studio. Then, in 1956 there were terrible frosts throughout the region that devastated the olive plantations, so the Mill probably ceased activity that very November — the month I was born, and my mother, recovering in the maternity ward in a Melbourne hospital, saw television for the first time in celebration of the Melbourne Olympics.

At the entrance to the pressing rooms stands Franco, Trevi's passionate homegrown historian who helped me last year with information on our chapel. He is in good form, as usual, in suit and tie among the jeans-and-parka set. As I greet him I reflect on how familiar his mannerisms and those of other Trevani have become over time. It seems so long ago that he first told me about St Costanzo. Seeing him reminds me how much there is still to discover about our resident saint, but I am aware I am becoming more like the locals, co-existing with the past, but delving less into it.

Franco asks us if we would like to have a tour of the *frantoio*, the processing room. We step over straw mats into a large room where all the machines are in action, for part of the *festa* is a demonstration of the oil-producing process. He explains that once cleaned of any leaves and twigs, the olives are ground to form a paste, and to release the oil that occurs as droplets in the cells of the flesh. For millennia this was done by a huge granite wheel, one of which is still in place here. It looks almost identical to the one in the Millhouse.

The oil and water in the paste are then extracted by powerful, noisy presses, and pumped into tanks to settle. The lighter oil then rises to the surface, to be drawn off. This oil is then mixed with warm water and separated by centrifuging; a step repeated several times. After this, the oil may or may not be filtered to achieve more clarity. It takes a lot of olives, for one needs about 100 kg to produce 10 to

12 litres of oil. That's a lot of handpicked olives! In this particular co-operative the members produce only filtered and unfiltered extra-virgin oil, and are very proud of the fact that there are no blends with inferior oils; no production of simple Olio di Oliva, extracted from low-grade olives and pulp residues, so bland in flavour after one has tasted the delicious velvety richness of extra-virgin oil.

An even lower-grade oil, obtained by solvent extraction from pulp residues, is used to make soap or refined for use in edible-oil blends, and is known as Olio di Sansa di Oliva. This is definitely considered a no-no around here, where high quality is the goal. It is one of the things that strike visitors to Umbria: this devotion to high quality, and the refusal of the inhabitants to accept second best — at least, as far as food goes. Then there's the fact that olive oil has become hugely popular in the last decade in countries that previously consumed massive amounts of butter and cream, so that the oil producers of Umbria feel themselves part of the vanguard. They all know of its curative and medicinal properties; how it protects arteries, lubricates intestines, helps the twentieth-century battle against cholesterol, and may even act as a preventative to some forms of cancer. Olive oil is the only oil extracted without the use of chemicals and therefore able to maintain its authentic smell, thus stimulating the taste buds and improving the digestion.

Giancarlo follows Franco into the little shop, and picks up a few samples of Olio Nuovo for friends in Rome, especially his Sardinian flatmate, Pino, who is passionate about good food. I shake hands with Franco, and join Aurora outside. She waves up to me as I come down the stairs. 'Come, Virginia, and have another little sip of wine — red wine now — to warm your blood!' The young woman behind the counter pours some out, and hands it to me.

'I'm almost tempted to try another hot *bruschetta*. It's freezing out here!'

Aurora gives me a hug. 'It's cold, yes, but look at the stars! *Salute!* Cheers! To olive oil, and to one of my old heroes, Plutarch, who knew

a thing or two. It was he who said something like "Olive oil is a gift of the gods to mortals". Let's drink to that!'

<p style="text-align:center">❡</p>

Towards the middle of November we are subjected to a few new shocks.

So it still isn't over. There's some general nervousness, but the tremors are never stronger than 4 or 5 on the Mercalli scale (2.5 on the Richter), although there is further damage to weakened structures in towns such as Sellano, where 80 per cent of the citizens are in containers or tents.

I cancel yet again another overnight trip to Rome, for I don't want the children feeling the ground shifting beneath them with me away. But what I would give at times to be far, far from here. I feel strangely rooted to the soil, but am beginning to resent it. What I need is a good holiday, but after the earthquakes I feel apprehensive, tied to Trevi, unable to leave. Chained to the earth, somehow. It is hard to explain to people who have not gone through it. There is no denying that life has become more complicated for everybody around here.

Leaving the disadvantages aside, I ask myself if I'm not getting what I'd always hankered for, in a roundabout way: a deep connection with a place, for better or for worse. That was what all this travelling was about in part, wasn't it? All that searching for a base, for terra firma.

When I voice my frustrations at all the emotional turmoil that rises in the earthquakes' aftermath, my feelings of claustrophobia, Giancarlo protests, 'It's just a bad patch! Do you think you're stuck in Trevi forever and ever? Don't be so dramatic! There is so much to do, anyway! We need to pick our olives in the next week or two, so just think about that, and about those exhibitions coming up, and your writing. You really could give me a hand when we get the nets to do the picking. Rome can wait — the world can wait.'

Can it? Won't I get left behind? '*Si, si, va bene*', I tell him.

<center>¢</center>

The following Saturday the weather is perfect. Sunny, clear, crisp and tangy once again. Good-time weather. We are out on the hillside soon after sunrise with two members of the Gasparini clan, forty-year-olds called Giorgio and Alberto, who have been roped in by Giuseppe to give us a hand — the deal is that they take half the oil, or be paid by the hour, whatever we prefer.

I am handed a hessian bag to sling over my shoulder and good tough gloves to protect my hands. But do I really need them? My hands have seen everything — rivers of turpentine, clay, cement, oil paints — the hands of a manual worker, more or less, despite the nail polish and the rings. I wave them about when Alberto offers me the gloves.

'No, *grazie*, there is no need. I'll be fine without.'

He clicks his teeth in disapproval. 'Signora, no! You must wear these. We all do. It's hard work, you have no idea. Your hands will be hurt badly if you don't protect them.' He's only trying to help, so I give in with good grace and quietly slip the gloves on. After just a few minutes it is clear just how right he is. Then Giorgio and Alberto give Giancarlo one of the large plastic combs and show him how to use it by taking one of the branches and pulling the teeth along it. All the olives drop into the net.

'Lots of leaves are coming off too, though.' Giancarlo looks dubious.

'*Non si preoccupa*, don't worry. A sort of fan strips them off at the mill. You'll see.'

I prefer the idea of handpicking into a hessian bag, and as the morning slowly moves on, I begin to admire those wiry old men and women I'd see up on ladders on my walks through the valley. This is damned hard work!

I pluck the fruit, one by one, from the plants, and with each

<center>298</center>

movement become more and more convinced that maybe mechanical picking is a good idea after all. But at least it is better than peach picking, I decide, as memories of Araluen Valley in Australia spring to mind and of summer vacations — twenty-five years ago now — spent peach picking with my friend Kath. I remember the maddening peach fur sticking to our hands; no one had offered me gloves then, come to think of it, during interminable hours spent in the packing line, filling wooden boxes to be sent to the markets of Sydney and Canberra. I think we only lasted a few days. The crack-of-dawn routine, the hours and hours standing in line waiting for teatime, the low pay, hadn't convinced us, even for a season. This is pure enjoyment when compared to that.

Giorgio and Alberto whistle as they work. I watch them, and wonder if they are as at peace with the world as they seem. They can't be! We pick the olives all that weekend — or rather, they do, as on Sunday Aurora declares she's whisking me away to Torgiano, a town near Perugia, to an exhibition of ceramics made by three well-known artists in honour of the new wine, Vino Novello, produced by the Lungarotti vineyards. She invites Giancarlo too, but he won't be diverted from the task at hand.

In Torgiano, home to some excellent wines, there's a good turnout of local artists, from Perugia, Spoleto, Orvieto, Todi. Franco from Spoleto is here too. He joins us in front of some of the contemporary ceramic jugs set up on plinths in the wine museum. 'It's hard for me to see anything that inspires me any more. The only thing that seems to be worth doing now is to create a highly personal *linguaggio poetico*, a poetic language.'

I know what he means. He is speaking of poesis, creation. The creation one sees all about in Italy, and why Italy still soothes the soul. The creating of form from chaos; reordering, making beautiful, like the new wine from the grapes and rich green olive oil dripping from the press.

We drive home in the last light to find our wooden boxes stacked high, each full of the fruit. I am impressed. Giancarlo is satisfied, grinning from ear to ear as he laps up Aurora's compliments. Giorgio says they'll come over tomorrow to take them to the press.

'We're booked in at 11 a.m. There are not enough here to make two *quintali*, so we'll add some from our harvest to bring the weight up.'

A quintal is equal to about 220 pounds (100 kg), and we need about double that to be eligible to use the press; or rather, the owners reserve the right not to prime the machines up for any less. We agree to press ours along with Giorgio's to make up the extra weight. So the next morning we fill sacks with the fruit, and drive over to the little hamlet of Pigge where the *frantoio*, the olive press, is found.

First, they weigh the bags. As Giorgio had told us, the fruit is then emptied into a sort of vacuum where a powerful fan separates the olives from the leaves, hundreds of which spew out onto the floor before being swept away. The olives are then ground under two great stone wheels turned mechanically to produce a thick purple-black paste. That, in turn, is spread in great layers between circular mats made of cord, with holes in the centre.

'The hole is so that they can fit over that pole there, one on top of the other, see?' says Giorgio.

We look at the steel pole over which the mats are piled one on top of the other. The olive pulp is then pushed slowly through the press until all the oil and water have been squeezed out. The final product is thick green olive oil, which is then siphoned off into our 5-litre demijohns. We get a total of 37 litres, which works out at about a litre for each tree.

'Do you want it filtered?' Giorgio asks.

'Why, do you filter yours?'

'No, but it's a personal thing. Some do, some don't. Come through to the other room, I'll show you what it looks like when it's been done.'

We go through into an equally spotless *cantina*, a cellar where the oil has been filtered from huge metal vats into bottles; the client has laid out before him a set of elegant green cans awaiting filling. The woman doing all the work pours a little of the oil into a jar to show us.

'Mmm, *capisco*, I understand', nods Giancarlo. 'It is just the way a good-quality oil looks commercially — a more transparent green, lighter, isn't it?'

'And there is no sediment, so it looks better. People prefer that.'

Alberto, who is a man of few words, suddenly pipes up, 'But you lose something of the taste too, remember that. Once you grow used to the unfiltered oil, it's hard to eat anything else. At least, that's the way we see it.'

I have to agree. There is no oil better than cold pressed, unfiltered olive oil from your own trees, lined up later in your own cellar.

'OK, we'll leave ours unfiltered.' Giancarlo turns to me. 'You know what we should do? Get some little bottles from the glassmakers in Spoleto — you know those 250 ml bottles like you see in the delicatessen — and give some to special friends. You can do an illustration, and we can label them.'

'Great Christmas presents. Our own exclusive brand!'

Alberto laughs. 'But you need a brand name then!'

I nod. 'Don't you worry about that.' I can see it all — the miniature long-necked bottles, the labels with an illustration of the chapel, the name. It couldn't be anything else if we were to be faithful to the hillside, the trees, and the spirit of the place. 'Olio di St Costanzo!'

'*Brava!*'

Everyone is happy with that.

¢

There is growing concern about the tourist industry, which has seen a massive reduction in visitors all over the region, despite the fact that overall only 13 per cent of the territory is directly affected — mainly

the area of Valnerina, Foligno, Assisi, and the hill-towns of the Marches. We all notice how few visitors there are; very few foreign cars around, no blond Germans and hill-walkers sitting in the bars, no different faces in the restaurants. To signal that there is life after earthquakes, the town council hosts a dinner for one hundred prepared by a famous chef called Paracucchi, who has plans to open up a cooking school in Trevi. He's a big fan of Trevi oil, and has bought a house here.

The location for the dinner is the renovated hall of the one-time Cocchetto restaurant, which rumours say might become a sort of private club for gourmets. The Cocchetto had been a famous restaurant in the 1960s and 1970s with its stunning location, for the view from the vast arched windows spreads right across from Spoleto to Montefalco. Lights sparkle below us in the clear night air. It's all very, very grand for Trevi.

The evening begins with spumante from Umbrian vineyards, and while the hundred or so guests gather in the big hall, an appetiser of tempura prawns and artichoke hearts is served. In the general confusion someone shows Giancarlo and me to our seats. At our table, conversation predictably revolves around earthquakes, rebuilding and the collapse of the tourist industry, which is hitting local people hard. When I sit down, the mayor is already deep in conversation with a glamorous woman to his left. He introduces me and continues, 'It's something else to give the next generation — we need to give work to our children. People here are very attached to the land, to the idea of *terra*. They call it *mia terra*', he tells her.

'But what do you hope for your children, for your two little boys? That they stay here?' she asks.

'I really haven't thought about it. But no, not always. I hope they go away — at least for a while. Here possibilities are limited, you know that. But at the same time, I'd hope they remain tied to the place emotionally, and return — to their place, *la loro terra*. It's

important. And they are lucky to come from such a beautiful part of the world, don't you think.' He turns to me.

'I know, I know', I say. 'Roots, *radici*. Like little plants.'

A waiter pours him a glass of white wine from South Australia, for one of the reasons that the dinner is being held is to celebrate recent business deals between that state and Umbria, mainly relating to potential olive plantations. The *Sindaco* takes a sip, and smiles at me, 'It is good. *Complimenti.*'

A lively discussion follows across the table about the relative qualities of French, Italian, South African, Californian and Australian wines. For some of the guests it is their first taste of Australian wine, and a revelation.

'You know,' laughs Carlo, 'I would never have thought that the old building down on the Costarella would have been bought one day, restored and that we'd be sitting here tasting your excellent Australian wines together. Life is full of surprises!'

He leans towards Giancarlo.

'I used to go down there, to the Millhouse, when I was a kid, twelve or so — you know, with some of my friends. Even though it is close to Trevi, it felt isolated; it was a sort of a magical spot with all those overgrown plants and the ivy clinging to the walls. We thought it was a bit scary.'

'And what did you do down there, exactly?'

Carlo turns towards me. 'There was a little room at the end of the building — dark, narrow, with a tiny window, 20 centimetres or so across–'

'I know, Gian!' I exclaim, 'Carlo's talking about Chiara and Julian's bathroom. That is where Giuseppe Gasparini said they used to keep pigs — you know, back in the 1960s.'

'No, no,' Carlo shakes his head, chuckling, 'it was too small for pigs. Maybe it had been used as a storage space or something like that. But when we went there the entire building was abandoned.

The main part was locked up, so we had just that hideaway. We used to go there, four or five of us at a time, a gang of twelve-year-old boys. I used to go down to my grandpa's house — he lived in Piaggia — with my cousin, sit with them for a while; there was always a fire going, I remember that. Sometimes we'd eat grilled snails–'

Giancarlo gets that distant, hunter-and-gatherer look in his eyes. *'Buoni!'*

'They were delicious', Carlo agrees. 'You know how he did them? Simple. I remember my grandpa would put them on the fire and you'd hear a sort of whistling sound, like air escaping. Then he'd take the snails out with a little prong-like thing — a sort of fork, I suppose — and roll them in coarse salt. *Buonissimi!* Anyway, one day an uncle of mine came to visit. He'd left Umbria in the 1950s and gone to Argentina. You know there was such a mass migration from Italy after the war.'

'Of course. Many ended up in Australia', I said.

'Ah, si. Around here, most went to South America. So this uncle came back and came to visit my grandfather, brought chocolate and other luxury items that showed he was doing all right. Everything was still very post-war, you know. I remember one day during that time that there was a packet of cigarettes left lying on the table, a white and red packet called Winston Double or some such thing. I think you can still buy them. To me, that packet was a fantastic symbol of other, distant worlds. We were used to homegrown brands. We smoked everything we could get our hands on!'

Giancarlo laughs. 'Like Nazionali, which you could buy one at a time. Remember them?'

'Si, si. And then there was Sax, or Alfa — you name it! The sort of rough cigarettes that would stupefy a bull! *Da stordire un torro!'*

'Sax were the worst.'

'Most probably! Anyway, I remember the day we stole a couple of these exotic Winston Doubles from my debonair uncle, and shot off through the arch at the end of your road. Come to think of it, I don't

think there was even asphalt on the road then. We needed a place where no one would see us, and discovered that little room at the Millhouse. We started going there often, sitting in that little room and chainsmoking; one or two other friends would come too.'

'Were there other gangs or whatever that used the Millhouse as a hideaway?'

Carlo shakes his head slowly. 'I don't think so', and adds, chuckling, 'Ah, I just remembered another thing! We used to take sweets with us to chew on afterwards, to try and get rid of the smell of the nicotine. But one of my friends got caught one day because his mamma smelt his hands, which of course just reeked. He was in big trouble. So we invented a sort of two-pronged fork out of suitable Y-shaped twigs. We would light the cigarette and place it in the Y so that our hands never needed to touch the smelly thing. We were really proud of that! Then after the big smoke we'd gobble down some liquorice, the real stuff, and think ourselves really clever!'

By now the whole table is listening to Carlo's story.

'Do you remember anything else about the building, the grounds?'

'No, we just made a beeline for that little room. I don't remember the chapel of St Costanzo that you can see so clearly now, for example. I don't remember it at all. It must have been hidden from view! I remember the weeds and high grasses. It all felt rather end-of-the-line-ish. At least to us boys. We never dared to try and break into the rest of the building, ever.'

I can see the chapel in my mind's eye. We have done nothing towards its restoration.

§

There is a cold spell, and I catch flu, this year's dreaded 'Milanesa'. I lie in bed for days and read a beautiful story of childhood and Ireland. I think of my own great-grandparents leaving Ireland in the 1850s,

and about my children, by some twist of fate, being schoolchildren in an Umbrian hill-town, with its slow rhythms, the smallmindedness of some of the inhabitants and the expansive generosity of others.

Then Giancarlo goes away for ten days, to South Africa and Mozambique. I try not to be jealous, but I need a holiday! While he is away, Mike the painter comes back, just for a week. He wants to visit his old haunts, walk in the mountains, clear his mind of Edinburgh drizzle.

I am so glad to see him again. But then, I am always glad to see people from Edinburgh. They always say I am far too generous about Scotland, that it really can be a stifling and unfriendly place, and how lucky I am to have found the Italian sun. But for me Edinburgh will always have the bittersweet tang of an unfinished love affair, and will stay forever young.

¢

Giancarlo comes back from Mozambique, and goes straight to work from Fiumicino airport. He rings me in the afternoon, his voice dragging along the current between us — from jet lag, from long waits in airports, and from the heat in Maputo.

'How was it?'

'Good, good. Everything went well. And Maputo was OK — better than I thought, actually, given all the problems. But let's talk about it when I come up to Trevi. How are things with you, with the children?'

'OK. Everything's fine here, even if it's getting really cold now. When are you coming? There are lots of things to talk about, Giancarlo, like that *motorino*, that moped, for Chiara. Remember?'

'I thought you didn't want her to get one yet!'

'I don't! But what can I do? She'll be fourteen soon — the last of her gang without wheels. I can't deny her this after she's put so much into being here, to fitting in. I suppose it will be all right if she stays away from the Flaminia', I add hopefully.

'Hmm. And always wears a helmet.'

'Of course. Look, I really need to go to Foligno and look at that shop I told you about. That's where all these kids here seem to get their mopeds. But I would prefer to go with you on Friday or Saturday. Does that sound OK?'

Giancarlo sighs, '*Si, si, va bene*'. Then I hear him drawing in a breath, as if hesitating.

'What is it?' I ask, curious.

'Well, there is something else actually. I didn't want to mention it yet, but I may as well. There was some news when I got back.'

'What sort of news, exactly? Not bad news?'

'No, no, nothing to worry about. It's just that I've been offered another posting.'

I feel as if everything is crashing around me. 'What? Another posting? But that's ridiculous! We only just got here!'

'*Si, si*. I know that, of course. We don't have to go. Or I could go first, next spring.'

'But, Giancarlo–'

'You could all come over at the end of the summer, in September', he adds, hopefully.

'And who will look after the Millhouse if we go away? And Hot Dog, and the cat?'

My head is reeling. I thought I had at least another year or two before confronting this. Anger bubbles up, not at him, at everything. 'It's impossible!' I almost shout down the phone, then immediately lower the tone, 'And what about St Costanzo's chapel? We haven't even started yet! I can't just abandon everything!'

'Oh look, this is not the time to talk at all — and it's probably a false alarm, anyway. You know how these things are', answers Giancarlo hastily. I can tell he wishes he'd never opened his mouth.

I pause, and count to ten. 'It's a bit of a surprise, to say the least. I need to think. And I need to really talk to you, even more than I thought.'

I feel pulled in two directions. It's a familiar feeling, repeating itself sooner than anticipated. Stay. Go. Later. Not now. Not ever. Not *ever!*

I take a deep breath. 'Listen, let's stay calm and talk it over on the weekend. You can't come on Thursday, can you — instead of Friday, I mean?'

'Doubt it, but I can try. I'll ring you before then. Tomorrow. Or even tonight. Listen, I've got to go now — there are some people waiting in the other office. *Ciao, cara.*'

I want to yell, 'Who cares about the people waiting. What about you, me, the kids?', but decide to behave myself. He really does have people waiting, after all.

Damn it, life was always going off in haphazard directions just when I thought the lines were straightening.

'*Ciao*, Giancarlo, *ciao*', I say, softly enough, trying to keep the brittleness out.

I hang up, and then walk over to the window and gaze into the valley. There is still a little huddle of olive pickers, purple spots dotting the silver-grey landscape, gathered in a field towards Bovara. Clouds are beginning to huddle together like sheep in the distance, way past Montefalco.

I have already warmed up the studio; I had turned the heater on ages ago. Time to work, but I feel restless and instead, walk towards the telephone again. I hesitate, then dial Giancarlo's number. The secretary puts me through.

'*Si?*'

'Giancarlo, it's me again. Just one little thing.'

'*Si, cara?*'

'Where?'

He laughs. 'I thought you'd never ask!'

'Very funny. No really, tell me. Where?'

He hesitates again, then whispers down the phone, slowly, softly, *pianissimo*, 'I'll tell you at the weekend'.

I nod, into the phone, into space, say goodbye and hang up again. Let's hope these questions, recurring when least wanted, about moving on and changing course midstream can be put on hold for a while, perhaps another year or two.

I go downstairs to the studio. To live like this, suspended, wanting terra firma for Chiara and Julian, for Giancarlo and me, but finding constantly shifting sands instead, challenges all that I have been trying to do here. The earthquake and its aftermath only served to reconfirm a lesson I try hard to avoid: that change is the only constant.

The big wooden door of my very favourite space, the place where masks are left aside, creaks open against my hand. I have started a new series of works, gone back to the origin of mark-making, to drawing. Before me, lining the wall are a series of large female bodies, strong, powerful forms with heads thrown back, each one set against a background of bright, thick yellow paint. For me, these are the bodies I've been looking for. They belong to all those empty shoes, all those footprints traversing the paintings of my previous work.

I set about preparing the paints, suddenly happy once engaged in the stuff of painting, the very physical act of personal creation, the acting-out of imagination. This, at least, is real and won't go away, whatever else happens; perhaps the only evolving part of my life that can potentially survive quite healthfully without a stable 'outside'. I put on my grubby, battle-worn painter's shirt, mix the colours for the skin tones, and set to work on the latest piece, rendering the roundness of the image's soft, female stomach.

I move the paintbrush in a large, sweeping circular movement, a never-ending female circle like the very roundness, the same generous sweeping movement, of the world.

Going back to the origin of mark-making, to drawing.

[Chiara Izzo]